BLACK

**EDITED BY
KIMBERLY DREW + JENNA WORTHAM**

FUTURES

**ONE WORLD
NEW YORK**

Copyright © 2020 by Kimberly Drew and Jenna
Wortham

All rights reserved.

Published in the United States by One World,
an imprint of Random House, a division of
Penguin Random House LLC, New York.

ONE WORLD and colophon are registered trade-
marks of Penguin Random House LLC.

Credits and permissions appear on pages 524-5.

Hardback ISBN 9780399181139
Ebook ISBN 9780399181146

Printed in China on acid-free paper

oneworldlit.com

randomhousebooks.com

987654321

First Edition

Jacket design: Greg Mollica

Interior design: Morcos Key

CONTENTS

INTRODUCTION
LETTER FROM THE EDITORS

Welcome to *Black Futures,* the first iteration of "The Black Futures Project" by co-editors Kimberly Drew and Jenna Wortham.

"The Black Futures Project" started a few years ago as a Direct Message exchange on Twitter and has evolved into a shared desire to archive a moment. In developing *Black Futures,* we sought to answer the question: What does it mean to be Black and alive right now?

We sought to make sense of our unique paradox: We have never been more empowered and yet, in many ways, are still so disenfranchised. Social media has granted Black folks a platform to tell our own stories, but it has also made us subject to a new brand of surveillance and unprecedented co-option. How can we find innovative ways to define ourselves, for ourselves, without fear of erasure or the deterioration of the Internet? We feel part of a long lineage of projects, artists, activists, thinkers, and creators centered on the Black experience. We consider *Fire!!* magazine, *The Black Book, The Black Woman: An Anthology, Conditions: Five: The Black Women's Issue,* the work of Kathleen Collins, and *9 More Weeks* by Sinazo Chiya as some of our most influential elders.

Black Futures is not designed to be a comprehensive document. Blackness is infinite— a single book cannot attempt to contain the multitudes and multiverse. This is just one manifestation of a project that spans millennia. We are in a continuum of those who came before and those who will come after and make a dent in the archival project that is required of us as humans on this planet. We strove to nod to those we admire who are making history, and those taking history and doing something anew with it. We aimed for a perspective that was global, atemporal, not dominated by America and the West, not constructed by binaries, and as dynamic as possible for a print book.

We invite you to read this book alongside a device so you can search out names and terms that intrigue you. See where they lead. Our in-tention is to encourage readers to follow their interests into a deep warren of rabbit holes and discoveries. This is not an art book. This is not a scholarly journal. This book is a series of guideposts for current and future generations who may be curious about what our generation has been creating during time defined by social, cultural, economic, and ecological revolution.

Like us, this book is not linear. Like us, this book lives and breathes beyond temporal Western frameworks. There is no past, present, or future, nor is there a beginning, middle, or end. Start where you please. This book was brilliantly designed by Jonathan Key and Wael Morcos to have its own geography, a map that can be navigated however you see fit. There are color schemes and indices throughout to serve as tools, but we did not want to subject the material to a major order, or any suggestion of a hierarchy. This is an invitation to create Black futures alongside us. For example, throughout the book, there are geometric symbols designed by Megan Tatem that resemble a fractal teacup. Those indicate recipes, or instructions, for you to consider implementing beyond our book.

Our process: We worked together and independently to collect these submissions. On these pages you'll find screenshots, original essays, manifestos, memes, artworks, poems, song lyrics, recipes, and creations of all types. Themes in this book will provoke you, entice you, enrage you, spark joy, and call you to action. Some of the connections are obvious, but many are not. We think that that's okay. Wherever possible, everything in this book was made by Black hands.

As you read, you may notice that some pages of the book are different colors. We made this choice with intention. Each color indicates a subgenre or theme that guided our collection process. Additionally, we wanted to ensure

XIV that there was as little white space as possible within the book. Pages that are yellow feature some key wisdom or observations of trends on social media. Pages that are black include prophetic prose and poetry. White pages indicate incendiary essays and artworks. You will also notice green pages, with a special geometric symbol designed by Megan Tatem, which indicate recipes. In some cases, it might be a recipe for something edible, like Pierre Serrao's coconut bread recipe on page 452. In others, it might be guidelines for how to start your own Black art collection—see page 316. We invite you to see these pieces as exercises to inspire you beyond the book, to care for yourself, to start an archive, and to feed you as you create your own Black Futures.

Thank you for trusting us enough to come on the journey with us.

In light, love, and solidarity.

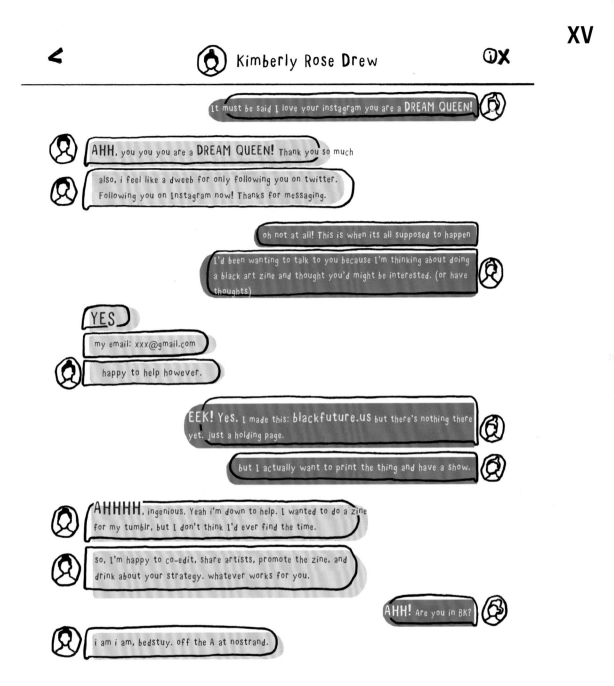

It must be said I love your instagram you are a DREAM QUEEN!

AHH, you you you are a DREAM QUEEN! Thank you so much

also, i feel like a dweeb for only following you on twitter. Following you on Instagram now! Thanks for messaging.

oh not at all! This is when its all supposed to happen

I'd been wanting to talk to you because I'm thinking about doing a black art zine and thought you'd might be interested. (or have thoughts)

YES

my email: xxx@gmail.com

happy to help however.

EEK! Yes. I made this: blackfuture.us but there's nothing there yet. just a holding page.

but I actually want to print the thing and have a show.

AHHHH, ingenious. Yeah i'm down to help. I wanted to do a zine for my tumblr, but I don't think I'd ever find the time.

so, I'm happy to co-edit, share artists, promote the zine, and drink about your strategy. whatever works for you.

AHH! Are you in BK?

i am i am. bedstuy. off the A at nostrand.

When Jenna slid into Kimberly's DMs, March 2015. Illustration by Jonell Joshua.

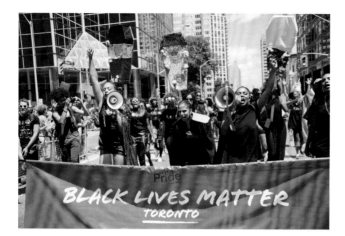

Black Lives Matter Toronto participates in Pride 2016 as an honored group. They later stage a sit-in and halt festivities to urge the inclusion of more Black LGBT members. Among their demands: a commitment to Black ASL and deaf interpreters and to increase indigenous visibility. After thirty minutes, leaders of Pride Toronto signed off on BLM's demands, hugged the demonstrators, and the parade resumed.

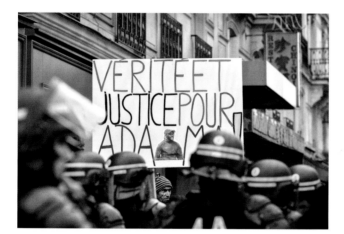

Demonstrators attend a protest over the death of Adama Traore in front of the Gare du Nord train station in Paris. The family of Adama Traore called for the truth on July 30, 2016, before a protest march in Paris. On July 29, 2016, a justice rejected the request to perform a third autopsy on the body of the young man, who died eleven days earlier during his arrest, said the prosecutor of Pontoise.

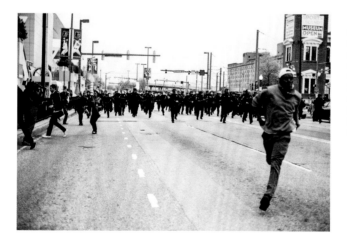

In mid-April 2015, the city of Baltimore erupted in mass protests in response to the arrest, hospitalization, and resulting death of Freddie Gray, who was severely injured while in police custody. This image is one of many captured by Baltimore native Devin Allen. His image would later be published on the cover of *Time* magazine.

BLACK LIVES MATTER

INVITED TO THE COOKOUT

DAVID LEGGETT

David Leggett
Invited to the cookout, 2017
Acrylic, oil bar, spray paint, and digital print on canvas, 84" x 84"
Image courtesy of the artist and Shane Campbell Gallery, Chicago

4

A

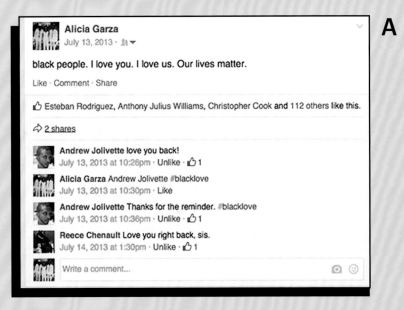

B

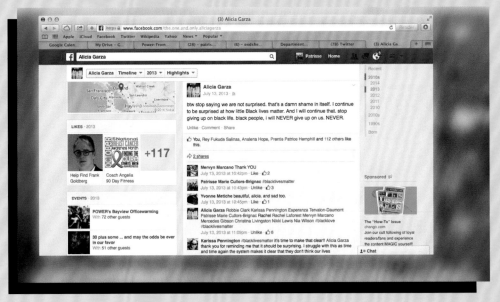

A.
Screenshot of Facebook
post from Alicia Garza,
July 13, 2013

B.
Screenshot of Facebook
post from Alicia Garza,
July 13, 2013

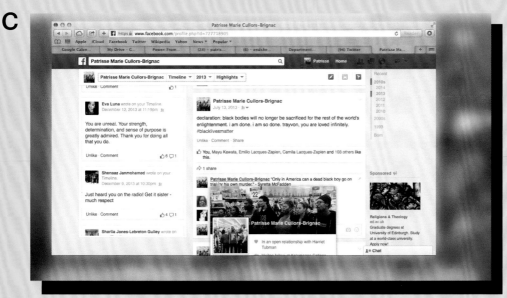

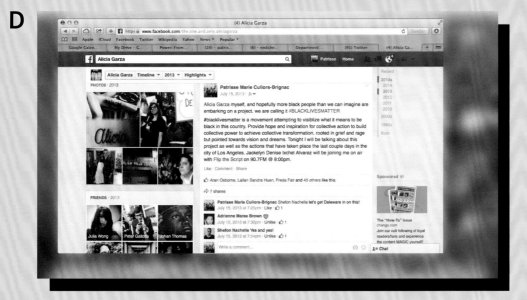

C.
Screenshot of Facebook
post from Patrisse Cullors-
Brignac, July 13, 2013

D.
Screenshot of Facebook
post from Patrisse Cullors-
Brignac, July 15, 2013

GARZA

The New York Times

Late Edition
Today, mostly sunny, warmer and more seasonable, high 84. Tonight, mostly clear, low 67. Tomorrow, sunshine and patchy clouds, high 86. Weather map is on Page C8.

VOL. CLXIII . . . No. 56,604 ©2014 The New York Times NEW YORK, MONDAY, AUGUST 25, 2014 $2.50

~~Two Lives at~~ Crossroads in Ferguson

A ~~Low~~ Profile Officer ~~With~~ ~~Unsettled Early Days~~

By MONICA DAVEY and FRANCES ROBLES

FERGUSON, Mo. — ~~On the early afternoon of Feb. 28, 2013,~~ Officer Darren Wilson ~~answered a~~ ~~police call of a suspicious vehicle where, the po-~~ ~~lice said, the occupants might have been making~~ ~~drug transaction after a struggle, Officer Wil-~~ ~~son subdued the suspect and grabbed his car~~ ~~keys before help arrived, the police said~~

~~A large amount of marijuana was found in the~~ ~~car, the police said, and the~~

~~20-year-old suspect was~~ ~~later charged, in~~
~~nection possession of~~
~~ijuana with the intent to~~
~~distribute marijuana af-~~
~~ter. The incident won Of-~~
~~ficer Wilson a commen-~~
~~tion, presumably by the po-~~
~~lice chief this year, as Offi-~~
~~cer Wilson stood, hands~~
~~clasped before him, and city officials looked on~~
~~It was, until this month, the work for which Of-~~
~~ficer Wilson was best known in his five years~~
~~with the police. But two weeks ago, Officer Wil-~~
~~son gained far wider attention when he~~ fatally
shot an unarmed black teenager named Michael
Brown, ~~setting off many nights of unrest in Fer-~~
~~guson and reopening a national debate over is-~~
~~sues of race and policing~~

~~"I'm a little shocked," said Doris Stewart, the~~
~~aunt of the man arrested in the vehicle, after~~
~~hearing for the first time this weekend that the~~
~~reportedly arrested had resulted in an award for the~~
~~same officer who had fatally shot Mr. Brown~~
~~"I'm also a little relieved that he wasn't badly in-~~
~~jured," she said of her nephew, Christopher~~
~~Brooks, who, like Mr. Brown, is black~~

~~The intense focus on Officer Wilson's actions~~

Continued on Page A16

A Teenager ~~Grappling~~ With ~~Problems and~~ Promise

By JOHN ELIGON

FERGUSON, Mo. — ~~It was 1 a.m. and~~ Michael
Brown Jr. ~~called his father, his voice trembling~~
~~He had seen something overpowering. In the~~
~~thick gray clouds that lingered from a passing~~
~~storm this past June, he made out an angel. And~~
~~he saw Satan chasing the angel and the demon~~
~~running into the face of God. Mr. Brown was~~
~~pranksio, so his father and stepmother check~~
~~ed it out~~

~~"No, no, Dad, No!" the~~
~~elder Mr. Brown recon~~
~~"Look at it," he said~~
~~For his son, who had just~~
~~recently graduated from~~
~~high school, the heavenly~~
~~display was a sign, even~~
~~though his father, who had just~~
~~took from high school, saw~~
~~in his father and stepmother~~
~~picture of the sky from~~
~~his cellphone "Now I believe," he told them~~
~~In the weeks afterward, until~~ his shooting
death by Darren Wilson, a white police officer,
~~on Aug. 9, they detected a change in him as~~
~~spoke seriously about religion and the Bible. He~~
~~was grappling with life's mysteries~~

~~Michael Brown, 18, due to be buried on Mon-~~
~~day, was no angel, with public records and in-~~
~~terviews with friends and family revealing both~~
~~problems and promise in his young life. Shortly~~
~~before his encounter with Officer Wilson, the po-~~
~~lice say he was caught on a security camera~~
~~stealing a box of cigars, pushing the clerk of a~~
~~convenience store who tried to stop him. He lived~~
~~in a community that had rough patches, and he~~
~~dabbled in drugs and alcohol. He had taken up~~
~~rapping in recent months, producing lyrics that~~
~~were by turns contemplative and vulgar. He~~

Continued on Page A12

Alexandra Bell
A Teenager With Promise, 2017
Digital inkjet on bond paper, 72" x 96" each; 144" x 96" combined
Image courtesy of the artist

The New York Times

Late Edition
Today, mostly sunny, warmer and more seasonable, high 84. **Tonight,** mostly clear, low 67. **Tomorrow,** sunshine and patchy clouds, high 86. Weather map is on Page C8.

VOL. CLXIII . . . No. 56,604 ©2014 The New York Times NEW YORK, MONDAY, AUGUST 25, 2014 $2.50

A Teenager With Promise

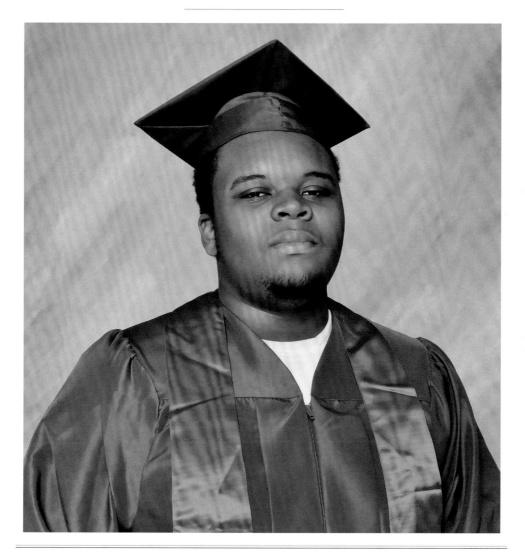

BELL

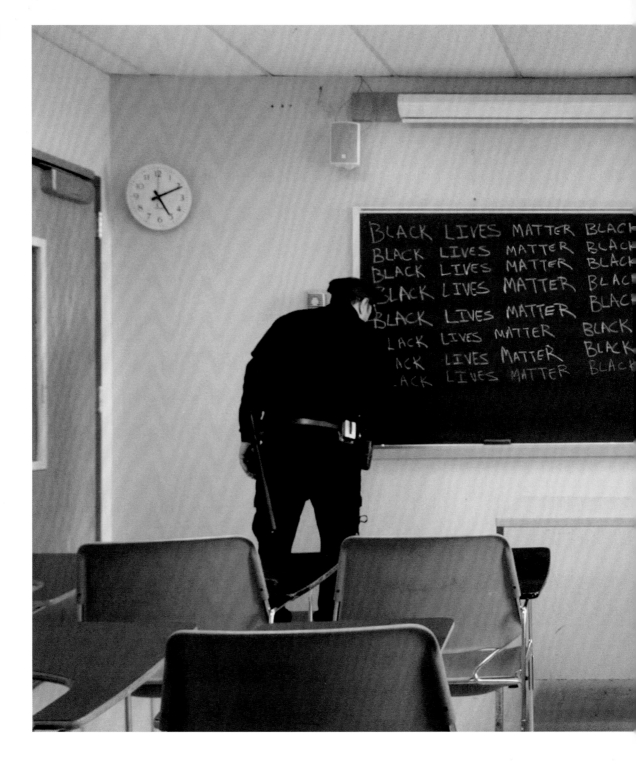

Sasha Huber & Petri Saarikko
Black Lives Matter, 2017
Video 7:19 min

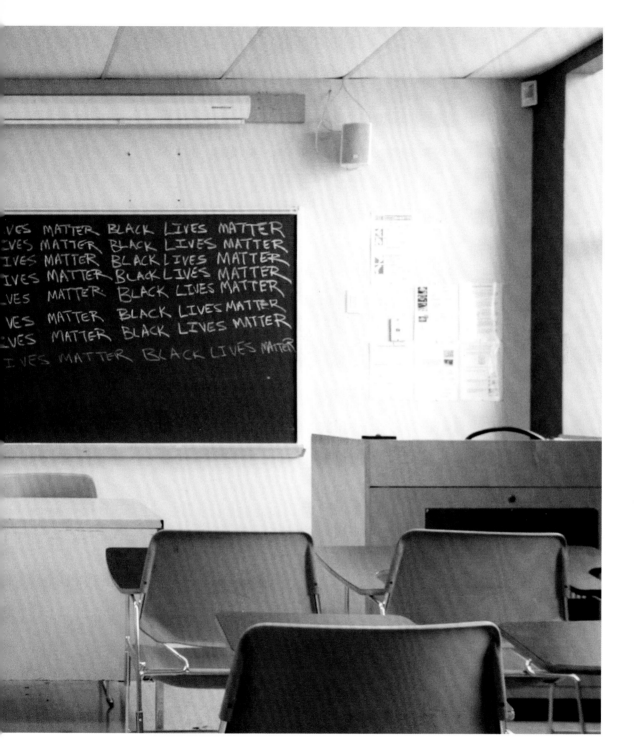

HUBER, SAARIKKO

BLACK SURVIVAL GUIDE

HANK WILLIS THOMAS

Hank Willis Thomas
Black Survival Guide, or How to Live Through a Police Riot, 2018
Screenprint on retroreflective vinyl, mounted on Dibond
13 components, 27 x 21 x 1¼ inches each (framed)

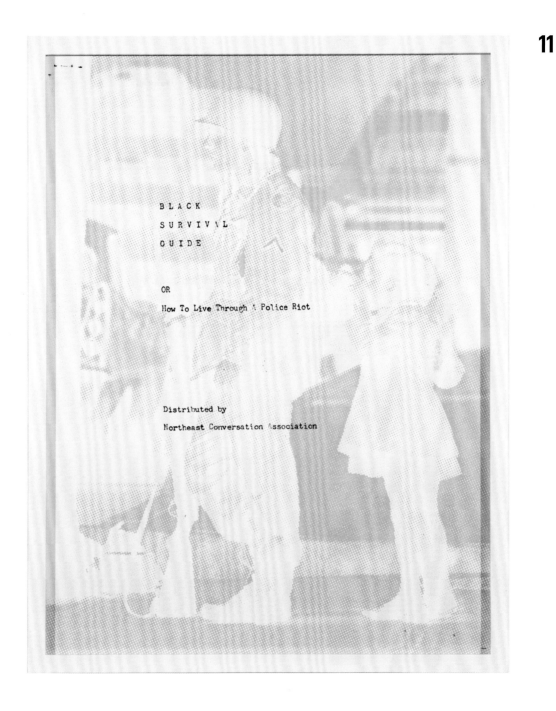

BLACK
SURVIVAL
GUIDE

OR

How To Live Through A Police Riot

Distributed by

Northeast Conversation Association

How to Live Through a Police Riot

THOMAS

IMPORTANT

Because you are black, this booklet is important to you.

It may help save your life.

Dr. Martin Luther King beleived in Non-violence.
He was murdered by violent white racism.

White USA says that it is going to kill more Black people.
Many have already died. Many more have been threatened.

They will use guns, gas, cannons, tanks, helicopters, spies,
lies, laws, twisted news reports, judges, jails and concentra-
tion camps.

This booklet tells what you must do if you and your family
want to survive!

If you think that they will not be after you, you're wrong.
They will be going after anything that is Black — WHOEVER
you are, WHEREVER you live, WHENEVER they get the word!!

Black survival (offensive and defensive) is the order of
the day — BY ANY MEANS NECESSARY!!!

EVEN IF YOU THINK THE ABOVE STATEMENTS

ARE FALSE, FOOLISH, OR IGNORANT, PLEASE

DO NOT THROW THIS BOOKLET AWAY.

PUT IT IN YOUR MEDICINE CHEST OR

WHEREVER YOU CAN GET TO IT IN CASE YOU

HAVE TO CHANGE YOUR MIND IN A HURRY.

Because you are black, this is important to you

WHAT WILL HAPPEN	WHAT TO DO

The Police Riot

1. A police riot begins when the police panic because they have created a situation that they <u>claim</u> is getting out of control.

They begin with a physical attack with <u>clubs</u> against groups of people. <u>Dogs</u> are sometimes used. <u>Arrests</u> usually begin here.

2. As the police riot progresses <u>more police</u> are called in. People trying to get away are run down and beat. <u>Guns</u> and <u>tear gas</u> are brought out.

Arrests and beatings continue. <u>Houses</u> may be invaded. <u>Cars</u> will be stopped.

3. When the shooting begins (it is usually police shooting at each other) the police riot is in full swing.

No one is safe, indoors or outside. Police will <u>shoot wildly</u> at everything..

Fires and explosions are common.

<u>Streets</u> are blocked. <u>Lights</u> are shot out.

There is widespread <u>confusion</u>.

1. ["no" unplanned or mis-leaд "demonstrations."] If you find yourself in a place where a police riot could begin, <u>clear out</u> -- fast. Stay alert.

Protect yourself. If you are arrested, know your rights and act accordingly.

2. If you cannot get away, <u>take cover</u> wherever you can.

<u>Gas masks</u> are the only defence against gas attack.

Be prepared to defend your home against unlawful entry.

3. <u>Do not expose yourself</u> in windows or doorways. Put out all lights.

Keep your family together, <u>away from windows</u>.

Fire extinguishers, sand buckets or water can be used to put out fires. <u>Try not to panic</u>. Do not count on help from the Fire Department.

Rope ladders or very strong ropes can help you escape from a fire. <u>Know</u> all the different ways to get out of your house.

Try to have someplace where you know you can <u>go and be safe</u> if you have to leave your house.

-3-

What will happen. What to do

WHAT WILL HAPPEN	WHAT TO DO

First Stages

1. **Increased tensions.**

 Radio, TV and newspapers will
 be used to spread "scare"
 propaganda and get people
 psychologically ready ---

 -"riot" commission reports
 -calls for "law and order"
 -war on "crime in the streets"
 -links to "communism"
 -frame-ups and conspiracies
 -use of Negro "leaders"
 -gun "clubs"

1. **Reduce your own tension by
 reducing your fear.**
 Be aware -- look for the real
 reason behind "establishment"
 activities. Read, think and
 act Black.
 Get involved -- support
 meaningful Black organiza-
 tions and activities.
 Engage in constructive community
 efforts.
 Think before you act.
 Do not spread rumors.

2. **Increased police activity.**

 Also designed to increase
 tensions and work on your
 mind ---

 -massive police forces
 -beefed-up patrols
 -more guns, tanks, etc.
 -National Guard and Army
 -"Riot" training
 -battle plans
 -use of unnecessary force
 -disrespect and abusive acts

2. **Aviod and ignore** them unless
 you have no choice.
 Know what you can do and proceed
 to take care of business.
 Be extra careful.
 Treat Afro police as humanely
 as possible. Help them to learn.
 Be prepared to defend your-
 self, your family and your
 home against unlawful attack.
 Let someone know where you are
 supposed to be at all times.

The Incident

1. According to the "riot" comm-
 ission report, "police actions
 (arrests or shootings) were
 final incidents before the
 outbreak of violence in half
 of the surveyed disorders in
 1967."

1. Do not interfere either
 verbally or physically with
 police actions.
 If you can, take notes and get
 names and addresses of whitnesses.
 Know what to say and do if
 you are arrested.

2. **The police are ready to riot.**

 They are fully trained, fully
 armed and fully ready to make
 war on Black people under the
 name of law and order.

 If they cannot get something
 started, they will use paid
 agents (Negro and White) to
 provoke a situation or create
 a disorder.

2. Avoid "spontaneous"
 demonstrations.
 Be alert for spies and paid
 agents. Deal with them in what-
 ever ways are necessary.
 Do not respond to unknown
 calls for action or mass
 meetings.
 Act as if your life depended
 on everything you do.

First stages

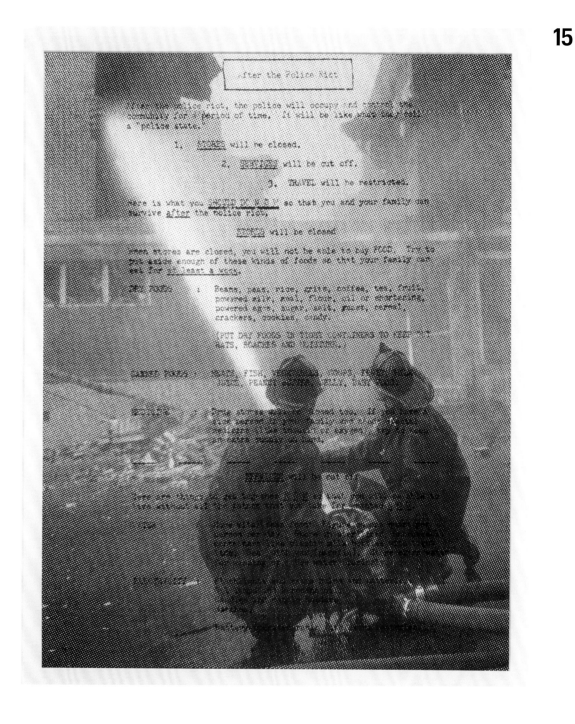

After the police riot (with Flash)

THOMAS

After the Police Riot

After the police riot, the police will occupy and control the community for a period of time. It will be like what they call a "police state."

1. STORES will be closed.

2. SERVICES will be cut off.

3. TRAVEL will be restricted.

Here is what you SHOULD DO N O W so that you and your family can survive after the police riot.

STORES will be closed

When stores are closed, you will not be able to buy FOOD. Try to put aside enough of these kinds of foods so that your family can eat for at least a week.

DRY FOODS : Beans, peas, rice, grits, coffee, tea, fruit, powered milk, meal, flour, oil or shortening, powered eggs, sugar, salt, yoast, cereal, crackers, cookies, candy.

(PUT DRY FOODS IN TIGHT CONTAINERS TO KEEP OUT RATS, ROACHES AND MOISTURE.)

CANNED FOODS : MEATS, FISH, VEGETABLES, SOUPS, FRUIT, MILK JUICE, PEANUT BUTTER, JELLY, BABY FOOD.

MEDICINE : Drug stores will be closed too. If you have a sick person in your family who needs special medicine (like insulin or exygen), try to keep an extra supply on hand.

SERVICES will be cut off

Here are things to get together N O W so that you will be able to live without all the things that you take for granted N O W.

WATER : More vital than food! Figure on one quart per person per day. Store in sterilized, unbreakable containers like plastic milk bottles with tight lids. Seal with wax (parafin). Store extra water for washing up. Use water sparingly.

ELECTRICITY : Flashlights and extra bulbs and batteries. Oil lamps and kerosene oil. Candles and candle holders Matches.

Battery-operated radio with extra batteries.

After the police riot (without Flash)

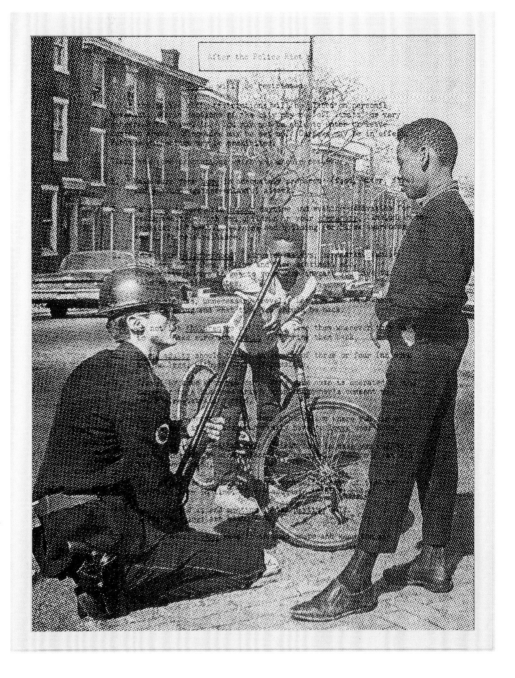

Travel will be restricted (with Flash)

THOMAS

After the Police Riot

<u>TRAVEL</u> will be restricted

After the police riot, restrictions will be placed on personal movement. Whole sections of the city may be "off limits" or very dangerous to travel in. You may not be able to enter or leave certain areas. Blockades may be set up. Curfews may be in effect. Public gatherings may be prohibited.

These are some precautions which you should observe:

1. Make sure your <u>home</u> is adequately prepared (food, water, fire) and guarded against unlawful attack.

2. Be ready to organize <u>indoor</u> daytime and evening activities for young adults, youth and children in your <u>community</u>. Include both physical and mental learning and building for Black awareness and Black self-reliance.

3. Know your <u>neighborhood</u>! streets, alleys, landmarks, public shelters, churches, police and fire stations, etc. Know various ways to get to your home in case you have to take alternative routes.

4. Avoid aimless, unnecessary travel. Let someone know where you are going and what time you should be back.

5. Do not let <u>children</u> go out alone. Take them wherever they have to go. Make sure some <u>adult</u> will bring them back.

6. <u>Young adults</u> should travel in groups of three or four (no more and no less) with an adult if possible.

7. Travel by auto when you can. Make sure auto is operated by the owner or by a licensed driver with the owner's consent and owner's registration card.

8. Arrange in advance to have some other place where you can go and be safe if you and your family have to leave your home.

9. Learn emergency medical care (First Aid) in case you cannot get an injured or sick person to a hospital. Keep a first aid kit in your home.

10. If curfews are in effect, allow yourself plenty of time to get back home in time. Carry adequate <u>identification</u>.

11. Schedule and attend meeting in the <u>daytime</u> only. Sunday mornings are best.

12. If you have a <u>car,</u> keep it in good shape and keep the gas tank full.

-6-

Travel will be restricted (without Flash)

APPENDIX 1

This outline shows a good way to organize the survival list.

SHELTER CHECKLIST

Food and Cooking Equipment:

Water (2-week supply, a minimum of
7 gallons per person)
Food (2-week supply)
Eating utensils
Paper plates, cups, and napkins (2-week supply)
Openers for cans and bottles
Pocket knife
Special foods for babies and the sick

Supplies and Equipment for Sanitation:

Can for garbage (20 gal.)
Covered pail for toilet purposes
Can for human wastes (10 gal.)
Toilet tissue, paper towels, feminine hygiene
Supplies, disposable diapers ordinary and
waterless soap Grocery bags, newspapers for
soil bag. Household chlorine (2 pt.) and DDT
(1 qt. of 5% solution) Waterproof gloves

Shelter Equipment:

Battery radio with CONELRAD frequencies
(640 or 1240) marked, and spare batteries for 2
week operation. Home use radiation instruments
Flashlights, electric lantern, and spare batteries for
2 weeks. Clothing, Bedding (rubber sheeting
and special equipment for the sick) A first aid kit
writing material, reading material, including a Bible
or other appropriate religious material. Screwdrivers,
pliers, and other house hold tools. Games and
amusements for children.

Items outside the shelter but within reach:

Compact cooking unit, such as those used by
campers, and matches Home fire-fighting equipment
Rescue tools

* For more details see "The Family Fallout Shelter"
Philadelphia Civil Defense Council, 504 City Hall Annex.

Appendix 1

THOMAS

Gas : Canned heat (Sterno) stove and fuel.
Charcoal (Hibachi) stove and charcoal.
Butane gas stove and gas cylinders.

TELEPHONE : When telephone service is cut off, block-to- block
communications will have to take over.
Stay in touch with other Black people on your block.
Be ready to alert the neighborhood if there's
trouble. Use other methods to signal and communi-
cate: bells, whistles, drums, walkie-talkies,
flags, etc.

FIRE
DEPARTMENT : May not be allowed to come into your area.
Equip your home with fire extinguishers if possible.
Buckets of sand and buckets of water can be used.
Know where all exits from your home are.
Make sure your family knows.

Set up a specific place safely outside your home
where your family should gather in case you are
driven out by fire or tear gas.

POLICE : You may have to defend your family and your home
against unlawful attack or entry. Be prepared.

Other USEFUL items

GENERAL : Garbage can with lid, plastic bags for garbage,
chemical toilet, toilet paper, soap, fly swatter,
matches, can and bottle opener, kitchen knives,
blankets, clean newspapers, paper cups and plates,
plastic forks and spoons, paper bags, helmets,
gloves, hand tools, rat traps.

FIRST AID : Instruction book, first aid kit, distilled water,
aspirin, vaseline, alcohol, boric acid, scissors,
aromatic ammonia, adhesive tape, gauze, cotton,
sterile bandages, tourniquets, slings,

Other useful items

EMERGENCY ACTION YOU SHOULD KNOW

APPENDIX 2

Bleeding

Priority

Outside Bleeding

Act fast when someone's losing blood, here's
what to do --

1. Press directly with fingers (unless steel,
rock, wood is embedded)

2. Press on Pad (handkerchief) to make blood
stop or ooze

3. Raise bleeding part of body

4. Get to doctor or hospital fast.

Don'ts--

1. Wash wound

2. Peel off blood clot

3. Use tourniquet or bandage too tightly

4. Take off pad--add more on top of bleeding
through

Inside Bleeding

Look for--

1. Coldness and paleness in appearance

2. Pulse is weak and faint

3. Pain

4. Restlessness

5. Eyesight goes dim

6. Thirst increases

7. Frosty, red or coffee colored blood is
spit up sometimes

Play it safe--Get medical aid

Emergency action you should know

THOMAS

6. Watch for chest fall while taking a deep breath (if nothing happens repeat process) 6 quick inflations then 10 a minute for adults and 20 lighter breaths a minute for a child.

7. If unable to open or use injured's mouth--use mouth to nose method--seal injured's mouth.

Watch for chest fall

End

I WILL PROTECT BLACK PEOPLE
YETUNDE OLAGBAJU

dedicated to nia wilson, her family, friends, and community

dedicated to those who came before us and remind us to not settle for silence

dedicated to those who are coming and demand us to grow

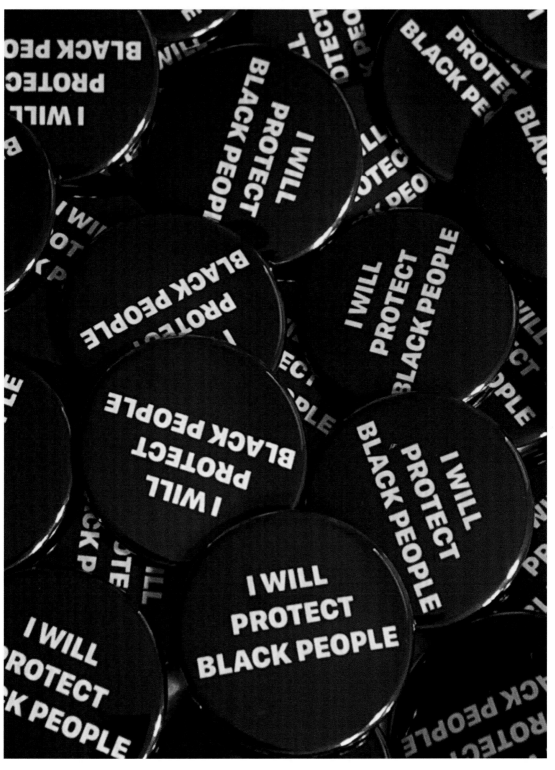

OLAGBAJU

I WILL PROTECT BLACK PEOPLE
Contract for Button

In order to receive the "I WILL PROTECT BLACK PEOPLE" button you must complete this community contract, sign the contract, and through your daily life adhere to these conditions. Everyday the safety of Black people is threatened. This comes in many forms: physical, mental, and spiritual. By signing this contract I am agreeing that this is an issue that -- through small everyday actions -- I can help combat.

1. IF I SEE A BLACK PERSON'S PHYSICAL SAFETY IN JEOPARDY I WILL PHYSICALLY STEP IN TO PROTECT THEM.

2. I WILL NOT ALLOW WHITE OR NON-BLACK PEOPLE TO HARASS, HARM, OR DEGRADE BLACK PEOPLE.

3. I WILL CHALLENGE ANY AND ALL ANTI-BLACK SPEECH / ACTION WITHIN MY HOME, WORKPLACE, AND ALL SOCIAL & PROFESSIONAL SPACES I OCCUPY.

4. I WILL CALL OUT ANY AND ALL MICROAGGRESSIONS THAT I WITNESS TOWARD BLACK PEOPLE.

5. I WILL PRIORITIZE THE SAFETY OF BLACK PEOPLE REGARDLESS OF THEIR GENDER, SEXUAL ORIENTATION, SOCIOECONOMIC STATUS, ETC.

6. I WILL CREATE OPPORTUNITY FOR BLACK PEOPLE. AT ALL COSTS.

7. I WILL DEDICATE SIGNIFICANT PORTIONS OF MY TIME, ENERGY, AND MONEY TO BLACK PEOPLE, IN VARIOUS CAPACITIES AND IN WAYS THAT ARE GENUINE.

8. I WILL LISTEN TO, RESPECT, HONOR, AND PROTECT BLACK PEOPLE TO THE BEST OF MY ABILITY.

IN ADDITION TO THESE PROMISES, I WILL LISTEN TO THE BLACK PEOPLE IN MY LIFE TO DETERMINE WHAT MORE I CAN DO AS AN ALLY AND ADVOCATE.

_____ _____

NAME DATE

AMERICA IS BLACK
TATYANA FAZLALIZADEH

Tatyana Fazlalizadeh
America is Black, 2016
Mural installed in Oklahoma City

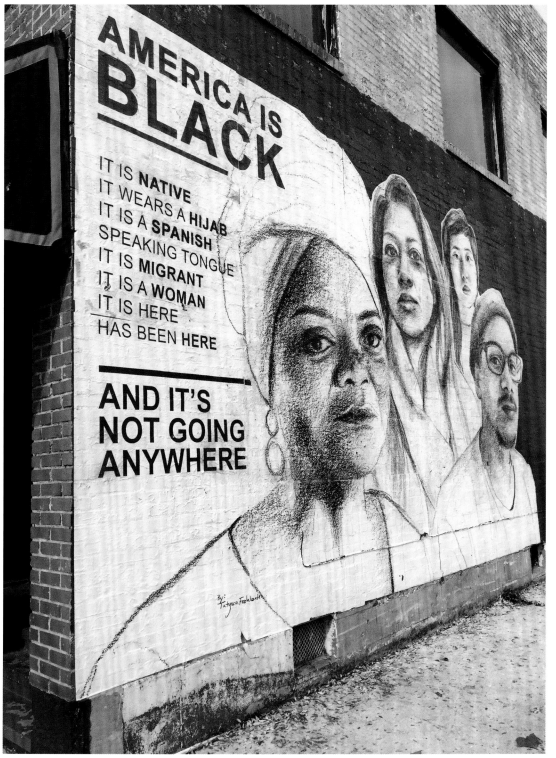

FAZLALIZADEH

A CALL TO ACTION
LATOYA RUBY FRAZIER

The Flint Water Crisis began on April 25, 2014. The corrosive Flint River caused lead to leach into the water system and the homes, businesses, and bodies of Flint residents. There is an estimate of 29,100 homes[1] that need service lines replaced, which has created a massive decrease in property value in addition to poisoning residents.

DEMOCRACY NOW! reported[2] that Flint residents are forced to drink, cook with, and even bathe in bottled water, while still paying some of the highest water bills in the country for their poisoned water. In 2001 and 2002, the Michigan Department of Environmental Quality issued permits to Nestlé, the largest water-bottling company in the world, to pump up to four hundred gallons of water per minute from aquifers that feed Lake Michigan. Nestlé is not required to pay anything to extract the water, besides a small permitting fee to the state and the cost of leases to a private landowner. In fact, the company received $13 million in tax breaks from the state to locate the plant in Michigan. The spokesperson for Nestlé in

Michigan is Deborah Muchmore. She's the wife of Dennis Muchmore—Governor Rick Snyder's chief of staff, who just retired and registered to be a lobbyist.

The American Academy of Pediatrics reported that given the disproportionate risk to low-income children and families, the impact of lead exposure in communities like Flint can be enormous. Children under the age of six years are more likely than adults to have lead pass into their brain, due to the immaturity of the blood-brain barrier. Lead is distributed into the blood, into soft tissues like the brain, and then to bone. Once it gets into the bones, it can be there for ten to twenty-five years depending on the length of the exposure.

When lead is ingested, it is directly absorbed into the body. In fact, children absorb more lead through the GI tract: 70 percent absorbed in children compared to 20 percent for adults.[3] Women who are pregnant or breast-feeding and have elevated lead levels may see an increase in the release of lead from the bone, resulting in a fetus having higher exposures and increased risk for neurotoxicity. Children with elevated lead levels are more likely to have behavior problems, attention deficit, and reading disabilities, and fail to graduate from high school. In Flint, Michigan, there are approximately 8,000 children under the age of six.[4]

Black people in America do not choose to be poor. Through systemic and institutional racism, along with racist public policies that impact our housing, education, access to healthcare, clean environments, and grocery stores with fresh, high-quality food, we have been sentenced to a slow, painful death, while governors like Rick Snyder are still in office. This is state-sanctioned murder!

I want you to imagine what your life would be like if you did not have access to clean drinking water for six years! Imagine what would happen to your mind, body, and spirit if you had no access to clean water for 2,190 days. If this testimony bears witness in your heart I want you to take action starting right now. You can do three things starting today:

1. Stop supporting Nestlé products, especially Nestlé bottled water.[5]

2. Start educating yourself on the water war in America: 94 percent of our tap water in the U.S. is contaminated with plastic.

3. Turn off mass media and start listening to and seeking out local artists in Flint, Michigan. There are incredibly resilient artists across Flint who found creative solutions to remedy this man-made disaster. But they need your support.

On April 4, 1967, in his speech "The Three Evils of Society," Dr. Martin Luther King, Jr., gave us a message and a grave warning; "We as a nation must undergo a radical revolution of values . . . when machines and computers, profit motives and property rights, are considered more important than people, the giant triplets of racism, materialism and militarism are incapable of being conquered."

1. www.freep.com/story/news/local/michigan/flint-water-crisis/2016/12/02/flint-water-improvement/94812360/

2. www.democracynow.org/2016/2/17/thirsty_for_democracy_the_poisoning_of

3. docs.house.gov/meetings/IF/IF14/20160413/104765/HHRG-114-IF14-20160413-SD006.pdf

4. docs.house.gov/meetings/IF/IF14/20160413/104765/HHRG-114-IF14-20160413-SD006.pdf

5. www.democracynow.org/2016/2/17/thirsty_for_democracy_the_poisoning_of

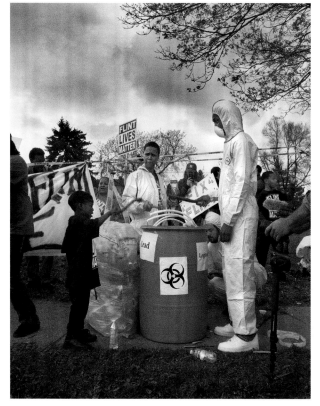

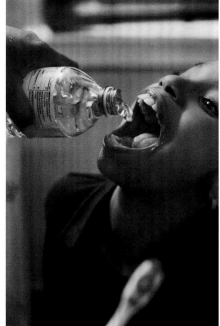

LaToya Ruby Frazier

Students and Residents outside
Northwestern High School (est. 1964)
awaiting the arrival of President Barack
Obama, May 4th 2016, II, 2016 / 2017
Gelatin silver print, 40 x 30 inches
(101.6 x 76.2 cm)

Shea brushing Zion's teeth with bottled
water in her bathroom, 2016 / 2017
Gelatin silver print, 40 x 30 inches
(101.6 x 76.2 cm)

The Grainery Natural Grocer Signage on
the corner of E. Court and Church St.,
2016 / 2017
Gelatin silver print, 40 x 30 inches
(101.6 x 76.2 cm)

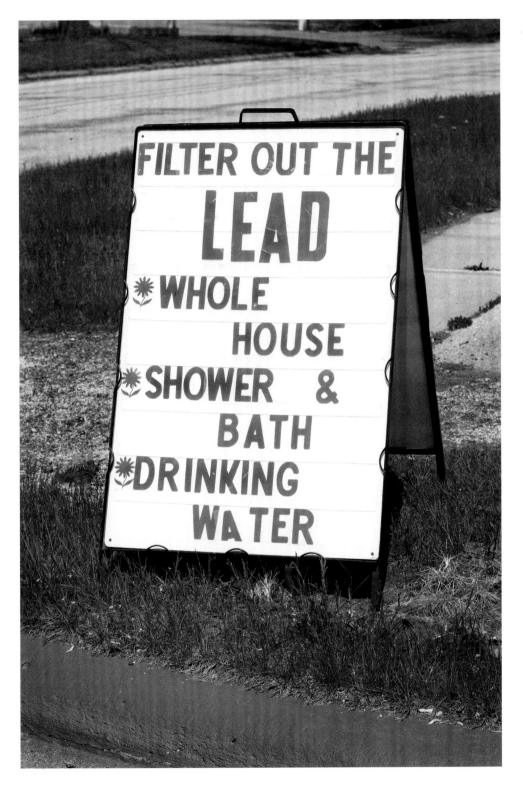

**"BLACK VIRALITY IS EVERYTHING
FROM HENRIETTA LACKS TO THE DAB."
— SALOME ASEGA**

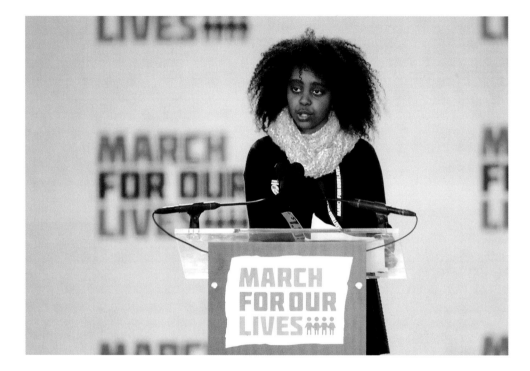

Eleven-year-old Naomi Wadler addresses the March for Our Lives rally
on March 24, 2018, in Washington, D.C. Hundreds of thousands of
demonstrators, including students, teachers, and parents, gathered in
Washington for the anti-gun violence rally organized by survivors of
the Marjory Stoneman Douglas High School shooting on February 14 that
left seventeen dead. More than 800 related events have taken place
around the world to call for legislative action to address school
safety and gun violence.

BLACK FUTURES

TODAY IS YESTERDAY'S TOMORROW

A MIX BY KING BRITT

Sonia Sanchez, "Black Magic"

Kelela, "Frontline"

Tirzah, "Gladly "

Nao, "Blue Wine"

R+R=NOW ft. Amber Navran, "Been On My Mind"

Travis Scott, "STOP TRYING TO BE GOD"

Tyler, The Creator, "Find Your Wings"

Rihanna ft. SZA, "Consideration"

Frank Ocean, "Pink + White"

AOE, "I'm Right This Time"

Peter Gabriel, "The Veil"

Sudan Archives, "Beautiful Mistake"

Dedekind Cut, "Tahoe"

Ursula Rucker ft. Tomasia, "Thinkin 'Bout U (Original)"

Swizz Beatz ft. Nas, "Echo"

Jorja Smith, "Blue Lights"

Marc Mac, "Soul Transformation"

Rickie Byars ft. Georgia Anne Muldrow, "Teleprompter"

Somi, "Black Enough"

Shabazz Palaces, "100 Sph"

5 Chuckles aka Ras G & Koreatown Oddity, "Da Po-Lice (phuck em)"

Flying Lotus, "Beginners Falafel"

Sevdaliza, "Human"

Saturn Never Sleeps (Rucyl + King Britt), "Lotus"

Solange ft. Sampha, "Don't Touch My Hair"

Georgia Anne Muldrow ft. Dudley Perkins, "These Are The Things I Really Like About You"

Common ft. Jill Scott, "I Am Music"

KAYTRANADA ft. Ty Dolla $ign, "NOTHIN LIKE U (Instrumental)"

Lesser Pieces (Diane Badie, Mike Slott) ft. ZHU, "5 AM"

4hero ft. Bembe Segue & Kaidi Taitham, "Something in the Way"

bit.ly/blackfuturesmix

BRITT

NOW MORE THAN EVER

MORGAN PARKER

This is a phrase used by Whites to express their surprise and disapproval of social or political conditions which, to the Negro, are devastatingly usual.

Often accompanied by an unsolicited touch on the forearm or shoulder, this expression is a favorite amongst the most politically liberal but socially comfortable of Whites. Its origins and implications are necessarily vague and undefined. In other words, the source moment of separation between "now" and "ever" must never be specified. In some cases it is also accompanied by a solicitation for unpaid labor from the Negro, often in the form of time, art, or an intimate and lengthy explanation of the Negro's life experiences, likely not dissimilar to a narrative the Negro has relayed before to dead ears. Otherwise, it is expected to be met with a solemn nod of the head and absolution from the circumstances occurring "now," as ever, but suddenly and inexplicably "more" than ever, as all Good Whites are convinced they deserve. When a time or era achieves "more than ever" status, many Negroes will assume duties kindred to those of priesthood, e.g., receiving confessions, distributing mercy, et cetera. Though, as noted above, the precise connotation of this phrase is quite obscured in its usage, it seems to be uttered in moments of "Aha!" or, more bluntly, "I straight up did not believe you before," wherein before = "ever." (See also: Negro Lexicon entries #42 & #43: "same shit, different day" and "samo samo.") Subtexts, then, underscoring this phrase are quite sinister in nature, varying from "Your usefulness, Negro, is married to your misfortune," and "Time is linear," the implications of which are that 1) value is time sensitive, 2) conditions of despair are temporary, and 3) anything at all can be new, belonging exclusively to "now," and untethered to "ever," (i.e., past, future). These understandings of time versus import are likely due to the fact that spurs to action and empathy for the White are often directly correlated to any present dangers facing their individual freedoms, or even simply when one "feels like it." (See also: Case Study #5: "Empathy.") This reveals in Whites a compulsion to reformation based upon desire, excitement, guilt, or otherwise self-indulgent emotions, whereas it would appear that the Negro must live the life of the Negro, ever, now, and ever notwithstanding.

Notes on the text.

The draft that follows was written in December 2016 at Poets House, downtown Manhattan. It was emailed to a small circle of artists along with the message: "I feel all of my White friends disappearing." The following draft is from an uncorrected proof of the author's collection, *Magical Negro* (2019), and is the product of several revisions, including a "more telegraphic" version manufactured by the (White) editors of *The Paris Review* before publication in the Winter 2017 issue.

There is no final draft to this text.

Performance Score.

The text is interpreted by you and the moment. Sometimes you make a joke before you begin reading. You almost always inhale deeply. Deliver as matter of fact. Delay, continue, pace, rest, continue, play, scream, collapse, delay, continue, continue ad infinitum. Anything may be a prop. Sometimes you storm out of the room. On the first floor of MoMA, you can walk through the glass doors and smoke a cigarette across from the pub on Fifty-Fourth Street.

42 "Now More Than Ever"

This is a phrase used by Whites to express their surprise and disapproval of social or political conditions which, to the Negro, are devastatingly usual. Often accompanied by an unsolicited touch on the forearm or shoulder, this expression is a favorite amongst the most politically liberal but socially comfortable of Whites. Its origins and implications are necessarily vague and undefined. In other words, the source moment of separation between "now" and "ever" must never be specified. In some cases it is also accompanied by a solicitation for unpaid labor from the Negro, often in the form of time, art, or an intimate and lengthy explanation of the Negro's life experiences, likely not dissimilar to a narrative the Negro has relayed before to dead ears. Otherwise, in response to the circumstances occurring "now," as ever, but suddenly and inexplicably "more" than ever, this is an utterance to be met with a solemn nod of the head and— eventually and most importantly—absolution, which all Good Whites are convinced they deserve. When a time or era achieves "more than ever" status, many Negroes will assume duties kindred to those of priesthood, e.g., receiving confessions, distributing mercy, et cetera. Though, as noted above, the precise connotation of this phrase is quite obscured in its usage, it seems to be uttered in moments of "Aha!" or, more bluntly, "I straight up did not believe you before," wherein before = "ever." (See also: Negro Lexicon entries #42 & #43: "same shit, different day" and "samo samo.") Subtexts, then, underscoring this phrase are quite sinister in nature, varying from "Your usefulness, Negro, is married to your misfortune," and "Time is linear," the implications of which are that 1) value is time sensitive, 2) conditions of despair are temporary, and 3) anything at all can be new, belonging exclusively to "now," and untethered to "ever," (i.e., past, future, world history). These understandings of time versus import are likely due to the fact that spurs to action and empathy for the White are often

directly correlated to any present dangers facing their individual freedoms, or even simply when one "feels like it." (See also: Case Study #5: "Empathy.") This reveals in Whites a compulsion to reformation based upon desire, excitement, guilt, or otherwise self-indulgent emotions, whereas it would appear that the Negro must live the life of the Negro, ever, now, and ever [. . .] and ever and ever and ever and ever and ever and ever and ever and ever and ever and ever and ever and ever and ever and ever and ever and ever and ever and ever and ever . and ever [. . .] and ever and ever and ever and ever and ever and ever and ever and ever and ever and ever and ever and ever and ever and ever (con't.)

THERE ARE BLACK PEOPLE IN THE FUTURE

ALISHA WORMSLEY

Alisha B. Wormsley
The Last Billboard (Jon Rubin project 2009-2018)
East Liberty, Pittsburgh, Pennsylvania
Photo by Jon Rubin 2018

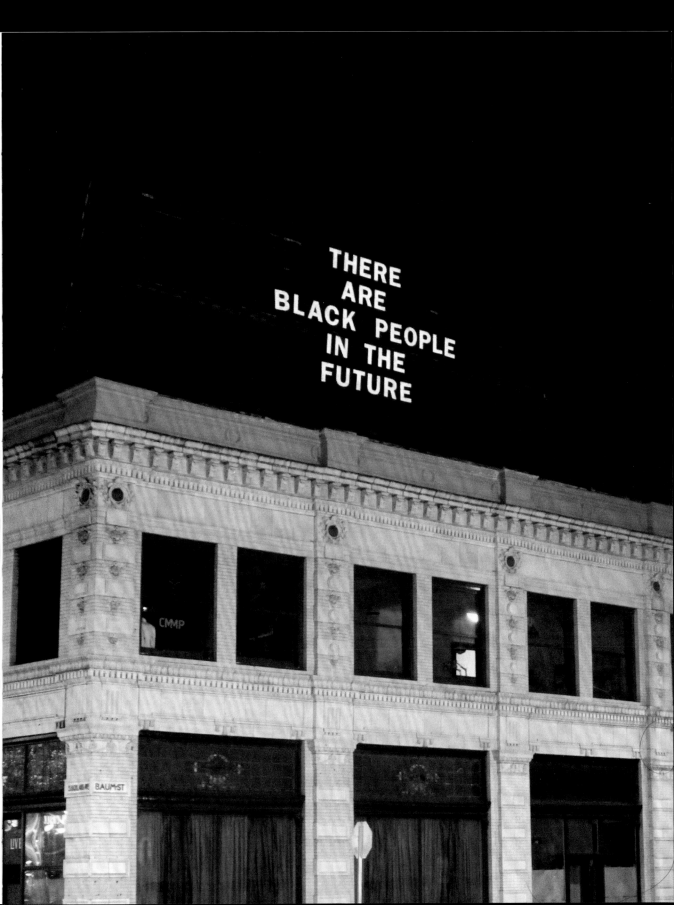

BLACK MAMAS BAILOUT DAY

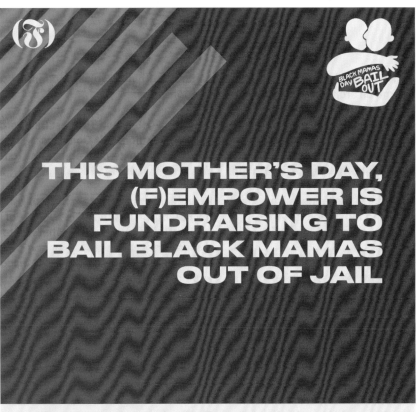

THIS MOTHER'S DAY, (F)EMPOWER IS FUNDRAISING TO BAIL BLACK MAMAS OUT OF JAIL

DONATE TO: bit.ly/freemamas

ALL IMAGES:
Black Mamas Bailout Day Campaign graphics by Lizzie M. Suarez with creative direction by Helen Peña

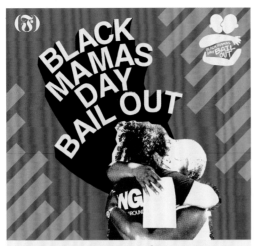

DONATE TO: bit.ly/freemamas

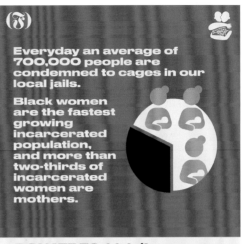

Everyday an average of 700,000 people are condemned to cages in our local jails.

Black women are the fastest growing incarcerated population, and more than two-thirds of incarcerated women are mothers.

DONATE TO: bit.ly/freemamas

Collective action by (F)empower in coalition with the National Bail Out collective and Southerners on New Ground.

On Mother's Day, May 12, 2019, (F)empower, an artist collective and community raising queer feminist consciousness in South Florida, tore down walls and built love bridges toward liberation. We are working in coalition with nearly two dozen groups across the country, the National Bail Out collective, to bail out Black mamas so they can spend Mother's Day with their families and to support Black birth mothers, trans mothers, and other women who mother and are entangled in the criminal legal system and sitting in a cell because they are unable to afford bail.

Originally conceived by Mary Hooks, director of Southerners on New Ground, the national bailout day raised awareness of the human and financial costs of money bail and emphasized its impact on Black folks. Black people are more than twice as likely to be arrested and once arrested are twice as likely to be caged before trial. Hundreds of thousands

of people, who have not been convicted of any crime, are locked in cages because our country has a system of money bail, in which the constitutional principle of innocent until proven guilty only applies to those with money.

When Black mothers languish in jail, our families and communities suffer. The costs are devastating: to the spirit, to their bodies, to their families, and to the communities they hold. People often face huge collateral consequences such as the loss of jobs, housing, and even children, only to be found innocent. Some women, like Sandra Bland, have lost their lives.

It is time we end the suffering of our sisters. We are taking a stand against a money bail system that tears up families and punishes Black mothers for being poor, by coming together and leveraging our collective power to set our mamas free.

(F)EMPOWER

CYRÉE JARELLE JOHNSON AND CAROLYN LAZARD

This conversation has been condensed and edited for clarity.
It took place in December 2018.

Author illustrations by
Loveis Wise

Cyrée Jarelle Johnson: Abled people are always telling me, "In the future we'll all be sick" or that disability is the most likely result of climate catastrophe. And I'm like, everyone I know *is* already sick. Most of the people I know are *already* disabled. Whether through illness, injury, trauma, congenital disabilities—all of those.

Being disabled can be like seeing into the earth's future. We already know what isolation and scarcity look like, and their consequences. We survived the eugenics, drank the poisoned water, swallowed the pills when no one could know the results. I think that disabled people already know how to remain resilient against the disabling future to come.

Carolyn Lazard: Yes! So much of what disability pride is for me is not necessarily a celebration of illness, injury, trauma, etc., but a pride in our resilience. Disability and futurity appear to be incompatible in an ableist world: The general vibe is that disability is a bad thing and we don't want it in the future. When nondisabled people envision an ideal future, it's one in which disability no longer exists. They want to have found ways to eliminate all potential manifestations of disability through the miracles of technological advancement. Not only is this unrealistic, it's incredibly ableist.

There is no possibility of a life which does not, in some way, produce disability. You cannot live in the world without getting hurt, going mad, or becoming sick. People long for life without disability but the experience of just being alive and disability are so intimately bound up in each other—especially for Black people. For me, dreaming of a Black disabled future is a radical practice.

People long for life without disability but the experience of just being alive and disability are so intimately bound up in each other—especially for Black people. For me, dreaming of a Black disabled future is a radical practice.

Johnson: I'm so glad we're having this conversation two days before Umoja— I always gather together with my loved ones on Imani and fulfill my Black New Year's food obligations. My Kwanzaa celebrations mostly take place in my house, so they're reasonably accessible to me.

So many other facets of Black life in community feel complicated for me as a Black disabled person, particularly when compounded by other marginalizations: my personality, my social relationships, etc. It's as though community and collectivity are a reward for being respectable and nonthreatening, with access to a well-maintained social network, which is a luxury that many Black disabled people aren't afforded.

I don't just mean party and gathering spaces here; movement spaces, healing spaces, and living spaces are all complicit in ableism. The dream of collectivity and collective living in all of its permutations can be risky and complex for Black disabled people, when we're not

JOHNSON, LAZARD

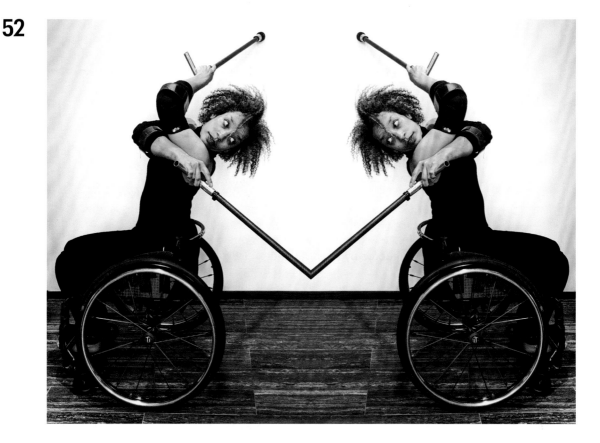

left out entirely. What's most harmful about this rejection is that Black disabled people would be and are greatly benefited by collective accountability, collective responsibility, and interdependence, but as usual ableism keeps us from getting what we need. Black disabled futures cannot exist without collectivity.

Lazard: I really feel you in the sense that the idea of community itself can be really inaccessible for a lot of Black disabled people. Disability is endemic to Black communities, because the conditions of our lives as Black people are inherently disabling. Black folks, like all people, are born with congenital conditions; we also develop chronic illnesses and injuries disproportionately in comparison to other races. The prison industrial complex is an entire industry predicated on disability as a reason for incarceration while simultaneously producing disability through incarceration. And yet, our communities

Alice Sheppard
Where Good Souls Fear, 2018
Photograph by Lisa Niedermeyer

Image description: Alice Sheppard, seated in her wheelchair with two crutches, crosses her body and arches her spine to look behind. The photo is a mirror reflection, and Alice looks back at herself as her crutches disappear into each other in a seamless touchpoint.

disidentify with disability and don't always know how to engage with disability honestly and respectfully. Black political movements could be so deeply enriched by actually looking at what's happening in our community and accounting for it in some kind of way. Like saying, "Oh wow, Black folks are really disabled. What's up with that?"

It would be absurd for us to have this conversation and not mention the work of the Harriet Tubman Collective (HTC), a consortium of Black disabled advocates, artists, and dreamers to which we both belong! HTC does advocacy focused on the intersectional lapses of Black social justice movements that deny the impact of ableism on Black communities and of the primarily White disability social justice movements that deny the inherently disabling nature of racism. Other Black disabled activists like Talila A. Lewis and Ki'tay D. Davidson have also done a lot of prison abolition work grounded in disability justice to support d/Deaf and disabled Black folks affected by state violence.

Johnson: I think it's also important to mention that HTC formed in response to Black Lives Matter's avowed ableism, both structural and interpersonal. It's so tempting to feel like just because movements for justice (occasionally) manage to stick disability at the end of a long list of marginalizations, that's the same as investing in politically disabled leadership.

It's vital that people don't get those two things confused. There will sometimes be disabled people that find themselves in positions of leadership, but without a framework of disability as a political and social identity, consequentially, their leadership may still be ableist. That's some of what I saw when HTC first started to work in coalition with the Movement for Black Lives, and it made me suck my teeth at first. Now it just makes me want to work with other cripples to create a disability justice movement that's more inviting to Black people, particularly multiply marginalized Black people.

In the future, disability justice will be irresistible because the work—both theoretical and interpersonal—is the sort of thing you reach for when your body is changed and there's no other map to consult.

Lazard: We have an entire history of social justice movements saying that "the personal is political" and yet disability has really struggled to be included in that statement. We are always being told that our impairments and our illnesses are ours and ours alone. So much of what disability justice provides is a framework for seeing one's personal experience extend to the realm of politics. It takes the hush-hush of disability and makes it public and political. And yet this too can be a complicated position to occupy: To be a Black person with a known or recognizable disability can put you at risk for all kinds of violence, whether you're read as being noncompliant by the police or losing your job for not being able to work in an ableist work environment (read: most work environments).

JOHNSON, LAZARD

Definitely. Collectivity can be challenging for Black disabled people too, particularly when the desire to be a part of community leads us to neglect our accessibility needs. Some of that silence comes from community pressure to pull one's own weight because of the great demands that antiBlackness mounts on Black people. That pressure coupled with duty and responsibility to community members and organizations can run sick and disabled people ragged.

The Cancer Journals and "A Burst of Light: Living With Cancer" are preeminent disability narratives and a great example of what that pressure looked like for Audre Lorde as a Black creative with cancer. Throughout both texts, you can see her rapidly advance a disability analysis. By the end of "A Burst of Light," she has politicized her cancer, shared that new knowledge, and assimilated it into her other political identities.

I hear the quote "Caring for myself is not self-indulgence, it is self-preservation, and that is an act of political warfare" all the time, but that quote doesn't typify the work. It comes all the way at the end of the book, after Lorde had traveled extensively with cancer and then she turns around and wonders how she would have felt if she made the choice to prioritize herself. It's so complicated and relatable to watch Lorde question herself about her quality of life and contributions to the Black lesbian community in the face of her own physical needs.

The Cancer Journals and "A Burst of Light" expanded and continue to expand how Black people who believe in justice think about disability.

They also provide a vision of what it means for Black people to be disabled and have close, violent contact with the medical-industrial complex on a structural level. There's this one part where she writes about prosthesis and is essentially like, why do you want me to have a prosthetic breast in here when I could just have no breast? The medical-industrial complex values my money and my appearance more than my life.

Lazard:

This thing that Audre Lorde outlines about taking care, for me, really relates again to ideas of survival. She was trying to develop a framework for the sustainability of her own work as a Black woman. These same ideas are reflected in other modes of writing by Black women too. I'm thinking specifically about science fiction and fantasy in the works of Octavia Butler and N. K. Jemisin; two authors writing at different times in different genres, but with a lot of crossover.

So many of Octavia Butler's protagonists are Black women who are trying to survive in the face of unthinkable destruction while negotiating the political, ecological, and social constraints of their lives. Oftentimes these characters are disabled in some way or another, for instance, Lauren Olamina's hyperempathy syndrome in Butler's Parable of the Sower or the orogenic capacities of N. K. Jemisin's characters in the Broken Earth trilogy. In both of these examples, these deficits or marginalized traits become points of

connection with others. Disability can fuck up your life but it can also be a source of transformation and power.

The Broken Earth trilogy also operates within geological time, taking place on a spiteful earth that hates its inhabitants and destroys itself over and over again. Jemisin is really thinking through to the other side of the apocalypse, which is basically what Black disabled people have been doing for generations! For a Black disabled future, these questions of ecological destruction are bound up with ableism and racism. It's like what you said earlier, "We drank the poisoned water" and we're still here. What do we do and how do we survive after the world ends?

Johnson: I actually haven't read N. K. Jemisin's work yet, but I'll put it on my reading list! That's such an important point because environmental racism is disabling. Environmental degradation is disabling. Of course there will be more illness now that our water is polluted with fertilizer and toxic waste is buried in the ground. Of course environmental catastrophes will leave people disabled by injury. Of course war and famine bring new plagues and bodies influenced by manipulated environments.

Disabled people survive and are created during each apocalypse—but no one can do so cleanly. With our new physical deformities, disabilities, and illnesses there will be new mental illnesses and addictions for which the outcome is unknown. I've read a fair amount of articles about Olamina's disability, hyperempathy syndrome, but I've never seen one about the new addiction that caused the transmission from parent to child. I also have never seen pyro users and their zeal for setting fires and watching them burn, sometimes dying in the process, situated in disability justice readings of *Parable of the Sower*.

Disability will sometimes be beneficial in the future, but some disabilities will be just as stigmatized and, yes, as difficult as what we currently experience. The present is the space where we can build collective care models that prevent emerging mental illnesses from consuming and isolating our loved ones and potentially ourselves.

Lazard: Yes, totally. It seems like the work that needs to happen now, to prepare for the Black disabled future, requires a radical look at why illness and disability are so stigmatized. Capitalism and white supremacy reinforce the idea that health is a personal responsibility, which means that if you aren't "healthy" then you've done something wrong. Wellness becomes this deeply individuated pursuit instead of something that requires collective accountability.

Johnson: Yeah, and if you're unable to fulfill the health goals that are seen as your responsibility to meet, you lose societal power and are blamed for your own marginalization. People think of disability as a kind of inherent worthlessness—a complete inability to do anything. In the

future there will be so many disabled people that we'll be forced to recognize the things that disabled people can do. Everyone can do *something,* even if they need assistance to do so, even if it is breathing or laying. Those are things that all people do. That's not nothing. No one is doing nothing. That's one thing that human beings can't do. Hearts beat, people recline, people sleep, people's eyes flicker. I think that people think of disability in the way that White people think of Blackness, like as an inherently abject state.

I think that it's very easy when you're living through an unpersonhood to not want to add another unpersonhood. I additionally think that to some extent Black people have less to lose than they think, because you're already unpersoned.

That's why the cultural work collectives like Sins Invalid do is so important. Art is a catalog of perceptions and lived experiences. Not ensuring that disabled artists can meaningfully participate in the creation of those testaments to living means that whole identities, relationships, activist work, and thought aren't added to our collective mythology. When disabled artists have their access needs met, they can make those contributions that change perceptions and deepen understandings of disabled life.

Lazard:

On a basic level, how can we even dream of the future without talking about accessibility? To be real, sometimes it feels like the Black disabled future is already here with Black people creating our own access and doing our own thing, anyway. Maybe everyone else will eventually catch up to us if they're lucky! The choreographer and dancer Alice Sheppard speaks to this in regard to her own work. I remember hearing her say something about how functionality isn't the only end point of accessibility. Access can also be beautiful and aesthetically innovative. I'm thinking about her dance company's piece *Descent,* which is performed on and with an architectural ramp installation. The work is so fantastic because it brings into being radical forms of movement and relation that come out of disability and dependency. Art is a catalog and it can also invent new experiences and perceptions.

TIME & MEMORY

RASHEEDAH PHILLIPS

Time & Memory survey is part of a long-term ethnographic research project, originally developed in 2002, exploring time, memory, and temporality as experienced by people and communities identifying as Black, African American, and/or Afrodiasporan. This survey explores cultural, communal, and personal temporal-spatial frameworks, and the relationship of psychic space to physical space. The survey asks participants about connections to time and memory, as well as questions about self, community, and family, having participants reflect on durational statements and everyday ways we talk about and think about time in our communities.

The questionnaire was originally developed in 2012 with a desire to add to the research and resources on practices and experiences of time and temporality in Black and African American communities in particular.

The document attempts to understand some of the ways in which Black people and people of color and their communities create, reclaim, and retain nonlinear temporalities, and the extent to which we are forced to assimilate or maintain dominant Western linear temporalities. In addition to deepening the field of research, we hope to help fortify temporal practices and ethics consistent with our experiences as diasporic, displaced Africans living in communities that have largely assimilated into a linear, progressive time construct that leaves us consistently behind.

AFRO
FUTURIST AFFAIR

BLACK QUANTUM
FUTURISM

Mirror

Light Path

L

Lamp

L = length of one trip

T = round trip time

C = speed of light

Time & Memory Survey

Name: _____ Date: _____ Location: _____

What are some of your earliest memories? What images or smells do you associate with it?

How do you define the concept of time? The future? How is it similar or different from how your family or your community defines it?

Which ancestor would pull you back into time? Do you know why?

Growing up, how did you envision your future self? Is it different from the person you are now?

How far back are you able to trace your roots? What evidence or documents do you have?

Talk about the first time you felt aware of your identity/identities (however you define it).

Are there places in your neighborhood or community where you feel like you belong? Out of place? What about these spaces make you feel different?

What is one event on the world timeline that you would alter and why?

Leave a message for your past self (optional: specify date and time):

Leave a message for your future self (optional: specify date and time):

Quantum Uncertainty Space: (affirmations, sealing symbols, doodles, love notes, your own clock, secret codes, etc.):

LOVE IS THE MESSAGE, THE MESSAGE IS DEATH

ARTHUR JAFA IN CONVERSATION WITH TINA CAMPT

This conversation has been condensed and edited for clarity.
It took place in December 2016.

Arthur Jafa: I'm gonna start off with one of the things that's really been troubling me about it. This is my own hangup for sure. A lot of people have come up to me and said, oh yeah, I'm really moved by [it], you know. I remember when I was putting it together, I actually was crying when I was editing the first pass of it. We put it together very, very quickly. We put this together in basically two or three hours. I remember crying when I was putting it together, and then I put it away for a few days. Then I added a few shots and that's the last time I remember feeling anything intensely about it. I've been really struck by the degree to which I don't feel anything when I see it. Which is striking to me. The last time I really felt anything strongly [about it] was when I saw it was at the opening because it was the first time I had seen it with a lot of people. I found myself standing next to people and channeling their feelings. On some level, I kicked into this place of kind of disconnectedness from it. So I've been really struck by that sort of disjunction between that and how a lot of people have been reacting to that piece. [I] want to talk specifically about some of Tina's ideas about listening to images and how images affect a viewer and how they can affect a viewer.

Tina Campt: I first encountered *Love Is The Message, The Message Is Death* on my computer as a clip that was sent to me by a friend. I have seen it about fifteen, twenty times. I would watch *Love Is The Message* over and over on my screen and I would find myself positioning myself backward and forward, closer to or farther away from the screen. I was not trying to see the photos, the images, more closely. The relationship [was] that I was trying to get the impact of the images and I needed to get that impact physically by way of the sound that you used to animate the bodies in it. We were talking earlier today about the difference or the relationship between movement and motion. We think of those two things as synonyms but they're not. Movement means "change in position of an object in relation to a fixed point in space." Motion, on the other hand, is a "change of location or position of an object with respect to time." One of the things that *Love Is The Message* is provoking us to do [is examine] our relationship to images at a certain velocity over time.

Where are the bodies moving? How do you see the choreography of bodies in violence through music? To open yourself up to a different sensory experience of this film or to a different sensory experience of these images means not just to watch them move across the screen and try to read what they are telling you but to actually put yourself in physical proximity to them. I think that physical proximity is through the sonic penetration . . . the way in which the music and the actual sound of it is what is actually connecting us to the images.

I wanna figure out how to make a Black cinema that has the power, beauty, and alienation of Black music.

JAFA, CAMPT

ALL IMAGES:
Arthur Jafa
Love Is The Message, The Message Is Death, 2016
Single-channel video (color, sound)
Courtesy of the artist and Gavin Brown's Enterprise, New York/Rome

Jafa:	I wanna figure out how to make a Black cinema that has the power, beauty, and alienation of Black music.
Campt:	Tell me, tell us what you mean.
Jafa:	One of the things I realized very early on, though, was the way in which this whole idea of Black cinema was being defined at the time [I was a film student at Howard] was somewhat narrow in the sense that it was a binary. They would say like, "Okay, what's Black film? It's not Hollywood or it's 'against Hollywood'" so that's a fairly radical idea when you're first confronted with it. We were like, "If Hollywood has narratives, does that mean Black film is necessarily like, non-narrative?" If Hollywood films are in color does that mean, you know, Black films have to be in black and white? We increasingly started to think, "Well, what would a real Black cinema be and how might we kind of define it now?" I'm still teasing out and trying to implement—fully implement—this idea of Black visual intonation. I realized at the core why Black music was powerful was the Black voice. You would never confuse Billie Holiday with Fela [Kuti] with Bob Marley with Charlie Parker or with Miles Davis, right? How do we understand these traditions or continuities of manipulating tonalities in a sense? **We're the illegitimate prodigy of the West and we came to the Americas with this deep reservoir of culture of expressivity.** There's a great quote by Nam June Paik, who is generally considered the godfather of video art, that said the culture that's gonna survive the future is the culture that you can carry around in your head. I saw the Middle Passage, in particular in terms of Black Americans, as a great example of that because the places where Black people are strong tend to be in those spaces where the cultural traditions can be carried on our nervous systems.
Campt:	In this piece, the motion of bodies is really crucial and it has to do with what we were talking about earlier of the relationship of Black people to spatial navigation, right? There's bodies in movement in violence, bodies in motion through dance, which is not always choreography—it's a relationship to rhythm or music. And then bodies in motion through athleticism. You've got Muhammad Ali, you've got the basketball, you've got the fans around the basketball court who are synchronizing with the people on the floor. One of the ways in which you understand Black people is through people's capacity to navigate space and trajectory.
Jafa:	Music is a great place to actually think through ideas because you can also share those ideas with people because people, particularly Black folks, we know all of the music. I mean, we know everything that anybody's ever made. We tend to be able to sing all the songs. Even if we don't know the words we know the trajectories or the inflections and things like that.

JAFA, CAMPT

JAFA, CAMPT

JAFA, CAMPT

When Black people dance, what's going on, on a phenomeno-
logical level, what's going on? I came up with this idea that, in terms of
the two things—Black Americans are acutely sensitive to rhythm. Most
people would acknowledge that Black Americans, Black people from
most places, right, have an acute sensitivity to rhythms.

Jafa: There's something to be said for making just explicit what is often
times implicit—which is Black people [are] just killed like we're not
human beings. How do you put something in a space in the way it
can cut through the noise, in a sense? There's ambiguity about [the]
appropriateness of having an image of a man being murdered like this.
First of all, this footage is all over the place. It's everywhere. It's not
like we're digging stuff out of archives that nobody's seen. It's literally
everywhere. The question to me became, how do you situate this
footage in a way so that people actually see it? How do you actually
make people see it? Simultaneously—there's something to be said
about [the] ability to be able to see beauty everywhere. It's something
that Black people have developed. We've actually learned how to not
just imbue moments with joy but to see beauty in places where beauty
doesn't necessarily exist. Now, the thing about this shot [is that] it's
a brutal example [of] what happens to Black people here. It's also an
incredibly beautiful shot.

Campt: One of the things that I kept thinking about during this film is what
you're asking us about empathy and the way you're focused on
that eye.

Jafa: I'm very much preoccupied with how the work that I do, at base, is
always trying to expand narrow notions of who we are, who is *we*,
you know, who identifies with what. Who *can* identify with what. This
whole idea of empathy being learned. People of color have better
empathy in cinema because they go to cinema all the time where they
see figures who don't look anything like them. And they have to have
the capacity to project themselves into that space and empathetically
take that experience. You know, we need more cinema because we
need more spaces for more types of people to be able to exercise that
empathy. It's one of the reasons I'm not interested in making films
with white folks. I'm really interested in making work that always is
foregrounding Black people's humanity, even when they're bad guys or
good guys.

JAFA, CAMPT

SHAWNÉ MICHAELAIN HOLLOWAY AND TIONA NEKKIA MCCLODDEN

This interview, which was conducted via Google Hangouts in November 2017, has been edited and condensed for this publication.

Author illustrations by
Loveis Wise

Tiona Nekkia McClodden: I'm in North Philadelphia looking at Shawné Michaelain Holloway sitting in her lovely office in Chicago, Illinois. First, we're gonna start off and let these folks know how we met. It was in April 2016. Kimberly Drew was doing a talk that Bruce High Quality Foundation was having in their new space in [Industry City] in Brooklyn. Kimberly was presenting on just a couple of artists, like maybe two to three, and I think the way that she was able to articulate your very complicated practice was really interesting. So interesting that I immediately added you on . . . I don't know . . . Instagram or Snapchat while I was sitting in the audience. The thing that stuck out the most was how she presented the empty browser as your workspace. And it was a pivotal moment for me because I had been very wary and also extraordinarily confused about what Internet artists did and how they worked, et cetera, and from that conversation and that presentation I then went to your website after I got out of there and was like, this is really interesting work, but I still have no idea what's going on. And from there I just added you across all of social media —I added you on Facebook, I added you on Instagram, you know, SoundCloud, you know, all these things. And then from that process I realized that's kind of the way to kind of get a hold of what your work is or who you could have been.

Following that, in the top of May, I traveled to Iowa as the first resident of the Center for Afrofuturist Studies in Iowa City to actually try and produce work that I had been expressing extreme angst over, which ended up becoming *Se Te Subió El Santo*—my first ever self-portrait series—as well as expanding on some ideas that I had around the artist Ana Mendieta, as she graduated from the University of Iowa and lived there with her sister while in exile from Cuba. I brought a document with me from a dissertation that was written on her years in Iowa with a focus on her artistic production, on a phrase that she and her sister used to say to people when they were acting unruly at parties, which was "¿Se te subió el santo?" Or "Are you in a trance?" And so the goal was to put myself in a position to take self-portraits that would be in conversation with the self-portraiture that Mendieta made during her time there. But with my self-portraits I was desperately looking for a place to try to figure myself as a full self, inclusive of all my identities. And during that documentation, that's when I first got . . . What are they called on Snapchat? They not even DMs.

Shawné Michaelain Holloway: Snaps.

McClodden: Yeah. You sent me a snap.

Holloway: I did! Well, you were completely opposite to what I was following at the time. I really try and follow people who are quite explicit and I don't really even know where you came from because maybe I just added everybody on Snapchat because nobody I really know had Snapchat

HOLLOWAY, MCCLODDEN

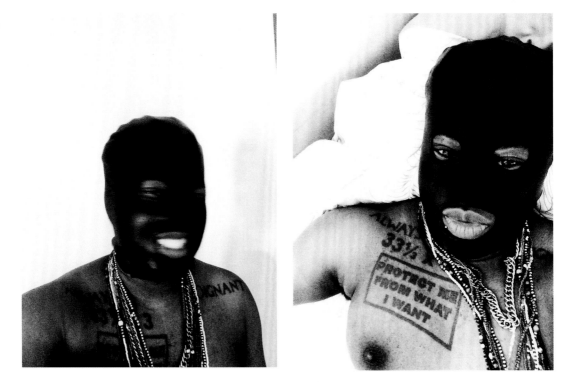

other than these kind of, like, spammy Internet people and at the time also it was just sort of general practice for me to make friends with everybody.

I was in Paris actively not thinking about art. Actively making art, but not thinking about art. I was scrolling down my Snapchat story feed. It was, you know, drunk parties, drugs, and then these portraits, and I recognize a kind of stillness in them. And I also recognized the mask that [you were] wearing in these particular photos as being a part of perhaps something alluding to participation in BDSM or something kinky.

I was just like, "Hi, how are you?" You know, "What are you doing there? I see you." And you said, I think you didn't even explain it to me, I think that was when you said, "I'm trying to get free."

McClodden: Mm-hmm.

Holloway: I mean, the context of, like, where my head was at is also really important because [the exchange] kind of picked me up and dropped

L:
Tiona Nekkia McClodden
Se Te Subió El Santo | [05.03.16], 2016.
Digital C Print
Courtesy of Tiona Nekkia McClodden

R:
Tiona Nekkia McClodden
Se Te Subió El Santo | [05.04.16], 2016.
Digital C Print
Courtesy of Tiona Nekkia McClodden

me back down in a certain way. I was kind of a socialite. Essentially my concerns were: "How do I get through school and what bar do I drink at next?"

McClodden: I think at that point I remember Snapchat was the first engagement online for me where I started to try to expand myself or show more than I had before because I was just so anti-social media in that way . . . something about the ephemerality or, like, the quickness of that snap thing made me feel a little bit more comfortable with putting stuff out there because it was going to go away. So when you responded and when you sent me that snap it was so startling. But at the same time I was like . . . "Yo, she's sending this and she's asking these kind of questions and let's just go." I think [that] was the beginning interaction of why I would even say something like "I'm trying to get free" because it was like the most boiled down, you know. It was just like "Tiona speak" because that's where I was at the end of the day, wrestling with immense fear. And in a very sensitive place around the work that I was producing because it was so new . . . The way you snapped was that I didn't know where you were. And I didn't know who you were really. There was all this language and it's just random, like you said, at parties, random glimpses, and I don't even remember a lot of bodies. You remained in this, like, kind of collage of this, like, you know, figure in this, like, liminal space so it was a nice kind of interaction which is why I felt oddly enough open, you know, to start going for it.

Holloway: And that's what I was trying to develop at the time too because my work, my video work, [and] the work that I presented as art, relied so heavily on people trusting me as a person or receiving presence openly or at least being, like, extraordinarily interested and able to approach my presence. A lot of what I was doing was trying to make others feel exactly that way. A lot of folks bring up questions about intimacy around my work for this reason. Intimacy itself is not something I tried to cultivate but, you know, I do try to remain this open platform for folks to talk to on the Internet.

You told me before once that I had said "I know what you're doing." I was wondering how that felt.

McClodden: It prompted me to then come out as being a part of the BDSM community, you know, and I mean I felt like it was a hand to say, "I see you, I recognize what you're doing." And that was something so specific, because at that point, you know, me putting on those masks and doing those portraits and doing the proofs . . . I was really concerned about how people saw the mask. And that mask, in this particular sense, was not a mask to hide. It was a mask to reveal. And so, if you were able to see what I felt was, like, okay, she's on some subjective shit with this, you know. And I felt really comfortable with coming out because no one else sent me anything like that. No one had ever seen me with these things. People don't even know what

HOLLOWAY, MCCLODDEN

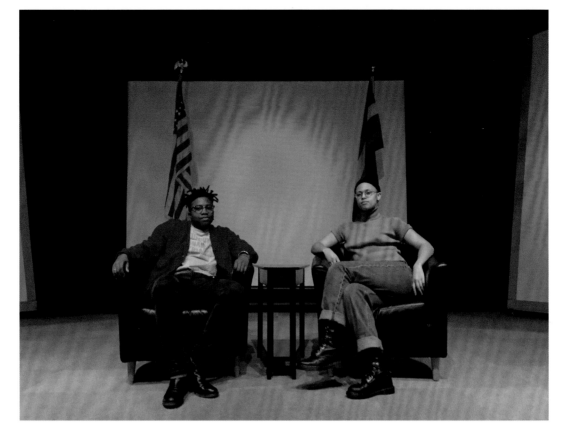

those things are. You know what I mean? And in the ways that I was dealing with it, it was just like it could easily go unseen. You know I think it was shortly after that I was like, "Yeah, this is what I'm doing. I feel like I'm doing, you know, some dangerous shit right now." By, like, you know, presenting all these identities. I mean, I told you I was a priestess. I told you, "This is what these beads mean." I have on my BDSM gear here. You know, every morning I'm trying to put this shit on and figure my body to be masculine and identifiable in regards to gender. I felt very, very open to, you know, share all that stuff and I felt like the way that you handled it was amazing.

Holloway: You know when you said, "I'm trying to get free," it was the first time I'd ever really, like, thought about what a full self was, you know? Especially through the Internet and seeing an artist doing that. Like, in the real world, rather than through some sort of abstract compilation

Tiona Nekkia McClodden + Shawné Michaelain Holloway at Leather
Archives and Museum auditorium, January 27, 2017
Courtesy of Tiona Nekkia McClodden

of things. Then I asked you if we could have a studio visit or
something. We decided we should talk on Skype.

I remember when we finally did Skype it was extraordinarily
formal. I wanted to hear about the work. I wasn't necessarily
interested in knowing who you were because, I don't know, maybe
I felt like I could learn from you or something. And it was the first
time too I was forging community with somebody outside of the
Internet community.

McClodden: What I ended up learning more from Skyping with you is how you
come about approaching the Internet as an online space of working.

Holloway: I have a studio practice but it's largely rooted in this real life sex
work and BDSM practice. The work that I was making at the time,
EXTREME SUBMISSION, was the first time where I had to package a
product up for the art world; all the works that I was making in that
time were works that I was putting on Xtube. I have an archive on
Xtube. I have actually a couple of archives on Xtube. One where I
was posting videos that pleased me. Another one that is just like
a collection of things that I like. And, you know, subscriptions and
things like that and then stuff that I say, "Here, art world, here's
this thing, here's this community that I post within." And so I didn't
place very much, maybe, importance on those things because
they have their own lives, right, and I just was in school; you're not
in a context where these things are important. What's important
is always, like, the next project and *EXTREME SUBMISSION* was
an acknowledgment of that. *EXTREME SUBMISSION*—that word
itself relates to submission when you hit submit on an upload thing
but also relates to submission as it is dominance and submission;
part of that submission of extremely submitting is, like, sort of this
constant sharing thing, this blurring of the lines of what am I doing.

McClodden: Our whole thing was literally talking about our methods of work
and production and, like, really interrogating each other off top.
Like, what is this, what does this mean to you? Even more [so]
because we're both coming from a place of dealing with these ideas
subjectively, and as you've said before, interiority with SM/BDSM
it is about it not being so explicitly about the physical body in
the ways that people would think, even though we were maybe
engaging with our respective bodies. But really trying to push
further into, like, conceptual theoretical and then trying to figure
out how to fashion these things in all these different forms like
video sculpture, et cetera. And I think that that's where we stayed
in that. I mean, I think it is important to mention that we've been
having formal conversations that we've been recording with each
other for over a year. To document how we've talked and conceived
our respective things but how we execute them because we've
executed a lot of projects as well in this time.

HOLLOWAY, MCCLODDEN

Holloway:	I think that was what a lot of those early conversations were about: BDSM as structure for a sexuality and not even necessarily our own sexuality but as an established form for our desire really. We both expressed to each other exactly what the role of BDSM plays in our own lives and perhaps why we were using art to kind of funnel this energy through and this goes back to that, like, practice space research thing. I think we're both people who are extraordinarily connected to the ways in which we work. And coming from the BDSM community, I realized very early that I had to approach you with a kind of, like, seriousness and respect around that language that I used to talk to you about it. Also, I think it's worth mentioning that a lot of people get very violent with me verbally or otherwise or cross boundaries with me because they have perceived, they have seen, my body online or they have seen a kind of, like, sexual deviance online that will be carried over into a more personal space because of the way that I put myself out there, and having these conversations that were so structured allowed me to open up more and more to you about my work. Even *EXTREME SUBMISSION:* That project, as distinct as it is, tells you nothing about me other than I experienced this one particular thing and maybe you did too.

I think that early on as well I came with the same kind of interaction because I think one of the things that I learned as a member of the SM community or that I really value within the BDSM scene is the structure around consent and conversation being the main part of everything. You can spend days, weeks, months negotiating, talking, and working through consent and then play for all of forty-five minutes. So it becomes this part of it but you really do value and you come to people with a certain kind of respect. But also there was another thing that I carried into our interaction, especially because we were talking about these things that could go into language that dealt with body, et cetera. The fact that as someone who is masculine and particularly engaging in work that is dealing with dominance and submission but more really working through and working up to this idea of domming myself and then you coming with work that you've been doing and occupying a certain kind of background that is explicit around sex work engagement, cam girl engagement, and submission, and also presenting what people would assume to be a feminine identity that could be X Y Z, you know. I was very aware of that and never wanted to put you in a place where you felt uncomfortable because I already knew. I mean just from the way that I even had to go about looking at your work. You go on Xtube and you have your work on Xtube, and great work, because, I mean, I remember I went there to get an idea of what you meant by the glitches that you were creating. These manual effects that you are making to glitch these videos and having them be on there and then also seeing the way people are commenting on the work and seeing how your work is being consumed. I think your work made me think a lot about this Internet space and made me have to confront a lot of my anxieties around art within the Internet space and also thinking about archive. This thing that I have that is very much a part of my practice, right, is in my investment in exploring and producing work from Black genealogies, Black queer genealogies. I'm in the archives, physical archives, going through this physical process of mining this information, engaging with people in real life as a part of my framework of exploring this idea of Black mentifact. The Internet was always a scary space for me because I don't understand if I'm looking at a copy or if I'm looking at the original. I did a project that dealt with Baudrillard and simulation and simulacra and it makes me think about, like, what that means. There's a line in his book that he says, you know, "When the real no longer exists, nostalgia assumes its true meaning." And what and how that relates to your work, right, because there is something that is at risk for there being, you know, this copy without an original. And what does that mean for people to have this desire for something that was never "real" in this online space because from our personal conversations I'm bringing in the information that you shared with me around the fact that none of this has to do with you. So, is this a created thing, being in whatever ways you want to be? Being physical or not in these Internet spaces that you've had complete control over,

HOLLOWAY, MCCLODDEN

presenting as you know to these folks who consume you or what they think to be you in many ways, whether it be transaction-based or literally the ways that you bring people into having to engage with your work on these sites. Can you talk a little bit about that?

Holloway: It's interesting how much that quote grates against the work that I do. I almost always think about what it means to sort of transfer or guide. I'm not quite sure what language I want to settle on for this, but to guide subjectivity into the browser. I think a lot of the studies that I do with the browser are as a living space and that has two meanings: one that is a living space as a space with life inside of it that happens without you, but also like a living room is a living space because you're able to customize it and make changes to it, et cetera.

Paris Snapchat composition, April 20, 2016
Courtesy of Shawné Michelain Holloway

You know, an original kind of doesn't exist and I go back to this question that people also ask me, usually after the question about intimacy: "Are people consuming your identity?" And even in the real world I can't pinpoint an original identity for me. I think part of coming out of this ethic of glitch art, right? Not only aesthetically but it's a lifestyle in a certain way—Dirty New Media, I guess Glitchy, Dirty New Media is about inconsistency and about infinite rearranging of data into an experiential format. The data becomes performative in a certain way. Seeing someone who was making work about very similar structures because we were making work structures with the immovability [or] the immovableness is quite striking. You know, I had to work that out.

McClodden: Yeah, we definitely do. I mean that's been some of the points of our more difficult conversations, like our blowouts.

Holloway: Every time.

McClodden: We have the most amazing arguments because it's like pushing at all the things that I need to expand upon and then I would venture to say things that maybe you should consider sometimes, but I feel I always leave with growth and I think that's a thing as well. And this is just the sidebar, but I like being able to argue and come from these strong standpoints and push in a way that it's not trying to kill each other. You know, like, not trying to destroy in these ways that I think can be quite toxic in other kinds of artists' friendships and workshops or collaboration in conversations because I think that we've been able to find a vulnerability to be able to share at the most vulnerable level of creation, which is ideation and concept, and then we talk about concepts and we go and do the thing and it's like, "Hey, look what I did." It's really a vulnerable process. I don't really have it with a lot of people, but I do want it.

HOLLOWAY, MCCLODDEN

THE BLACK SIMMER

AMIRA VIRGIL

All images are of custom Sims and packs created by the author.

84 The Black Simmer forum came into existence simply because I realized that people of color did not have a designated space where we could collectively vent and share content within the *Sims* community.

The Sims is a game that simulates life, with customizable characters. Other spaces in the *Sims* community are not welcoming to POC Simmers and content creators. Racist trolls would populate the official forums, telling Simmers that hair that looks like theirs should be optional custom content, in addition to various microaggressions Simmers would constantly deal with in primarily White spaces. Nonblack Simmers making Black Sims, and deciding that they suddenly wanted to implement a "negative" storyline, filled it to the brim with stereotypes. These constant attacks—paired with content creators and the game developers catering to one demographic while Simmers of color are left alone to figure it out—led to Black Simmers either

deciding to stop playing the game altogether or making the decision to conform. As a content creator, I found that the issue of the skin tones that originally shipped with *The Sims 4*, with the darker skin tones having gray undertones, opened up a big conversation with my audience. I asked questions like "Why do Simmers always have to create White/lighter Sims?" "Where are the Black families? Or the Black families with darker shades of brown?" If you scroll down your Simblr (tumblr for Simmers) timeline now in comparison to three years ago, there is a huge difference. It speaks to a much larger discussion on the gaming industry, which has a very long way to go dealing with matters of diversity and inclusivity.

CARNIVAL
CREATE A SIM

Melanin
pack
2

VIRGIL

JUNE JORDAN'S VISION OF A BLACK FUTURE

DOREEN ST. FÉLIX

An aerial blueprint of an alternative future disoriented readers of the gentlemen's magazine *Esquire* in April 1965. Three rivers—Harlem, Hudson, and East—carve this divergent Harlem as they carve the known Harlem, producing its shape, that maligned almost rectangle. The blueprint's topography suggests a fiction, or a prophetic vision: Fifteen towers rise above the stubborn city grid, and they are softly curved as if caught spinning on a potter's wheel, or "abstract, stylized Christmas trees," to quote the plan's author, and the towers are connected by a reticulation of thin highways elevated aboveground, and this network originates from an imagined bridge, drawn at the eastern boundary of 125th Street.

The article attributes this Harlem—the Harlem that does not exist—to the architects Richard Buckminster Fuller and Shoji Sadao, collaborators and insurgents designing against the popular credo of public space. (There is the joint signature, scrawled below the East River.) Text, written nearly one year after the murder of James Powell by police lieutenant Thomas Gilligan caused a summer of rage uptown, elaborates on the plan in the rhythm of manifesto. "Harlem is life dying inside a closet," the writer begins, and then later, "Skyrise for Harlem is a proposal to rescue a quarter million lives by completely transforming their environment." The vigor of the writing juts out like the towers, puncturing the reader's received knowledge as to why the Blacks in Harlem were so poor, so riotous, so eternally chained to that undesirable life's station. The author writes of life in the housing towers: "No one will move anywhere but up." Of the reorganized ground near the towers: "Skyrise for Harlem creates cultural centers decked into the sky . . . offering practice studios for musicians, concert halls, theatres, workshops, forums for symposia, dancing pavilions, and athletic fields as well as pathways for strolling under trees." Of the force oppressive enclosures exert on the human psyche: "There is no evading architecture, no meaningful denial of our position." Of this Harlem's spiritual improvement on the known Harlem, "The design will obliterate a valley of shadows."

ST. FÉLIX

RODAN TEKLE, SEAN D. HENRY-SMITH, AND DESTINY BRUNDIDGE

This conversation has been condensed and edited for clarity.
It took place in Brooklyn, New York, December 2017.

Rodan Tekle: It's said [that] Mami Wata is the manifestation of centuries-old West African religious traditions forced to integrate into a capitalist system. So it's in the spirit of "I need to gather all my shit and create some kind of alchemy here to survive this," that the interface came about.

How do we engage with mass information of everyone's lives and everyone's story? Not just contemporary stories but throughout history. Everything. Black joy, Eritrean refugees, Nigerian comedy. With Black life there's a lot of suffering included, too. What if the spirit of Mami Wata was here now to help navigate it all? [The] avatar in Hindu culture is literally a manifestation of a deity, or divine teacher; and in this project, the avatar of Mami Wata is a Black digital representative, a symbol for spiritual guidance through the chaos of the Internet. The idea was that Mami Wata is an interface that could help me study, process, and play with my past data.

But why can't we actually have access to *all* of our past engagements? And [wouldn't] that archive be a great tool in terms of healing? What if all of our past interactions were archived in a real and dynamic way, where we could study our digital lives? That was the main idea behind it—a reminder that the Internet is still in its infancy and that we should try to imagine a more creative, better future version of it.

One aspect of this prototype interface I made, in a way, is not too different from that thing Facebook does—how they have some algorithm that assembles your data and puts it together and plays it back as a sad li'l film. Different in the sense that in the prototype you are able to interact with the making of it, in a live way, toggling between different apps, times, functions, and platforms, and the avatar is present there, functional, but also as a representation of an Internet that *actually* cares for you and yours.

Sean D. Henry-Smith: One of the first things I fall into in your work is how it's nonlinear. What the linear does is that thing that Facebook does, like here are all your videos, and forces a memory that isn't actually accurate of what happened around that time. Your project fills in gaps—like what was the tab that brought you to the other tab? I think where you lose focus is actually an important part, [or] where the focus changes, rather— and that's where the human is introduced into the machine.

Tekle: That reminds me of something that I was hearing about Black jazz musicians: In America, at that height of their golden era, there would be notations of their improvisations, and people would try to re-create it but it would never be the same, because there is all this stuff in between the notes that can't be written out—the human spirit.

TEKLE, HENRY-SMITH, BRUNDIDGE

Henry-Smith:	The thing that is consistent is, again, that nonlinear experience, like half reading an article and then being like "Oh, what's that word again?" and then looking up that word and then going on the Wikipedia binge, or like halfway through, forgetting it altogether and being like, "Oh, I really want to hear this song."
Tekle:	A lot of people expressed, in response to my piece, that they weren't interested in having access to an organized archive of their generated data. I understand that.
Henry-Smith:	I think there's an importance to forgetfulness as well.
Tekle and Destiny Brundidge:	Yes, true.
Tekle:	I don't think it's necessarily a requirement, for a better quality of life, to have full access to the past data you've generated. Our stories, even the ones we tell ourselves, have always been very controlled, and the stuff that you don't think matters, or that you're ashamed of or that you don't want to surface would just not surface. I mean, I'm terrified that all this stuff that I deleted is not deleted, that it can come back to me in a folder or could be published. A nightmare.
Henry-Smith:	We are not in control of it.
Tekle:	But it seems that people don't want to be in control of it either!
Henry-Smith:	Do you feel like you would experience it differently if you were the only holder of it?
Tekle:	That's the idea in the piece—the data is yours, you own it, the avatar is the protector and a sort of alchemist of it, and will feed it back to you as you need, in an intelligent and deeply meaningful way.
Brundidge:	Ooh, that's interesting—how do you program care?
Tekle:	Yesss.
Brundidge:	There's that Black robot . . .
Tekle:	Oh, Bina?[1]
Brundidge:	Yeah, what's her name?

TEKLE, HENRY-SMITH, BRUNDIDGE

FAR BEYOND THE STARS

AYANA JAMIESON

The Octavia E. Butler Collection of literary manuscripts housed at the Huntington Library is a vast archive comprising more than eight thousand individually cataloged items that span Butler's four-decade-long career. [Octavia] kept everything—from grade school report cards, personal journals, letters, brochures, notes, drafts, unpublished writing, grocery lists to photographs, library call slips, research, and much more.

She kept drafts and photocopies of letters she wrote. Her imperative to deliberately and consciously shape her own legacy was driven by the facts of her life and identity, a nexus where Black experience, womanism, and history intersected. Her collection reminds us what we have, what we've lost, and what can be gained by leaving behind self-curated libraries.

JAMIESON

104 Some strategies for building your own archive for the Black future:

Keep a physical record: Whether it is a conventional journal, a memory planner, a bulleted list of tasks, or a graphic vision board with commentary, it is essential to reflect in words/images that come from everyday life. Some people write down dreams, current events, or daily activities to revisit them later. Handwriting, doodles, drawings, and so on reveal things about ourselves that are not available in typed script.

Save ordinary artifacts: Ticket stubs, gallery guides, receipts, school assignments, canceled checks for paid bills, diplomas, greeting cards, thank-you notes, and other things we collect through life are artifacts of our particular time, interests, existence, and experiences. We don't need to be published authors, artists, or famous to have historically relevant possessions.

Curate your life beyond (and in addition to) the algorithms of social media and digital existence: Regularly print out photos and playlists, and transcribe recordings stored or shared electronically in a way that does not require technology. Cloud storage, corporate media platforms, and hard-drive storage may become inaccessible or obsolete.

Cultivate affinity relationships with other folks: Collaborate, engage, and designate stakeholders in shaping your shared legacy in the event of your absence. Do this with letters, postcards, events—virtual and tangible. Take photos, record testimonies, create artifacts such as zines and shared writing that communicate shared goals and aspirations for a communal inheritance.

Become familiar with inheritance and bequest requirements in your state or country. Create a digital living will to designate what happens to your social media content, emails, and other online accounts along with your physical and intellectual property.

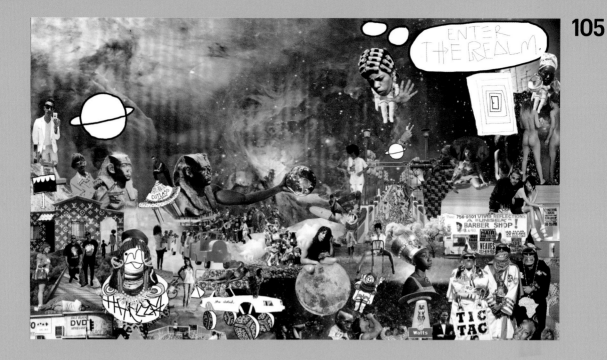

Lauren Halsey
Untitled (blueprint), 2012
Digital collage

PULiTZER Kenny

Rapper Kendrick Lamar performs on the
Rock Stage during day 1 of Grandoozy on
September 14, 2018, in Denver, Colorado,
after winning the Pulitzer Prize for Music
on April 16, 2018.

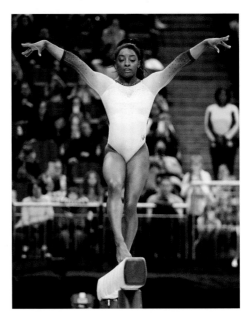

Simone Biles representing the United
States during her beam performance at the
Superstars of Gymnastics at O2 Arena,
London, England, on March 23, 2019.

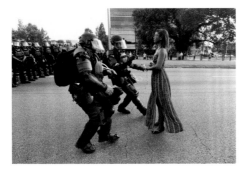

Ieshia Evans, a nurse from Pennsylvania,
protests police brutality in Baton Rouge,
Louisiana, on August 11, 2016, following the
murder of Alton Sterling. Moments after this
photo was taken, she was arrested.

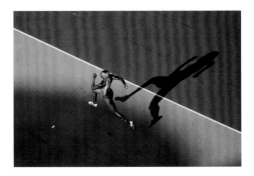

Priscilla Frederick of Antigua and Barbuda
competes in the women's high jump final
during athletics on day 10 of the Gold
Coast 2018 Commonwealth Games at Carrara
Stadium on April 14, 2018, on the Gold
Coast of Australia.

POWER

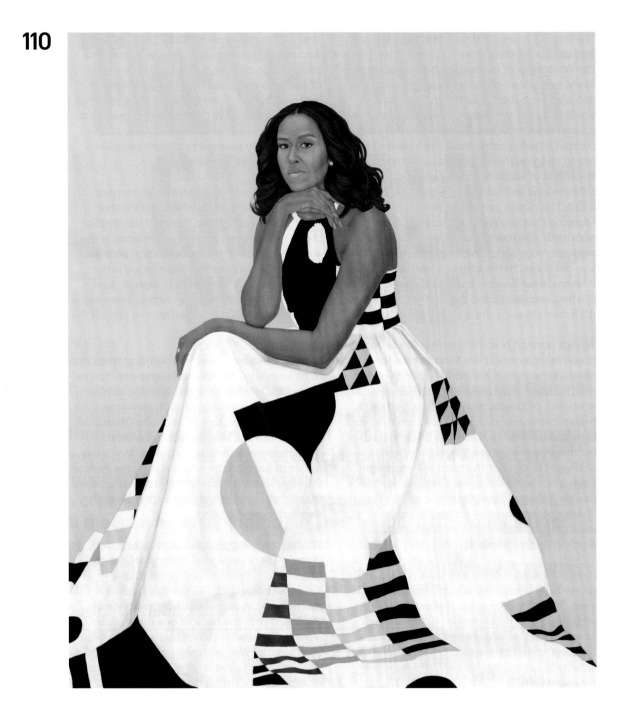

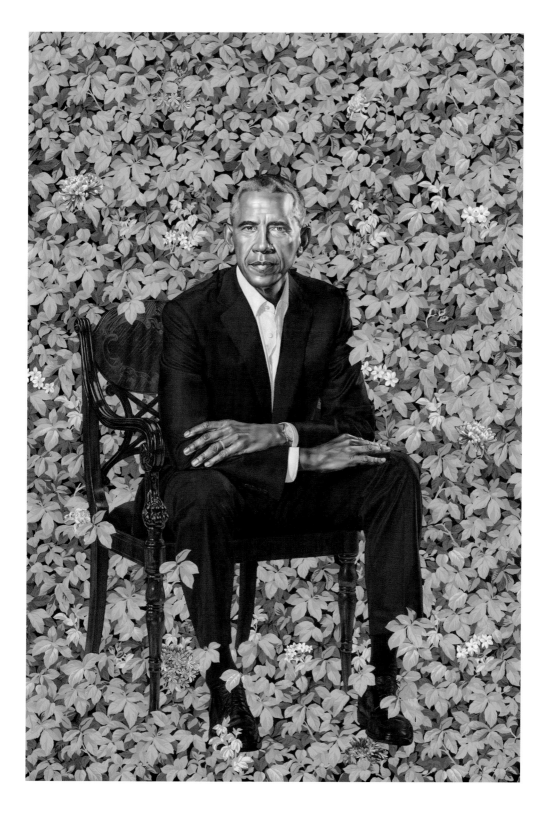

MORRIS

the boogie-woogie phase of an artist like Piet Mondrian. The dress is a dress, but also a character, a quilt, a canvas upon which to splash your awe or befuddlement.

The reason to spend any time thinking about the dress is because the dress isn't an accident or accent—nothing that takes up a third of a canvas is accidental. It's a crown by another name. On anybody else, that dress is wearing them. But on Obama, it's a complement. Its complexity, capaciousness, mystery, impossibility (how do you put it on, wear or walk in it; and since it's too long for the canvas to contain it, where does it end?); its brightness, warmth, generosity all could be Obama's. It seems to issue out from her.

Here's a garment that lets her be. And what, in this portrait, is she being? Regal? Demure? Polite? Actually, Obama looks contemplative, captured in a moment of reflection. She would have sat for Sherald at the end of her White House tenure. There would have been time to think about all that she saw and that she came to mean, perhaps the lack of precedent for most of it. I can feel history in this portrait. I can also feel something glum. The blues happen to be part of the Amy Sherald project. That's the actual color of the skin of the people she paints. A deep unsaturated blue. But also a whiff of melancholy. Kehinde Wiley's portraits want to glorify the neglected and majestify the maligned. I think Sherald's simply want to observe. Their ambition is to ask who else these people are besides the Black folks they would be tagged as. You look at Sherald peering into Michelle Obama and you're rocked. She's a figure of majesty, too. But she's also another of Sherald's everyday people. And for all the looking we've done at this woman, you really do wonder whether she's ever truly felt seen.

IMAGE, PAGE 110
Amy Sherald
Michelle LaVaughn Robinson Obama, 2018
Oil on linen
Courtesy: National Portrait Gallery,
Smithsonian Institution

IMAGE, PAGE 111
Kehinde Wiley
Barack Obama, 2018
Oil on canvas, framed: 92¼ x 65¾ inches
© 2018 Kehinde Wiley
Courtesy: National Portrait Gallery, Smithsonian Institution

DUST II ONYX

SOLEIL LEVÉ
BON MAMBO
ELIZABETH RUTH

Courtney Alexander
Ain't Je-Mammy (Queen Mother/Empress), 2017
Acrylic, pastel, spray paint, gold leaf paint, and magazine
clippings on bristol paper, 14 in x 17 in (35.56 cm x 43.18 cm)
Image courtesy Courtney Alexander

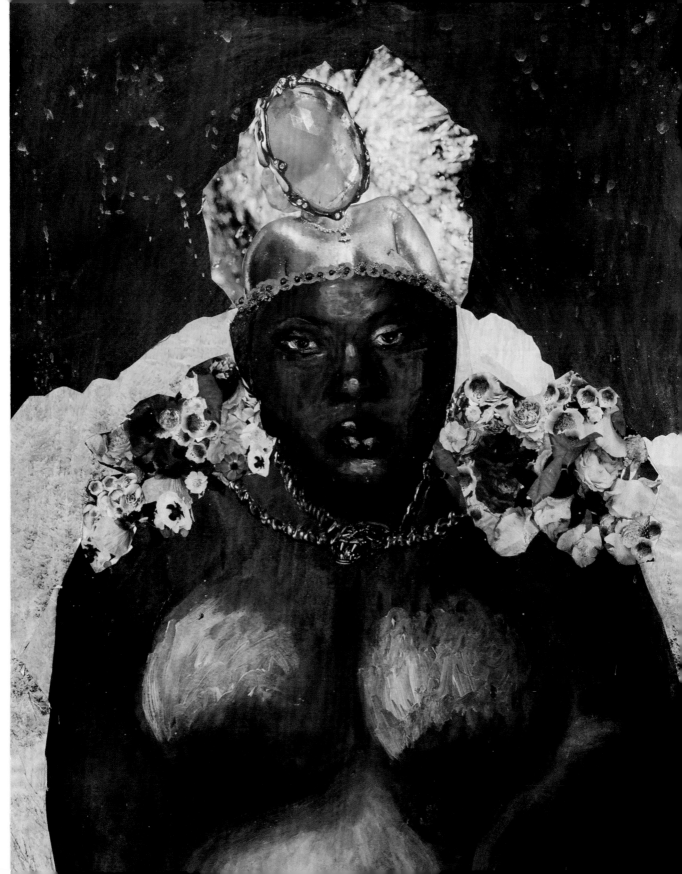

BLACK TO THE LAND

LEAH PENNIMAN

Learners in the Soul Fire Afro-Indigenous
Farming Immersion gather on graduation day.

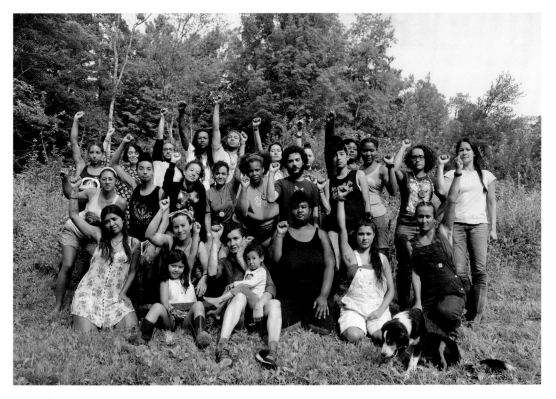

Our ancestral grandmothers in the Dahomey region of West Africa braided seeds of okra, molokhia, and Levant cotton into their hair before being forced to board transatlantic slave ships. They hid sesame, black-eyed pea, rice, and melon seeds in their locks. They stashed away amara, kale, gourd, sorrel, basil, tamarind, and kola in their tresses. The seed was their most precious legacy, and they believed against odds in a future of tilling and reaping the earth. They believed that we, Black descendants, would exist and that we would receive and honor the gift of the seed.[1]

PENNIMAN

Along with the seed, our grandmothers also braided their ecosystemic and cultural knowledge. African people, expert agriculturalists, created soil testing systems that used both taste to determine pH and touch to determine texture. Cleopatra developed the first vermicomposting system, warning citizens that they would face harsh punishment for harming any worm.[2] Ghanaian women created "African Dark Earths"—a compost mixture of bone char, kitchen scraps, and ash that had built up over generations—which captured carbon and fertilized crops.[3] African farmers developed dozens of complex agroforestry systems, integrating trees, herbs, annuals, and livestock. The farmers built terraces to prevent erosion and invented the most versatile and widely used farming tool: the hoe.[4] Our people invented the world's initial irrigation systems five thousand years ago and watered the Sahel with foggaras that are still in use today. They domesticated livestock and established rotational grazing that created fertile ground for grain crops. Our ancestors created sophisticated communal labor systems, cooperative credit organizations, and land-honoring ceremony. On Turtle Island, Black agriculturalists like Booker T. Whatley, George Washington Carver, Fannie Lou Hamer, and Harriet Tubman brought us the CSA (community-supported agriculture), organic/regenerative farming, cooperative farms, land trusts, and herbalism. Even as the colonizers raped the soil of 50 percent of its carbon in their first generation of settling, we used ancestral techniques like mounding, deep mulching, plant-based toxin extraction, and cover cropping to call life back into the soil. Our grandmothers braided all this wisdom and more into their hair and brought it across the Middle Passage. It is our heritage.

Of course, the project of the Empire is to make us forget, to confuse us and colonize our hearts, to make us name the land "enemy" and relinquish all claims of belonging. The DNA of the food system in the United States is the stolen land of Indigenous people and the stolen labor of African people. This DNA remains intact and unrectified. Even after emancipation, the Black codes, convict leasing, and sharecropping kept Black farmers in a state of neoslavery. When our folks fled racial terror, the more than forty-five thousand lynchings and house burnings in the South, as part of the Great Migration, that labor force was replaced with "guest workers" born outside the borders, and subject to unfair labor conditions.[5] The Black farmers who remained in the South, attempting to hold on to their land, were discriminated against by the federal government and denied access to the USDA programs to which they were entitled. In the North, Black folks attempting to access land met other forms of discrimination—redlining, denial of mortgages through the G.I. Bill, and the persistent 16:1 White/Black wealth gap that originated with the ten trillion dollars gained from the unpaid labor of our enslaved forebears.[6] We further faced food apartheid, that system of segregation that meant little to no availability of fresh, culturally appropriate foods in our neighborhoods, and the resultant epidemic of diabetes, obesity, and heart disease. The Empire is pleased when we turn our backs on the Earth, allowing White people to control 98 percent of the farmland in this country, consenting to their ownership of the soil, the groundwater, the minerals, and the food supply.

Yet, in every generation there were Black people who remembered the gift of the seed and the legacy of belonging to the land. We pay homage to one such rememberer, Fannie Lou Hamer, who said, "When you have 400 quarts of greens and gumbo soup canned for the winter, no one can push you around or tell you what to do." In 1969, Hamer founded the Freedom Farm Cooperative on forty acres of prime Delta land. Her goal was to empower poor Black farmers and sharecroppers who had suffered at the mercy of White landowners. She said, "The time has come now when

A.
Healers from Harriet's Apothecary, Brooklyn, New York, prepare to offer a community healing village at Soul Fire Farm.

B.
Healers from Harriet's Apothecary, Brooklyn, New York, hang onions to cure in the barn at Soul Fire Farm.

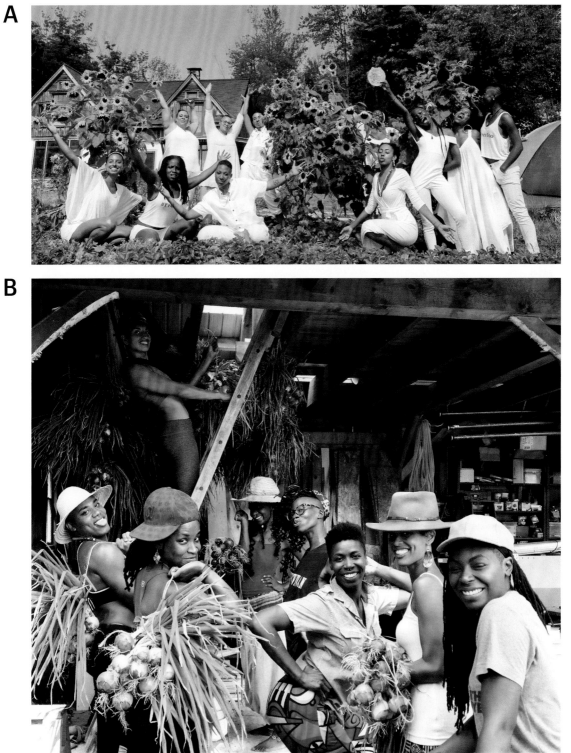

we are going to have to get what we need ourselves. We may get a little help, here and there, but in the main we're going to have to do it ourselves." The co-op consisted of fifteen hundred families who planted cash crops, like soybeans and cotton, as well as mixed vegetables. They purchased another 640 acres and started a "pig bank" that distributed livestock to Black farmers. The farm grew into a multifaceted self-help organization, providing scholarships, home-building assistance, a commercial kitchen, a garment factory, a tool bank, agricultural training, and burial fees to its members. Thank you, Mama Hamer, for keeping the seed alive.[7]

The seed is passed to you, Black child of Black gold. If we do not figure out how to continue the legacy of our agricultural traditions, this art of living in a sacred manner on land will go extinct for our people. Then, the KKK, the White Citizens' Councils, and Monsanto would be rubbing their hands together in glee, saying, "We convinced them to hate the Earth and now it's all ours." We will not let the colonizers rob us of our right to belong to the Earth and to have agency in the food system. We belong here, bare feet planted firmly on the land, hands calloused with the work of sustaining and nourishing our community.

1. Carney, Judith. *Black Rice: The African Origins of Rice Cultivation in the Americas* (Cambridge, MA: Harvard University Press, 2001).

2. Minnich, Jerry. *The Earthworm Book: How to Raise and Use Earthworms for Your Farm and Garden* (Emmaus, PA: Rodale Press, 1977).

3. Fairhead, James et al., "Indigenous African Soil Enrichment as a Climate-Smart Sustainable Agriculture Alternative," *Frontiers in Ecology and the Environment* 14, no. 2 (2016): 71–76.

4. Schons, Mary. "African American Inventors II," *National Geographic*, June 21, 2011. www.national geographic.org/news/african-american-inventors-19th -century.

5. *Regaining Ground: Cultivating Community Assets and Preserving Black Land* (New York: Center for Social Inclusion, 2011). www.centerforsocialinclusion.org/wp -content/uploads/2014/07/Regaining-Ground-Cultivating -Community-Assets-and-Preserving-Black-Land.pdf.

6. Shin, Laura. "The Racial Wealth Gap: Why a Typical White Household Has 16 Times the Wealth of a Black One," *Forbes*, March 26, 2015. www.forbes.com/sites /laurashin/2015/03/26/the-racial-wealth-gap-why-a-typical -white-household-has-16-times-the-wealth-of-a-black-one.

7. "Fannie Lou Hamer Founds Freedom Farm Cooperative," SNCC Digital Gateway. snccdigital.org/events/fannie-lou -hamer-founds-freedom-farm-cooperative/.

C.
(L to R) Chanelle Crosby, Fresh Roberson, and Noah McDonald participate in the 2018 Soul Fire Afro-Indigenous Farming Immersion.

D.
Alixa Garcia and Donnay Edmund harvest garlic at Soul Fire Farm.

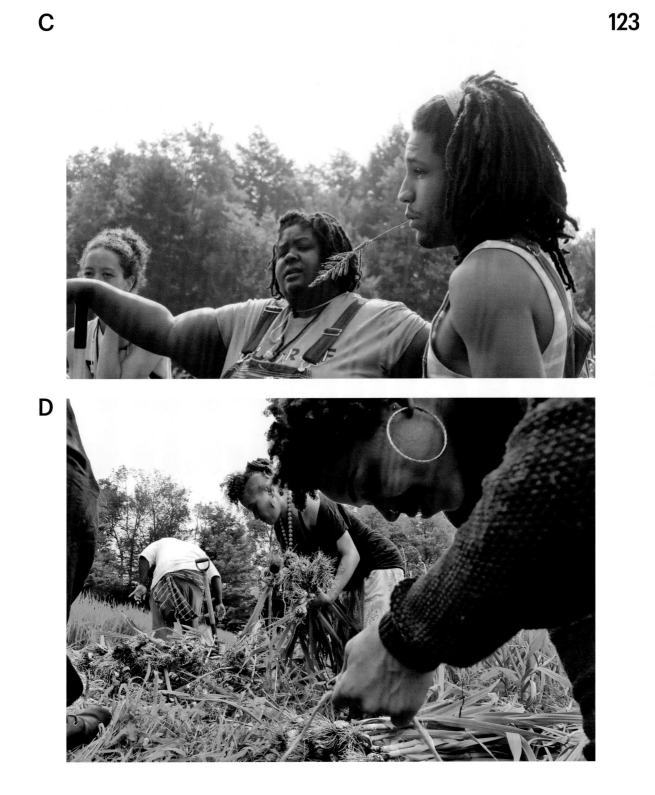

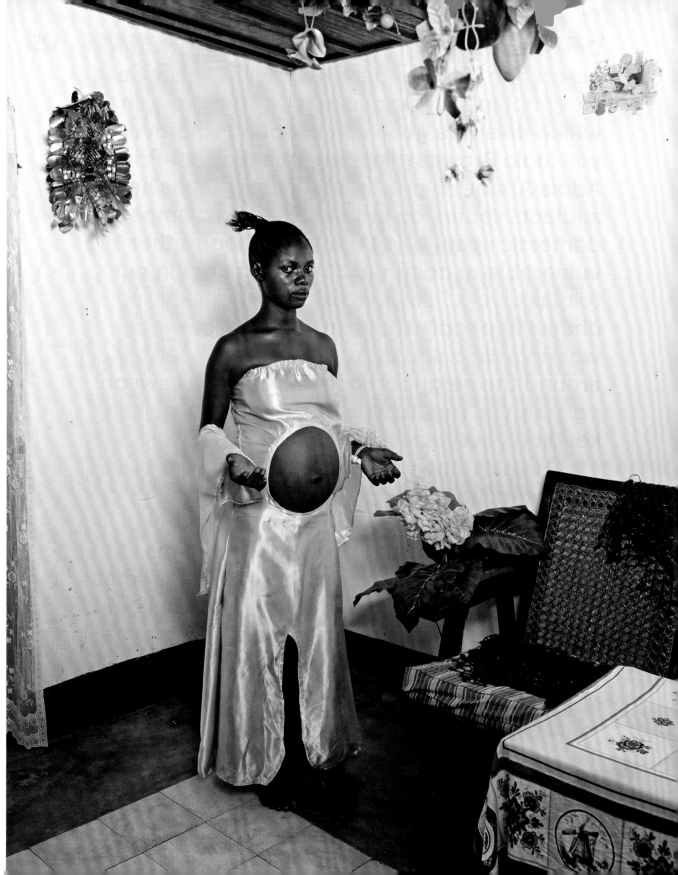

Circumstances are in no way hidden or re-moved from the shot; nothing is tidied up or away, and everything is included. Dirty laundry is aired in public (and appears on the floor). Half-painted walls, faulty wiring, sheetless mattresses, cardboard boxes filled with old-format technology, beat-up couches, frayed rugs, curling tiles, broken blinds. That these circumstances should prove so similar—from New York to Jamaica, from Haiti to the Democratic Republic of the Congo—carries its own political message. But the repetition also takes on a mystical cast, as we note visual leitmotifs and symbols that seem to reoccur across time, space, and cultures. Paragraphs could be written on Lawson's curtains alone: cheap curtains, net curtains, curtains taped up—or else hanging from shower rings—curtains torn, faded, thin, permeable. Curtains, like doors, are an attempt to mark off space from the outside world: They create a home for the family, a sanctuary for a people, or they may simply describe the borders of a private realm. In these photographs, though, borders are fragile, penetrable, thin as gauze. And yet everywhere there is impregnable defiance—and aspiration. There is "kinship in free fall."

In *Living Room* (2015), taken in Brownsville, Brooklyn, all the scars are visible: the taped-up curtain, the boxes and laundry, the piled-up DVDs, that damn metal radiator. At its center pose a queen and her consort. He's on a chair, topless, while she stands unclothed behind him. They are physically beautiful—he in his early twenties, she perhaps a little older—and seem to have about them that potent mix of mutual ownership and dependence, mutual dominance and submission, that has existed between queens and their male kin from time immemorial. But this is only speculation.

Despite being on display, like objects, and partially exposed—like their ancestors on the auction block—they maintain a fierce privacy, bordered on all sides. They are exposed but well defended: salon-fresh hair, with the edges perfect; a flash of gold in her ear; his best blue jeans; her nails on point. Self-mastery in the midst of chaos. And the way they look at you! A gaze so intense that it's the viewer who ends up feeling naked.

In the history of photography that has concerned itself with Africa and its diaspora, the concept of the portal has been central. In a newspaper, say, a photograph of a black subject is usually conceived as a window onto another world. Even the most well-meaning journalistic images of black life have the intention of enabling a passage, from the first world to the third, for example, or from one side of the railway tracks to the other. It might be impossible for a black photographer in a largely white art world ever to wholly divest herself of this way of seeing, but in Lawson's *Portal* (2017, p. 129) we come as close as I can imagine. What are we looking at? A ripped hole in a couch. That's all: no human figures, no other context. Just a hole in the kind of couch with which Lawson has made us, by now, very familiar. After staring at it awhile, you might notice that it is almost Africa-shaped, but what you see initially is its magical properties. Like the voodoo practitioners Zora Neale Hurston met in Haiti, Lawson has the rare capacity of being able to take an everyday domestic object and connect it to the spiritual realm. Her work does not show us "how the other half lives." Rather, it opens up a portal between the everyday and the sacred, between our finite lives and our long cultural and racial histories, between a person and a people. *Portal* presents, in abstract, what Lawson is doing in every other photograph:

> I feel a lot of the figures that I use, I want them to be like a pivotal point, or like a vehicle or a vessel for something else. Diane Arbus was always keen on this idea of what the photograph is and what it does. What you see in the photograph is one thing; the specifics or what it references or what it's symbolic of is greater than that. She said the subject is always more complex than the picture.

What you see is not what you get. We are more than can be seen. We are here and elsewhere.

Deana Lawson
Mama Goma, Gemena, DR Congo, 2014
Pigment print, 35 x 44⅛ inches (88.9 x 112.1 cm)

SMITH, LAWSON

Deana Lawson
Portal, 2017
Pigment print, 43 x 53 inches (109.2 x 134.6 cm)

SMITH, LAWSON

COLOR(ED) THEORY
AMANDA WILLIAMS

Amanda Williams
Crown Royal Bag, from *Color(ed) Theory Suite*, 2014–16
Image courtesy of the artist

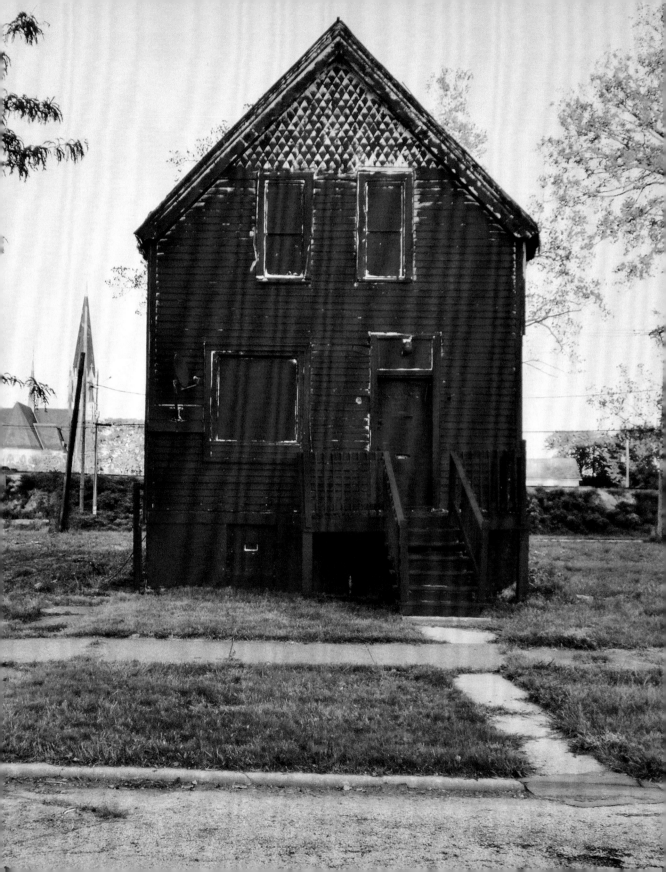

134 Launched in 2014, *Color(ed) Theory* is a multiyear exploration of color, language, and racially charged city spaces. In the project, Williams asks: What color is urban? What color is gentrification? What color is privilege? Williams (along with friends and family) covertly painted empty houses in and around Chicago's Englewood neighborhood, which were slated by the city for demolition. In addition to painting the houses, Williams photographed each house, calling attention to its architectural details and its isolation in its respective landscape.

Williams developed a unique, culturally coded, monochromatic color palette based on hues primarily found in consumer products marketed toward Black people along commercial corridors on Chicago's South Side. The project revealed how colors have socially constructed associations that are inextricably linked to the politics of race and class in America.

Amanda Williams
Ultrasheen, from *Color(ed) Theory Suite*, 2014–16
Image courtesy of the artist

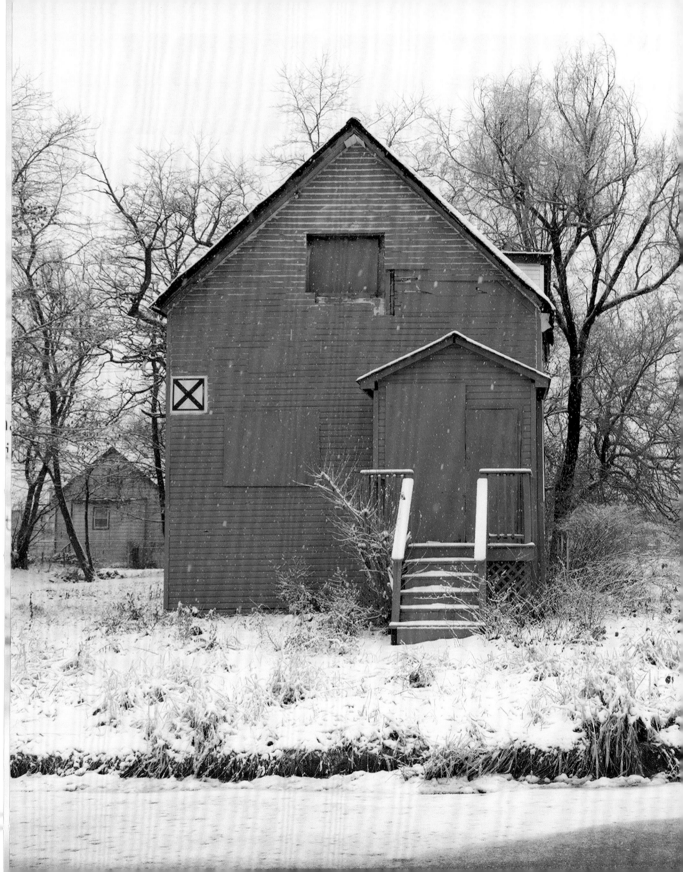

FIRELEI BÁEZ
ON
KOLEKA PUTUMA

Firelei Báez
Ciguapa Pantera (to all the goods and pleasures of this world), 2015
Acrylic and ink on paper, 95 x 69 inches
Courtesy of the artist and James Cohan, New York
Tiroche DeLeon Collection & Art Vantage PCC Ltd.

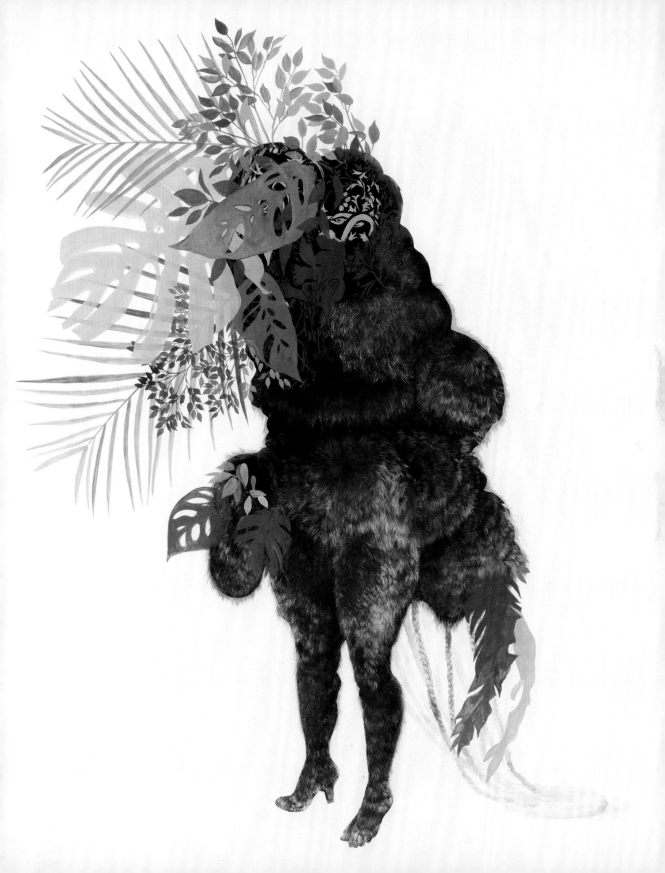

142 After my mother left for the States, when I was around five, I was a wild little tomboy who'd run around with my cousins climbing trees, going into giant pipes, collecting odd branches and shiny rocks from the surrounding hills. One day I came home with a bunch of splinters in my hands, most of which my aunt couldn't remove. They festered and became little slippery pools of pus. It was awful—as a hyperactive little girl, who knew the world around me best through constant, fluttering touch—to feel the stillness of being wounded. One day a friend came by and slathered my hands in Vicks VapoRub (a heal-all I grew up knowing as one word—*vivaporú*). By the end of the day little shards of wood started slipping through the shiny tingly goo.

Koleka Putuma is a British South African powerhouse poet who, through language, recontextualizes our notions of memory and history. She wields it in a way that traps the air out of wounds that have been festering inside us, leaving no room but for them to reveal themselves and start to heal. She masterfully transforms the very language we confidently think we know, to interlocute between many worlds. This in-between space is the playground laboratory where she airs out all the inherited cultural baggage and constructs we've so desperately outgrown.

I first met Koleka when she squeezed in next to me in a booth, both of us running away, surrounded by a party celebrating our successful wrap-up of the Berlin Biennale. She gently took apart my sad wish to be present when so much remove and sacrifice is demanded in our work. This unexpected exchange had me suddenly recalling my childhood friend who brought the *vivaporú*. As children of empire— both of us raised between places and cultures: ones that birthed us and those with binding colonial tendrils—we are constantly required to master, and in doing so, transform, tools not native to ourselves. We are expected to transmute truthful experiences, through art forms whose very structures are meant to erase us.

FAIRVIEW

JACKIE SIBBLIES DRURY

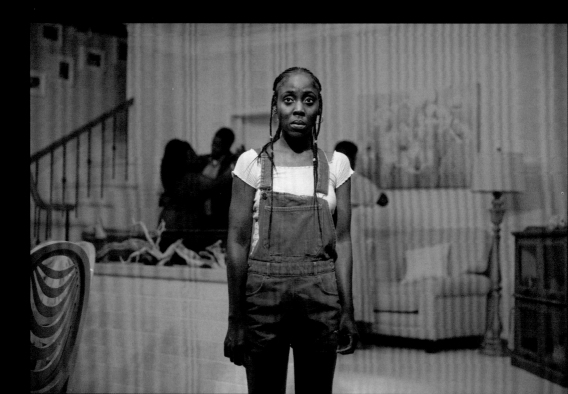

KEISHA (*aside-ish*)
Do you think that I could—
What if I could?
But if I could ask the folks who call themselves white to come up here,
do you think they would?
Could I ask them to come up in here,
so that we could go down out there?
Do you think I could ask the folks who call themselves white to do that?
To switch for a little while?
How should I ask them, if I could?
Could I say,
Hi, white people.
Come here, white people. Come on up here.

KEISHA steps through the fourth wall. It's as simple as that.

Could I say,
Come up here folks who identify as white,
you know who you are.
You can choose to come up here
to where I've always been, where my family has always been.
Sit on the couch.
Make yourself a plate.
Look out from where I am.
And let me and my family go out to where you've always been.
Could I say that?
Could I ask them that?
How should I ask?
If I asked would they do it?
How long would it take?
Would it help if I told them that the show is ending?
Would it help white people to go up there, to where I've been,
if I tell them that we'll all leave soon?
That there are things in motion already?
That we are all going to leave anyway?
Could I tell them that those seats are not theirs,
even though they paid for them?
That no one can own a seat forever?
That no one should?

Could I say,
See, there's Terri.
She's our stage manager.
She's amazing.
She's white.
She's coming up here.
You can come on up here too.
[You can take the stairs.
You can take the elevator.]
[Maybe you stand on the stage.
Maybe you stand near the stage.]
Leave your coats. Leave your bags. Leave your things.
Just stop worrying about your things, for a minute,
and worry about where you can go,
what you can do to make space for someone else for a minute,
if you could.
Do I sound naïve?
Does that matter?
Do I have to keep talking to them
and keep talking to them
and keep talking only to them
only to them
only to them
until I have used up every word
until I have nothing left for
You?
I've been trying to talk to You.
This whole time.
Have you heard me?
Do I have to tell them that I want them to make space for us
for them to make space for us?
Do I really have to tell them that?
Do I have to tell them why I want them to go up there
for them to go up there?
Why I want them to sit on the sofa
and sit on the chairs
and sit on the carpet
and touch the walls
and touch the fake food
and touch your own face pretending to look in a mirror
but really looking into the lights?
They're bright, aren't they?
Should I tell them that the lights are there to

DRURY

help people see them not to help them see anything?

So I could be out here with all my people of color?

With all my colorful people?

And we could be all of us together alone?

And if I were to be out here with my colorful people,

could I tell us a story?

If I were out down here, just us, I'd want to tell us a story.

A story about ending.

Or about leaving.

Or about remaining.

And how they're all the same thing if the same people do them.

But that's not the story I want to tell us all.

If I could tell the story I want to tell us,

my people,

my colorful people,

you would hear it

if I could tell it,

and it would be something like

a story about us, by us, for us, only us.

But that's not telling the story.

If I could tell the story I want to tell it would begin like this:

Once upon a time, there was a bright little girl who knew that if she worked twice as hard as—

No.

That's not what I wanted to tell.

Once, there was a little boy born with the deck stacked—

No.

Once, there was an exceptional—

It's difficult because I've already heard so many stories.

It's hard to find the one I'd wanted to tell.

It would be something like . . .

Once . . .

Well, not once,

not at all once.

Many many many many times,

there was a person who worked hard,

a person who tried to work hard,

and tried to do their best,

and tried to do well by their family,

and tried to be good, and tried to do better.

Many many times they tried this.

And so.

The person became who they always were—

who we all always are—

A Person Trying.

So they tried and they tried and they looked around

at the mountains of effort that they had built with their trying

at the piles of half-built bests

at the heaps of family

at the hills of good enough and the hills of better next time,

and as they looked around,

as they took in the view,

they saw what they had done to make the life that they had lived.

And they looked to the left and saw what you had done

to try to make the life that you have lived,

and they took in that view.

And they looked to the right and saw what you had done

to try to make the life that you have lived,

and they took in that view.

They took it all in.

And in their estimation

they found all of it,

their view over all of it,

the sum of all of it,

to be fair.

End of Play.

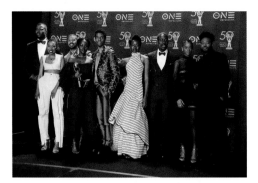

(L-R) Winston Duke, Carrie Bernans, Michael B. Jordan, Lupita Nyong'o, Chadwick Boseman, Danai Gurira, Sterling K. Brown, Letitia Wright, and Ryan Coogler pose in the Press Room at the 50th NAACP Image Awards at Dolby Theatre on March 30, 2019, in Hollywood, California.

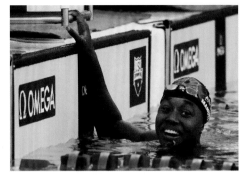

Simone Manuel reacts after placing second in the Women's 200m freestyle final during the Swimming Winter National Championships at the Greensboro Aquatic Center on November 30, 2018, in Greensboro, North Carolina.

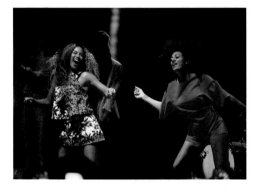

Beyoncé and Solange perform during the Coachella Valley Music & Arts Festival on April 12, 2014, in Indio, California.

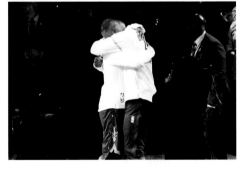

Kyrie Irving (#2) and LeBron James (#23) of the Cleveland Cavaliers hug as they receive their championship rings before playing the New York Knicks on October 25, 2016, in Cleveland, Ohio.

JOY

Black Power Naps is an art installation designed for soft interruption. *Black Power Naps* is a Black Hole that melanates the White institution, swallowing its edges and creating circular and soft surfaces for energetic reparation. The Black Power Naps movement resists the hypermasculinity of cityscapes, obsolescing its hostility and waste economies, and puts forth a sensory space that welcomes rest.

In a world designed to keep people on high alert—transient and armored—we've found that places traditionally marked as "leisurely" are often also places of performance: basketball courts, skate parks, soccer fields, open air gyms, etc. These places frame athleticism, achievements, and feats as the only possibility for the leisurely body in cities. This performance-based leisure is exclusionary (racialized, classed, and gendered): The people that have access to these "rejuvenating" spaces are largely able-bodied, White, cis, male, documented citizens.

Modes of leisure in public spaces need to be reexamined if we are to truly engage in writing equitable Black futures. Therefore, urbanism, landscaping, architecture and design, historically chromophobic fields that interact in what we call "public space," need to take a note or two from the Black body at rest.

According to our thirty-plus years of research, *Black Power Naps* presents a hoelistic[1] place of leisure reuniting several elements essential to rest:

Worship: Wherever there is rest, there is spirit. As you step into the installation, you feel a vibration of quiet joy, cohesive wave patterns, and prayer. As in any church or mosque, it is taboo to disrupt worship. We appreciate your consideration of this request as a means of protection for those who wish to worship.

Idleness: Discontinuing productivity and/or consumerism. Visitors are invited to simply exist, supported by technologies of rest. For example, the Sensory calming bath depriortizes sight, which is the primary sense solicited by visual capitalism and comparison. The installation is designed to interact with all our senses. Instead of creating cognitive arousal, the ways in which the senses are amplified create a calming environment conducive to rest. Remember, sleep is always an option.

Playfulness: Play is defined by an enjoyment-driven engagement, as opposed to a productive or commodifiable result. As adults, we lose occasions, time, and space to play, swamped by the need to be productive. An inclusive space of rest welcomes playfulness both in adults and children, creating an intergenerational shield of non-productivity that is energetically transformative.

Functionality: Every surface of the installation has both an aesthetic direction and a practical function. The Polycrastination bed frame recharges cellphones and laptops. The survival blankets that surround the black bean bed trap body heat, which vaporizes the fresh lavender bundles that hang above the pit full of two tons of black beans.

Consent: Everyone has a right to interpersonal, group, and spatial consensual practices. Some may sleep, some may jump on the trampoline, some may read, some may cuddle, and some are organizing. All these seemingly disparate activities can happen at the same time in a hoelistic place of leisure, supported by consensual practices ranging from deep observation to asking: Is it okay if I wild out . . . ?[2]

1. Hoelistic: hoe-friendly wholesomeness, an interruption to the whorephobic wellness movement led by White feminism.

2. "You Mind If I Wild Out?" refers to an online dance challenge in which people are recorded wildly dancing on the sidewalk while a driver loudly plays rap music nearby. The term originates from a video recorded on July 25, 2016, by the rapper Fly Young Red.

ACOSTA, SOSA

#THANKSGIVING WITHBLACKFAMILIES

ZIWE FUMUDOH

From competitive dishes of macaroni and cheese to an elder relative's fundamental misunderstanding of the phrase "short prayer," the hashtag #ThanksgivingwithBlackFamilies showcases a collective Black experience. What makes Black Thanksgivings so different are the unspoken cultural elements that each family member brings to the proverbial and literal table. Our embrace of Thanksgiving is complex: How do we make sense of the celebration of the genocide of indigenous people of this continent? But if you are interested in learning more about Black cultural traditions, look no further than the virality of tweets from Black Twitter discussing the merits of a good sweet potato pie, the arbitrary Thanksgiving dinner time of 3:00 P.M., and the very specific differences between "dressing" and "stuffing." #ThanksgivingwithBlackFamilies trends annually on Twitter. For Black Twitter users, these tweets are a brief reprieve from the realities of a world that has marginalized them, subjugated them, and mined their art for culture only to turn around and devalue them as progenitors of culture. #ThanksgivingwithBlackFamilies serves as a constant reminder that while many Black Americans are not able to trace their lineage due to the horrors and impact of the transatlantic slave trade, rich cultural traditions connect them to other Black families across the country and globe. And all this is communicated in 280 characters or less.

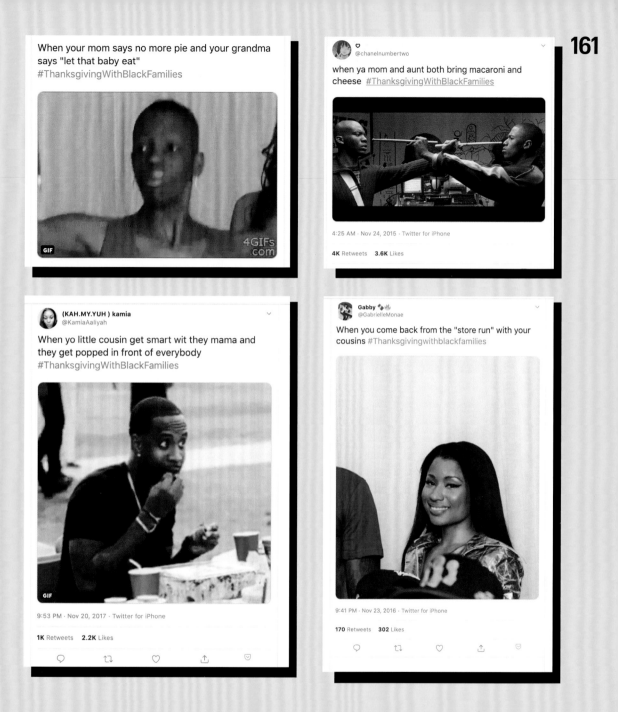

When your mom says no more pie and your grandma says "let that baby eat" #ThanksgivingWithBlackFamilies

@chanelnumbertwo

when ya mom and aunt both bring macaroni and cheese #ThanksgivingWithBlackFamilies

4:25 AM · Nov 24, 2015 · Twitter for iPhone

4K Retweets 3.6K Likes

(KAH.MY.YUH) kamia
@KamiaAaliyah

When yo little cousin get smart wit they mama and they get popped in front of everybody #ThanksgivingWithBlackFamilies

9:53 PM · Nov 20, 2017 · Twitter for iPhone

1K Retweets 2.2K Likes

Gabby
@GabrielleMonae

When you come back from the "store run" with your cousins #Thanksgivingwithblackfamilies

9:41 PM · Nov 23, 2016 · Twitter for iPhone

170 Retweets 302 Likes

FUMUDOH

IT'S TIME TO RECLAIM OUR SKIN

ADRIENNE MAREE BROWN

Shadi Al-Atallah
I used to feel (before Lamictal), 2018
Mixed media on unstretched canvas, 57¹⁄₁₀ × 70⁹⁄₁₀ in.

This is a time where everyone needs to bring their best selves. We are actively making a case for our species to exist on this beautiful planet. Can we be just? Can we practice freedom together? Can we rediscover right relations with each other, including between humans and the earth? Can we remember what it is to be alive with each other, beyond suffering and survival?

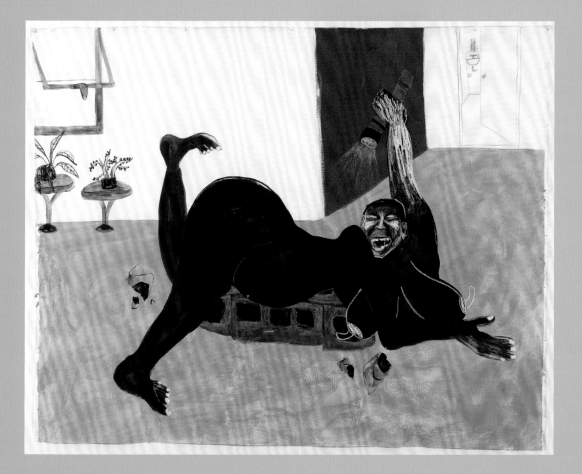

BROWN

I believe yes, against all evidence to the contrary. I believe yes because I have had so many experiences of vulnerability, moments where I saw that we all struggle with belonging, with finding home, with being honest, with adapting, with getting our needs met, with cultivating safety. With being unapologetically ourselves, not in a defensive way, not in a performative way, just . . . us.

My late comrade Charity Hicks called this "getting naked." She said that when we come into meetings and movement spaces with each other we need to drop the pretense and manipulation and salesperson-ing, and get naked. When she'd say it, some of us would blush and others would say "Ase!" Others still would find a way to escape the space altogether.

There are so many reasons why people are scared to get naked. We are told over and over again by capitalism that our true selves are not good enough. We are told that only the wealthy deserve to be well and to receive care. That our bodies are not beautiful because we are disabled or fat or not White or not pleasing to a man or . . .

I want to offer that the same practices we use for getting naked in the realm of sex and intimacy—the unveiling of skin—can teach us to bring our unapologetic selves into any space where we need to get naked.

Know Your Own Nakedness

In my early years of hooking up, I never looked at myself naked. I would get my outfit on, and once things were sucked in and lifted up and shaped into a stiff mannequin version of my body I would look in the mirror and approve. Later, if the night went well, as the clothes were coming off I would turn off or move away from bright light and hope the other person didn't notice the difference between presentation and reality.

I am grateful for formative experiences where I got to practice being naked around others, in relationships, at hot springs and bathhouses. I am grateful for children who love my soft enveloping hugs. And for lovers who said, "You're beautiful."

But the most meaningful work was a year of personal practice: looking in mirrors at my naked body and finding something I liked. It's tender to remember that at first I could only say "my left pinky," but it was a beginning: "Left pinky, you are smooth and unbitten. You look delicate, and your nail is beautiful."

My standard was that I couldn't repeat a body part. Eventually, I got to the stretch marks, scars, and dimples of cellulite. Eventually, I got to a place of seeing myself whole, in motion, decompartmentalized. Eventually, I realized it was a sacred and beautiful body.

I have been through a similar process for my emotions, for my spirit, and for my movement worker self.

Knowing this nakedness allows me to have more than gumption when it is time to show myself to others; it allows me to have dignity. I keep up the practice, and these days I sometimes find it hard to keep any clothes on at all.

Be Good to Your Body

Moisturize. Eat your greens. Stretch. Say nice things in the mirror like, "Damn god/dess, you look delectable today."

Be Sure You Want to Be Naked

If you're in a situation where keeping clothes on *feels* right, listen to that feeling without judgment; be curious. What is the data inside that feeling that can help you understand yourself and the situation? There's a lot of fun and sexy sex to be had in various states of partial dress, and I support all of that. Or there might be a question of safety or comfort that needs attending to that hasn't been articulated or agreed on yet.

And while there's nothing that compares to the experience of skin on skin, it has to be in the right setting with the right person or people. Nakedness is vulnerability. Vulnerability is something we offer where it is earned; as it is held well, we can offer more. So ask yourself, has this moment earned my nakedness?

If you find yourself naked with someone who doesn't look at you with the love, care, and worship with which you see yourself, reclaim your skin—there are always more lovers in the sea or the app. Someone wants your body whole. Wait for that.

Get Consent

While it's amazing that this needs to be said, don't get naked in front of others without consent. Don't show up and just whip off your raincoat or expose yourself on someone's lawn as a romantic gesture. You don't know how your nakedness will impact another. Permission and boundaries—those powerful acts of saying maybe or no—allow for real freedom within a connection.

Get Naked

Your miraculous body is a gift to you and a gift to those who get to see it and be with it. Undress in that manner, as if you are untying a bow around a precious and well-thought-out gift. Make eye contact and see your power and desirability in your lover's eyes. **This is your living body; this is what aliveness feels like.**

RITUAL FOR SELF-COMPASSION AND CARE

SIEDEH FOXIE

This act of self-care is to acknowledge the body as an altar: a place of loving worship and devotion. Your physical vessel honoring those who came before, and those who will come after.

The following ritual is meant to soothe and nourish the multidimensional aspects of your being: physical, emotional, and spiritual. All it requires is that you give complete attention and awareness to your soul, granting yourself a moment to connect and instill harmony.

Begin by preparing an indulgent rose salt scrub, created to brighten the aura and enhance radiance. Follow with a healing ritual bath that utilizes a calming breath meditation to cultivate self-compassion and care.

For the rose salt scrub you'll need:

```
1 cup dried roses, crushed
1 cup raw unrefined coconut oil, melted
¼ cup pink Himalayan sea salt
5–7 drops rose otto essential oil (optional)
```

Roses have a wealth of benefits for the skin and therapeutic properties that can aid in relieving depression and stress. Coconut oil helps regenerate and restore elasticity, while pink Himalayan sea salt banishes toxic energy to balance emotional and mental well-being.

Combine dried roses and pink Himalayan sea salt in a large bowl. If using, add rose otto essential oil to melted coconut oil. Carefully pour the coconut oil mixture into the bowl with the roses and sea salt and stir. If it appears too dry or coarse, you can add more coconut oil. Transfer finished product into a glass mason jar or container with lid.

For the healing ritual bath you'll need:

```
1 white candle
1–3 cups fresh red, pink, or white rose petals
(if store-bought, make sure they are pesticide
free)
Sandalwood essential oil
Neroli essential oil
3 whole bay leaves
```

Fill the bathtub with warm water (not too hot or the skin will become dehydrated).

As you wait patiently for the bathtub to fill, light a white candle and sing your intention, prayer, or song aloud, allowing the vibration of your voice to infuse and bless the bathwater.

Add 5 to 7 drops of each essential oil. Sandalwood is known for inducing serene, meditative states; uplifting Neroli balances emotions, bringing about feelings of self-recognition, worthiness, and joy.

When the tub is half full, add the bay leaves to cleanse any negative energy and bring wishes into fruition. Finally, add the fresh rose petals. As the stream of water disperses them, continue to infuse loving intention into the bath.

Step into the bath and while standing, gently scrub your body using your hands, slowly massaging in a clockwise motion from the neck down, all the way to the soles of the feet. As you do this, sing or hum to activate the heart center and call in divine guidance and support.

Once finished, lie down in the bath. Close your eyes, and tune in to your breath. Simply observe how the breath is moving through your body, being mindful how you feel in this moment. Let yourself acclimate to the feeling of the water and petals against your skin, the fragrance of oils permeating the air. Allow yourself to drift for a moment, sending your awareness into the heart.

Start to deepen the breath, inhaling from just below the navel, visualizing the breath as a luminous thread of white light. Take in a full belly of air, allowing this breath of healing white light to naturally flow into the chest, stirring there for a moment as you exhale slowly through the mouth with a soft *haa*. Repeat cycles of this breath for 5 to 7 minutes or longer if you wish. You'll notice the nervous system shift into total relaxation, as the sound *haa* activates the heart center to invite more calm and sweetness.

In this transcendent state, invite any feelings or sensations to be explored and released with each exhale. Use the full inhale of every breath to call in all that you wish to receive, feeling the blessing of new possibility expand

through every inch of your skin. Rest in this place for as long as you wish, noticing the quality of your thoughts. Are they kind and compassionate? What aspect of your life deserves more tenderness? Where and how are you showing up for your dreams and desires?

When the water begins to cool, let it drain as you say a closing prayer in gratitude. Visualize all of your fears, sadness, judgment, anger, resentment being washed down the drain and transmuted for the highest good. Allow yourself to air dry to retain moisture, and so that the healing properties of the bath can continue working. Collect the rose petals that now contain your energetic imprint and return them to nature by placing them at the base of a tree or rose bush the next day.

MUSLAMIC RAY GUNS

MUNA MIRE

In March 2011, a curious video took the Internet by storm. In an interview with UK outfit PressTV, a member of the English Defence League (EDL), a far-right, racist, and Islamophobic "protest group," gave a quote that would live on in Internet infamy. "The muslamic law . . . they've got their law. Obviously it's their law, isn't it, we can't do anything about that but we're just trying to stop . . . you've got muslamic rape gangs nowadays." He trails off into incoherence. The gathering of protesters behind him is restless and dour. The crowd is angry, the broadcaster announces, but no one seems to be able to articulate why.

But the Internet, particularly on this side of the ocean, zeroed in on something else entirely. The EDL protester with his heavy accent sounded as though he said he was concerned about "muslamic ray guns." This mishearing lent itself to the perfectly absurd tone of a meme. "Muslamic," of course, isn't a word. It's a portmanteau of "Muslim" and "Islamic." And ray guns are themselves a fictive technology reserved for the most cartoonish villains—the classic example is Goldfinger from the James Bond movies. Bring those two nonsense elements together and voila, the racist vitriol being spewed is a parody of itself, ripe for the memeing. At the height of the meme's popularity in 2011,

a remixed version of the EDL rant was set to techno music and garnered more than two million views on YouTube.

Black Muslims in particular, who sit at the intersection of Black Twitter and the newly self-identified Muslamic Twitter, continue to have a lot of fun with the meme. The word "muslamic" is by now memeic language, or meme elided into language. If we think of language as tech, the meme continues to be a usefully applied tool, one that serves several purposes: to ridicule racism by pointing out that it is as fanciful as it is ignorant, to identify members of an in-group, and to signify the aesthetics and ideals of that in-group.

MIRE

healing buffering
@IsaiahThinks

Follow

I hate when I really wanna knack a babe, and after she's sent me nudes that's when she suddenly wants to go mad muslamic on me. Come back here and sin with me right now.

7:53 PM - 10 Sep 2018

28 Retweets **69** Likes

2 28 69

Tweet your reply

@xgndyj

Follow

Right, who's RTing muslamic power rangers onto my tl

Iqra @_iqraan
Only gang I wanna be in 😍

7:57 PM - 11 Feb 2017

525 Retweets **629** Likes

💬 6 ⟳ 525 ♡ 629 ✉ ⌄

MIRE

TEXAS ISAIAH ON AHYA SIMONE

In the spring of 2016, I stumbled upon Ahya Simone's music on YouTube. I was astounded by her dynamic cadence as a musician. It was a treasured discovery. Ahya is a Detroit-based harpist, singer-songwriter, and filmmaker who fuses R&B/soul, jazz, experimental, and electronic elements into multifaceted musical landscapes.

After connecting via Twitter, I traveled to Detroit to meet Ahya in person in November 2018. I had always had a curiosity about Detroit, but Ahya inspired me to get there. Ahya told me once, "My hope for Detroit is that it remains the tenacious and defiant city it has always been, one of the many major cities that shakes shit up and calls shit out in a way that reverberates across the world."

Sharing space with Ahya invokes a burst of spirit. She is charming, witty, and insightful. Her infectious qualities are marvelously reflected in her work. I look forward to the opportunity to see her perform one day in the near future. I trust that it will be Black meditation—an ancestral blessing—a continuation of the beauty that she continues to bring into my life.

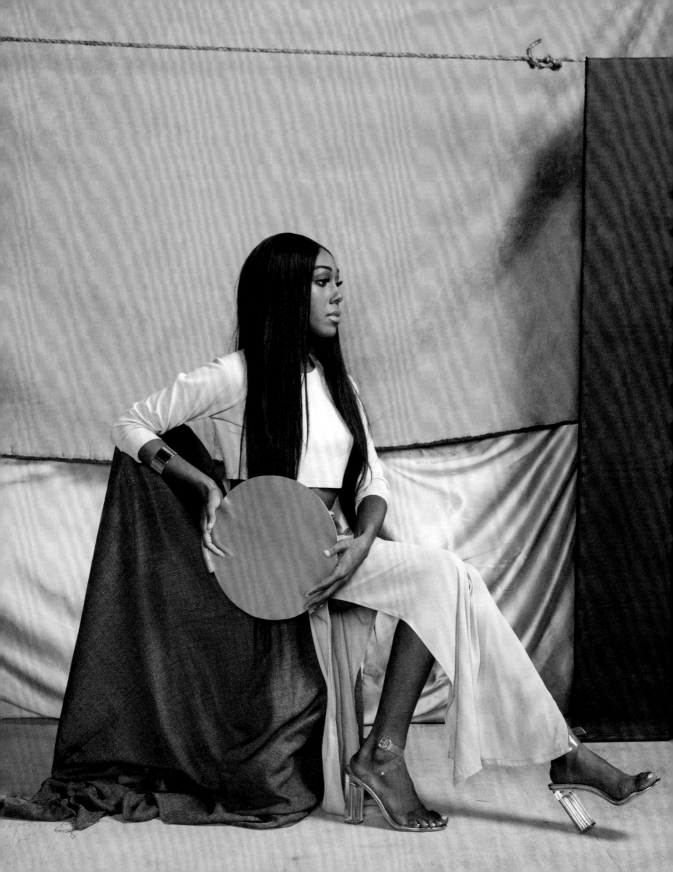

Jonathan Lyndon Chase
Bend, 2018
Acrylic, marker, graphite, and glitter on cotton bedsheet, 72 x 60 inches

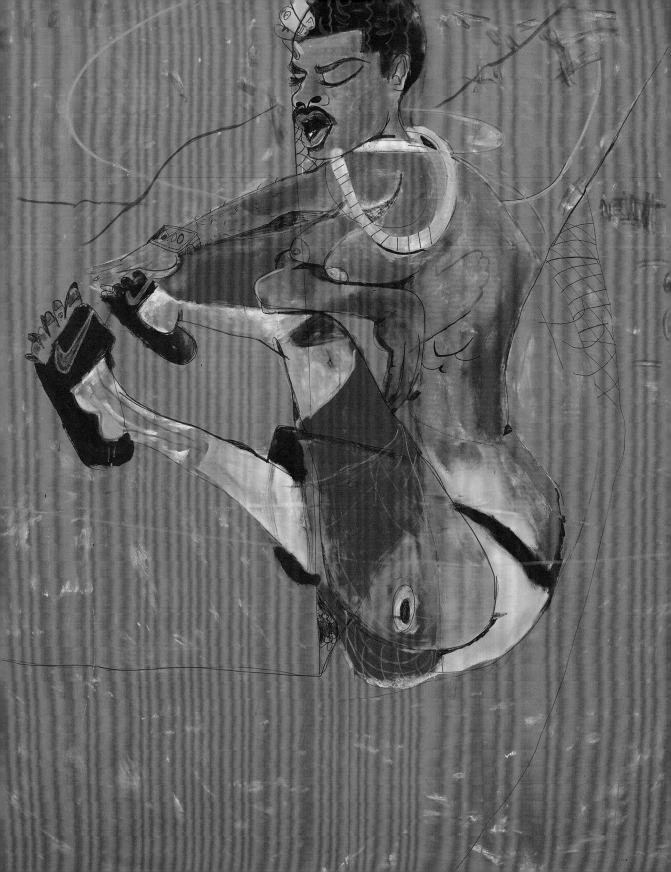

there is nothing in the universe worth more than the dance floor at a good black wedding

or possibly the sound my light-skinned uncle makes when a song he forgot was his song comes on

i tell you this so you can understand how i think of memory, currency, wealth, that kind of shit

my favorite story to tell: once, on the porch, watching *The Wheel,* my mom was screaming all kinds of wild shit at the TV, then my grandma said it's a place, fool. That joke may sound lame here but it kills on the porch. might could be the happiest i've ever been. we was laughing so hard & all alive. nary a cancer had touched us, not a single sick was nursing off our gut, loosening the stools, unbraiding us as we mothered it

i just want you to understand how I understand happiness. summer is my favorite season cause it's when you can sit still with someone by a tree quiet as hell & call that a good time. I pride myself on being regular & black

i believe in god the most amid wet acts: sex, birth, rain, mid electric slide. i believe because the people i love the most told me to, easier to name the luck which keeps me alive

fact: there is nothing more beautiful than a black woman on the way to whatever she considers church

fact: sister bernitta lost 16 pounds when she started catching the holy ghost once a day

fact: i know a woman who pearls a beautiful blunt & could out gospel yolanda adams any day

fact: today i passed my grandma, said a joke & she laughed, i knew then that i had a purpose

i just want you to understand how i understand everything. i was raised by people who believe there is a way to raise a child. i grew up black & quite happy all things considered. i was loved & had good friends & bad friends who i no longer fuck with. i won fights & got my lip busted & cried in my closet & danced with girls & called a boy a faggot & had a fade & was shot at once & only once & finger painted & felt indescribable loneliness & was given twenty bucks when i was going to the mall. i was homecoming king & pookie's son & track team captain & played a

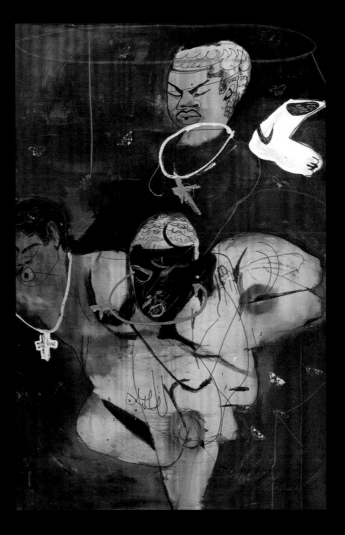

vulture in *The Wizard of Oz* & was a virgin & then wasn't & ate chicken & there
was never a question of if i was going to college or not

i was quite normal, quite boring

i tell you this so you can understand this: when that man filled me with what
had to be a ghost, i knew i was no longer normal, rushed into a new standard.
when he jimmied his way into my blood & broke something that felt like a vow,
i wasn't surprised when, while lotioning, i touched my back, felt feathers

SMITH

HAITIAN INDEPENDENCE DAY

ZOÉ SAMUDZI

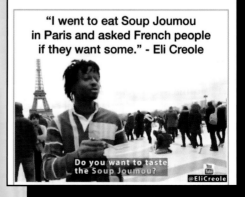

Lunionsuite
@LunionSuite

"I went to eat Soup Joumou in Paris & asked French ppl if they want some."- Eli Creole

Jan 1st, Haitians celebrate Haiti's Independence Day w/bowls of Soup Joumou. It's consumed to commemorate Jean-Jacques Dessalines' proclamation of Haitian independence frm France, Jan 1, 1804

"I went to eat Soup Joumou in Paris and asked French people if they want some." - Eli Creole

Do you want to taste the Soup Joumou?

@EliCreole

n.evangelion
@NateKnowsNada

Follow

Violence is what got niggas liberated.

Dont let anybody tell you any different.

Happy independence day Haiti

2:16 PM - 1 Jan 2019

There isn't a single more elegant "new year, new me" flex than celebrating independence on New Year's Day. Haiti marked the end of its successful revolution against and independence from France on January 1, 1804— it is the only uprising of enslaved (or rather, formerly enslaved) peoples that led to the founding of a nation-state that was free of slavery. Haiti was the world's first liberated Black nation, and her freedom in 1804 became a blueprint for Black insurrection and self-determination on both sides of the Atlantic Ocean. On January 1, in this post-Obama but not yet post-racial Trump and global fascist moment, it seems we've difficulty understanding the legacy and lessons of the revolution,

especially as often derailing goals of "diversity and inclusion" seem to supplant more ambitious goals of freedom and autonomy. But the Haitians taught us—and this is, of course, far easier abstractly understood than done—that there can be no compromises in assertions of Black humanity, even as we're punished for attempting to bring that too-long-deferred dream to fruition (just as Haiti has been punished for the past two hundred years). But even as capitalism digs its talons into our resources and political imaginations, we are learning and storytelling and scheming and dancing—just as the Haitians danced at the vodou ceremony at Bois Caïman on the evening before their revolution began.

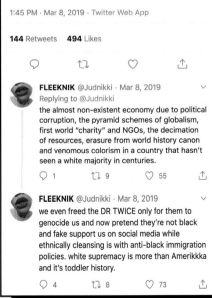

FLEEKNIK
@Judnikki

Haiti is the blackest black power movement that ever was and its current condition should serve as an honest look at how white supremacy continues its cancerous state.

1:45 PM · Mar 8, 2019 · Twitter Web App

144 Retweets **494** Likes

FLEEKNIK @Judnikki · Mar 8, 2019
Replying to @Judnikki
the almost non-existent economy due to political corruption, the pyramid schemes of globalism, first world "charity" and NGOs, the decimation of resources, erasure from world history canon and venomous colorism in a country that hasn't seen a white majority in centuries.

1 9 55

FLEEKNIK @Judnikki · Mar 8, 2019
we even freed the DR TWICE only for them to genocide us and now pretend they're not black and fake support us on social media while ethnically cleansing is with anti-black immigration policies. white supremacy is more than Amerikkka and it's toddler history.

4 8 73

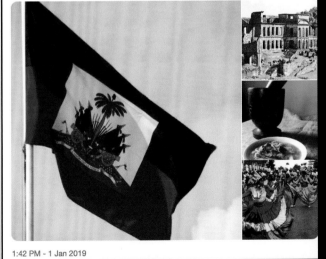

FSU CSA
@FSUCSA Follow

Happy Independence Day to Haiti 📧🎉 !! . Haiti was the first country in the Western Hemisphere to obtain it's independence and abolish slavery in 1804. We hope that all of our Haitian family and friends have a great day and enjoy the delicious soup joumou 😊 .

1:42 PM - 1 Jan 2019

FRIED PIG EARS, FOR SNACKIN'

KIA DAMON

I've been going back and forth with myself about food and what it means for present day and future Blackness. To really think about that relationship between Blackness and food, I feel like you have to look to the past and understand what food has always meant for us. It was always about having a little and making a lot. Taking the scraps and doing the damn thing with them. Just like this book, food has been and will always be a tool for survival.

As a Queer, Femme, Black woman, I am continuously fighting for survival on all fronts, but I always find spiritual strength in the food I make and the spaces I create with it.

Chef Kia Damon
Photo by Alana Yolande

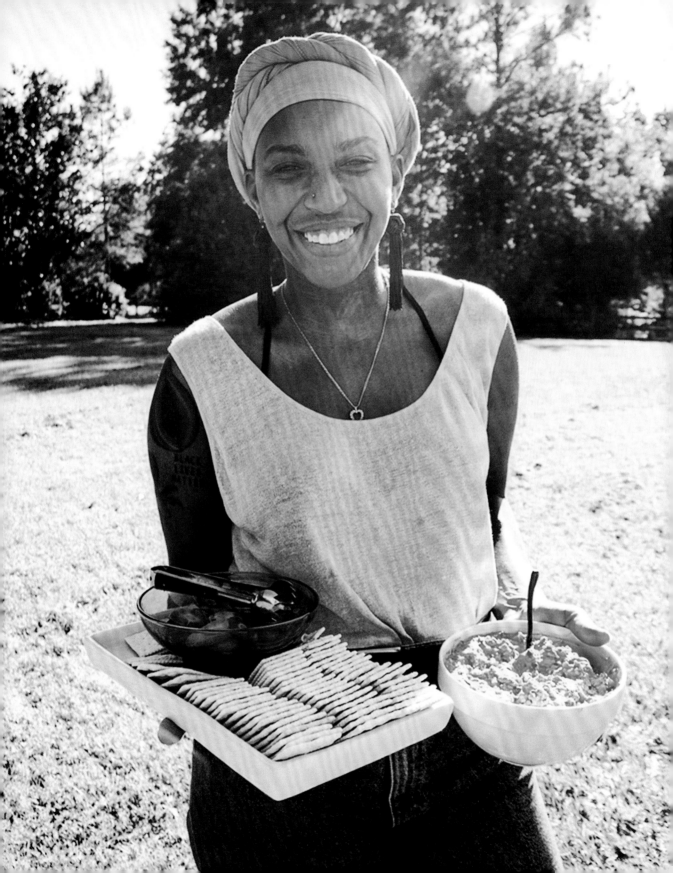

194 Fried Pig Ears, for Snackin'

1 pack pig ears

1 onion, halved and peeled

3 large carrots, halved

2 bay leaves

½ tablespoon whole black peppercorns

1 bunch thyme, tied up

Vegetable oil

¾ cup cornstarch, more if desired

Put pig ears, onion, carrots, bay leaves, peppercorns, and thyme in a large pot, and cover with water up to about 5 inches above the ears. Bring pot to a rolling boil then reduce to a steady boil for 2 hours. Check doneness by piercing one ear with a knife. It should easily pierce the cartilage.

Prepare a heavy-bottomed pot with 3 inches of vegetable oil. Heat to 350°F.

Remove ears from pot and discard liquid. Pat dry, cut into ¼-inch slices, toss ears in cornstarch to coat, shake off any excess, and fry in small batches until golden brown. Drain, season, enjoy!

ABOVE
Fried Pig Ears, for Snackin'
Captured by Alana Yolande

BELOW
I was introduced to a lot of Southern cuisine by my grandma Jeannie Morgan (pictured here). It wasn't until I moved away from home, of course, that I began to really long for that food. I had an opportunity to cook a dinner influenced by the matriarchs in my family and my grandma inspired the dish. I never got to cook it for her, but I feel close to her whenever I make them. Also, I was too terrified to make chitlins back then so I went for the pig ears instead.

DAMON

ON TIMES I HAVE FORCED MYSELF TO DANCE

HANIF ABDURRAQIB

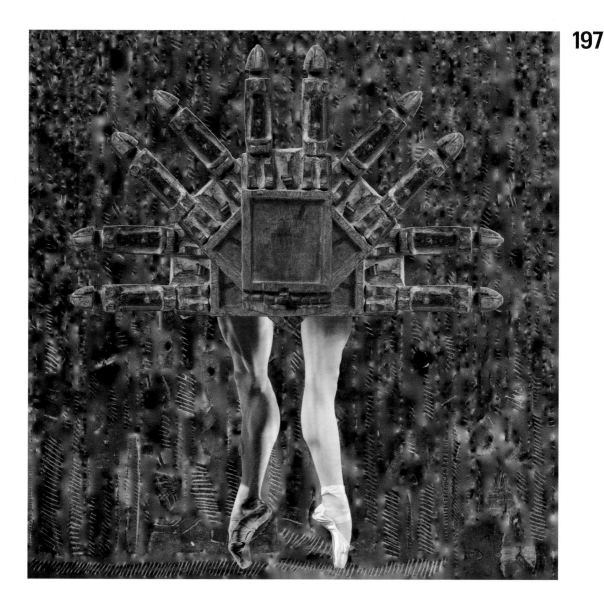

Safe to say none of the other Muslim kids on the eastside of Columbus got MTV or BET in their cribs & we do at my crib sometimes like after pops got a promotion or after grandma moved in & kept a bible on her nightstand & had to

ABDURRAQIB

watch the channel where her game shows ran 24/7 & so it is also safe to say that I was the only one in the Islamic Center on Broad Street who got to stay up & watch the shows on MTVthat came on after my parents cut out the lights & went up to bed & it was only me & the warmth of an old television's glow & the DJs spin-ning C+C Music Factory for people in baggy & colorful getups & bounc-ing on a strobe-light-drenched floor & so it is safe to say that only I danced along the slick surface of my basement floor with the moon out & all the lights in the house out & the television playing hits & this wasn't exactly practicing dance moves as much as it was learning the different directions my limbs could flail in & there is no church like the church of unchained arms being thrown in every direction in the silence of a sleeping home & speaking of church to be Muslim is to pray in silence sometimes even though the call to prayer is one of the sweetest songs that can hang in the air & there is no praise & there is no stomping in the aisles & there is no holy spirit to carry the blame for all manner of passing out or shouting or the body's pulsing convulsions & I do not want a spirit to enter me but I do want a girlfriend or at least a kiss from a girl at the Islamic Center where we go on Friday afternoons in the summers for Juma'ah prayer & kick our shoes off on the carpet & slip into the hallway where the boys & girls would congregate briefly before being separated for prayer & it is absolutely safe to say that with my socks on the marbled tile of the Islamic Center on Broad Street I felt overcome by something we will call holy I suppose for the sake of not upsetting the divine order & this was the mid '90s & so no one was really doing the moonwalk anymore & even when they did no one was doing it right & there is only one Michael & I am not that nigga & still with the girls at the Islamic Center standing in line for the water foun-tain I thought now is the time & I was decidedly not in the dark of my basement anymore where I knew the floors & I understood every cor-ner of the architecture & I slid back on the top of my toes & no one even turned their eyes toward me & so no one could tell me about the stairs I was sliding toward & so no one saw my brief moment of rhythm before it unraveled & just like that I was in a pile of discarded shoes & it is safest to say that there was no girlfriend for me that summer or the summer after & the cable at my house got cut off in the year my mother died.

ALL IMAGES:
Brendan Fernandes
Move in Place, 2015
Digital C-print, 30" x 30" each. Series of 8.
African art images courtesy of the Agnes Etherington Art Centre, The
Justin and Elisabeth Long Collection of African Art. All images courtesy
of the artist and Monique Meloche Gallery, Chicago.

ABDURRAQIB

I ALWAYS PICKED THE GIRLS WHEN I PLAYE
THAN OUT OF SHEER SPITE AT THE EASE OF
WITH THEIR UN-INTERESTINGLY PHALLIC/I
ASSUMPTION THAT THERE WAS SOME S
PRINCESS PEACH'S MARIO KART 64 PERFC
THE CUNT'S MEOW SCREECHING FROM EV
BODY FUELED MY RAGE AGAINST BOYHOO
'BOYISH' OF MEANS. I DISCOVERED, USING M
TRAPEZIUSES OF ANTHROPOMORPHIC CY
SHORTCOMINGS OF PUBESCENT LIFE COUL
AT A TIME. LIKE MOTOKO KUSANAGI, MY WO
MY MIND AND THE TINGLING SENSATION IN
A NEW LEVEL, ESPECIALLY ONE UNLOCKEI
LUNGS LIFTED INTO THE AIR AS IF I WAS
AFFECT AS I SPREAD MY AMAZONIAN LEGS /
TRACES THE FANTASTICAL SKYSCRAPERS
POST-APOCALYPTIC INDUSTRIAL WAR-ZONE
TASK OF FIGHTING OFF THE TENTACLE
CHUCKLES OF MY PEERS SIMULTANEOUSL
THAT I COULD WITNESS THEM LOSE
DEPICTIONS OF THE SAME FIGURES THEY
FEAR-INSPIRING FEMME FATALE'S WHO TH
BATTLE IN THE REAL; THE SAME IMAGINARY
WOULD (AND STILL DO) TEMPT THEM TO TO
TUNA OF MY BODY.

Juliana Huxtable
Untitled (For Stewart), 2012
Image courtesy of the artist and JTT, New York

D VIDEO GAMES. IF FOR NO OTHER REASON,
IDENTIFICATION THE BOYS AROUND ME HAD
KAMEHAMEHA SUPER-HEROES... WITH THE
SORT OF INHERENT OR TRAGIC FLAW IN
ORMANCE. CHUN-LI'S ABSURD CURVES AND
VERY TURN OF HER HYPER-PORNOGRAPHIC
D, ALBEIT THROUGH ARGUABLY THE MOST
Y VIRTUAL PUSSY TO STRADDLE THE BEEFY
YBORG ATTACKERS, THAT THE AWKWARD
D BE OVERCOME ONE PELVIC HEAD CRUSH
MANHOOD WAS ENTIRELY ARTIFICIAL, SAVE
MY SPINE PRESENT AT THE REVELATION OF
D AS A SECRET—EACH TIME MY ARTIFICIAL
ÆON, BRAVELY DENYING VERTIGO OF ITS
AND TAKE IN THE RAPIDLY MOVING AIR THAT
OF BREGNA. IMMERSED IN A WORLD OF
S, I ASSUMED THE ETHICAL AND POLITICAL
AGGRESSION OF HENTAI RAPE AND THE
Y. I WENT TO EVERY LAN PARTY IN HOPES
BATTLE AFTER BATTLE TO HYPERBOLIC
WOULD LATER JERK OFF TO; THE SAME
EY WOULD, AT SOME POINT ATTEMPT TO
CUNTS AND PHANTASTICAL PUSSIES THAT
UCH AND CONQUER THE VITAMIN-ENRICHED

HUXTABLE

INDEPENDENT SUBTEXTS
DEVIN N. MORRIS

Zines, with their endless design possibilities and low production cost, provide ample opportunity for expression. They serve as a space where one can own one's media and communicate directly to a public. This agency is not often offered to Black creators or Black people in environments outside of their homes. I founded 3 Dot Zine as a canvas for sharing the words, thoughts, and visuals created by marginalized peoples who are liberated through creative expression. Here's a selection from my personal library of materials I've collected over the years.

All images taken by
Devin N. Morris

Bolaji Badejo Screen Test from Alien
(Flip book)
Maker: Samuel Hindolo

What it do: So, not many know this but the person who played the alien in *Alien* was a Nigerian visual artist and actor. I learned of this fact after picking up this book and meeting Samuel Hindolo for the first time at BABZ Fair 2017 at the Knockdown Center in Queens. Bolaji Badejo was chosen for his sheer height— he was 7'2" tall. I loved the ambiguity of this book; you wouldn't know why it was created unless you researched the title or were told by a friend or Hindolo themself. Thank you for the code, Samuel.

Townies, Issue 1
Published: May 2017
Maker: Ife Olujobi

What it do: *Townies* made me cry. This is a sentiment I am sure to express when describing other zines or experiences. The book is self-described as follows: "*Townies* is a zine cataloging the lived experiences, stories, and imaginations of PoC and LGBTQIA+ folks who live or have lived in pockets of suburban, rural, and small town America that have culturally and politically been associated with and claimed by whiteness and bigotry." Reading "My Culture Journey" by Brianna set me in rural classrooms with an American woman of Native American and Cape Verdean descent. Reading about her experiences of racial injustice and her journey to eventually taking pride in her complex identity resonated with my own challenge of trying to assume a fractured identity. I look forward to many more run-ins with the Townies.

MORRIS

Diffuse Glow
Maker: Karen Kaye Llamas

What it do: The allure of the zine as a self-publishing force might lie in its ambiguities and endless options for design and conception. *Diffuse Glow* is a visual poem, or at least that's how I like to read zines that feature no text but provide visual context. The heavily saturated and light-filled images explore seemingly urban localities and domestic spaces. I enjoy the hints of human existence in images of blurry passersby shot from a train, a community bulletin board advertising neighborhood organizing and entertainment efforts, nail salon advertisements, and the inside of a trash can with a lone ball of aluminum foil. These images offer the viewers the freedom to determine their relationship to the environments.

The Girls Who Spun Gold
Published: 2017
Maker: Nydia Blas

What it do: When I look at the images of Nydia Blas, I whisper to myself, "Glory." I want to run with them, hide under them, use them as proofs. They are emboldened, curious, powerful, and show a multitude of relationships between women, objects, possibly desire, and overall make you think a lot. Thank you, Nydia.

Reparations Now
Maker: Coloured Publishing

What it do: *Reparations Now* takes a very distracted and collaged look at how Black bodies are used in media and TV consumption. Its images juxtapose nostalgic cartoon characters, fine art, and texts that are serious, funny, poignant, and challenging to form a critique of sorts on race in America. The zine opens to an image of a Black woman KKK member opposite instructions on creating your very own "Classic Napkin Holder" by Paula Scher. Grace Jones covers the zine and is shown throughout in her many different roles alongside White counterparts. The zine is carefully crafted and although it questions race in America, it does not reject or offend. Instead, it provides space to appraise the ways that Blackness and Black bodies have been used and discarded.

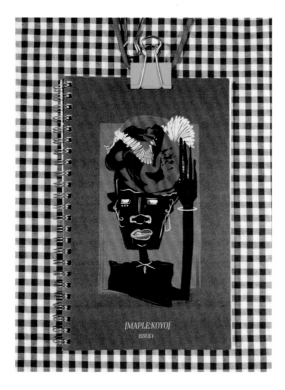

Maple:Koyo
Published: 2017
Maker: Jermel Moody

What it do: *Maple:Koyo* is a tome, a beautifully thick and swaying zine. It is spiral-bound with silver wire and the pages glide and creak over the spine with a sound akin to a swing on a playground. This zine feels as if it's dedicated to healing, contemplation, and interrogation, and survives under the phrasing, "Black boy be," a phrase Jermel also places on T-shirts and sweatshirts that are available for purchase. The book features a multitude of writers, artists, and thinkers all investigating their relationship to joy and freedom.

MORRIS

206 *Blkgrlswurld Zine,* Issue 4.3
Maker: Christina Long, produced with Trifecta Studios

What it do: The books of *#BLKGRLSWURLD* serve as diary-like appreciations of heavy metal music, tales of love lost, and a sharing of photography, poetry, and art via a rotating cast of contributors, although its creator, Christina Long, is always present. I really enjoy their honesty and rigor. Christina goes to a lot of metal shows and documents those experiences within the books, but you may also get an education on gastronomy.

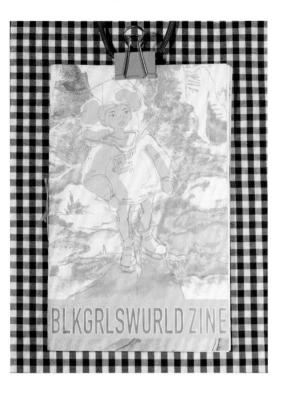

Learning from Lexington
Published: 2017
Maker: Markele Cullins

What it do: *Learning from Lexington* is a course at UMBC, where students create public history zines and ten-minute podcasts exploring the rich history of the Lexington Market, a Baltimore institution. I spent many days walking through the market, smelling the peanuts from Konstant's Peanuts roasting near the Eutaw Street entrance and then going deeper into the market for the nutty smell to be replaced by a sweet candy aroma. The dull and bright scents of fried foods and fresh fish followed. Lexington Market has a long history in Baltimore, and its faithful customers, primarily Black, worry that the soon-to-be remodeled complex may not center their desires and laughter, as it does now. For now, let's bask in its rich history with *Learning from Lexington*.

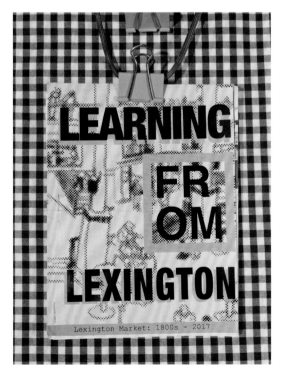

The International Review of African American Art
Published: 2017
Maker: Published by Hampton University Museum

What it do: *The IRAAA* provides an insightful look at African American artists, collections, critics, and scholars. Readers can find many exhibition notices, reviews, articles, and other materials about visual culture. I appreciate the rigor and intention behind this publication. I am a Black artist and homes like this are important to be exposed and shared.

True Laurels, Issue 3
Published: 2017
Maker: Lawrence Burney

What it do: *True Laurels* is a Baltimore-centered magazine that exposes local musicians, authors, artists, and writers to its community of readers. Lawrence is a music journalist and many can speak to him being an early champion of their careers—he served as an early inspiration for my starting *3 Dot Zine.* Seeing a Black guy who grew up similarly to me start a print zine blew my mind. What Lawrence does with *True Laurels* provides that space for many people who encounter his work. Forever grateful to him for that.

MORRIS

208 *Olympics,* Volume 2
Published: 2017
Maker: Khari Johnson-Ricks

What it do: Let's get physical, in a sense.
Olympic opens with a story from Khari, detail-
ing his sometime morning ritual of awakening
his senses and body with a brisk run on the
track behind his house. There is a tender-
ness described in the story that permeates
throughout the book, although most of the
images depict a figure in action. What sticks
with me most is the need to prepare to acti-
vate your body and mind for physical pursuits
and what these actions, in turn, prepare us
for. Sports feels like a testament to endurance,
and not just the physical kind, but spiritual as
well. What we do under the sun, being a sun
people, resonated with me as I experienced
Khari's art.

*Sentiments: Conversations—My People Are
Open to Movement*
Published: 2017
Maker: Kearra Amaya Gopee in conversation
with Kimi Hanauer

What it do: Press Press is an interdisciplin-
ary publishing initiative in Baltimore that
hosts conversations through the ongoing
Sentiments series between peoples consid-
ered "immigrants" in America. *Sentiments* is
described as a compilation of the sensitivi-
ties, hacks, gestures, and actions that we, as
immigrants, have used to bring our lives into
being. Diaspora is a beautiful term but I am
rarely able to fully engage with the lives of
people not from the United States. Witnessing
this conversation felt like a privilege and I'm
happy that Press Press is providing space for
these dialogues.

Photographs by Justin Xavier Soto
Published: 2017
Maker: Justin Xavier Soto

What it do: I love these photos and am happy to have run into Justin at the New York Art Book Fair. We just exchanged zines and sometimes that's how relationships are organically built in the self-publishing community.

Jean & Dinah
Published: 2017
Maker: Jean x Dinah

What it do: Jean & Dinah travel through the world of LGBTQ+ identified women and femme creators across the Caribbean. In issue #1, we begin with two characters letting loose on the dance floor in Maya Ramesar's *Flocking Madness*. There are some beautiful works here and I love zines that act as resources for study and discovery.

MORRIS

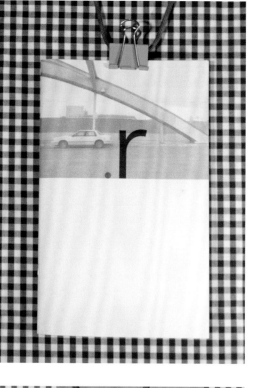

.r
Published: 2017
Maker: Devin N. Morris

What it do: *.r* is a zine I created as a rumination on memory; it was the first zine I designed and features only my work and writings. As a zine maker who normally operates within collaborations and with a designer, I am proud to see these works come together. This year I want to do more publishing for artists with singular books displaying their works. In *.r* I explore the emotional memory of objects in photographs of chairs and delve into personal experiences through fictional writings, drawings, and collage.

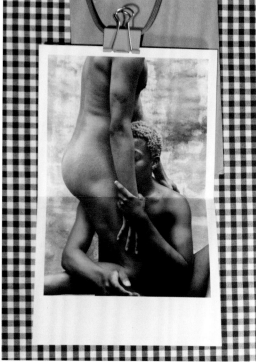

A Brief Conversation
Maker: Elliott Jerome Brown, Jr.

What it do: These early photographs by Elliott are dynamic and hard to find today as his works continue to develop. I feel lucky to own one of these sweet books as they were made in a small edition. Visual poetry in a photo zine. Some of my favorite zines feature nothing but visual content.

DOCUMENTING THE NAMEPLATE

Documenting the Nameplate is an open-call book project that celebrates nameplate jewelry and its myriad styles and cultural traditions. Marcel Rosa-Salas, cultural anthropologist and documentary filmmaker, and Isabel Flower, writer and editor, hold public events at which attendees can have their nameplates photographed and share their stories. They have also created an online portal through which anyone, worldwide, can submit images and/or anecdotes, which can be found at documentingthenameplate.com.

ABOVE
Azikiwe Mohammed
Ronnette's nameplate, October 7, 2019
Taken in Queens, New York
Image courtesy of the artist

BELOW
Naima Green
Janel's Childhood Name Ring, January 21, 2018
Taken at Cafe Erzulie in Brooklyn, New York
Image courtesy of the artist

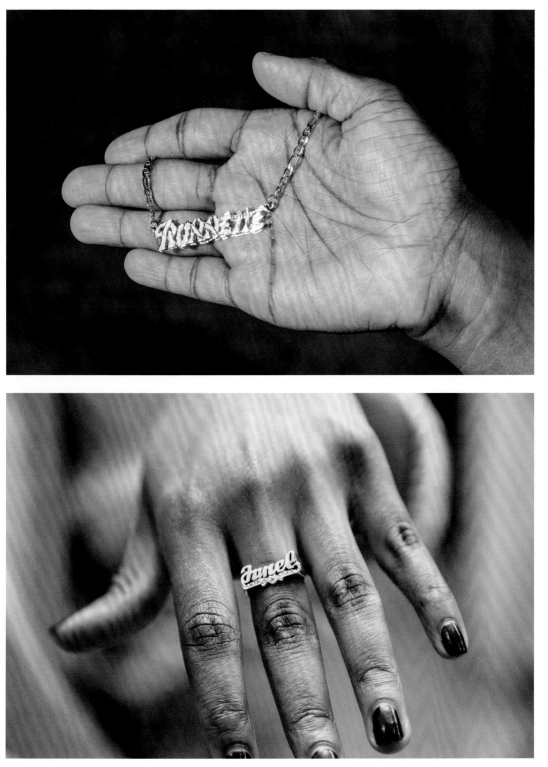

DOCUMENTING THE NAMEPLATE

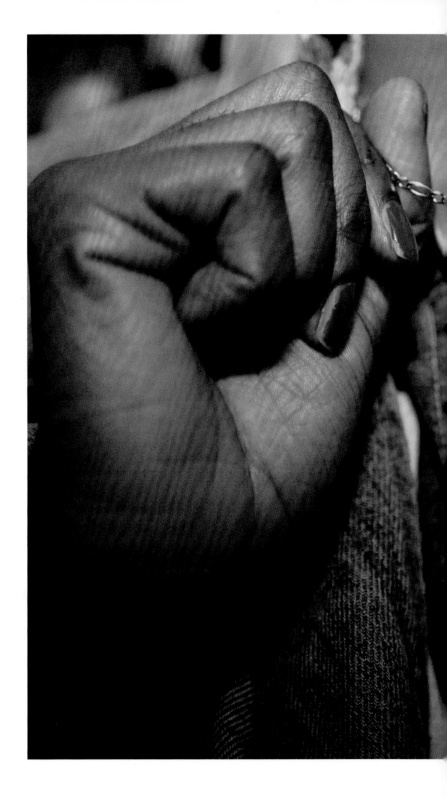

Naima Green
Ashley's nameplate, January 21, 2018
Taken at Cafe Erzulie in Brooklyn, New York
Image courtesy of the artist

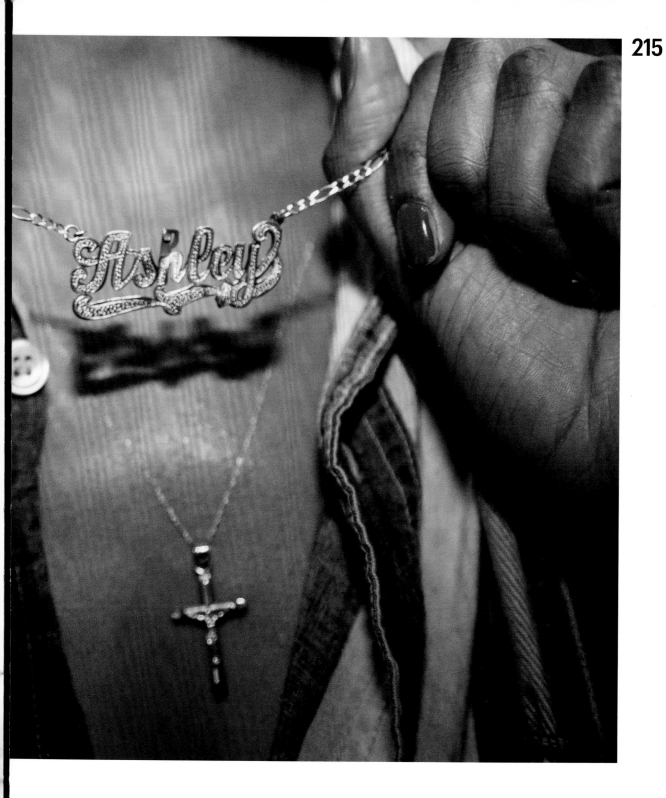

DOCUMENTING THE NAMEPLATE

CHARLEENA LYLES

#SAYHERNAME
BLACK DISABLED LIVES MATTER
BLACK MOTHERS MATTER

Poster created by Micah Bazant with Vilissa K. Thompson and Cyree Jarelle Johnson of Harriet Tubman Collective, after the murder of Charleena Lyles by Seattle Police Department. Image description: Black and white pencil drawing of a Black woman with long hair, looking directly at the viewer. Text at the top says "Charleena Lyles" in bold black letters. Text at the bottom says: "#SayHerName, Black Disabled Lives Matter, Black Mothers Matter."

Thousands gathered in Selma, Alabama, on March 7, 2015, to commemorate the fiftieth anniversary of the civil rights march across the Edmund Pettis Bridge, including President Barack Hussein Obama.

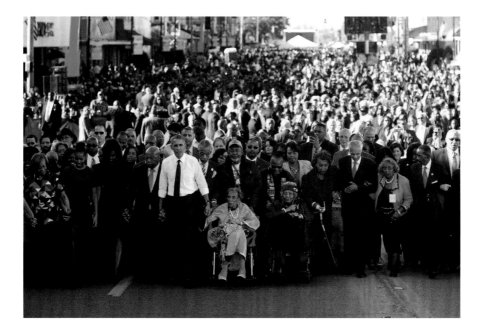

JUSTICE

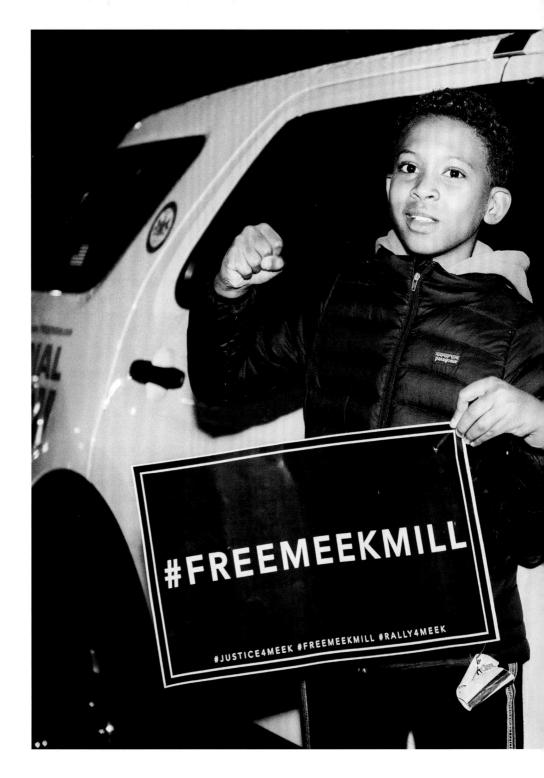

Scene from Philadelphia's Rally to
#FreeMeekMill on November 14, 2017
Image courtesy of the artist
© Aaron Ricketts, The Ricketts Company

RICKETTS

UNEARTHED
YOUSRA ELBAGIR

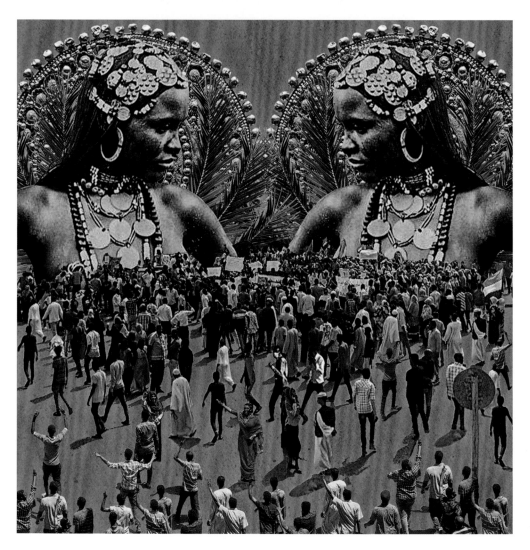

Yasmin Elnour
Mother Sudan Is Watching, 2019
Digital, 55 x 55 cm.
Image courtesy of Yasmin Elnour (Kandaka Chronicles)

The one-eyed warrior Queen Amanirenas, of the Meroitic Kingdom of Kush in ancient Upper Nubia, reigned between 40 and 10 BC in a region within what is now known as modern Sudan.

Her title, Kandaka, was reserved for the ruling matriarchs of the prosperous and influential Nubian kingdom—one of the new ancient civilizations where women had political power on top of their symbolic significance. In 24 BC, Amanirenas launched an attack on Roman-occupied Egypt and a year later, captured a series of Roman forts in the south. After an undeniable victory, her troops returned with the bronze head of a statue of reigning Emperor Augustus. Amanirenas ordered for the head to be buried one meter below the threshold of one of her temples.

Two millennia later, her female descendants metaphorically decapitated another despot. In April 2019, Islamist military dictator Omar al-Bashir was toppled after nearly thirty years of presiding over modern-day Upper Nubia, in a popular uprising led by Sudanese women, aptly called Kandakas.

But only a select few of them even know who Amanirenas was.

Sudan's Nubian heritage has been trampled and maimed throughout history. During the colonial era, British imperialists ruled over Sudan and Egypt in a joint Anglo-Egyptian administration that triggered the erasure of Sudan's antiquity, lumped for the rest of the twentieth century under "Egyptology." After discovering the treasures and pyramids of the Black Kushite Pharaoh Taharqa of the Twenty-Fifth Dynasty, who ruled over Egypt and Palestine from his kingdom in northern Sudan, Harvard professor George Reisner attributed

the findings to an ancient Egyptian governor, rather than Taharqa's bountiful kingdom. In a 1918 bulletin for the Museum of Fine Arts in Boston, he claimed that "the native negroid race had never developed its trade or any industry worthy of mention, and owed their cultural position to the Egyptian immigrants and to the imported Egyptian civilization."

The iconic significance of Sudan's Black royalty was marred by the racism of early excavators. Later, it was bleached by a post-independence "Arabization" campaign, fueled by the medieval Arabian slave trade that entrenched ethnic divisions and created an environment of Arab supremacy: a legacy that left Sudan's national curriculum void of Nubian history, depriving schoolgirls and schoolboys of learning about the glory of Amanirenas, her fellow Kandakas, the pharaoh Taharqa, and the territorial stronghold of the very Black and very powerful Twenty-Fifth Dynasty.

In the three decades leading up to the 2019 revolution, the empowering vernacular of Nubian "Queen" or "King" had probably been used more in the Black barbershops of America than the streets of Sudan's capital, Khartoum.

The burial of this heritage has been figurative, intellectual, and very literal. In 1959, the construction of the controversial Aswan Dam displaced 52,000 Nubians in Sudan and Egypt and drowned many ancient relics. Again in 2003, the $1 billion Merowe Dam displaced 50,000 Sudanese locals and flooded a vast

ELBAGIR

230 13th Amendment to the U.S. Constitution
Passed by Congress January 31, 1865.
Ratified December 6, 1865.

Section 1.

Neither slavery nor involuntary servitude, except as a punishment for crime whereof the party shall have been duly convicted, shall exist within the United States, or any place subject to their jurisdiction.

Section 2.

Congress shall have power to enforce this article by appropriate legislation.

Property is preserved through inheritance. Legal and economic adaptations have maintained and reconfigured the property interests established by the economy of slavery in the United States. The 13th constitutional amendment outlawed private chattel slavery; however, its exception clause legalized slavery and involuntary servitude when administered "as a punishment for crime whereof the party shall have been duly convicted." Immediately following the passage of the 13th amendment, the advent of laws designed to criminalize black life, known as Black Codes, aligned the status of the ex-slave and the pre-criminal:

> Every southern state except Arkansas and Tennessee had passed laws by the end of 1865 outlawing vagrancy [understood as either homelessness or joblessness] and so vaguely defining it that virtually any freed slave not under the protection of a white man could be arrested for the crime.[1]

Using the 13th amendment, Southern state governments effectively enmeshed themselves within the antebellum cycle of accumulation. The system of convict leasing financialized prisoners by leasing their labor to private industry. Many former slaves were leased back to former slave owners, now as a fully fungible labor force.[2] Although no longer designated as private property, ex-slaves functioned as a kind of public property whose discounted labor benefited both the governments that leased them and the corporations that received them.[3]

U.S. steel, coal, and railroad industries grew as a result of extensive convict lease programs in the South.[4] Corporate production was limited, however, by insubstantial Southern

roads. In the early 20th century, the majority of roadways in the rural south were unpaved dirt roads. Due to rain, sections frequently became impassable. In 1904 less than three percent of Georgia's 57,000 miles of roads were paved with gravel, stone, or sand clay, and none with bituminous macadam.[5] The U.S. Department of Agriculture Office of Public Roads, established in 1905, and local, nongovernmental "good roads" associations influenced Southern Progressive politicians in prioritizing road development. Up to this point, most Southern states had employed the largely ineffective statute labor system, which conscripted all citizens of a state to work on the roads four to five days per year. As a more reliable alternative, politicians turned to convict labor: "In North Carolina and elsewhere in the South where enthusiasm for good roads reigned, convict leasing was attacked, and the state was urged to put convicts to work on the roads; the good roads movement became 'identified with the movement to take the prisoner out of the cell, the prison factory and the mine to work him in the fresh air and sunshine.'"[6] The Progressive rhetoric of penal reform emphasized mutual benefit—William L. Spoon, a civil engineer and good roads advocate in North Carolina, stated in 1910: "The convict is forced to do regular work . . . and that regular work results in the upbuilding of the convict, the upbuilding of the public roads, and the upbuilding of the state."[7]

Unlike convict leasing, which facilitated private corporations' use of prisoners' labor, the chain gang system restricted the labor of the incarcerated to "state-use."[8] Organized labor championed this restriction as convict leasing competed with "free market" labor.[9] Progressive politicians rationalized the alternative chain gang system via a procedural legal framework that continues to characterize liberal reforms today: "the punishment [of convicts] ought not to be at the hands of a private party who may be tempted by the exigencies of business . . . to make punishment either more or less."[10] More contemporary liberal reforms to reduce judicial discretion include

the establishment of mandatory minimum sentences. As Naomi Murakawa describes, while this kind of proceduralism reduces the variance of punishment, it also contributes to the "pursuit of administrative perfection" and effectively strengthens U.S. carceral machinery.[11] By 1928, every U.S. state's convict lease laws had been repealed in favor of laws that restricted prison labor to state-use. In this way:

> [T]he state became the direct exploiter of that labor in an effort to build and maintain a transportation infrastructure that might contribute to the expansion of the manufacturing and commercial sectors. And just as that earlier system of forced labor was driven primarily by the dictates of political economy rather than humane penology, so too was the decision to remove the South's forced labor pool from private enterprise and give it to the "people" in the interest of a more public notion of economic development.[12]

The interwoven economy of road improvement and prison labor expanded on previous stages of industrialization. The development of transport infrastructure and logistics was a precondition for the shipping of slaves across the Atlantic, and was the primary purpose of the slave and convict leased labor used to build U.S. railroads. The transition to chain gang labor extended this genealogy, adapting it to the development of publicly owned infrastructure.

The rate of incarceration in the U.S. remained at approximately 110 people per 100,000 from 1925 to 1973.[13] Following the passage of the Omnibus Crime Control and Safe Streets Act of 1968, signed by President Johnson, and the Comprehensive Drug Abuse Prevention and Control Act of 1970, signed by President Nixon, the scale of prison development and the rate of incarceration increased dramatically. By 2014 the rate of incarceration had risen to 612 people per 100,000.[14] Despite the rhetoric of colorblindness, the administration of racialized law has effectively maintained racial

234 The profits incurred by these policies are still intact within Aetna.

In 1989 Congressman John Conyers of Michigan first introduced Congressional Bill H.R. 40, which would "Establish the Commission to Study Reparation Proposals for African Americans to examine slavery and discrimination in the colonies and the United States from 1619 to the present and recommend appropriate remedies." The bill would convene a research commission that would, among other responsibilities, make a recommendation as to whether a formal apology for slavery is owed, whether reparations are owed, what form reparations would then take and who would receive them. Conyers has reintroduced the bill to every session of congress since then. This bill acquired 48 cosponsors in 1999–2000. Currently it has no cosponsors.

In 2000 the state of California passed the bill SB 2199, which required all insurance companies conducting business in the state of California to publish documentation of slave insurance policies that they or their parent companies had issued previously. In 2002 a lawyer named Deadria Farmer-Paellmann filed the first corporate reparations class-action lawsuit seeking disgorgement from 17 contemporary financial institutions including Aetna, Inc., which had profited from slavery. Farmer-Paellmann pursued property law claims on the basis that these institutions had been enriched unjustly by slaves who were neither compensated nor agreed to be uncompensated. Farmer-Paellmann called for these profits and gains to be disgorged from these institutions to descendants of slaves.

The Reparations Purpose Trust forms a conditionality between the time of deferral and continued corporate growth. The general purpose of this trust is "to acquire and administer shares in Aetna, Inc. and to hold such shares until the effective date of any official action by any branch of the United States government to make financial reparations for slavery,

Cameron Rowland
Disgorgement, 2016
Reparations Purpose Trust, Aetna Shares

including but not limited to the enactment and subsequent adoption of any recommendations pursuant to H.R. 40 - Commission to Study Reparation Proposals for African-Americans Act." As a purpose trust registered in the state of Delaware this trust can last indefinitely and has no named beneficiaries.

The initial holdings of Reparations Purpose Trust consists of 90 Aetna shares. In the event that federal financial reparations are paid, the trust will terminate and its shares will be liquidated and granted to the federal agency charged with distributions as a corporate addendum to these payments. The grantor of the Reparations Purpose Trust is Artists Space, its trustee is Michael M. Gordon, and its enforcer is Cameron Rowland. The Reparations Purpose Trust gains tax-exemption from its grantor's nonprofit status.

6 — *1st Defense NFPA 1977*, 2011, 2016
Nomex fire suit, distributed by CALPIA
50 × 13 × 8 inches
Rental at cost

"The Department of Corrections shall require of every able-bodied prisoner imprisoned in any state prison as many hours of faithful labor in each day and every day during his or her term of imprisonment as shall be prescribed by the rules and regulations of the Director of Corrections." —California Penal Code § 2700

CC35933 is the customer number assigned to the nonprofit organization California College of the Arts upon registering with the CALPIA, the market name for the California Department of Corrections and Rehabilitation, Prison Industry Authority.

Inmates working for CALPIA produce orange Nomex fire suits for the state's 4,300 inmate wildland firefighters.

7 — *1st Defense NFPA 1977*, 2011, 2016
Nomex fire suit, distributed by CALPIA
50 × 13 × 8 inches
Rental at cost

"The Department of Corrections shall require of every able-bodied prisoner imprisoned in any state prison as many hours of faithful labor in each day and every day during his or her term of imprisonment as shall be prescribed by the rules and regulations of the Director of Corrections."—California Penal Code § 2700

CC35933 is the customer number assigned to the nonprofit organization California College of the Arts upon registering with the CALPIA, the market name for the California Department of Corrections and Rehabilitation, Prison Industry Authority.

Inmates working for CALPIA produce yellow Nomex fire suits for the state's non-inmate wildland firefighters.

8 — *Insurance*, 2016
Container lashing bars, Lloyd's Register certificates
102 × 96 × 11.5 or 149 × 18 × 4.5 inches

Lloyd's of London monopolized the marine insurance of the slave trade by the early 18th Century. Lloyd's Register was established in 1760 as the first classification society in order to provide insurance underwriters information on the quality of vessels. The classification of the ship allows for a more accurate assessment of its risk. Lloyd's Register and other classification societies continue to survey and certify shipping vessels and their equipment. Lashing equipment physically secures goods to the deck of the ship, while its certification is established to insure the value of the goods regardless of their potential loss.

9 — *Insurance*, 2016
Container lashing bars, Lloyd's Register certificates
102 × 96 × 11.5 or 149 × 18 × 4.5 inches

Lloyd's of London monopolized the marine insurance of the slave trade by the early 18th Century. Lloyd's Register was established in 1760 as the first classification society in order to provide insurance underwriters information

ROWLAND

#FEESMUSTFALL
PONTSHO PILANE

On Wednesday, October 14, 2015, the University of Witwatersrand in Johannesburg, South Africa, came to a complete standstill. A handful of students barricaded most of the entries into the university. Their cause? To protest the 10.5 percent fee increment that was proposed by university management for the following year.

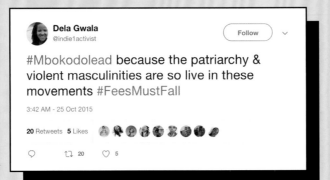

Dela Gwala
@indie1activist

Follow

#Mbokodolead because the patriarchy & violent masculinities are so live in these movements #FeesMustFall

3:42 AM - 25 Oct 2015

20 Retweets 5 Likes

20

5

Within an hour, a backlog of frustrated students and staff were still unable to make it into the university. The hashtag #WitsShutdown, which would later become #FeesMustFall as students across the nation joined in the call for zero percent fee increase and free university education, was born. What started off as fewer than a hundred people quickly became thousands of students. And then tens of thousands of young South Africans, referred to as "the rainbow nation," demanded the promises of the liberation movement—the right to equal education. For years, students at poorer, previously Black-only universities had taken to the streets, but it wasn't until Black students at previously White-only institutions like Wits joined in that the government and the country started to listen.

Regothabetse
@me_rego
Follow

Ain't gonna rely on Media news anymore for future reference, I was there (Wits Protest) and the media twisted stories
#TheRealWitsStory

10:29 AM - 18 Oct 2015 from Johannesburg, South Africa

13 Retweets 3 Likes

13 3

Koketso Moeti
@Kmoeti
Follow

#FeesMustFall is not only about the students that are currently studying, but the many others who weren't able to.

6:11 AM - 11 Oct 2016

PILANE

Twitter, through various hashtags, evened out the playing field and allowed students to tell their own stories when they felt as if mainstream media was misrepresenting them. Twitter was also instrumental in amplifying the story beyond South Africa. For example, students started the #TheRealWitsStory hashtag to refute media reports that protestors were holding the Wits vice-chancellor Adam Habib hostage.

As students rallied around the collective fight for free education, another problem needed to be addressed: the erasure and silencing of Black womxn activists in the student movement. Black womxn at Wits refused to put their womxnhood at the altar of sacrifice in the name of the "collective struggle," which resulted in #MbokodoLead. The hashtag was created as a way to uplift the various womxn who were part of the disruptions and also to combat the misogyny, patriarchy, and violence they experienced within the movement. #RapeAtAzania was another way the patriarchy was laid bare.

Students from various universities declared October 23, 2015, #NationalShutdown. They marched to the Union Buildings in Pretoria to hand over the demands for free education to the then-president Jacob Zuma. Meanwhile, students in Cape Town disrupted Parliament. Both groups were met with extreme violence from the police. Three students have lost their lives fighting for free education since 2016: Benjamin Phehla, Katlego Monareng, and Mlungisi Madonsela. These hashtags are among the few remaining active records of the myriad of efforts by students to campaign for educational equality. Former president Jacob Zuma announced free education in 2017, but students have yet to see its realization.

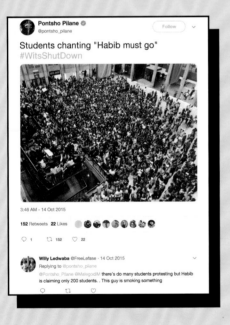

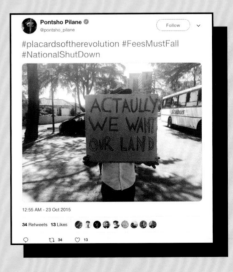

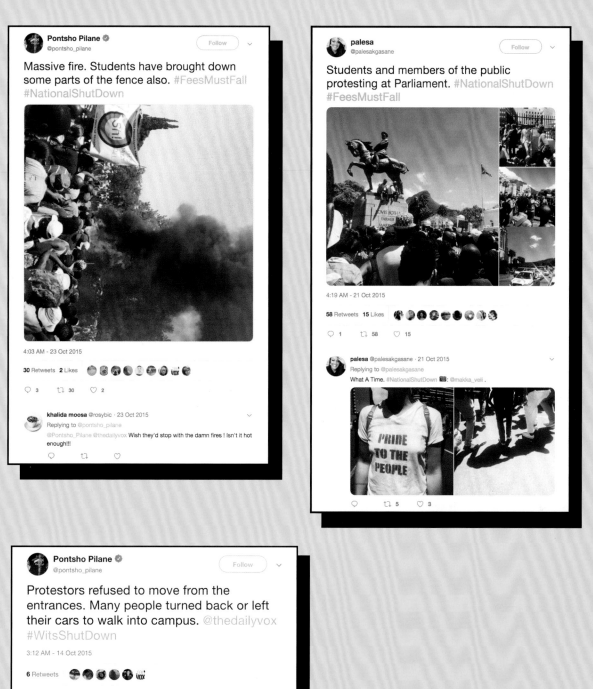

Pontsho Pilane @pontsho_pilane
Follow

Massive fire. Students have brought down some parts of the fence also. #FeesMustFall #NationalShutDown

4:03 AM · 23 Oct 2015

30 Retweets 2 Likes

3 30 2

khalida moosa @rosybic · 23 Oct 2015
Replying to @pontsho_pilane
@Pontsho_Pilane @thedailyvox Wish they'd stop with the damn fires ! Isn't it hot enough!!!

palesa @palesakgasane
Follow

Students and members of the public protesting at Parliament. #NationalShutDown #FeesMustFall

4:19 AM · 21 Oct 2015

58 Retweets 15 Likes

1 58 15

palesa @palesakgasane · 21 Oct 2015
Replying to @palesakgasane
What A Time. #NationalShutDown 📷: @makka_veli .

PRIDE TO THE PEOPLE

5 3

Pontsho Pilane @pontsho_pilane
Follow

Protestors refused to move from the entrances. Many people turned back or left their cars to walk into campus. @thedailyvox #WitsShutDown

3:12 AM · 14 Oct 2015

6 Retweets

6

PILANE

242 In 2006, at the age of sixteen, Cyntoia Brown was tried as an adult and convicted for shooting a man who she said paid her to have sex with him and threatened her life. Cyntoia was sentenced to fifty-one years in prison. My artwork "Free Cyntoia" was created in 2017 to draw attention to and put pressure on officials to reopen her case and protect minors forced into sex trafficking. A year later, after a lot of media attention and people calling to action, Tennessee governor Bill Haslam granted Cyntoia clemency. She was released on August 7, 2019, after serving fifteen years in prison.

Jana Augustin
Free Cyntoia, 2017
Digital artwork
Image courtesy of the artist

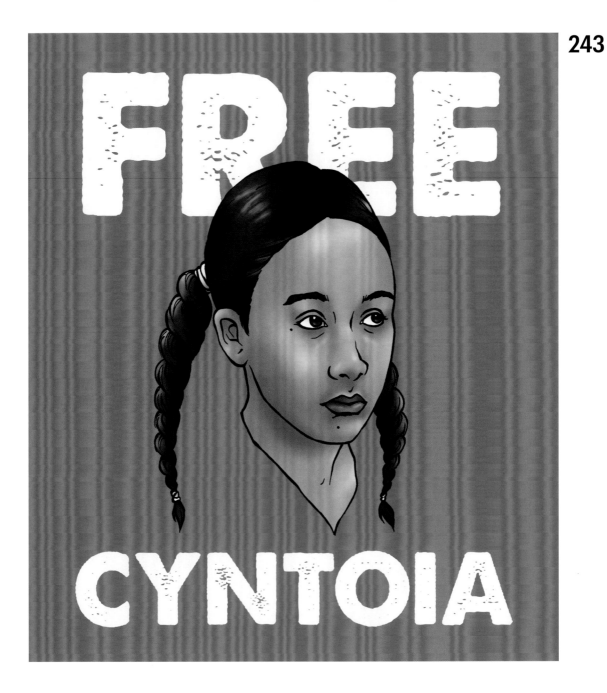

AUGUSTIN

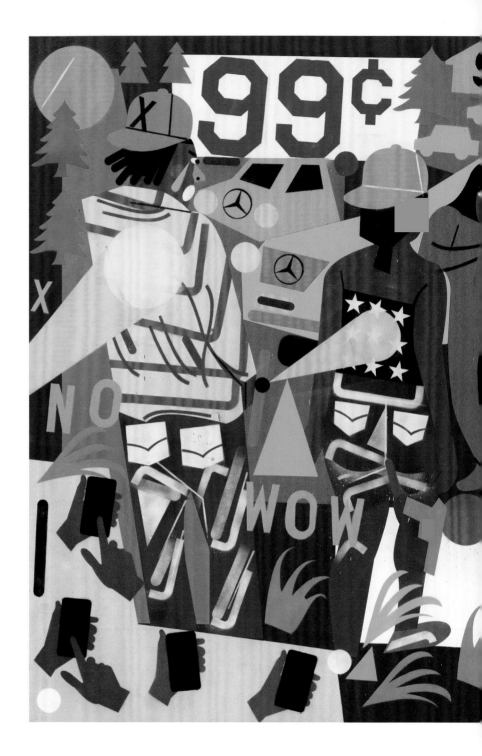

Nina Chanel Abney
Penny Dreadful, 2017
Acrylic and spray paint on canvas, 84" x 120"
Image courtesy of the artist

WHAT I KNOW ABOUT THE OCEAN

AYANA ELIZABETH JOHNSON

Here is what I know. The ocean is not separate from us or our daily concerns. It is our nourishment, protection, livelihood, and the air we breathe. It is culture, joy, and freedom. All this is at risk, and we need ocean justice.

RELATED ENTRIES:
Leah Penniman, 118
De'Ara Balenger, 96
Navild Acosta and Fannie
Sosa, 156

Nadia Huggins
Transformations No 6., 2015
Image courtesy of the artist

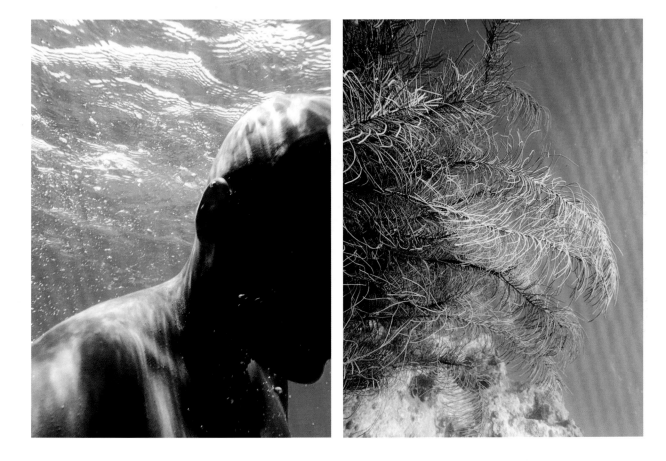

Ocean conservation is about people—more specifically, it's about marginalized people. Sometimes it seems we've been duped into thinking ocean conservation is just about fish, dolphins, whales, corals, and remote tropical islands. The well-being of communities of color and of poor and working-class folks is deeply affected as the ocean's health degrades. No different than on land, we are either excluded from accessing ocean resources or relegated to the most denuded and polluted places. Although we bear the greatest brunt of the impacts, we often had the least hand in causing them. A healthy ocean is critical to food security, economies, cultures, and our own health. Right now, overfishing, pollution, coastal development, and climate change are jeopardizing all of that. In addressing these threats to ocean health, we must consider who benefits from ocean exploitation and from conservation, and who does not.

We need ocean justice. While the concept of environmental justice—defined by the U.S. Environmental Protection Agency as "the fair treatment and meaningful involvement of all people regardless of race, color, national origin, or income, with respect to the development, implementation, and enforcement of environmental laws, regulations, and policies"—may have finally permeated the zeitgeist, the concept seems to end at the shore.[1] Communities of color and poor communities remain most disastrously affected by pollution, overfishing, human rights abuses, loss of coastal ecosystems, storms strengthened by climate change, and sea-level rise. Tackling these challenges will require working at all levels from micro-local to global, and building political power. We cannot afford to wait for governments and international bodies to lead. We—coastal communities who have the most at stake—must chart a path out of this mess mostly not our making.

There are not, in fact, many fish in the sea. Nearly 94 percent of fish populations are over-fished or fished to their maximum capacity.[2] Biggie rapped about "remember when we had to eat sardines for dinner," as a sign of poverty. But that's actually what we should be eating: small, fecund fish rich in omega-3s, not top predators like tuna whose numbers have plummeted by more than 50 percent[3] (bluefin by 97 percent[4]) since we got a taste for them. Technologies developed for war—radar, sonar, helicopters, spotter planes—are used to seek and destroy the remaining fish. While some places are fished sustainably,[5] wild fish simply can't make babies fast enough to keep up with our plunder. Yet, around three billion people rely on seafood as a significant source of protein.[6] The adage about teaching a man to fish doesn't work if there are no fish to catch. We must kill fewer fish. We must go from the 2 percent of the ocean that is currently protected to the 30 to 50 percent that scientists recommend.[7] Closing the high seas to fishing—the poorly managed two-thirds of the ocean that no one "owns," and where fishing is often profitable only with massive subsidies[8]—is a key step.

Unsustainable, unregulated fishing is a human rights disaster. Working conditions for fish workers are often perilous, and labor law violations and wage theft abound.[9] In Africa and Asia, fish scarcity has spurred women traders to barter sex to get priority to purchase fish—not sex for fish, but sex to get to the front of the line to *buy* fish.[10] This has contributed to the spread of HIV. Meanwhile, large seafood companies are enslaving fishermen on Pacific tuna vessels, and if your shrimp was imported, it may have been peeled by slaves in Thailand.[11] Then there are the pirates. Overfishing by Asian corporations in the Gulf of Aden caused some Somali fishers to turn to piracy since they could no longer make a living fishing, which in turn makes it dangerous for the remaining fishermen to go out and fish.[12] We must think beyond the science of sustainability and economics of the supply chain and consider the people upon whose work this industry is built.

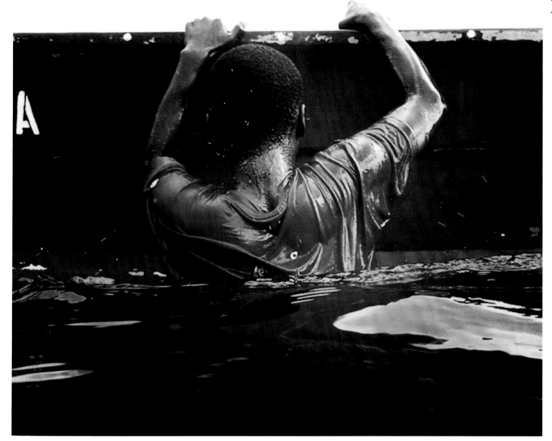

Emptied and polluted oceans hollow out cultures. Overfishing happens in shallow areas first, and governments often sell off fishing rights to the highest, often foreign, bidder. This means coastal communities that have relied on seafood for centuries, can no longer put fish on the table. Artisanal fishermen can't afford the gas and the bigger boats required to go farther from shore, and don't have access to capital to join this race for fish. Degraded coastal ecosystems destroy not just economies, but cultures. Water too dirty to swim in. Sand riddled with plastic. No teaching kids and grandkids to fish. No fish fry on the beach. No jambalaya, no crawfish boils. We must acknowledge that some traditions don't scale, that some of the old ways can't

be sustained with this many people and with such depleted ecosystems. We must also find ways to preserve invaluable cultural connections to the sea.

We need to farm the ocean. No, not industrial salmon farms that pollute the water and require tons of feed. For our food security and for sustainability, the future must include seaweed and shellfish farms dotting our coastlines. With "regenerative ocean farming" mussels grow on hanging ropes, while oysters and clams grow in cages on the seafloor, and kelp grows on lines between it all.[13] No fertilizer, fresh water, or feed required. Through photosynthesis and the formation of shells, ocean farms absorb tons of carbon, so can be

Nadia Huggins
Circa no future, 2014
Image courtesy of the artist

256 South—states which, incidentally, *lost the wars they started,* and always will, precisely because there is no way those White racisms can survive the earth without the rest of us types upholding humanity's best, keeping the motor running on civilization, being good, and preserving nature and all the stuff worth working and living for?

Anyway, this is a show of works on paper and on linen, drawn and collaged using ink, blade, glue, and oil stick. These works were created over the course of the summer of 2017 (not including the title, which was crafted in May). It's not exhaustive, activist, or comprehensive in any way.

Kara Walker
Spooks, 2017
Oil stick and Sumi ink on paper collaged on linen, 90 x 72 inches (228.6 x 182.9 cm)
© Kara Walker. Image courtesy of Sikkema Jenkins & Co. and Kara Walker

WALKER

GIRLTREK

VANESSA GARRISON & T. MORGAN DIXON

This conversation has been condensed and edited for clarity.
It took place on the mainstage at TED in Vancouver, Canada, in April 2018.

In September 2018, GirlTrekker Trina Baker from
Seattle, Washington, arrives at the #StressProtest,
an annual self-care retreat for Black women held in
Estes Park, Colorado, in the Rocky Mountains.
Photo by Joti Lindsay

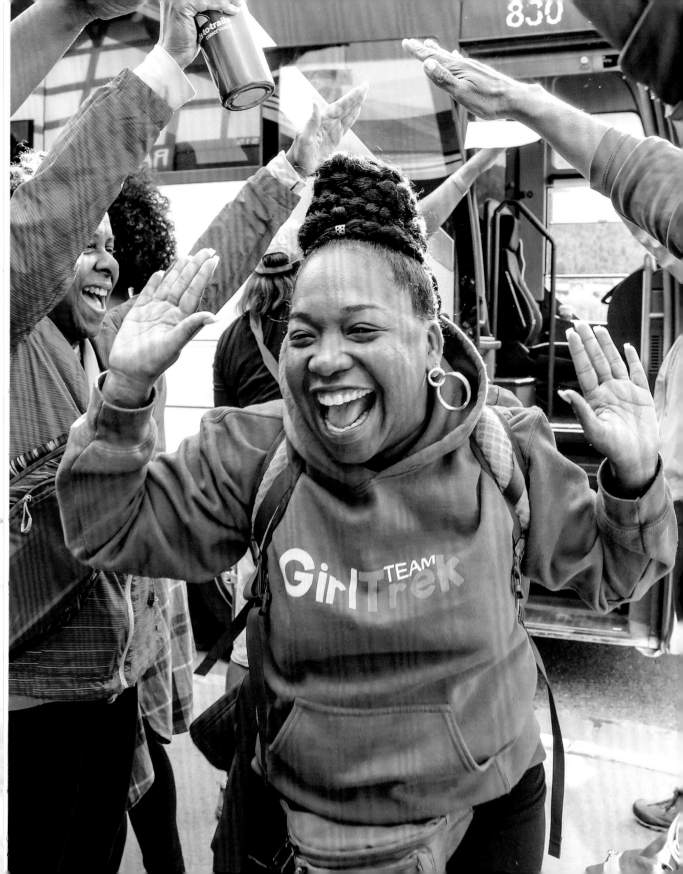

264 "I think it's really great that people are inspired to want to do Pride marches for themselves, and to celebrate themselves, but I think it's important for people to maintain and understand that the reason we have Pride events for marginalized people—the Women's March, Pride, Black History Month—it's taking those things and it's celebrating them, it's taking those things and we're enriching them.

Straight people aren't killed for being straight. You know, I saw somebody on my Instagram who was talking about white Pride—it's really important for people to be proud of who they are and to maintain a sense of confidence but I think it's also important for people to maintain that the reason we have Pride is because people who are having Pride events about themselves get killed for being who they are."

—Model, actor, and activist Indya Moore, via an Instagram post, June 12, 2019

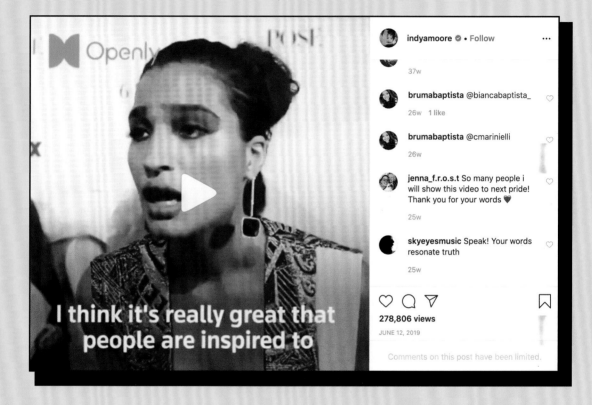

Portrait of Nipsey Hussle from a photography session for BET in February 2018, a year before he was slain in front of his store, Marathon Clothing, in his hometown of Los Angeles, California.

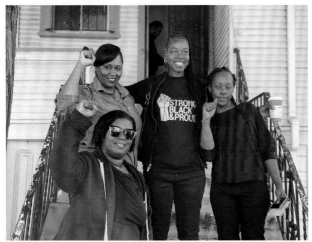

On November 18, 2019, four unhoused women (left to right, Sharena Curly, Sameerah Karim, Tolani King, and Dominique Walker) and their children occupied a vacant home on Magnolia Street in West Oakland, California. The demonstration was in response to California's severe housing shortage and growing homeless population.

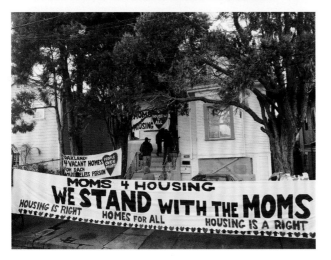

Supporters gathering in West Oakland, January 2020. Image displays a Moms4Housing sign that says, "Moms 4 Housing. We Stand With the Moms. Housing Is Right. Homes for All. Housing Is a Right."

OWNERSHIP

TUTU
AND THE WORTH
OF BLACK ART

ALEXIS OKEOWO

Ben Enwonwu
Tutu, 1974
On canvas
Courtesy of the Ben Enwonwu Foundation

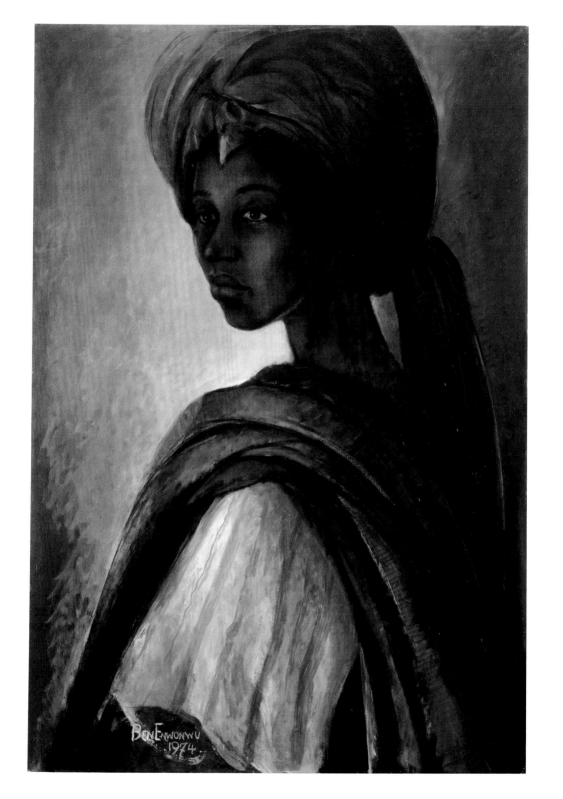

OKEOWO

A LESSON IN READING

JEROME HARRIS

Jerome Harris
Patti on haters, 2019
Digital/typography

"Haters are people who read with no resume and critique with no credentials. Is that you?"

is that you?

YouTube user Patti LaHelle's series *Got 2B Real* was a viral phenomenon between 2011 and 2015. Her flawless impersonations of beloved Black music divas found the perfect balance between paying homage and parodying their infamy. Rumored celebrity feuds between our favs, like Patti and Aretha, Beyoncé and Rihanna, and Whitney and Mariah are amplified through some of the most clever, witty banter I've ever heard in my life. Even now, almost four years after the end of the series, the episodes still make me laugh just as hard as they did when they first premiered.

Got 2B Real lived on YouTube as a fictional serial, sporadically posted parody of reality television shows. The format of the show seemed to mock *The Real Housewives of Atlanta,* placing these divas in social situations like housewarming or engagement parties, as they throw shade at one another in various interactions. In the first episode, Patti says to Aretha, "Just because I have on a watch, don't assume I have time for your bullshit." Within days of my discovering this Internet treasure back in the summer of 2011, this line and many more had found a common place in the conversations of me and my friends. Then they told their friends, and these lines became viral cultural elements quickly spread by imitation, or more simply, memes. Through 2015, when the series ended, the creator left her viewers with enough reads to address any situation. ("Reads" act as one version of the traditional witty banter found in Black American culture, also once known as playing the dozens. Dorian Corey in the iconic film *Paris Is Burning* explains reading as "the real art form of insult.") In the 1990s, growing up in Connecticut, we called it "cutting," but I soon realized after meeting other Black folks from the Northeast and mid-Atlantic areas as a student at Temple University in Philadelphia, there were other names for it, including: "bussing," "ranking," and "hiking." The term preferred by *Got 2B Real,* however, is "reading." I suspect Patti LaHelle's use of the term originates from its roots in Black queer culture. Black culture is layered so effortlessly in *Got 2B Real.* Even in writing this piece, I'm still finding new levels of genius in the show.

The parody series speaks to my Blackness, queerness, voice as a curator, sensibilities as a designer, and curiosity as a researcher. Formally, the editing and choice of video clips are perfectly paired with their respective voice-over lines. Details like the facial expressions and gestures of the divas in each clip increase the impact of the comedic timing. The writing is chock-full of clever pop culture references that make the jokes much funnier if you happen to catch them. On a personal note, I've always had a hard time defending myself against insults, even in playful settings. However, since *Got 2B Real,* I can pull out lines like "Haters are people that read with no résumé, and critique with no credentials. Is that you?" Then, *BAM,* I'm reading like a pro. In addition, LaHelle celebrates the legacy created by living and deceased legends by honoring them through uncanny renditions of both celebrated and notorious characteristics of these powerful Black women in music. It makes up for moments when the Grammys allow Alessia Cara to pay tribute to the late Aretha Franklin and Jennifer Lopez to do so for the enduring legacy of Motown. These missed opportunities are disrespectful to the tradition of R&B and soul music, as well as to the level of influence these stars have on American culture. Patti LaHelle generated an online cultural relic through which we can memorialize these divas through a fan fiction steeped in Blackness—the bonus is that she also blesses us all with a dissertation on the art of throwing shade.

HARRIS

RAWIYA KAMEIR AND THEBE KGOSITSILE (EARL SWEATSHIRT)

This conversation has been condensed and edited for clarity.
It took place in April 2018.

Artist illustrations by
Loveis Wise

Rawiya Kameir: What's your memory of how we met?

Thebe Kgositsile: I saw something you wrote and I really liked it and then I got the gumption one day to send you a dang DM and then, yeah, threw you some screenshots from this B2K video I had been watching. They seemed pretty emotive, like an "I choose you" vibe.

Kameir: Ew!

ON SELF-PRESERVATION/PRESENTATION ONLINE

Kgositsile: I really wish that I had the ability to just really not care. Sometimes I'm envious of people that can say whatever they want to say 'cause I feel passive, you know what I'm saying? It's a double-sided thing, 'cause I say I understand that I need to be thoughtful because of my platform. There's a certain amount of influence that comes—it sounds gross to say that—but it's a level of responsibility and also self-preservation.

Kameir: I think, though, that it's a good quality, and maybe one of your best qualities, that you do care what people think. I think we've lionized the concept of not caring and that's trash. Caring is important. The world would be a better place if people cared—not if people cared so much that it made them feel pressured into not being genuine or that they needed to shrink themselves or hide themselves or whatever—but caring is great. You *should* care, especially on the Internet because there's so many people on the Internet who don't care. So for the few of us who do, I think, our job is balancing out the bullshit, there's some value there.

Kgositsile: It's important to care.

Kameir: But it's also really hard too. Even if you care, right, once you put something on the Internet, it doesn't belong to you anymore. Let's say you thought really deeply about something that you wanted to tweet. You worded it, you had all your commas in the right place to make sure your clauses are on point and that it wasn't going to be misinterpreted. Once you post it, it doesn't belong to you anymore. Because people are gonna react to whatever they want to react to. People are gonna use it in whatever ways are convenient for them.

ON ENGLISH ON THE INTERNET

Kameir: So you claim that you never used an emoji until you sent me one.

Kgositsile: That's a big fact.

Kameir: How is that even possible?

KAMEIR, KGOSITSILE

Kgositsile: I was an old man. I am working on not being garbage, you feel me? I've come a long way.

Kameir: But using emojis doesn't equate to not being garbage.

Kgositsile: I was a fucking asshole, bro. Like, children use pictures to communicate. I'm a big man with words.

Kameir: Then why did you switch? Because you love an emoji now.

Kgositsile: Come on, dawg, because it's kinda fresh, man. We moving on. There's mad ways to express yourself. We decolonizing our minds, bro. Sometimes you don't need English. Sometimes English don't cut it. Sometimes I'm tryna say something that only the tearface emoji can express. Maybe that's universal. The tearface emoji.

Kameir: There's a lot of sentiments and meanings, things that just don't have words in English. As someone who speaks different languages but whose main language is English, I bump up against that all the time.

Kgositsile: Hell, yeah. Man, as someone who just spent time around other languages and has seen when something has been explained in another language, its concept is explained in another language that then I need translation for and someone's like, "I can give this rough translation to you but it's not . . ."

Kameir: Yeah, that's why, like, slang and, like, Black vernacular in its so many different forms is, like, so valuable. You know what I think about all the time? The word "auntie." How I could describe someone as my auntie to you and you know all the ways that she could possibly fit into my life. But if I explain that to someone who doesn't understand, it just means she's my mom's or my dad's sister. A limited use of a word.

Kgositsile: Black people so creative. We tryin', bro. Black people been trying, bro. Black Americans. Niggas is armed with only English. Just like, you know, how often don't you think in English?

Kameir: If I'm really upset at myself or if I'm having a conversation with myself that's not very abstract and that's, like, basic human emotion, my thoughts come to me in Arabic, even though I'm no longer fluent in Arabic. When I speak to my mom it's mostly English. When I speak to my dad or other family members it's a combination of Arabic and English.

Kgositsile: I love that shit. I love your Arabic English, bro.

Kameir: Thanks, but still, because it's my mother tongue that's why when feelings are immediate and raw it comes to me in Arabic and then I

translate it to English. Isn't that weird? Like my heart speaks Arabic more than I do. It's crazy.

Kgositsile: Yeah, that's very crazy. Reverse way. In my situation, like, going back home just now, going back to South Africa right now, I'm not fluent in Setswana at all or any of the native languages at home but just 'cause of my proximity to it when I was younger and just feeling, there's a lot that I understand in my family when they're speaking to each other. I be knowing when niggas be talking about—I remember there were times when niggas would say shit I would react appropriately and my cousins was like, you know—"Excuse me, like, do you understand what's going on?"

Kameir: Actually, yeah.

Kgositsile: Like, yeah. Sidetrack. There was times when I had to really challenge myself to not think in English. And when you don't have another language, that shit gets real crazy. You start thinking, Aw shit. There was, like, where I was thinking in colors, you start thinking visually.

Kameir: Yeah, oh my god, I just finished this book, *The Girl Who Smiles Beads*, and it's this memoir of this woman named Clemantine Wamariya, who was made a refugee by the Rwandan genocide—she was like five or six when it started. She was with her older sister, who's only barely older, and they were traveling all through southern and eastern Africa escaping the war and trying to find safety. And eventually she ended up in America and one thing that she talked about multiple times in the book was that—and she speaks a ton of languages—there were things she still didn't have language for when it comes to the brutality of the war and so she thinks in color. And it's sorta like synesthesia but it's a step beyond.

Kgositsile: And sometimes it was a saving grace because sometimes English gives me anxiety, bro.

Kameir: There's a lot of really shitty things in English, yeah, for sure. Do you think the Internet has made English better or worse? Within the American context specifically . . .

Kgositsile: Uhh, better. Everyone gets to—the diaspora, I mean America, whatever. We talk about that, diaspora in America. Different slangs from—bro, there's different slangs from like . . . What's the thing that was posted the other day? They had the wall chargers, like all the wall chargers, say what you call this where you're from? And niggas was coming with wildly different answers and that's everything. Like, "mid"—on one side of the country means boof. Well, "boof" on one side of the country means bad. "Boof" on the other side of the country means good.

KAMEIR, KGOSITSILE

Kameir: In a lot of ways the internet's just like one huge violation.

Kgositsile: One *huge* violation because one thing that I would be remiss if I did not bring up is what I brought to my mother with the Internet. The whole Free Earl shit villainized my mom. The shit that really broke me when I was inside the Coral Reef Academy. I was fighting really, really, really diligently to, like, ride hard for my friends when my mom thing was like, "This is really fucked up." And the thing that really broke me was when I was in there and my mom was like, "Nigga, do you understand that I am scared to go to work in the morning? I get emails, I get calls." This is peak OF. We old heads now, we washed. This shit don't matter. But this shit was huge, so the kids were rabid, bro. There was people driving past my mom's crib, and my mom's not a delusional person. There were people at my fucking house. People found out where my mother worked.

Kameir: On the flip side, do you ever feel sometimes like the Internet made you a better person?

Kgositsile: Hell, yeah!

Kameir: Like, I definitely feel like there's things about myself that I love, that I don't know if I would have gotten here without the people that I met online, the things that I've read, you know?

Kgositsile: 100 percent, 100 percent. It's the information superhighway.

Kameir: [laughs] It is. How did the Internet make you better?

Kgositsile: Get to see Black women's opinions. That's really, like, first and foremost. If you ever wanna, there it is. Just improve yourself with, just cut yourself on Black women's opinions, if you got the heart.

1. Term for weed that is not great. So, people use it to mean something that's meh—not good but not exactly trash either.

As a womxn of color studying art, seeing Himid take the prize made me clench my fist and hold it firmly above my head—one small step for society, one giant leap for the art world, or so I had hoped. After receiving the news on Thompson being short-listed, I clench my fists again, but this time not with pride. This is a blow. It didn't take long for the art world to get back on its bullshit.

I first became familiar with Thompson's work when he gave a lecture during my first week studying fine art at Central Saint Martins, where all my fears and doubts about the art industry were confirmed. His body of work was a list of instances of racist violence and Black trauma, which he had polished and carefully composed to be consumed by the predominantly White, middle-class gaze of the art world. Thompson has not just made one or two pieces about racial violence—almost all of his art centers on it. It is his obsession. While Thompson does not identify as White due to his mixed European and Fijian heritage, he is White-passing, meaning that he benefits from White privilege within our White supremacist society. In short, Thompson is a White-passing male, making work and profiting off the violence and suffering of Black and marginalized people.

When asked during the lecture why he didn't put descriptions next to his work, he argued that it isn't his job to educate people. I wondered then, *If it is not your job to educate people, then whose job is it? And if you wish to take these painful and deeply distressing events as your subject matter, but are not doing so in order to educate, what exactly is the intention of this work?* He made no reference to supporting the communities which he was studying, and did not seem concerned whether his art or his practice was of benefit to those whose experience it leeches upon. For me, Thompson's work does not feel like a sensitive awareness-raising project, but a process of extraction, sensationalism, and commodification.

The piece of art he's been short-listed for is a 2017 work, *Autoportrait,* which profiles Diamond Reynolds, the girlfriend of Philando Castile, who was shot by police during a routine traffic stop in Minnesota in 2016. When speaking about Diamond, Thompson very proudly boasted that he was the only artist that she had allowed to film her.

It is a "predatory," calculated, and "voyeuristic" gaze through which he captures these people and their stories, and shares them with us— a gaze that people of color know all too well.

Dana Schutz's painting *Open Casket* (a White artist's abstract interpretation of Emmett Till's dead body), which was included in the 2017 Whitney Biennial, springs to mind. The inclusion of this work prompted the infamous open letter penned by Hannah Black, who called for the removal of the work, stating that "those non-Black artists who sincerely wish to highlight the shameful nature of white violence should first of all stop treating Black pain as raw material." The piece also inspired a performance artist named Parker Bright to protest the work's inclusion by standing in front of it wearing a T-shirt that read: BLACK DEATH SPECTACLE.

Hannah Black's letter[1] prompted many critics to come running with cries for artists' right to freedom of speech and creativity, an argument which no doubt many will use to let Thompson off the hook. However, with our sordid history of White violence against Black bodies being celebrated as sport and entertainment—should it really be non-Black artists telling these stories? And are we really still prioritizing the "creative freedom" of White artists over the sensitive and painful histories and realities of people of color?

1. Greenberger, Alex. "'The Painting Must Go': Hannah Black Pens Open Letter to the Whitney About Controversial Biennial Work," *ArtNews*, March 21, 2017. www.artnews.com/art-news/news/the-painting-must-go-hannah-black-pens-open-letter-to-the-whitney-about-controversial-biennial-work-7992/.

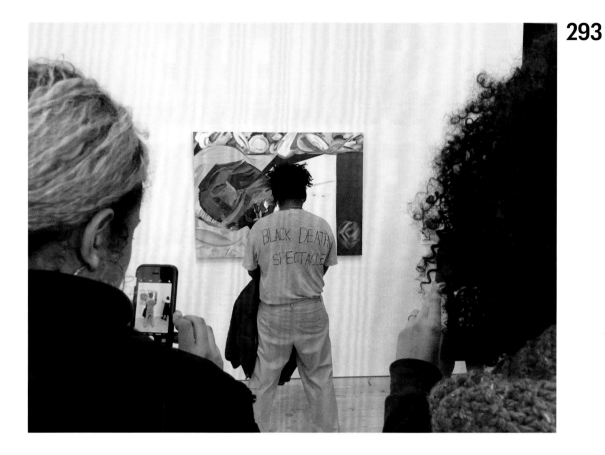

Documentation of artist Parker Bright's demonstration
at the Whitney Museum of American Art, 2017
Photo by Michael Bilsborough © Michael Bilsborough

TOWARD A BLACK CIRCULATIONISM

ARIA DEAN

Black people love social media, and social media love Black people. According to a 2015 Pew survey,[1] nearly half of Black Internet users use Instagram, as opposed to less than a quarter of White users. Twitter is more evenly distributed but still mostly minority-driven. Alongside the rise of the meme in Internet culture, we have witnessed Black-user-produced content[2] drift toward center stage. Not only is Blackness broadly attracted to the Internet, technology, and the future at large—exemplified by the rich traditions of Afrofuturist literature, house music, hip-hop videos, and more—but the Internet is a prime condition for Black culture to thrive.

Historically, our collective being has always been scattered, stretched across continents and bodies of water. But given how formations like Black Twitter now foster connections and offer opportunities for intense moments of identification, we might say that, at this point in time, the most concrete location we can find for this collective being of Blackness is the digital, on social media platforms in the form of viral content—perhaps most important, memes.

While I want to argue for an entwinement of Blackness and memes, I would be remiss—irresponsible, even—to go any further without noting another way that Blackness continues to circulate, with perhaps less frequency but with just as much, if not more, reach: through the aggressive circulation of videos that document Black death or violence in general against Black people. These videos proliferate alongside memes, brushing up against each

other on the same platforms. Further, Black death and Black joy are pinned to each other by the White gaze, and if we see their intersection anywhere, it's in the neo-mandingo fights of WorldstarHipHop. While these forms overlap in their mode of transmission and their involvement of Black bodies, such violent clips are no longer thought of as "memes." The term has evolved: Once used to describe ideas or behaviors that are passed from person to person, "meme" now refers metonymically to Internet memes, which are as trope-filled and easy-made as stock imagery, but are unprofessional and intentionally funny, with often absurdist text floating on or above a low-res image.

Beyond the obvious, "meme" has taken on a more difficult and speculative connotation: that of #relatability, an ability to provoke a feeling of identification in the viewer. It is conceptually linked to the French *même,* which

DEAN

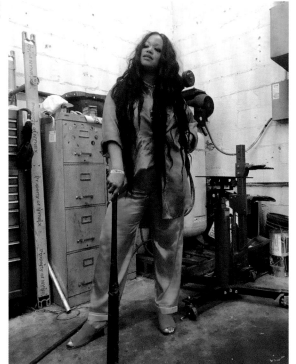

This was the morning I woke up and found out my dad had passed, but I still had to travel to New York and play a gig for the Panorama Music Festival. The festival was canceled halfway through my set due to weather conditions; I had rain dripping through the DJ booth over the CDJs. Not the happiest of tales but definitely an interesting one—and one that stands out. —Kerrie Ann Murphy, aka Bearcat

TOP
Bearcat backstage at Panorama Music Festival, Randall's Island, New York City, July 27, 2018

BOTTOM
Discwoman flyer for Boiler Room party hosted on February 26, 2016

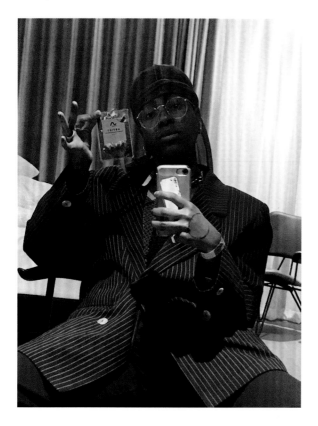

It was my second time in Poland. Somehow, the universe has brought me here twice in one year. Each time, I've met people and heard sounds that challenged me. The Unsound Festival brings together dozens of artists from across the globe to descend onto Krakow. I spent the weekend running from lecture to lecture in the day and writhing on the dance floor at night. It was the convergence of all of the medias I love. During this, I decided I was going to only wear a blazer for the weekend and began to start referring to the festival as a conference and my fellow DJs as colleagues. The theme of the festival was Simulator Sickness so I decided to embrace it by making comparisons to white-collar jobs. I closed out this year's conference by delivering one of the best sets/presentations of that leg of the tour.
—Yulan Grant, aka SHYBOI

Selfie taken at Forum Przestrzenie, Krakow, Poland, October 13, 2018

RENÉE MUSSAI AND ZANELE MUHOLI

Somnyama Ngonyama x Faces and Phases

Letter II: The Courage That Fuels Your Counter-Archival Impulse

Dear Muholi:

For you, photography is "not a luxury," to borrow your own words, if I may, echoing those of Audre Lorde, or casual leisure-for-pleasure, but a burning necessity: a mode of survival, a suturing, a "weapon to fight back."

After a decade of tirelessly documenting Black LGTBQIA+ individuals in South Africa and beyond, you invite us to "Hail the Dark Lioness" in *Somnyama Ngonyama*, the intimate visual memoir in which you are both image-maker

and protagonist, merging politics with aesthetics, private and public spheres, in new and confounding ways . . . driven by the same counter-archival impulse that had previously fueled the creation of *Faces and Phases'* living archive of Black lesbian, gender nonconforming, or bisexual women and transmen.

In this growing archive of the self, you forge a new genre of decolonial, socially engaged auto-portraiture, each photographic frame posing critical questions about social (in)justices, human rights, and contested representations of the Black body, with a stance that is at once personal and political.

A visionary mosaic of identities, an exquisite empire of selves: affirmation and reclamation, refusal and perusal, unapologetic in your artistry, unafraid in an open(ended) dialogue with the image archive—past and present . . . a visually seductive call to arms, a protective mantle, occupation, manifesto, and invitation: All of your portraits are, essentially, about courage—the courage to exist, the courage to resist, the courage to insist, and to persist, the courage to see, to be, to be seen, to step in front of the camera, to "face" yourself.

Pointing both inward and outward, both series constitute radical acts of inscription: inscribing your community, and yourself, into history—defiantly executing a demand for justice and visibility: "to be counted in [South African] history, to claim full citizenship," as you have said many times.

Again and again, you strategically deploy photography as a decolonizing tool to produce visual evidence en masse, picturing your participants as human beings worthy of recognition, as courageous history-makers and cultural producers . . . defying dominant portrayals as vilified "others," forgotten victims of hate crime, or disenfranchised members of

a subordinate subculture in a post-apartheid South Africa that too often, still, refuses to see them.

At the core of your cultural activism— *Somnyama Ngonyama* as well as *Faces and Phases*—is the blueprint for what I think of as "remedial visual practice": seeing differently with a commitment to care, to "imagine otherwise, to counter abandonment, to try to look, to try to *really* see."[1]

And collectively, these portraits also serve as invaluable reminders of the critical importance of extending curative care to ourselves because caring for the self "is not self-indulgence, it is self-preservation, and that is an act of political warfare."[2]

To move toward Black futurity—to bathe in "the warm illumination of a horizon imbued with potentiality,"[3] requires profound courage born from a yearning that propels us forward . . . the kind of courage that you unwaveringly exhibit through continual inscription of radical emergent queer subjectivities, and through your beautiful, and necessary, preoccupation with putting the self in the frame: impassionedly, triumphantly, transgressively.

With gratitude and admiration
Yours, always
Renée

1. Sharpe, Christina. *In the Wake: On Blackness and Being* (Durham, NC, and London: Duke University Press, 2016).

2. Lorde, Audre. *Your Silence Will Not Protect You* (London: Silver Press, 2017).

3. Muñoz, José Esteban. *Cruising Utopia: The Then and There of Queer Futurity* (New York: New York University Press, 2009).

MUSSAI, MUHOLI

Zodwa, Paris, 2014

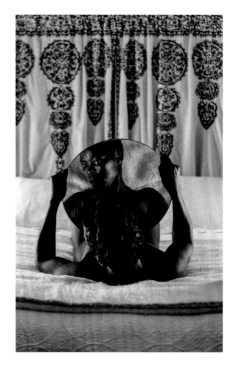

Bona, Charlottesville, 2015

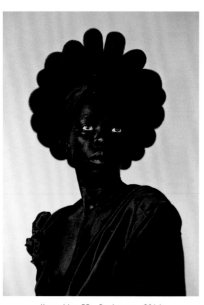

Ntozakhe II, Parktown, 2016

All quoted material by Zanele Muholi

"I'm reclaiming my blackness, which I feel is continuously performed by the privileged other. My reality is that I do not mimic being black; it is my skin, and the experience of being black is deeply entrenched in me. Just like our ancestors, we live as black people 365 days a year, and we should speak without fear."

"As photographers, we get carried away; we tend to focus on other people and forget about ourselves. I have made the choice to expose myself because I felt that nobody could do it for me. In order for me to remember me, and also to be remembered [. . .] finding that moment of tranquility where you connect with yourself. Just that moment, where anything is possible. You hold up the mirror to yourself. How else would you remember that you were there?"

Zodwa, Paris, 2014. Gelatin silver print. Image and paper: 35½ x 23⅛ inches.

Bona, Charlottesville, 2015. Gelatin silver print. Image: 31¼ x 20 inches. Paper: 35¼ x 24 inches.

Ntozakhe II, Parktown, 2016. Gelatin silver print. Image: 39½ x 28¼ inches. Paper: 43½ x 32¼ inches.

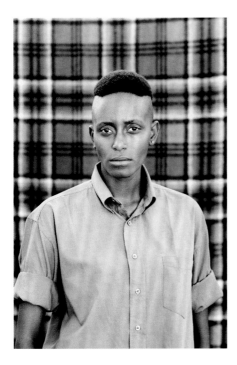

Sinenhlanhla Lunga, Kwanele South,
Katlehong, Johannesburg, 2012

"For me, photography is not a luxury, but visual activism. It's important to mark, map, and preserve our mo(ve)ments through visual histories for reference and posterity so that future generations will know that we were here . . . to (re)write a black queer and trans visual history of South Africa: for the world to know of our resistance and existence at the height of hate crimes in South Africa and beyond."

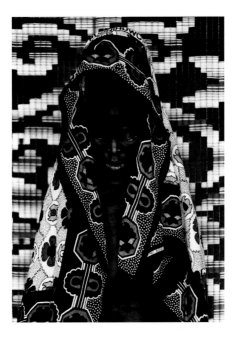

Bester IV, Mayotte, 2015

"It's a painful and difficult archive to create, a painful history to write, to make visible. I'm visualizing our lived experiences, combating and filling these gaps of silence and erasure by addressing absence through participatory image-making: introducing other ways of being, seeing and being seen—to instill pride in who we are, and what we represent, despite the dangers we face as a community. My life is about our collective lives; it's autobiographical, it's biographical; it's about the lives of black LGBTQIA+ individuals, especially human beings who I love, and care for deeply."

Sinenhlanhla Lunga, Kwanele South,
Katlehong, Johannesburg, 2012. Gelatin
silver print. Image: 30 x 20 inches.
Paper: 34½ x 24 inches.

Bester IV, Mayotte, 2015. Gelatin
silver print. Image: 31¼ x 22½ inches.
Paper: 33 x 24 inches.

MUSSAI, MUHOLI

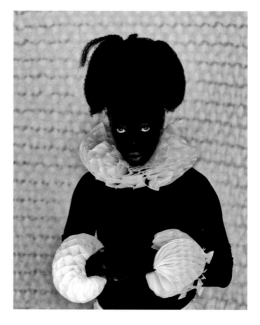

Thuleni, Bjilemer, Amsterdam, 2017

Vuyelwa "Vuvu" Makubetse, Parktown,
Johannesburg, 2016

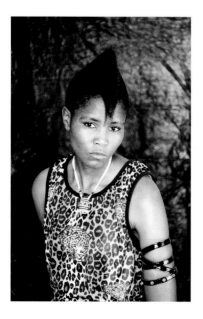

Thembela Dick, Vredehoek,
Cape Town, 2012

"Hence I am producing this photographic document to encourage individuals in my community to be brave enough to occupy spaces—brave enough to create without fear of being vilified, brave enough to take on that visual text, those visual narratives. To teach people about our history, to rethink what history is all about, to reclaim it for ourselves—to encourage people to use artistic tools such as cameras as weapons to fight back."

"What was initially a visual project became the creation of an unprecedented archive of photographs for my community and our country.
I wanted to fill a gap in South Africa's visual history that, even 10 years after the fall of apartheid, wholly excluded our very existence. However, as I began to photograph friends, comrades, neighbours, the lovers of lovers, I became curious.
I asked questions and looked into the eyes of black lesbian mothers, sisters, daughters and sons, wives and husbands. I was invited into their lives and I learned of their individual joys, hopes, longings, scars, suffering, and endless love."

Vuyelwa "Vuvu" Makubetse, Parktown,
Johannesburg, 2016. Gelatin silver
print. Image: 30 x 20 inches.
Paper: 34½ x 24 inches.

Thuleleni, Biljmer, 2017. Gelatin
silver print. Image and paper:
27½ x 22¼ inches.

Thembela Dick, Vredehoek, Cape Town,
2012. Gelatin silver print. Image:
30 x 20 inches. Paper: 34½ x 24 inches.

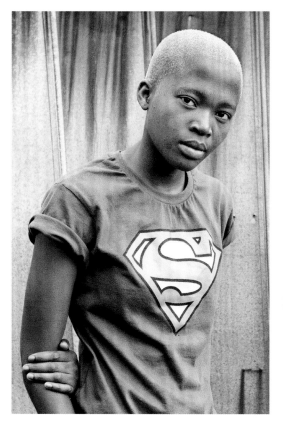

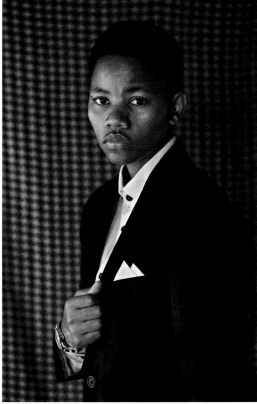

Mbali Zulu, KwaThema, Springs,
Johannesburg, 2010

Lebo Leptie Phume, KwaThema, Springs,
Johannesburg, 2016

"Faces and Phases is an insider's perspective that both commemorates and celebrates the lives of the black queers I have met in my journeys . . . *Faces* express the person, and *Phases* signify the transition from one stage of sexuality or gender expression and experience to another. *Faces* is also about the face-to-face confrontation between myself as the photographer/activist and the many lesbians, women and trans(wo)men I have interacted with from different places."

Mbali Zulu, KwaThema, Springs,
Johannesburg 2010. Gelatin silver
print. Image: 30 x 20 inches.
Paper: 34½ x 24 inches.

Lebo Leptie Phume, KwaThema,
Johannesburg, 2016. Gelatin silver
print. Image: 30 x 20 inches.
Paper: 34½ x 24 inches.

MUSSAI, MUHOLI

Names and how they are pronounced, revered, and understood reveal a lot—about classism, stereotypes, and history. As part of Dr. Deborah Roberts's research for the *Pluralism* series, she typed the names of more than two hundred and fifty African American women into her computer. As she typed, red lines appeared under nearly every name to indicate that the names were spelled incorrectly. For each name, there was a correct and an incorrect way that they should be rendered. "These names are African American names," Roberts notes. "These are names born from an American history. How can they be wrong?"

—as told to Lise Ragbir, director of the Art Galleries at Black Studies at the University of Texas at Austin

Deborah Roberts
Pluralism, 2016
Serigraph on paper, 30 X 22
Image courtesy of the artist

Raeschell Niakya Wakiesha Sumata Latrella Sahirah Keytra Resheda Tashenia Flisha Quitalla Kolethia Kesia Dabratzi Snicka Chalay Rovetta Meosha Tamikka Nakia Mirmala Tanika Jemelah Laneeda Lkiesha Sonyette Contrennia Jacinda Khadija Ginnette Tynette Veneitte Talana Keshia Lennette Salathia Peninnah Chanteria Roneshia Coletta Mishayla Tawana Shamecca Lakesha Inetha Tenera Desibrace Coletha Keesha Drwilda Shiqundia Queenlana Delinda Ayanna Malique Argirtha Fekisha Sharnell Jamaka Tetelalisa Khepri Claretta Hairothea Caprolanda Niakya Demetra Sumatra Neeama Cleastine Tashondria Lashon Natacha Shadelle Theresia Valkisha Bethena Kianna Nichelle Shemika Everloyce Sharkesha Jenise Ziondrea Latanza Noella Syretta Ghalyah Shalako Jilisa Tafreesa Sheritta Keyah Latifah Charisa Renneda Quonish Kiyanka Tanisha Shonta Shennelle Mandisa Tonisha Kenisha Makayla Narie Jerrica Shontel Felisha Tizza Moniqua Lashae Tinisha Tawonda Shanita Shonek Hazline Jazmin Shkise Tiara Shranda Sakura Ronisha Anaijah Raeschell Sha'Shauna Gerschell Zoriyah Evaretta Malyaia Qadeera Camesha Tynisha Briahna NaTasha Schanta Curtisa La'tonia Kalia Oryntha Mikayla Ebonee Chantel Quentera Keziah Shekila Cludetta Aaleah Ebony Danette Shanice Takira Sharee DeNisha Nalsya Tekena Thomeka Malvina Laquinda Sharleene Nekasa Kwadi Ja'Tovia Rashida Anunnaki Nashira Faizah Shayna Lethia Phelisa Dronellar Meechala Hynifah Nikia Shiann Akllah Shamiyah Shatora Larrika Lavetta Meosha Jaterra Zeldra Natanya Daleshawna Shawanna Lateatha E'monie Destine Kamildh Denisha Carlette Glenshler Deecoily Shantil Tamala Tamielya Nakeisha Tamisha Khlana Schnika Charnell Tiyon Shantelle Jzonque Ca'tina Joscalyn Shawnya Shalonda Ral'Nece Chalandra Taloria Tiffanique Tanachi Jakyra Zanaysha Chieboni Aivaye Jakerria Janieka Raenette Michel'le VeEtta Chanell Jawon Ronette Kawanda Seechanna Denishia Senalka La-a . . . Harlow Bristol

ROBERTS

DISPATCH FROM THE COLORED GIRLS MUSEUM

ERRIN HAINES

The Black pocket-sized doll that Vashti DuBois found in a store in upstate New York as a young woman wasn't something most people would consider art. But to her, the trinket felt urgent, and spoke to her in a way that she knew she had to own it, possess it, reclaim it.

As the founder of The Colored Girls Museum in Philadelphia, DuBois is still collecting three decades later. In 2015, she turned her 130-year-old home in the city's historic Germantown neighborhood into an homage to Black girls, and a sanctuary of celebration for Black women.

Each of the three floors is filled with images of Black girlhood and womanhood. I initially went down for a story, but have found myself returning again and again for a cup of tea, to hold a doll, and reconnect with the shy, skinny, bookworm Black child who is never far from the surface. I've also taken some of the Black women in my life who I care about and who I want to have the same journey, as a way of paying forward this unique bond of sisterhood.

A doll draped in an American flag, the words "We Shall Overcome" stitched into the hem. An achingly gorgeous portrait of a cocoa-skinned woman gazing from the canvas, her Victorian-era dress made entirely of paper, the locket hanging from her neck and resting over her heart containing a depiction of an actual lynching. The familiar childhood note where a girl named Lorrie asks a boy named Greg, "Do you love me?" with the word "love" crossed out and replaced with "like." An intricate Japanese woodblock piece depicting Black women at work, in front of a vanity, and in the kitchen, a subversive translation of highly skilled art depicting highly skilled art, often overlooked.

In many ways, DuBois's museum mirrors Black homes in America, with sitting rooms curated to show off our finest possessions, on display for visitors and waiting to be passed down to children and grandchildren. "People assume that we don't have collections, but of course we have collections," DuBois told me. "Our wealth is our memory. These are our legacies and how we're able to hide them in these artifacts that are of significance to us. We assign the value to these pieces. This is not assigned by other people."

For DuBois, the acquisition of Black art is a duty and a calling. After centuries of plunder across the diaspora dating back to colonialism that continues in the present day, Black people must become guardians of our own legacy. "These are our children. So many other people were collecting our babies. The only people that should be collecting them should be us," DuBois said. The task is almost spiritual. "When I purchase, I feel like I'm freeing my ancestors. I'm buying my people off the block, because I know that they're in there."

The Colored Girls Museum is an example of the power of the idea of ordinary things having value—especially representative art that taps into a cultural and emotional connection for a potential collector. Investing in Black art can and should be deeper than a commercial venture.

For many Black people, including DuBois, collecting is about reclaiming memories and

a cultural inheritance. In owning our cultural exports, we take control over how our stories are told, and how our precious, yet everyday objects are revered. "What we pass on to our children has value, and not because anybody else says so, but because you say so," DuBois said. "It's so important for Black people to begin to say so, whenever we see ourselves out there, to say, 'That's our shit.'"

HOW TO START YOUR OWN PERSONAL BLACK ART COLLECTION

Buy art that you like. Learn to trust your taste.

Whenever possible, buy from living artists. Buying art is a chance to invest in an artist's practice.

Only buy artworks from reputable galleries to ensure the artwork's provenance, or the work's history of ownership. Provenance is almost like the artwork's birth certificate.

Investing in and buying art is about owning objects that you want to live with. When you're considering making a purchase, you should ask yourself: What do I see? What do I feel? What do I like? What do I dislike? What do I understand?

—Errin Haines

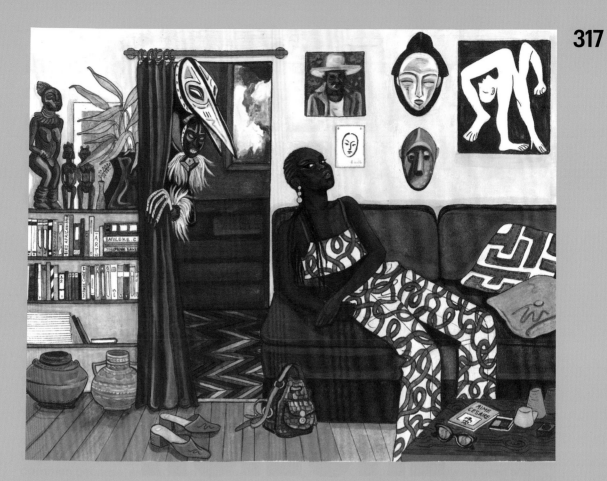

Maty Biayenda
Untitled
Gouache sur papier

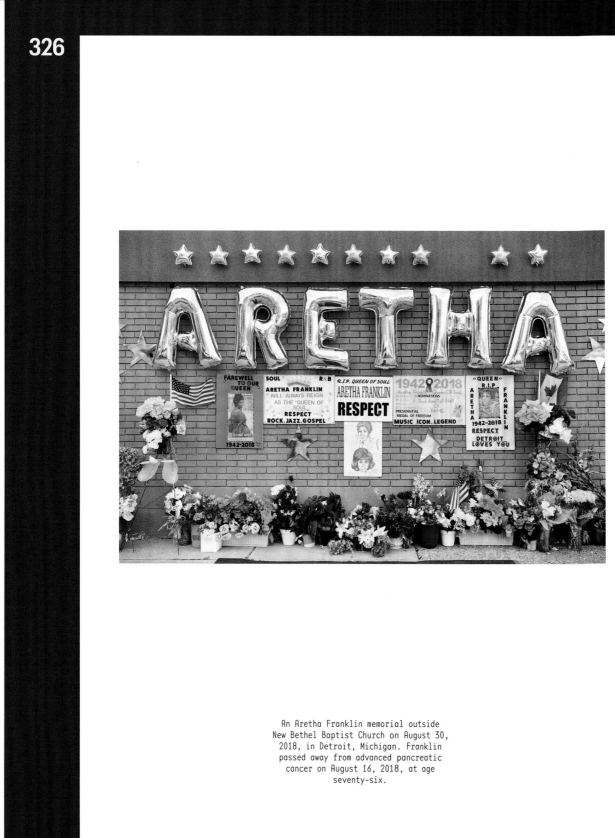

An Aretha Franklin memorial outside
New Bethel Baptist Church on August 30,
2018, in Detroit, Michigan. Franklin
passed away from advanced pancreatic
cancer on August 16, 2018, at age
seventy-six.

MEMORY

ON AND OFF AGAIN

KIA LABEIJA

"Yes, I'm in the geish." Reflections, in self-portraits and writing, on sacred healing spaces and the upstaging of glamor by daily routine.

Kia, are you taking your pills?

Sometimes.

Sometimes,

when I feel a breeze go by.

LABEIJA

AFFIRMATION

EVE L. EWING

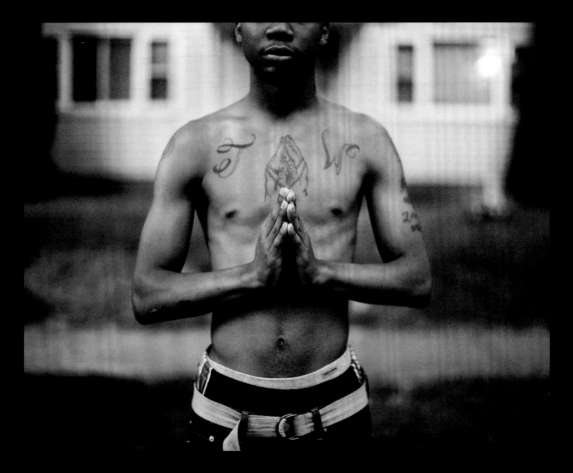

Zora J. Murff
Jaeshawn at 16, 2014
From the series "Corrections"
Image courtesy of the artist

A few years ago, I was doing a poetry show at the type of venue where at the end of the night, the only payment was a wad of cash culled from whatever the take at the door had been, and where artists are therefore encouraged to bring and sell whatever they might have to bring and sell.

I had no book to my name and no enthusiasm about putting together a chapbook for this purpose, and therefore nothing to bring and sell. I decided instead to sell commissioned poems. If people donated a certain amount of money to an organization of my choosing, I would write a poem on a topic they selected. They could do whatever they wanted with the poem, although I reserved the right to publish it if I wished.

The organization I chose is called Liberation Library. They are a volunteer group that provides books to young people who are incarcerated in prisons in Illinois. The books they provide are based on the requests of the young people themselves. I think that detail matters a lot. I believe that for Black people, reading remains a radical act, and the self-determination inherent in choosing *what* one would like to read—the idea that young people deserve an element of desire, of joy, of autonomy in this regard—is radical as well. (I mean this in both senses of the word: Children in prison choosing books for themselves is countercultural and transformative, and it also brings us to the very root of what reading means and what literature is for.)

One person emailed me with a simple request. She said that she did not need a poem. Instead, she asked that I write a poem for the young people themselves, something that I thought would be good for them.

Rather than try to write a poem rooted in identity, I decided to try to write one rooted in utility. I wanted to write something that someone could memorize easily, and therefore call on in moments of distress or uncertainty even if the text was not available. I thought about the many children who I have seen memorize "Hey Black Child" by Useni Eugene Perkins, or "Phenomenal Woman" by Maya Angelou, and decided to try to write a poem in that vein— one with a structure and series of repetitions that would facilitate memorization. I wanted the poem to focus on the ever-present consistencies of the small miracles of our being. I was also inspired by Assata Shakur's "Affirmation" poem, which asserts the loveliness of similar small miracles. "I believe in living," Shakur writes. "I believe in sunshine. / In windmills and waterfalls, / tricycles and rocking chairs."

This is the poem that I ended up with. It's been printed and mailed and tucked inside of books shipped to young people in juvenile detention centers across the state of Illinois. I hope it can serve as a small reminder to them of how miraculous they truly are.

Brittany "Bree" Newsome removes the
Confederate flag from a pole at the State
House in Columbia, South Carolina,
on June 27, 2015. Newsome was later
arrested for her action.

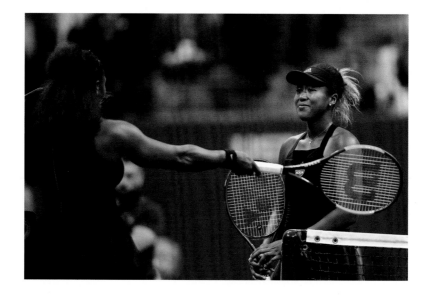

Naomi Osaka hugs Serena Williams after
winning the Women's Singles finals match
during the 2018 U.S. Open in New York
on September 8, 2018.

OUTLOOK

GAYBY LOVE
LINDA VILLAROSA

Beginning in the early '90s, my mother started jonesing for grandchildren. As soon as the feeling hit, right away she bore down on my heterosexual sister. She began gently, "Thinking about kids?" Then, a bit more heavy-handed. "Our family is wonderful; isn't it about time to extend the gene pool?" Next, guilt: "I'm getting old. I want a grandchild before I die." Then bullying: "Am I ever going to get a %@#! grandbaby?"

Finally, after several months of this, my non-kid-loving sister had had enough. "Mom, wrong tree," she said. "If you want a grand-child, talk to your lesbian daughter." My mom—God love her—is a transactional woman. She flipped the script, fast, and started in on me. She was basically, "If your sister isn't going to do this *for me*, then it's on you. I don't know how you're going to make it happen—and I don't want to know—but give me a grandbaby!"

In those days, before the gayby boom, I was considering motherhood. I do think my family—my father, mother, sister, and other relatives and ancestors—are wonderful, and I wanted to extend our gene pool. I'm transac-tional like my mother, which means it didn't take long for my partner and me to research

how to actually get pregnant, find a gay male friend to be the donor father, and then make it happen with instructions from the nascent Internet.

Generally, when you're pregnant, people fawn over you—even the most well-spoken member of New York City's chattering class can be-come rhapsodic about the "miracle of birth," the "circle of life," when they see a woman with child. But not everyone in my activist queer circle was excited about my pregnancy. I squared off with one of my friends at a pot-luck in the spring of 1996. As I walked in with a cilantro rice salad resting on my bulging belly, through hooded eyes she looked me up and down and said, "There goes your activ-ism." My body unwieldy and brain scrambled by hormones, I didn't respond. When I think about it now, I feel a surge of white-hot anger. The following year as I moved down 5th Ave-nue in cutoffs and Doc Martens, pushing my one-year-old through the Dyke March, another surly friend, uniformed in a ripped Act Up tee, chased me down. "You're trying to be just like them," she said.

Intellectually, I understood what was behind each of these comments: Having children

Jordan Casteel
Twins, 2017
Oil on canvas, 72" x 56" / 182.9 x 142.2cm.
Image courtesy of the artist and Casey Kaplan, New York

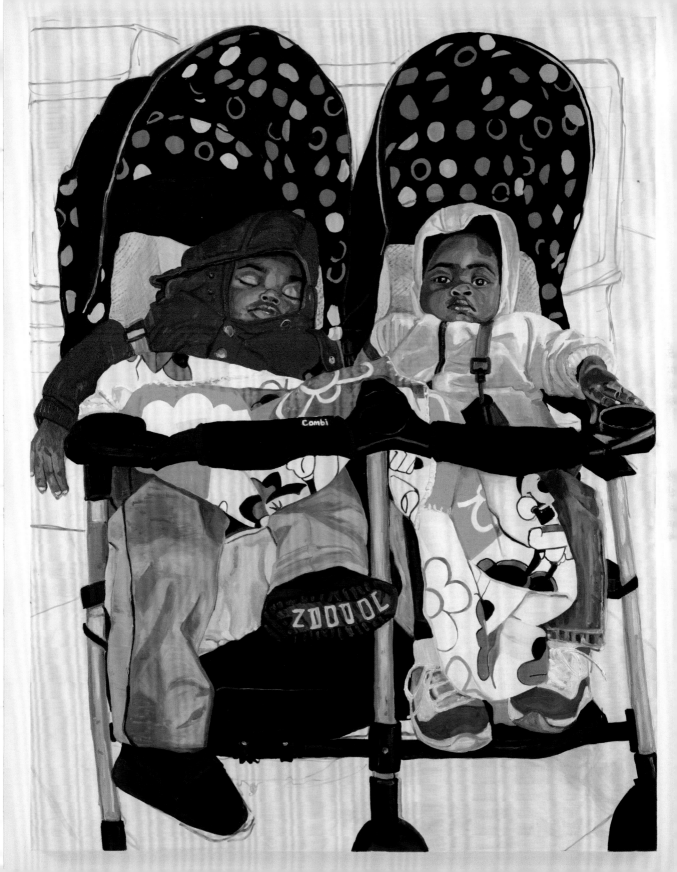

AN UNEVEN PEACE
RAHAWA HAILE

In 2000, Eritrea and Ethiopia signed the Algiers agreement and concluded a brutal border war. The agreement stipulated that an independent boundary commission would determine whom the disputed lands belonged to. When the boundary commission declared that several territories, including the highly contested town of Badme, would go to Eritrea, Meles Zenawi, then prime minister of Ethiopia, rejected the ruling, stating that his country would only accept the boundary commission's findings "in principle." The fallout from this single action would go on to dominate both countries' histories in the twenty-first century, often to their detriment.

If nothing else, it is important to understand that the recent peace deal between Ethiopia and Eritrea, as surprising as it was, did not appear out of thin air. This moment was sixteen years in waiting, spearheaded by a new, progressive Ethiopian prime minister, Abiy Ahmed, who upon entering office, repeatedly stated a desire for peace with his neighbor to the north.

Prime Minister Ahmed has freed countless political prisoners and opposition leaders and ended the state of emergency in the country. Relations between Eritrea and Ethiopia are equally impressive, with commercial flights and the ability to make phone calls between the countries restored for the first time in twenty years, and families who'd spent decades cut off from one another finally reunited.

Eritreans, however, have seen few changes in their circumstances. No elections have been scheduled, the country's constitution remains unimplemented, and the terms of conscription are still nebulous. It would appear the primary shift in the lives of Eritreans since peace was declared is knowing that the shackles that bind them belong to their leader alone. Some in the diaspora are cautiously optimistic. Others are demanding more immediate reforms. For now, there is nothing to do but wait and hope.

Shushan
@halohafte

Follow

All these pictures of Habesha folk who have gotten to reunite so far making me cry. I just want that for the rest that are still facing persecution. #Eritrea

9:49 AM · 18 Jul 2018

2 Likes

2

Vanessa Berhe
@VanessaBerhe

Follow

To All Eritreans: For 17 years, our government has used the war with Ethiopia as an excuse for their oppressive rule. Now that war is over, we need to hold them to account. Put pressure, be loud, don't give up - the future of Eritrea is determined by how we act now.

0:14 25.7K views

4:41 AM · 10 Jul 2018

532 Retweets 1,127 Likes

94 532 1.1K

J. Kolo
@BunaTime

Follow

Ethiopia in the last 7 days:
- Frees rebel leader Andargachew
- No longer in State of Emergency
- Agrees to give back Badme to Eritrea
That boy Abiy out here putting in the work.

Hewete Haileselassie ✔ @Hewete
#Ethiopia says it has decided to fully accept the outcome of a border commission which awarded the disputed border territory of Badme to #Eritrea
It says the decision is in a bid to make peace with #Eritrea

10:08 AM · 5 Jun 2018

305 Retweets 1,119 Likes

13 305 1.1K

Mel@ @EthioMelat25 · Jun 5
Replying to @BunaTime
"That boy Abiy" 😂 he's doing such amazing things in the short time he's been PM I'm a fan and hope other leaders follow his lead and energy.

1 26

negārit, awakener ✚
@mielafetaw

Follow

This is my fear. Peace between Eritrea and Ethiopia does not change the persecution, oppression and forced national conscription of the country.

If Western countries are so quick to "deport migrants" because of new and unrelated peace, then their govts are very misinformed.

Bronwyn Bruton @BronwynBruton
A Swiss court has just ruled that it is OK to deport migrants back to #Eritrea. End of conflict with #Ethiopia will make it easier for Europe to reject Eritrean asylum seekers = one of the side effects of the peace that needs more media attention.
israelnationalnews.com/News/News.aspx...

5:30 AM · 17 Jul 2018 from Wheaton, MD

17 Retweets 21 Likes

1 17 21

Individual-እንጀራ @the_etheropian · Jul 17
Replying to @mielafetaw
Misinformed or willfully ignorant? The U.K. has played this game before too

Individual-እንጀራ @the_etheropian
UK govt asylum acceptance for Eritreans dropped from 87% to 48% based on an at best flawed/at worst dishonest study twitter.com/ajenglish/stat...

M.Woldemariam
@MikeWoldemariam

Follow

Breathtaking. The only word I can muster to describe events of the last two weeks. In the blink of an eye, the regional order has been remade. Happy days for the sisterly peoples of Eritrea, Ethiopia, and the Horn.

Fitsum Arega @fitsumaregaa
#Ethiopia and #Eritrea made a historic breakthrough & agreed to end the state of war that lasted for two decades today. Following this, the same day Ethiopia officially submitted a request to the visiting #UN Secretary General for the @UN to lift sanctions it...

10:15 AM · 9 Jul 2018

51 Retweets 123 Likes

2 51 123

Mahlet Mesfin @mahlet_mesfin · Jul 9
Replying to @MikeWoldemariam
Mike dear, pls allow me to brag a bit 😊 I TOLD YOU SO 💃💃💃
Congrats 🙌🏾🙌🏾 to all of us!!!

1 4

shereen
@delashereen

Follow

if eritrea n ethiopia can get over this then all of u can move on from ur ex there actually isnt any excuse

12:06 PM · 9 Jul 2018

36 Retweets 143 Likes

36 143

HAILE

AN UNEXPECTED PEACE
HANNAH GIORGIS

My mother, who came to the United States from Ethiopia in 1981, spent her college years working in a restaurant. First as a student, and later as a woman who had outstayed her visa but had not yet outrun a tangible fear of the military coup that had taken over her homeland, my mother waited tables with the scent of injera, berbere, and onions wafting through the air. The New York restaurant where she worked was Eritrean-owned.

As a waitress, my mother was privy to boisterous conversations among cab drivers, who debated the future of Ethiopia—and the then-province of Eritrea, which had been annexed under Emperor Haile Selassie's rule. The 1980s, it seemed, was an era of revolution; for many Eritreans, that meant forging ahead with the bloody war for independence.

The following decade, Eritrea won its sovereignty from Ethiopia (the UN would not recognize the country's independence for another two years). The two decades that followed brought with them protracted violence within the country, especially along its southern border with Ethiopia. The area was militarized. Families were separated. Phone lines were disconnected. The diaspora was fractured. The price of freedom was a kind of splintering.

I have never known a world in which the countries I love most do not repel one another. But now, seventeen years after the (first) end of a merciless war, it feels surreal to observe recent developments in the Horn of Africa. In June, the new reformist prime minister of Ethiopia, Dr. Abiy Ahmed, extended an olive branch to Eritrea's president, Isaias Afewerki. Soon after, the countries formally restored diplomatic relations, air travel, phone service, and later, even border access. To call this peace—however tenuous—unthinkable is not an understatement.

Nearly every day since the summer began, I've refreshed my Twitter feed to see not only good news, but also other Ethiopians' and Eritreans' responses to it. The reactions to the countries' tentative new path reflect the diasporas' sometimes conflicting senses of hope, melancholy, enthusiasm, skepticism, and joy. The tweets on the following pages, culled from what is sometimes called "habesha Twitter"—the subset of the platform shared by Ethiopians and Eritreans, especially those who identify with a sense of cultural unity—are just a sampling of that dynamism.

Henok ≈ ሃኖክ 🏴
@hennakoti
Follow

Oh Gosh, I am so excited over this EthioEritrea thingy, I just called on a random number in Asmara and had a nice chat with a lady named Frtuna and She speaks Amharic 😮😂😄😃😄 #Ethiopia #ThankyouAbiy

1:30 PM - 9 Jul 2018

28 Retweets 168 Likes

♡ 8 ⟲ 28 ♡ 168

Adiam @Eriitrea91 · Jul 9
Replying to @henokkf
While I doubt the veracity of this story. How arrogant of you to assume you would find someone that either was forced to learn amharic during the time our language was illegal or someone who was deported from Ethiopia.

♡ 2 ⟲ ♡

Mik Awake
@AwakeMik
Follow

In a week that saw an official end to the 20-year war between Ethiopia and Eritrea, I'm thinking of the words of artist/curator Meskerem Assegued: "Coexisting is a survival tool."

My @ARTnewsmag feature on the Afrofuturists of Ethiopia went live today.

Ethiopian Enterprise: Artists Build a Future in Addis Ababa ...
A writer travels to his ancestral homeland to investigate development of different kinds. Read More
artnews.com

7:58 AM - 10 Jul 2018

5 Retweets 7 Likes

♡ ⟲ 5 ♡ 7

Ayantu 🏴👤
@ayantu_t
Follow

What are we to make of the fact that most of the coverage in western media about what's currently happening in the Horn is focused entirely on the rapprochement between #Ethiopia and #Eritrea without little discussion about how this relates to conditions within both countries?

6:27 PM - 26 Jul 2018

2 Retweets 21 Likes

♡ 3 ⟲ 2 ♡ 21 ✉ ⌄

negārit, awakener ✦
@mielafetaw
Follow

Peace is great, but 'making peace' is not unifying, combining, merging, marrying, or becoming united.

Eritrea is, and will remain, Eritrea.

ig: sarontes @s_tesfamariam
Repeat after me : Eritrea and ethiopia are making peace.
They are NOT unifying !
Okay ?! I don't wanna see any " we gonna be one soon " tweets anymore

11:00 AM - 2 Jul 2018 from Washington, DC

2 Retweets 12 Likes

♡ 1 ⟲ 2 ♡ 12

Yohannes @YohannesFa · Jul 3
Replying to @mielafetaw @s_tesfamariam
No marrying?

♡ ⟲ ♡

ሚጡ-ፃ feminist
@tizita_
Follow

My favourite part about this Ethiopia Eritrea dialogue is there's no direct flight from Asmera to Addis. So the delegation had to fly to Dubai first. Imagine leaving the continent, just travel a few hours down south.

5:22 AM - 26 Jun 2018

179 Retweets 639 Likes

♡ 14 ⟲ 179 ♡ 639

Zecharias Zelalem @ZekuZelalem · Jun 27
Replying to @tizita_
lol I think you broke the internet

♡ 1 ⟲ ♡

Semhar
@Semhar
Follow

Ugh. I'm a mess. Real tears. We waited so long for this day. So long. Four generations of Eritreans. Who fought so hard. Loved so hard. Prayed so much. Lost so much.

But it's time. For peace and love prevail. #Eritrea #Ethiopia

6:51 AM - 26 Jun 2018

44 Retweets 174 Likes

♡ 8 ⟲ 44 ♡ 174

Elizabeth Alexander ✓ @ProfessorEA · Jun 26
Replying to @Semhar
💜💜💜💜💜

♡ ⟲ 1 ♡ 1

GIORGIS

PROTECT ILHAN OMAR
DECOLONIZE THIS PLACE

MTL+/Decolonize This Place
Militant Love, 2019
Digital, 9" x 7.25"
Original photo by Mandel Ngan
Background pattern uses William Morris's *Tulip*, 1875
Image courtesy of the artist and MTL+/Decolonize This Place

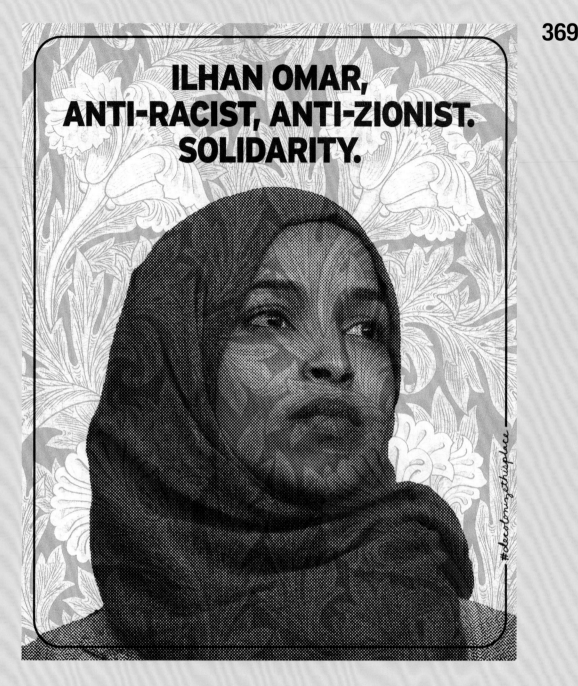

ILHAN OMAR, ANTI-RACIST, ANTI-ZIONIST. SOLIDARITY.

"We stand in solidarity and militant love with Ilhan Omar. We are never under any illusions about the electoral process and politicians, but it is important to stand with Ilhan as someone who is speaking truth to power." —Decolonize This Place

DECOLONIZE THIS PLACE

KIESE LAYMON AND CHOKWE ANTAR LUMUMBA

This interview has been edited and condensed for publication.
It took place in June 2019.

Author illustrations by
Loveis Wise

Kiese Laymon: Yo, man. It's so good to talk to you, fam. I don't even know how to ask somebody as busy as you how you doing. Are you less busy in the summer, or does it ramp up?

Chokwe Lumumba: It's no season for it, man. It's an all-year-round thing. But I'm good, I'm enjoying it. A lot of challenges, but I look forward to them, bro.

Laymon: I think that you and the movement have made a lot of people look at Jackson in ways they hadn't looked at Jackson before. I think the notion of Jackson being the most progressive, radical city in the world, in the country, is something that has drawn folks. Do you feel like, in order to be the most radical city in the country, that you have to be the most radical mayor in the country? Is there a correlation between those two?

Lumumba: I think how I'm viewed, in terms of how radical I am, is for someone else's interpretation. What I would say is, this movement really is a people's movement. As my father [Chokwe Lumumba, mayor of Jackson, 2013–2014] would say, "A selection of our leadership represents the readiness of the people." It means that the people of Jackson are ready for something. They're very consciously going after something that is pushing the envelope. That is forcing us to look inward, forcing us to address our contradiction, forcing us not only to look at our society and our city in terms of how it provides dignity to people, how it addresses issues of self-determination and people's ability to dictate their lives, but also how it delves into me as a man— how I live in a patriarchal, sexist society.

How do we begin to leverage our power so that we can start building institutions that we own as a community? Institutions [where] the mission of them is to serve the community, and they don't go anywhere unless the community says so. I certainly support Black business. I certainly think in an 85 percent Black city, it's not even a matter of race. It's a matter of economics. If 85 percent of your population is left-handed, then you need some left-handed jobs.

Laymon: That's right.

Lumumba: Even beyond that, a Black business is like any other business in a capitalist society, in exploit markets. Once it's taken all that it can from the market that gave birth to it, it might just leave and vacate the community that gave rise to it and look for higher returns. That's why cooperative enterprise, worker-owned cooperatives—where people can not only dictate their labor, but dictate what the fruits of their labor will be—enables us to have a holistic view of how we fill our voids and at the same time take better care of one another.

LAYMON, LUMUMBA

Lena Waithe arrives for the 2018
Met Gala at the Metropolitan Museum
of Art in New York. Waithe wears
a custom rainbow flag by Carolina
Herrera, accentuated with Verdura
cross brooches. The gala's 2018
theme was *Heavenly Bodies: Fashion
and the Catholic Imagination*.

Caster Semenya, South African
runner and Olympic gold
medalist, photographed by Dana
Scruggs for the August 2019
cover of *Out* magazine.

A model at the 2018 Bronner
Brothers International Beauty Show,
held annually at the Georgia World
Congress Center, August 5, 2018,
in Atlanta, Georgia.

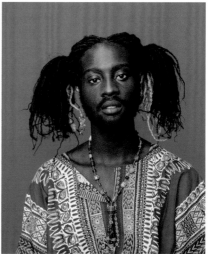

Cheikh photographed by Awol
Erizku at the 2014 AfroPunk Music
Festival in Brooklyn, New York,
for *Vogue* magazine.

BLACK IS (STILL) BEAUTIFUL

THIS HAIR OF MINE

AKINOLA DAVIES, JR., AND CYNDIA HARVEY

"This Hair of Mine" premiered at a Nataal-curated exhibition
at the first edition of AKAA (Also Known As Africa)
in Paris at the art fair in Carreau de Temple.

Creative direction & hair styling: Cyndia Harvey
Video direction & editing: Akinola Davies, Jr.
DOP: Jack Wells
Styling: PC Williams
Makeup: Nami Yoshida
Models: Abena, Halima, Hanna, Inemi, Jenn, Funmi, Rosetta, Xalan, and Hamda
Casting: Mischa Notcutt & Troy Fearn at TM Casting
Production assistant: Nellie Owusu
Colorist: Jason Wallis at ETC
Music: "Wound," courtesy of Arca
Sound: Callum Harrison, J Harrison, and Joseph Bond

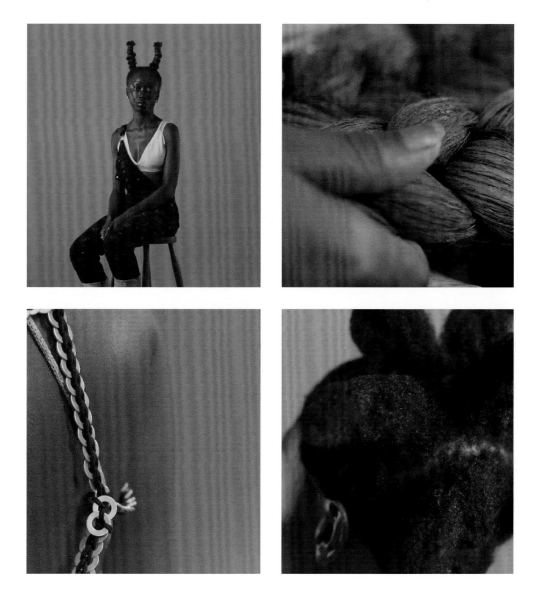

DAVIES, HARVEY

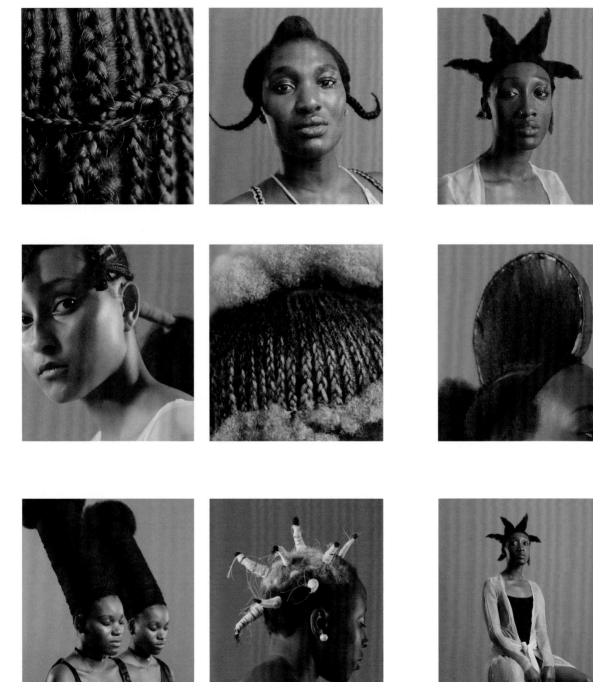

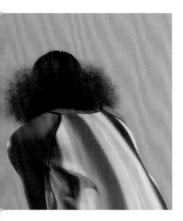

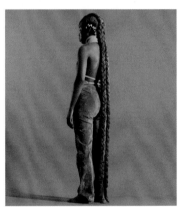

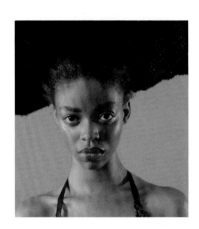

DAVIES, HARVEY

WELCOME TO THE TRANS VISIBILITY ERA

RAQUEL WILLIS

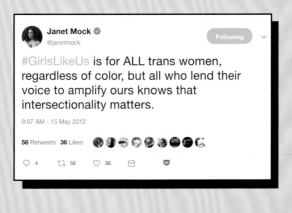

While social media isn't always a bastion of inclusivity and respect, marginalized groups have been able to leverage its power for access. With the advent of platforms like Facebook, Twitter, Instagram, and YouTube, trans folk have been baring their stories and perspectives in an unprecedented way. What was once an underground community has found its footing in the mainstream.

WILLIS

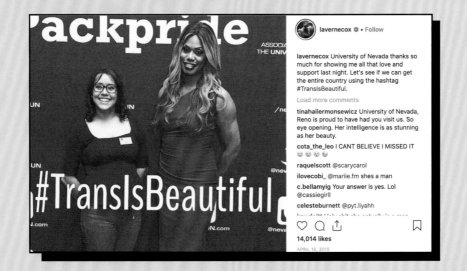

At the height of the current Trans Visibility era, two prominent Black trans women (author and television producer Janet Mock and Emmy Award–winning actress Laverne Cox) have also played a key role in aiding the trans community writ large to step out from the shadows online. In 2012, Mock pioneered the viral hashtag #GirlsLikeUs,[1] initially to garner support for transgender beauty pageant contestant Jenna Talackova, after her disqualification from Miss Universe Canada. The hashtag swiftly became a rallying cry for trans women and femmes and became a collective identifier included at the end of our posts and proudly within our profiles. In the early 2000s, being in the closet was par for the course for queer people, much less trans people. Witnessing my sisters boldly claim their experiences and identities so openly was powerful. It meant we were finally making our way out of the shadows of stigma and shame. Prior to the hashtag's emergence, many trans people on the Internet were open only in their own little silos, and there was still great fear for what outing yourself could mean in terms of real-world consequences.

Just three short years later, Cox made the bold statement of declaring #TransIsBeautiful to combat the devaluing messages that trans people confront on a daily basis. "All the things that make me uniquely and beautifully trans—my big hands, my big feet, my wide shoulders, my deep voice—all of these things are beautiful. I'm not beautiful despite these things; I'm beautiful because of them," she said in her acceptance speech for the Maybelline New York Make It Happen Award at the 2015 Fashion Media Awards.[2] To this day, you'll find trans people in every corner of the Internet defiantly reiterating the powerful mantra in their own ways.

Years after their creation, #GirlsLikeUs and #TransIsBeautiful continued to elevate the myriad ways that trans people exist in the world, and gave rise to other hashtags with a similar goal. In a time when the trans community has been facing widespread pushes for anti-transgender legislation and an epidemic of violence has plagued trans women, the community needed something positive to lean on. While we now understand how fraught the concept of visibility is—since it also makes marginalized folk more of a target for discrimination and violence—these micro-movements encouraged trans folk to be more authentic and vulnerable publicly. Now that trans folks are more outside of the closet than ever before, it will be near impossible to ever push us back in.

1. Mock, Janet. "My Journey (So Far) with #GirlsLikeUs: Hoping for Sisterhood, Solidarity & Empowerment," JanetMock.com, May 28, 2012. janetmock.com/2012/05/28/twitter-girlslikeus-campaign-for-trans-women/.

2. Chernikoff, Leah. "Laverne Cox's Explanation Of Why #TransIsBeautiful Will Make You Cheer And Cry," *Elle*, September 11, 2015. www.elle.com/culture/celebrities/news/a30388/laverne-cox-trans-is-beautiful/.

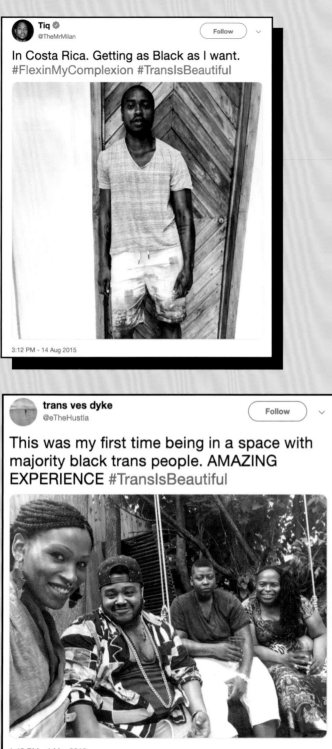

#YOAMOMIPAJON
SANDRA GARCIA

In 2011, Carolina Contreras created the #YoAmoMiPajon hashtag to encourage Dominican women to embrace their natural hair. Carolina is the founder of Miss Rizos, the first natural hair salon in the Dominican Republic. *Yo amo mi pajon* roughly translates to *I love my messy, or puffy, hair*. Ms. Contreras got tired of people on the street urging her to fix her hair, so she made a T-shirt with the slogan.

More people on the island began to see curly big, rowdy hair as beautiful and as a side of them that they should embrace and not press out with heat.

The hashtag has come to represent support for Carolina, support for Dominican women who choose to go natural, self-empowerment, and support for the Afro in Afro-Caribbean and Afro-Latino.

The #YoAmoMiPajon hashtag fully embodies the moment when an Afro consciousness woke in the heart of Latinidad (meaning all Latinos, even those not born in a Latin country). The hashtag is the eye of the intersection between accepting Blackness and the self. Many women and men with curly hair use the hashtag on social media to proclaim their African ancestry, to proclaim themselves as they are, and to rebuke the European beauty standards that have been drilled into society for ages.

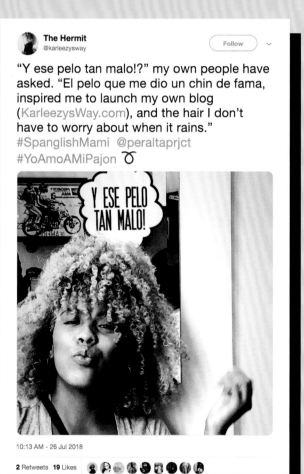

GARCIA

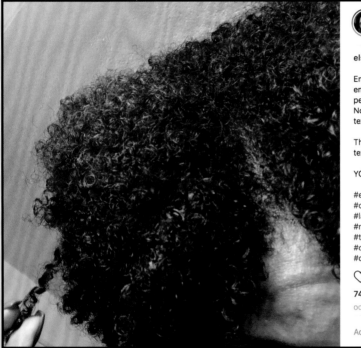

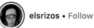 elsrizos • Follow

elsrizos TEXTURE TUESDAY:

Embracing this coily texture has been so empowering even when I get those "ay ese pelo malo looks." ♂
No hay cabello malo ni bueno, solo diferente texturas que hacen cada persona única.

There is no bad or good hair, only different textures that make every person unique.

YO AMO MI PAJON - I LOVE MY FRO.

#elsrizos #rizoscurls #curlyhair #curls #curlsfordays #curly #afro #afrosandrizos #latinahair #latina #rizosnaturales #naturalhairtips #naturalhair #naturalista #texture #curlyhairroutine #washandgo #coils #kinks #yoamomipajon #curlyhairstyles #supercurlyhair

74 likes

OCTOBER 23

Add a comment...

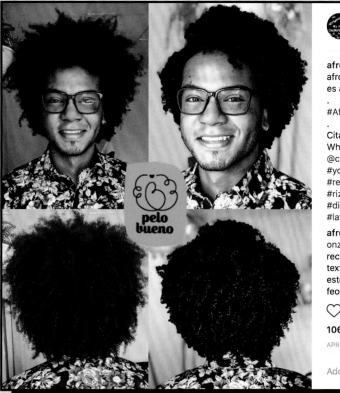

afrolatinos.siempre.palant • Follov

afrolatinos.siempre.palante " Ese pelo afro no es pa' hombre, eso solo se le ve bien es a las mujeres"...
.
#AfroMan #AfroHair #YoSoyPeloBueno
.
Citas en abril, en Cartagena, escribiendo al WhatsApp ▮▮▮▮▮ #Repost de @cirlepelobueno
#yoamomipajón #afrolatino #pelobueno #reclamacion #afrolatinidad #afrolatina #rizos #cabellorizos #cabellorizadonatural #diáspora #naturalhair #blackboymagic #latinegro

afrolatinos.siempre.palante @ggdiazg onzalez Realmente no me importan los reclamos de discriminación cuando las texturas de pelo como la mía y como este tipo siempre han sido vistos como feos o malos por los latinos como tú. Tu

♡ 106 likes

APRIL 12

Add a comment... ...

GARCIA

SHEENA ROSE ON SIMONE ASIA

Born in 1990, Simone Asia is a Barbadian artist whose oeuvre includes pen and ink and mixed media drawings. Asia's drawings of hybrid celestial figures express her personal experiences and engage themes of love, trauma, and gender roles. In the creation of her alternate worlds, she uses dreams, geomancy, and her personal journals as source material.

Simone Asia
Isolation, 2017
Pen and ink, 25" x 30"
Image courtesy of the artist

The alternate worlds are her way of escape from her reality and reveal her state of mind of anxiety, reflection, and hope. Informed by her dreams and journal entries, Asia constructs and adds detailed lines that surround the portrait and create ornate landscapes.

In her work *Isolation* (2017), one of her hybrid figures appears exhausted under the weight of twigs, feathers, and organic forms, all tangled together in the shape of a headpiece. Within the seemingly unmanageable tangle, there are intricate lines and clustered forms. On the left side of the canvas, there is a small black moon, which may signal an escape for the hybrid seeking to release its burden.

Escapism is a recurring theme in many of Asia's works. For Asia and many of my fellow Barbadian artists, living in an idyllic tourist destination often pigeonholes creatives into making what some may call "tourist art." Instead of portraying the beach, coconut trees, and green monkeys, Asia's work aims to portray a truth that is closer to her own experience as a young Black woman. As a Black Barbadian female artist, I too can relate to her quest for self-worth and self-discovery. For so many of us, the isolation caused by living outside of major art hubs and the veils of false smiles maintained for tourists can be mentally exhausting. Asia uses her craft to seek understanding and to demand an opportunity to be appreciated as an artist, human, Black woman, and someone that matters.

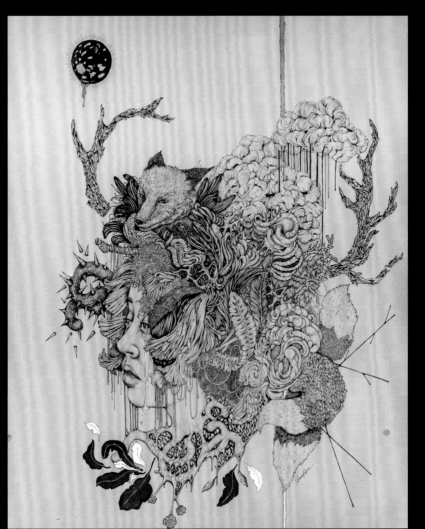

POP FOR YOU
JUNGLEPUSSY

This pussy don't pop for you
This pussy don't pop for you
This pussy don't pop for you
No more
This pussy don't pop for you
This pussy don't pop for you
This pussy don't pop for you
At all
No more
No more

I got so much to give
Sometimes I give it to the wrong niggas
Ungrateful motherfuckers
Soul suckers
Try to take what I got
You look up to these dudes to tell you
who to screw
What she'll look like if she ya type
Compliment her if she light
If she black don't get her hype
Because I don't know how to act
I'm only here for dick from the back
A hot meal or a snack
And I just so happen to be the only one
who got your back
Your big ass head your ashy buttcrack
Who else gonna twist your dreads and
snatch yo nigga naps

You got a nasty attitude
I don't like the way you treat me
I don't get horny when you look at me
You wanna know what turns me on?
I knew this one thoughtful motherfucker
He came from Planet Good Nigga or
some shit
This dude deadass took me to the zoo
The zoo? The zoo
Last nigga bought me leopard print lin-
gerie
I'm like
I got niggas taking me to see live animals
and you're pulling up with animal prints?

I can't believe
No I can't believe I done gave it for free
Gave it to you but you took it from me
Bust it open for you, it was the Hennessy

This pussy don't pop for you (this pussy
don't pop)
This pussy don't pop for you (this pussy
don't pop)
This pussy don't pop for you
No more no more no more
This pussy don't pop for you
This pussy don't pop for you
This pussy don't pop for you
At all

RELATED ENTRIES:
adrienne maree brown, 162
King Britt, 38

Image of JunglePussy performing "Pop for You" from her
album *Pregnant with Success* at The Box in New York City
Image courtesy of the artist

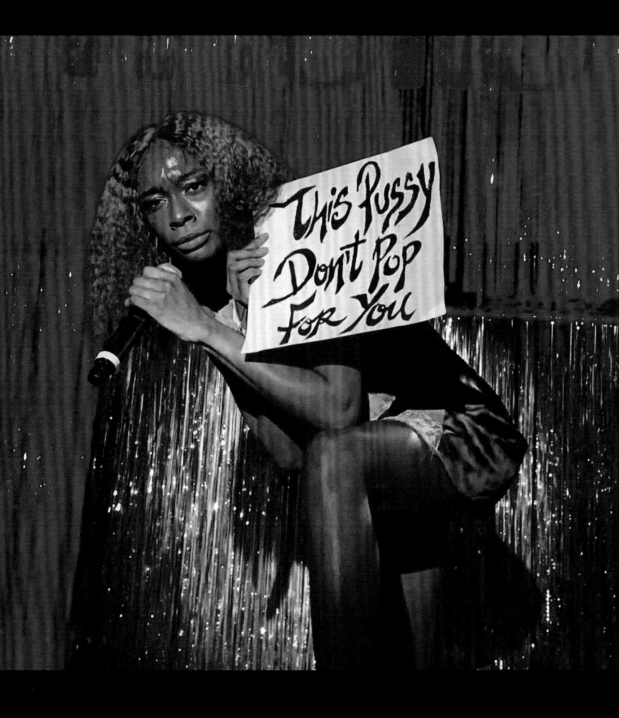

A TRUE PICTURE OF BLACK SKIN

TEJU COLE

What comes to mind when we think of photography and the civil rights movement? Direct, viscerally affecting images with familiar subjects: huge rallies, impassioned speakers, people carrying placards ("I Am a Man"), dogs and fire hoses turned on innocent protesters. These photos, as well as the portraits of national leaders like Martin Luther King, Jr., and Malcolm X, are explicit about the subject at hand. They tell us what is happening and make a case for why things must change. Our present moment, a time of vigorous demand for equal treatment, evokes those years of sadness and hope in Black American life and renews the relevance of those photos. But there are other, less expected images from the civil rights years that are also worth thinking about: images that are forceful but less illustrative.

One such image left me short of breath the first time I saw it. It's of a young woman whose face is at once relaxed and intense. She is apparently in bright sunshine, but both her face and the rest of the picture give off a feeling of modulated darkness; we can see her beautiful features, but they are underlit somehow. Only later did I learn the picture's title, *Mississippi Freedom Marcher, Washington, D.C.* (1963), which helps explain the young woman's serene and resolute expression. It is an expression suitable for the event she's attending, the most famous civil rights march of them all. The title also confirms the sense that she's standing in a great crowd, even though we see only half of one other person's face (a boy's, indistinct in the foreground) and, behind the young woman, the barest suggestion of two other bodies.

The picture was taken by Roy DeCarava, one of the most intriguing and poetic of American photographers. The power of this picture is in the loveliness of its dark areas. His work was, in fact, an exploration of just how much could be seen in the shadowed parts of a photograph, or how much could be imagined into those shadows. He resisted being too explicit

in his work, a reticence that expresses itself in his choice of subjects as well as in the way he presented them.

DeCarava, a lifelong New Yorker, came of age in the generation after the Harlem Renaissance and took part in a flowering in the visual arts that followed that largely literary movement. By the time he died in 2009, at eighty-nine, he was celebrated for his melancholy and understated scenes, most of which were shot in New York City: streets, subways, jazz clubs, the interiors of houses, the people who lived in them. His pictures all share a visual grammar of decorous mystery: a young woman in a white graduation dress in the empty valley of a lot, a pair of silhouetted dancers reading each other's bodies in a cavernous hall, a solitary hand and its cuff-linked wrist emerging from the midday gloom of a taxi window. DeCarava took photographs of White people tenderly but seldom. Black life was his greater love and steadier commitment. With his camera he tried to think through the peculiar challenge of shooting Black subjects at a time when Black appearance, in both senses (the way Black people looked and the very presence of Black people), was under question.

All technology arises out of specific social circumstances. In our time, as in previous generations, cameras and the mechanical tools of photography have rarely made it easy to photograph Black skin. The dynamic ranges of film emulsions, for example, were generally calibrated for white skin and had limited sensitivity to brown, red, or yellow skin tones. Light meters had similar limitations, with a tendency to underexpose dark skin. And for many years, beginning in the mid-1940s, the smaller film-developing units manufactured by Kodak came with Shirley cards, so-named after the White model who was featured on them and whose Whiteness was marked on the cards as "normal." Some of these instruments improved with time. In the age of digital photography, for instance, Shirley cards are hardly used anymore. But even now, there are reminders that photographic technology is neither value-free nor ethnically neutral. In 2009, the facial-recognition technology on HP webcams had difficulty recognizing Black faces, suggesting, again, that the process of calibration had favored lighter skin.

An artist tries to elicit from unfriendly tools the best they can manage. A Black photographer of Black skin can adjust his or her light meters; or make the necessary exposure compensations while shooting; or correct the image at the printing stage. These small adjustments would have been necessary for most photographers who worked with Black subjects, from James Van Der Zee at the beginning of the century to DeCarava's best-known contemporary, Gordon Parks, who was on the staff of *Life* magazine. Parks's work, like DeCarava's, was concerned with human dignity, specifically as it was expressed in Black communities. Unlike DeCarava, and like most other photographers, he aimed for and achieved a certain clarity and technical finish in his photo essays. The highlights were high, the shadows were dark, the mid-tones well-judged. This was work without exaggeration; perhaps for this reason it sometimes lacked a smoldering fire, even though it was never less than soulful.

DeCarava, on the other hand, insisted on finding a way into the inner life of his scenes. He worked without assistants and did his own developing, and almost all his work bore the mark of his idiosyncrasies. The chiaroscuro effects came from technical choices: a combination of underexposure, darkroom virtuosity, and occasionally printing on soft paper. And yet there's also a sense that he gave the pictures what they wanted, instead of imposing an agenda on them. In *Mississippi Freedom Marcher,* for example, even the whites of the shirts have been pulled down into a range of soft, dreamy grays, so that the tonalities of the photograph agree with the young woman's strong, quiet expression. This exploration of the possibilities of dark gray would be interesting from any photographer, but

DeCarava did it time and again specifically as a photographer of Black skin. Instead of trying to brighten Blackness, he went against expectation and darkened it further. What is dark is neither blank nor empty. It is in fact full of wise light which, with patient seeing, can open out into glories.

This confidence in "playing in the dark" (to borrow a phrase of Toni Morrison's) intensified the emotional content of DeCarava's pictures. The viewer's eye might at first protest, seeking more conventional contrasts, wanting more obvious lighting. But, gradually, there comes an acceptance of the photograph and its subtle implications: that there's more there than we might think at first glance, but also that when we are looking at others, we might come to the understanding that they don't have to give themselves up to us. They are allowed to stay in the shadows if they wish.

Thinking about DeCarava's work in this way reminds me of the philosopher Édouard Glissant, who was born in Martinique, educated at the Sorbonne, and profoundly involved in anticolonial movements of the '50s and '60s. **One of Glissant's main projects was an exploration of the word "opacity." Glissant defined it as a right to not have to be understood on others' terms, a right to be misunderstood if need be.** The argument was rooted in linguistic considerations: It was a stance against certain expectations of transparency embedded in the French language. Glissant sought to defend the opacity, obscurity, and inscrutability of Caribbean Blacks and other marginalized peoples. External pressures insisted on everything being illuminated, simplified, and explained. Glissant's response: No.

And this gentle refusal, this suggestion that there is another way, a deeper way, holds true for DeCarava, too.

DeCarava's thoughtfulness and grace influenced a whole generation of Black photographers, though few of them went on to work as consistently in the shadows as he did. But when I see luxuriantly crepuscular images like Eli Reed's photograph *Boys' Choir of Tallahassee* (2004), or those in Carrie Mae Weems's *Kitchen Table Series* (1990), I see them as extensions of the DeCarava line. One of the most gifted cinematographers currently at work, Bradford Young, seems to have inherited DeCarava's approach even more directly. Young shot Dee Rees's *Pariah* (2011) and Andrew Dosunmu's *Restless City* (2012) and *Mother of George* (2013), as well as Ava DuVernay's *Selma* (2014). He works in color, and with moving rather than still images, but his visual language is cognate with DeCarava's: Both are keeping faith with the power of shadows.

The leading actors in the films Young has shot are not only Black but also tend to be dark-skinned: Danai Gurira as Adenike in *Mother of George,* for instance, and David Oyelowo as Martin Luther King, Jr., in *Selma.* Under Young's lenses, they become darker yet and serve as the brooding centers of these overwhelmingly beautiful films. Black skin, full of unexpected gradations of blue, purple, or ocher, sets a tone for the narrative: Adenike lost in thought on her wedding day, King on an evening telephone call to his wife or in discussion in a jail cell with other civil rights leaders. In a larger culture that tends to value Black people for their abilities to jump, dance, or otherwise entertain, these moments of inwardness open up a different space of encounter.

These images pose a challenge to another bias in mainstream culture: that to make something darker is to make it more dubious. There have been instances when a Black face was darkened on the cover of a magazine or in a political ad to cast a literal pall of suspicion over it, just as there have been times when a Black face was lightened after a photo shoot with the apparent goal of making it more appealing. What could a response to this form of contempt look like? One answer is in Young's films, in which an intensified darkness makes the actors seem more private, more self-contained, and at the same time more

dramatic. In *Selma,* the effect is strengthened by the many scenes in which King and the other protagonists are filmed from behind or turned away from us. We are tuned into the eloquence of shoulders, and we hear what the hint of a profile or the fragment of a silhouette has to say.

I think of another photograph by Roy DeCarava that is similar to *Mississippi Freedom Marcher,* but this other photograph, *Five Men, 1964,* has quite a different mood. We see one man, on the left, who faces forward and takes up almost half the picture plane. His face is sober and tense, his expression that of someone whose mind is elsewhere. Behind him is a man in glasses. This second man's face is in three-quarter profile and almost wholly visible except for where the first man's shoulder covers his chin and jawline. Behind these are two others, whose faces are more than half concealed by the men in front of them. And finally, there's a small segment of a head at the bottom right of the photograph. The men's varying heights could mean they are standing on steps. The heads are close together, and none seem to look in the same direction: The effect is like a sheet of studies made by a Renaissance master. In an interview DeCarava gave in 1990 in the magazine *Callaloo,* he said of this picture: "This moment occurred during a memorial service for the children killed in a church in Birmingham, Alabama, in 1964. The photograph shows men coming out of the service at a church in Harlem." He went on to say that the "men were coming out of the church with faces so serious and so intense that I responded, and the image was made."

The adjectives that trail the work of DeCarava and Young as well as the philosophy of Glissant—opaque, dark, shadowed, obscure—are metaphorical when we apply them to language. But in photography, they are literal, and only after they are seen as physical facts do they become metaphorical again, visual stories about the hard-won, worth-keeping reticence of Black life itself. These pictures make a case for how indirect images guarantee our sense of the human. It is as if the world, in its careless way, had been saying, "You people are simply too dark," and these artists, intent on obliterating this absurd way of thinking, had quietly responded, "But you have no idea how dark we yet may be, nor what that darkness may contain."

DON'T TOUCH MY HAIR

SOLANGE KNOWLES

RELATED ENTRIES:
Momo Pixel, 148
Nontsikelelo Mutiti, 422

Solange Knowles, photographed by
Carlota Guerrero, in Barcelona, 2016
Image courtesy of the artists

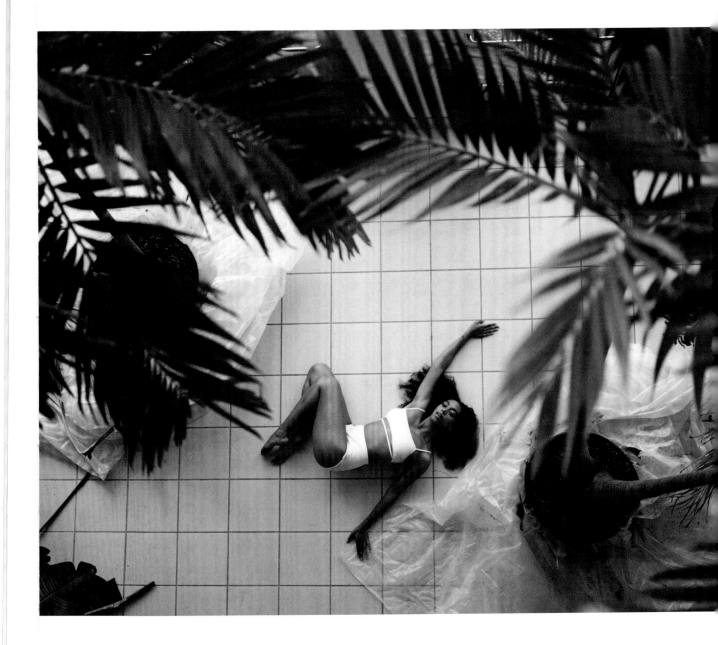

KNOWLES

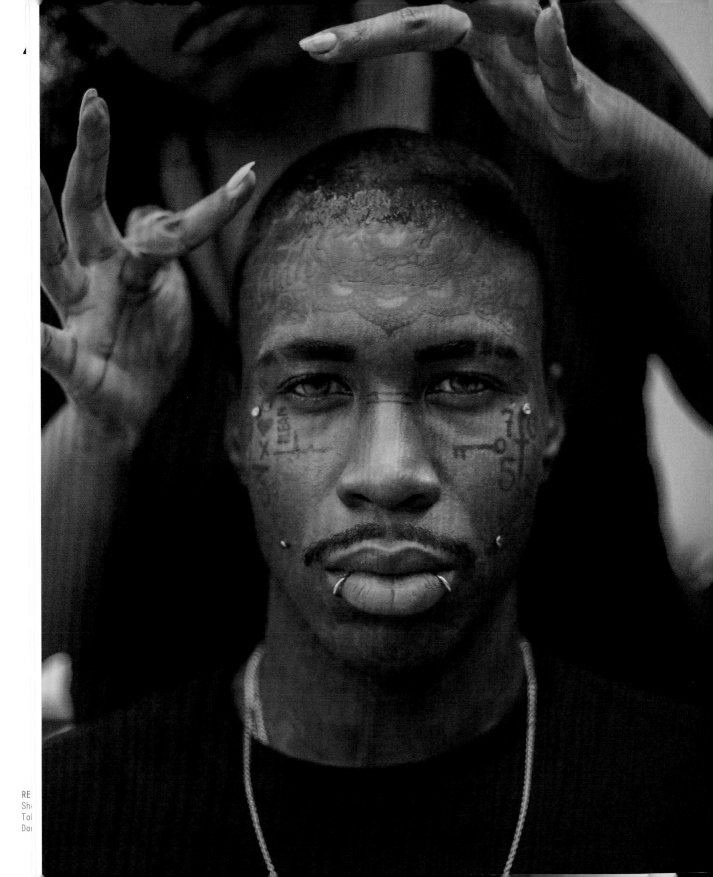

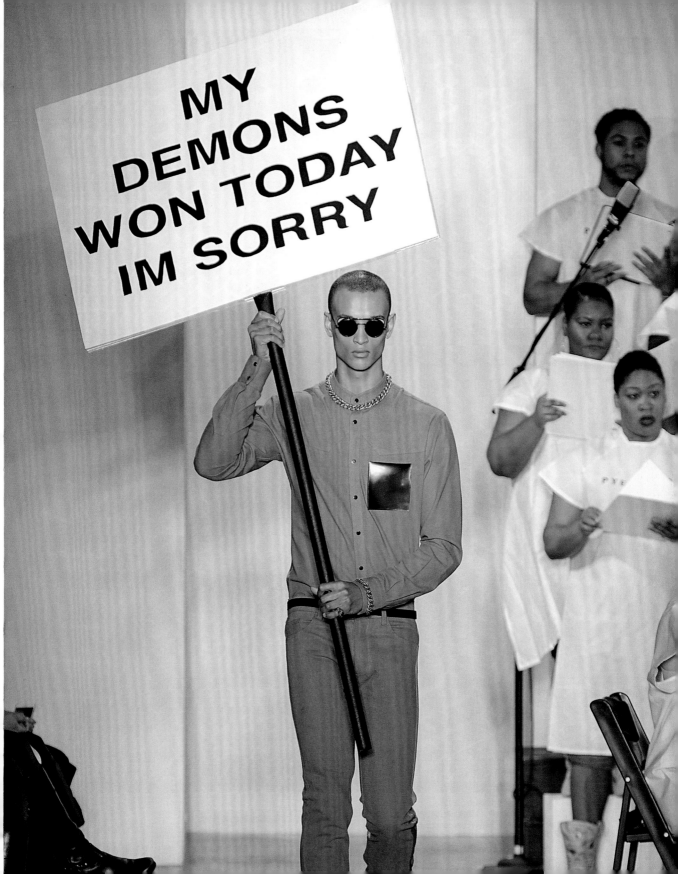

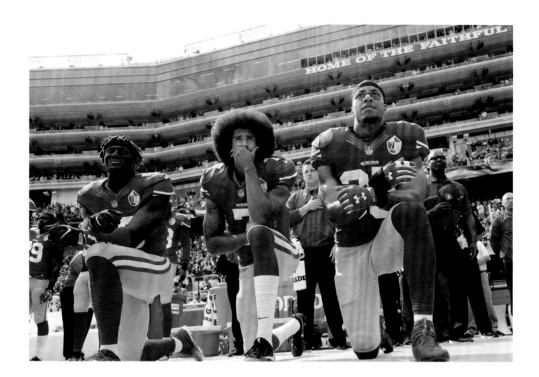

San Francisco 49ers outside linebacker Eli Harold, left, quarterback Colin Kaepernick, center, and safety Eric Reid kneel during the national anthem. October 2, 2016.

Dwyane Wade (#3) of the Miami Heat hugs his daughter Zaya Wade after his final career home game at American Airlines Arena on April 9, 2019, in Miami, Florida.

LEGACY

MARTINE ROSE

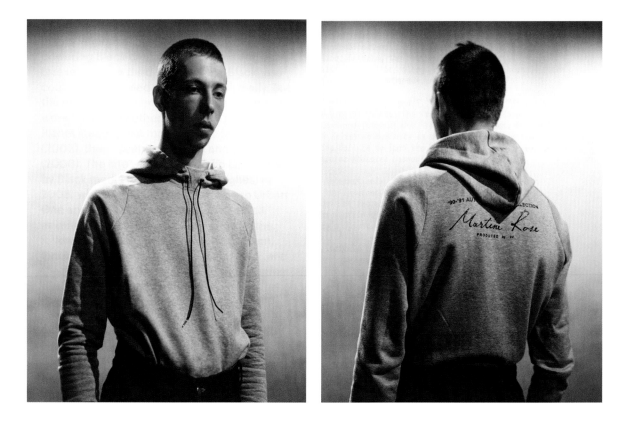

AW15 Presentation
Model: Frank
Stylist: Max Pearmain
Photographer: Virginia Arcaro

A/B.
AW16 Presentation
Model: Alex
Stylist: Tamara Rothstein
Photographer: Pascal Gambarte

C/D.
AW13 Catwalk
Model: Boyd
Stylist: Max Pearmain

A B

C D

E F

E/F.
AW16 Presentation
Model: Alex
Stylist: Tamara Rothstein
Photographer: Pascal Gambarte

ROSE

REMBERT BROWNE
AND
EZRA
EDELMAN

This conversation has been edited and condensed for clarity.
It took place in Brooklyn, New York, in December 2017.

Author illustrations by
Loveis Wise

Ezra Edelman:	The thing about Kaepernick that I find fascinating and so empathy-promoting is that dude stuck his neck out. Like, when no one would stick his neck [out] . . .
Rembert Browne:	In a sport that's, like, very anti neck-sticking-out.
Edelman:	In my mind, if he has not been given the space to move forward however he deems fit, I find that unfortunate because I want him to be as much of a voice as he desires to be. I believe that he is more capable based on what I have heard from him, based on that action. So in some ways, because we/I invest more, potentially we might invest more into him because of his willingness to have crossed that line. But by dint of having crossed the line, I still feel like he has done his part.
Browne:	I think that phrase "doing your part" is also kind of interesting because it's a blessing and a burden that lots of Black people feel. Do something. It's kind of healthier to think about it like that instead of waiting for one person to fix everything, which has been a moment we often seem to wait for. You know, like the messiah complex, all of that. He's already exceeded what he was supposed to do. It felt weird thinking this, but I was more impressed by him because it's hard to figure out where it came from. Knowing Kaepernick's background—White parents, grew up in the fucking whitest . . . I'm impressed that he got there. It felt super self-inspired, because no one was expecting it.
Edelman:	I mean, seriously, he's on his own journey in terms of where he fits in. He's trying to figure out how to be him within the course of America, within the course of Black America, within its trajectory or landscape. Is he an activist? Do you think he would describe himself as an activist?
Browne:	Like on a business card?
Edelman:	I was going to say a one-word profession on his tax form, is he an activist or an ex-athlete? Or is he an athlete?
Browne:	I bet he'd describe himself as an activist before, like, a leader. I would probably classify him as the opposite. He's not very active; he's, like, a learner.
Edelman:	If Colin Kaepernick ends up coaching youth football ten years from now, do you think he would be a disappointment to people?
Browne:	I guess which people . . .
Edelman:	Not necessarily to you, but that's the question. What burden have we placed on him?
Browne:	It's kind of interesting, thinking about, like, John Carlos. I pretty much know nothing about his life after 1968. I still know who John Carlos is, which is impressive.

BROWNE, EDELMAN

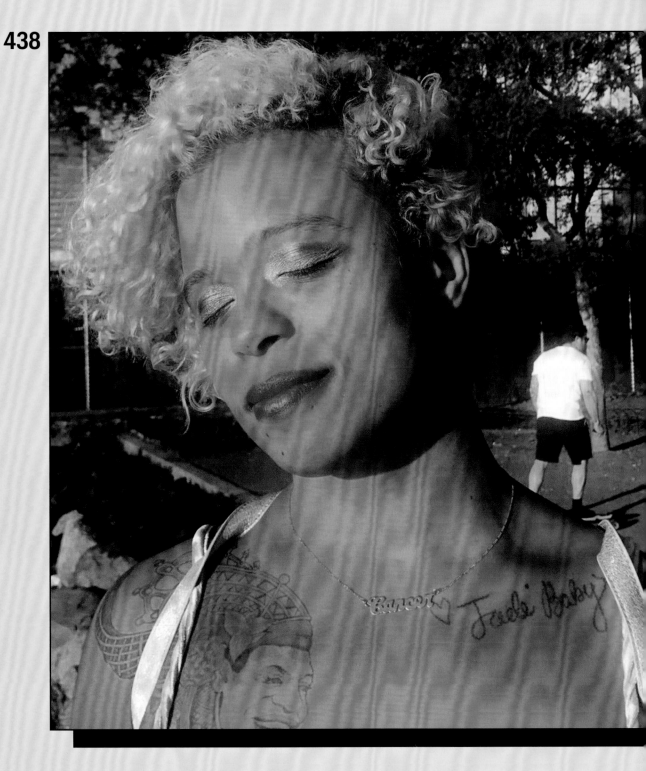

tourmaliiine ✓ • Follow

Neptune

tourmaliiine ✓ #deepshare #realtruth
this week while I'm borrowing money to
pay rent, david france is releasing his
multimillion dollar netflix deal on
marsha p johnson. i'm still lost in the
music trying to #pay_it_no_mind and
reeling on how this movie
came to be and make so much $ off of
our lives and ideas. david got inspired
to make this film from a grant
application video that @sashawortzel &
I made and sent to Kalamazoo/Arcus
Foundation social justice center while
he was visiting. He told the people who
worked there -i shit you not- that he
should be the one to do this film, got a
grant from Sundance/Arcus using my
language and research about STAR,
got Vimeo to remove my video of
Sylvia's critical "y'all better quiet down"
speech, ripped off decades of my
archival research that i experienced so

♡ ⬠ ◁ 🔖

6,184 likes

OCTOBER 6, 2017

TOURMALINE

THE NOTION OF PRIDE

RAHIM FORTUNE

As an Afro-Indigenous child, I was always told by my grandmother to "be proud to be Native," although I most often thought of myself as Black.

Rahim Fortune
Shinnecock Powwow, 2018
Image courtesy of the artist

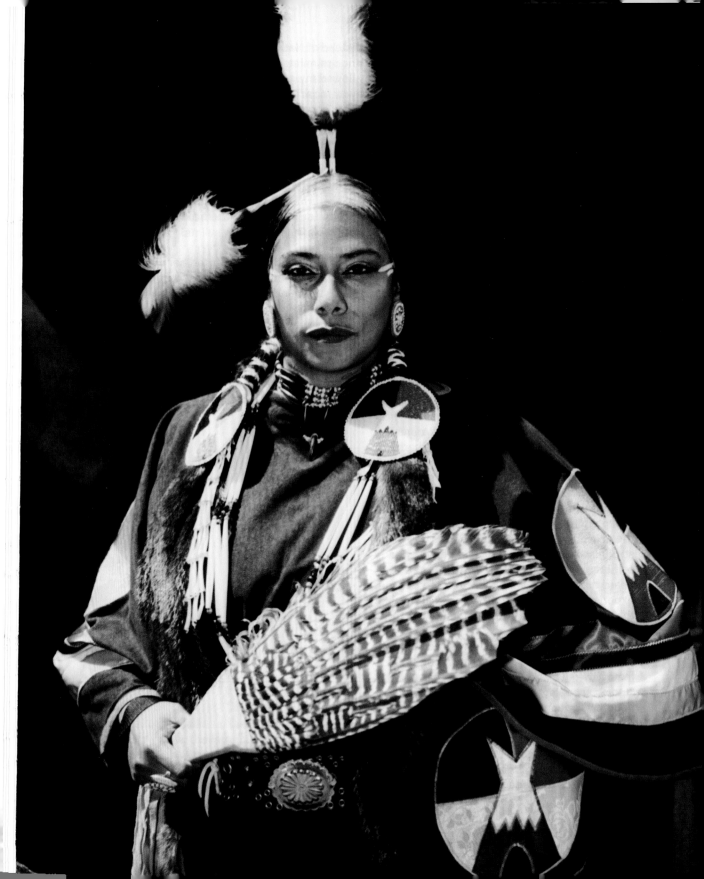

AUNTIE YVONNE'S COCONUT BREAD

PIERRE SERRAO

Most families keep their prized recipes close to home; I believe in sharing valuable information and delicious recipes. If I had to choose one to leave behind for the people of the future, there's no question: It could only be Auntie Yvonne's coconut sweetbread. I'd want it as my last bite ever. Not last meal—last bite.

Everything about me and my childhood is captured by the magic of this slightly crumbly yet moist loaf. Among my grandmother and her sisters, there was always sibling rivalry over which one of them made the best sweetbread.

As far back as I can remember I had my role to play, spending eternity standing on a chair in the kitchen, working fresh coconut against an old box grater. Every Sunday, the entire street would fill with the essence of coconut and hard spices baking at a low temperature for hours and hours.

Back then, it would take an hour at most until each loaf was demolished after the first slice was cut. Don't be surprised if the same goes for you.

Mina Elise Echevarria
Chef P, 2018
Mixed media, 9 x 12 inches
Image courtesy of the artist

454 AUNTIE YVONNE'S COCONUT SWEETBREAD

415 g Tipo 00 flour

4 g baking powder

2 g salt

2 g ground nutmeg

2 g ground cinnamon

115 g granulated sugar

115 g light brown sugar

180 g freshly grated coconut

1 egg

220 ml coconut milk

120 g melted unsalted butter

15 g almond essence

15 g vanilla essence

Demerara sugar

MIX FOR THE MIDDLE

114 g freshly grated coconut

2 g ground cinnamon

2 g ground nutmeg

3 dashes almond essence

40 g light brown sugar

Preheat the oven to 300°F.

In a medium bowl, sieve flour and baking powder together.

Add the rest of the dry ingredients to the flour and mix well.

In a separate medium bowl, whisk the egg, the coconut milk, and the almond and vanilla essence to make a homogenous mixture.

Stir the melted butter mixture into the coconut milk.

Pour the wet mixture into the dry mixture.

Combine all ingredients for the filling.

Pour half of the bread mixture into the pan.

Run the coconut mixture for the middle in an even line down the center of the bread pan.

Cover the shredded coconut mixture with the rest of the batter and spread evenly.

Sprinkle with demerara sugar.

Bake on the top rack for 1 hour and 20 minutes, remove, and cool before slicing.

P'S COCONUT SWEETBREAD

120 g coconut purée

90 g coconut oil

90 g cake flour

44 g egg yolk (about 2)

1.2 g ground nutmeg

1.2 g ground cinnamon

1.2 g baking soda

80 g freshly grated coconut

36 g freeze-dried banana, crushed

60 g egg whites (about 2)

3.6 g salt

120 g light brown sugar

Preheat oven to 325°F.

Stir together coconut purée, coconut oil, flour, egg yolk, nutmeg, cinnamon, and baking soda.

Fold in shredded coconut and crushed banana.

In a stand mixer with whisk attachment, place the egg whites and salt. Start mixing on high.

Once the eggs are lightly frothed, add the sugar.

Whisk meringue until medium peaks form.

Using a spatula, gently fold ⅓ of the meringue at a time into the batter.

Add any extras at this point if you would like.

Coat a loaf pan lightly with cooking spray and dust with a little flour. Tap the bread tin once, upside down on the counter, to remove excess flour.

Bake to internal temperature of 194°F, about 25 minutes.

Let cool. Remove bread from tin.

For a crisp crust, allow to cook uncovered.

For a moist crust, immediately wrap the loaf in plastic wrap and let cool.

For a more dense bread, cool overnight in the fridge.

SERRAO

THE ENDURING LEGACY OF BALTIMORE'S ARABBERS

LAWRENCE BURNEY

Gioncarlo Valentine
Tony the horse starting his route in West Baltimore, May 23, 2018
Archival inkjet print, 8 x 10
Image courtesy of the artist

458 Heritage and tradition in Black communities are forms of currency that have proven to be somewhat impervious to the historically consistent theft, drainage, and redistribution of the community's material resources. Black people in various corners of the world have learned to—or maintained the innate ability to—preserve culture in a way that is spiritually enriching regardless of the cheer or agony they experience. The most documented aspect of this ancestral urge has been what comes out in the music and dances of the diaspora. More than anything else, there is a detectable through line in the way that people on the African continent, the Caribbean, and the States move their bodies to drums and how the music advances communication in a way that language sometimes falls short. But, as migration and relocation have shown, the spirit of preservation can be carried into new customs that are created. Arabber culture along the United States' Eastern border is a crucial example of this.

A.
Gioncarlo Valentine
Tiffany getting a daily grooming session,
Baltimore, Maryland, May 23, 2018
Archival inkjet print, 8 x 10
Image courtesy of the artist

B.
Gioncarlo Valentine
B.J., one of the most visible arabbers
in Baltimore, May 23, 2018
Archival inkjet print, 8 x 10
Image courtesy of the artist

Arabbing—selling goods by way of a horse and wagon—became popular in the late nineteenth century just after the Civil War ended. The trade became a quick and accessible way for newly freed Black Americans to earn a living, but the relationship of an arabber to their community is one that transcends monetary gain. In a 2004 documentary called *We Are Arabbers,* men of the trade in Baltimore—where the culture still holds strong—talked about the joy of providing necessities to the people on their routes, the agency it granted them over their lives, and the art of adding individual flavor to their yells out to people on the street. But as technology continues to evolve and the need for human-delivered goods by way of wagon diminishes, arabbers are not able to provide for families the way they did in the nineteenth and much of the twentieth centuries. A bigger crackdown on the safety of horses has also led to the closing of stables in places like Baltimore.

Arabbing, as it has been known over the past hundred years, is in jeopardy, adding urgency to why the culture needs to be preserved and documented more than ever right now.

There's a particular joy to sitting on a Baltimore stoop or sitting in traffic and hearing bells jingle, the wheels of a wagon turning, and the click-clacks of horse hooves ringing down the block in unison. That sequence is the music of tradition. It's the sound of nurture. And it's a lullaby of nostalgia. Arabbing happens with less frequency than it has in recent memory, but it's still very alive in Baltimore City. Unfortunately, few people are given the chance to see the care that goes into getting horses and carts ready for the road.

During the late spring of 2018 when the weather just began to break into signature Maryland humidity, a group of men at West Baltimore's Fremont Street stable opened their doors to be photographed every step of the way before hitting the streets. They bathed horses, organized the produce on their carts, and planned how they'd get fresh foods to people in the city. If there's ever been a case for ensuring that arabbing stays alive for no reason other than saving a part of Black history, these photos make a convincing one with ease.

BURNEY

C

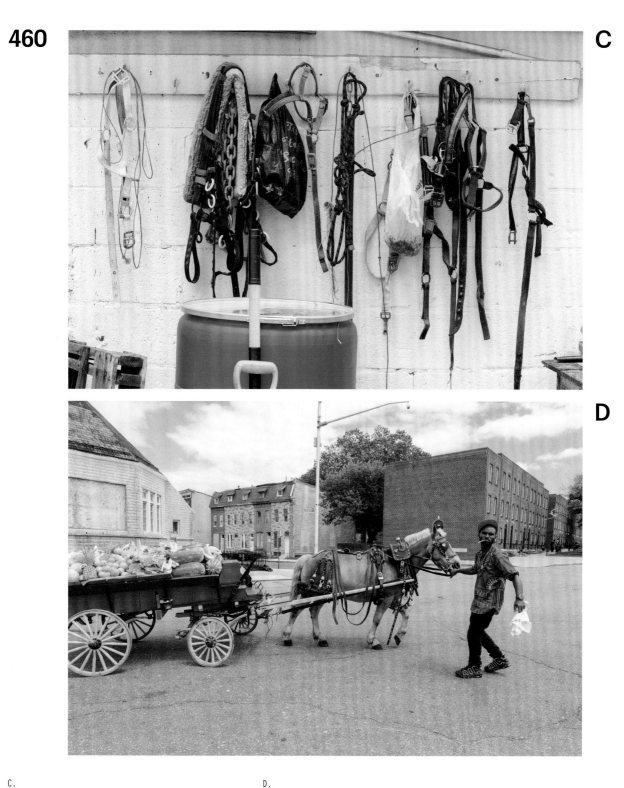

D

C.
Gioncarlo Valentine
An assortment of horse harnesses at the Fremont Ave stable, Baltimore, Maryland, May 23, 2018
Archival inkjet print, 8 x 10
Image courtesy of the artist

D.
Gioncarlo Valentine
B.J. taking Tony out on the road,
Baltimore, Maryland, May 23, 2018
Archival inkjet print, 8 x 10
Image courtesy of the artist

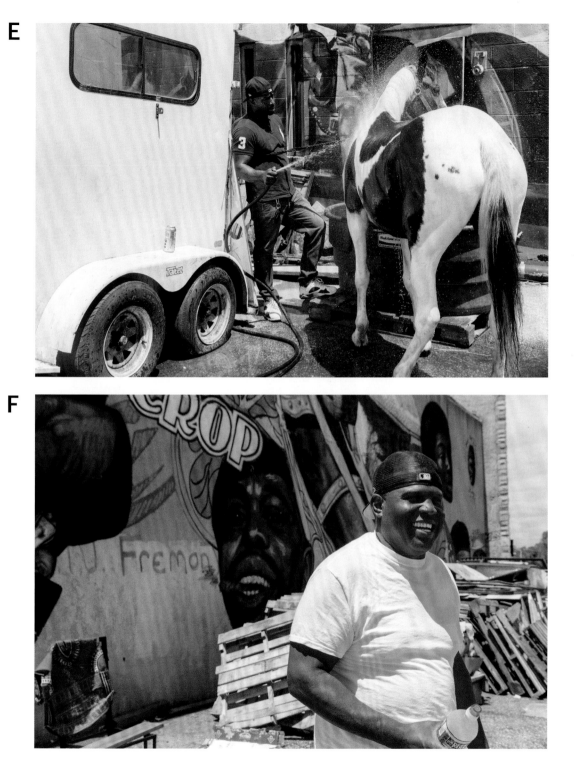

E.
Gioncarlo Valentine
Dwayne giving one of the stable horses a bath in the summer heat, Baltimore, Maryland, May 23, 2018
Archival inkjet print, 8 x 10
Image courtesy of the artist

F.
Gioncarlo Valentine
James Chase, owner of stable on Fremont Ave, Baltimore, Maryland, May 23, 2018
Archival inkjet print, 8 x 10
Image courtesy of the artist

SIMONE BROWNE AND SADIE BARNETTE

This conversation has been condensed and edited for clarity.
It took place in October 2017.

Author illustrations by
Loveis Wise

Sadie Barnette
Untitled (Dad 1966 and 1968), 2017
Archival inkjet prints on custom vinyl wallpaper, 47 x 96 in.
Image courtesy of the artist and Charlie James Gallery

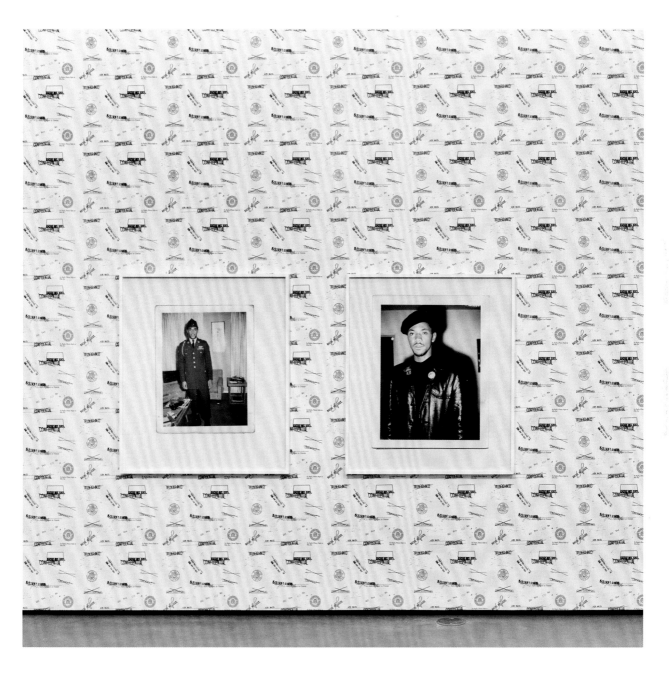

One of the things that's been really important to me in thinking about surveillance is how artists, and particularly Black artists, through the expressive work that they do, provide a way of thinking about surveillance, theorizing surveillance, and also disrupting its sources and methods. I'm thinking of Solange's "Don't Touch My Hair"[1] or even the poet Ashaki M. Jackson's collection of poetry where she explores what happens to us, as Black people, when we continually consume the never-ending list of video footage of police killing Black people— the choke holds, the sounds of the gunshots, the grief.[2] That kind of way of exploring surveillance through creative text, for me, is what brought me to your *Dear 1968* show. I hope you could explain it a bit to me more, how you work with the declassified files from the FBI's years-long surveillance of your father, Rodney Barnette, beginning in the 1960s. You make them tell a different story from the one that the FBI is giving us with their redactions and the various memos that try to situate your father as an internal threat to national security.

I was shocked—but to see the FBI director J. Edgar Hoover's signature and his chilling sign-off of "very truly yours," that's just to show you how close they were. By that I mean how close the state's crosshairs were trained on your father. It was startling for me. So I'm going to start by asking you to say a little bit about the work that you did with *Dear 1968* and *My Father's FBI Files*. Can you tell me about your creative labor and what it meant for you to work with these documents?

Sadie Barnette:

Four years after my family filed a Freedom of Information Act request, we were all surprised by the size and scope of what we received—over 500 pages of really intense surveillance, intimidation, and harassment. I think sometimes the word "surveillance" can take a benign, passive tone—like COINTELPRO was merely information gathering—but within these pages are articulations of infiltration, disruption, disinformation, and the undoing of lives.

Browne:

There's really a lot of violence and suppression that came with it.

Barnette:

Yes. After we received the FBI files and started going through them together as a family, I knew the documents would make their way into my work and that it was my duty, and honor, to try to tell my father's side of the story. The challenge was finding a way to do that in which I'm not getting in the way of how powerful this source material is, how frightening it is, and how emotional it is, but at the same time reclaiming the narrative and celebrating the resistance.

The first time I allowed this work to be exhibited was at the Oakland Museum's "All Power to the People: Black Panthers at 50" anniversary show in 2016. Because the project is so personal as well as political, I didn't want it to be in the wrong hands. **The Black Panthers are often simplified and aestheticized. The story just becomes about the leather jackets and the guns. People forget about the international and intersectional politics, the class analysis, and the**

life-saving community service programs they initiated. But I knew the Oakland Museum's mission was to offer a deeper understanding and contextualization of the history of the Panthers and I trusted that my work would be supported by a multi-layered investigation and celebration of Oakland history.

So I had to figure out what material interventions I would take to create the work. The FBI pages are black-and-white, heavily redacted and punctuated with officious markings and handwritten margin notes. I splashed the pages with bright pink spray paint gestures pointing to graffiti and "tagging" (an act of reclamation), to my own lexicon of redactions and the unknowable, and to the "girldom" of this father-daughter conversation. I wanted the viewer constantly reminded that this person is a father, while being targeted by our government as a subversive. Really what's at stake in this activism is fighting for families, trying to create a world where little Black children can be fed and can have childhoods and can grow up and rise without being cut short by the police.

I also adorned pages with pastel rhinestones, hearts, and crowns, in an attempt to heal some of the pain and violence and to honor the names of those listed in the files who did not live to tell.

Browne:

Why did you choose to bring that kind of bling and shining into your work? And I'm thinking of the role of Black brilliance. I was thinking of Ralph Ellison when he talks about the hyper-visibility of Black people creating something around the White gaze that leaves Black people and their bodies unseen. The B-side of that is that Black brilliance becomes unseen by the White gaze. But we always see our brilliance, you know?

Barnette:

I really like that reading. There was a moment in my installation at the Oakland Museum that consisted of a single pencil drawing hanging on a nine-foot-long magenta pink glitter-wall. The drawing is of the only image that appears in the FBI file: a mug shot of my father. I wanted to transcend the dehumanizing function of a mug shot by rendering the image by hand in detailed mark-making and restoring my father's individuality. The drawing occupies a small amount of space on the paper, and a small amount of space on the glittering wall, but demands to be seen. This bling and pink glitter I also thought would be what J. Edgar Hoover would hate the most.

In other iterations of my work, glitter and reflective surfaces serve as a kind of placeholder for imagined liberated spaces. In the photos and collages that depict more contemporary West Coast/Oakland landscapes and people, I often insert otherworldly sparkle to suggest a dimension beyond the reach of state surveillance, beyond gentrification and police brutality—what do cities look like for Black people without those things? And I don't always know the answer, you know? But we have to believe they're possible in order to work for them. So the glitter-scapes provide space to imagine . . .

BROWNE, BARNETTE

466 Browne:

That's a good entry to get into your exhibition *Compland,* and this piece being about new forms of imaginaries and new forms of spaces. It's a very rich, evocative, almost visual love letter to what you call a disappearing Black city.

What does it mean to love Black places and Black faces when they're disappearing?

Barnette:

A "visual love letter," I like that. Someone asked me recently what role love plays in my work. I suppose it is a very loving act to look at and document each other.

Browne:

That's a system of love that I think is captured in such an amazing way and that works.

Barnette:

And it's a love for family—a love for the way we've survived and thrived and held each other up, from public spaces of protest to "living room" sanctuaries. Combing through page after page of state-sanctioned attempts to discredit, frame, and destroy my father and his activism, I realized how lucky I am that he is alive, that I was born. So there is a joy and aliveness in the work, a celebration of resilience.

There's also a level of restraint or distance that I try to play with in my work. That's why I use the formal strategies that I do, be it minimalism or playing with size and scale, making the figures so small, the hand-drawn elements concealing their own labor, a coolness and synthetic materials . . . I'm not giving full access to the intimacy of this family. There's still something that's guarded and protected. Does that make sense?

Browne:

It does make sense. I want to talk a little bit about place-making or guarding.

There's an MLK Boulevard in every city. I'm here in Austin and the MLK Boulevard is increasingly becoming a gentrified space with coffee shops and little cupcake shops, where Black people and Latinx people are being pushed out of the areas in which they historically had lived post-emancipation here in Austin. I love what *Untitled (Lady with Glitter)* represents. Could you tell me a bit more about that moment, and what that piece means to you when we think about what it means to witness disappearing Black cities?

Barnette:

Yes, I saw this woman sitting in her walker, catching the sunshine in front of this teal stucco, very California-looking building . . . she just caught my eye when I was walking down MLK Blvd. I don't often take pictures of people I don't know but she was just so compelling to me. I asked her if I could take her photograph and she just lit up when I asked. She was happy to be seen, I think. I imagine that she has witnessed so much and for me to see her was an acknowledgment of

A.
Sadie Barnette
Untitled (Young Woman on Money), 2017
Collage on glitter paper, 12 x 12 in.
Image courtesy of the artist

B.
Sadie Barnette
Untitled (Baby Dress), 2017
Collage on glitter paper, 12 x 12 in.
Image courtesy of the artist

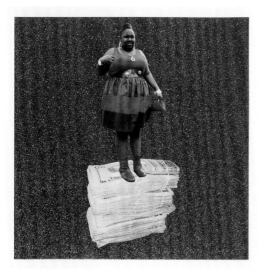
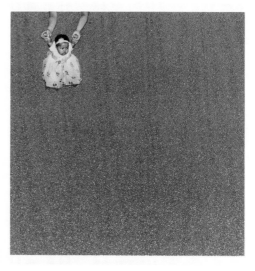

A

B

that. Later when I looked at the photo, how she's in front of these two big garage doors—I just imagined that she was, like, the gatekeeper of another reality. So I cut away one of the doors and collaged in the glitter/holographic element to suggest a magic portal. Perhaps she's guarding this portal to a parallel-Oakland universe where she can't be displaced. I think about those spaces a lot, being born and raised in Oakland and seeing the rapid gentrification that happens so fast here that it just feels violent, and like an erasure. That's where my title *Compland* comes from—it imagines a mythical cultural space, though geographically impossible, blending the cities of Compton and Oakland in an act of preservation.

Browne:

I just want to move on to the question that I asked you about when I met with you at Fort Gansevoort. I was asking you about whether you had any soundtrack to your work as you're working or as you're thinking about it. In my head I was guessing probably, like, Kendrick Lamar, something uniquely West Coast.

But when I asked that question, you turned me around and I faced your work *Untitled (Gotta Broken Heart)*. And it was Prince—Prince Rogers Nelson.

Barnette:

Yes, one of what will probably be my many homages to Prince. I used what I call an "in-camera-collage" technique to rephotograph an image from his *Dirty Mind* album. I actually made the photograph of him before he passed away, but of course after he died, it just looked like he was in this stately rest. So I hung the photo above an all-white keyboard that I made to reference the white bicycles seen in street

BROWNE, BARNETTE

memorials. These elements hang in a corner of the gallery that has a bar feature so I covered the bar in purple glitter plexi to create a space meant for toasting and celebrating the legacy of Prince.

I've just always thought that Prince had this way of using things that seem purely aesthetic or frivolous in the service of a powerful assertion of individuality and confrontation of patriarchy and racism, in a way where lace or leather can become these really charged tools. When Prince died I was just devastated. Normally I find it ridiculous when people are mourning celebrities that they don't know. But I just wasn't ready. I wasn't in any type of big-picture mood about it. I was really into being on the same planet as Prince.

Browne:

You mentioned this effortless cool—and that effortlessness, seemingly— but it came with a cost on his body, the toll that he paid for. The night you mentioned that we have to protect our cool or brilliance, or protect our Blackness or Black people, and I think that will get us to the last question about Black futurity. What is the world that you're working toward?

In terms of abolition, in terms of survival, and, as you say, protecting our people.

When we think about Black futures, what do we want?

C.

D.

C.
Sadie Barnette
Untitled (Gotta Broken Heart) (Detail), 2016
Collage, 19 x 17 in.
Image courtesy of the artist

D.
Sadie Barnette
Untitled (Gotta Broken Heart), 2016
Collage and painted keyboard, 26 x 24 in.
Image courtesy of the artist

Barnette: This is the question, right? We spend so much time fighting against, and surviving in, what we don't want—war, prisons, imperialism, homelessness, state-sanctioned violence . . . the depth and vividness of these ills make it easier to picture this world than another we haven't known yet. And it is okay that the future we want remains somewhat abstract because we are still dreaming it and making it, but it looks to me something like new ideas of "land ownership" and care for each other and the land; it looks like abolition and something more comprehensive even than "reparations." To me it looks like starting over from the ground up—changing everything, using love and consciousness as a guide. I've found encouragement and inspiration from folks who have spent much time on these subjects, including Patrisse Cullors, Zoé Samudzi, Eve L. Ewing, and our always-from-the-future leader Angela Davis.

1. Lyrics for Solange's "Don't Touch My Hair" appear on page 412.

2. Jackson, Ashaki M. *Surveillance* (Los Angeles: Writ Large Press, 2016).

Sadie Barnette
Untitled (Dad's Mug Shot), 2016
Pencil on paper, 30 x 22 in.
Installed on a glitter wall at the Oakland Museum of California
Image courtesy of the artist

BROWNE, BARNETTE

SERPENTWITHFEET

I originally started writing this song thinking about how much Toni Morrison's novels have guided me through my adult life. Then I began thinking of all the self-possessed Black men I met in NYC.

I wanted the song to feel patriotic and anemic. I'm a product of all the loving, abundant Black men I've encountered; because of them I gave myself space to be abundant, too.

In the second verse, I'm thinking of how the boundless Black men in my life have shown me how to reject the inadequate emotional tools given to me by my father. Thinking of Milkman's coming of age in *Song of Solomon*.

This song is about redesigning myself.

Shani Jamila
Morrison (Well Read Black Girl Memorial), 2019
Chromogenic print, 20" x 30" (50.8 x 76.2cm)
Image courtesy of the artist

SERPENTWITHFEET

I'd be a stencil of a man
I'd taste the sting of violent hands
If it weren't for you, if it weren't for you
I'm sorry for calling your love "sickness"
I needed your strength but mocked your thickness
But I owe so much to you, owe so much to you

Whatever makes you cold freezes me
Even when we grow old you'll speak to me
Whatever makes you cold freezes me, freezes me, freezes me

He straddles the equator, not the fence
Taught us to break our wrists, not our promises
Not our promises, he always keeps his promises
Because of him lesser men have set their father's homes ablaze
And as the smoke billowed all those men became
The boys they never got to be, never got to be

Whatever makes you cold freezes me
Even when we grow old you'll speak to me
Whatever makes you cold freezes me, freezes me, freezes me
Oh, I'm committed to you

C

D

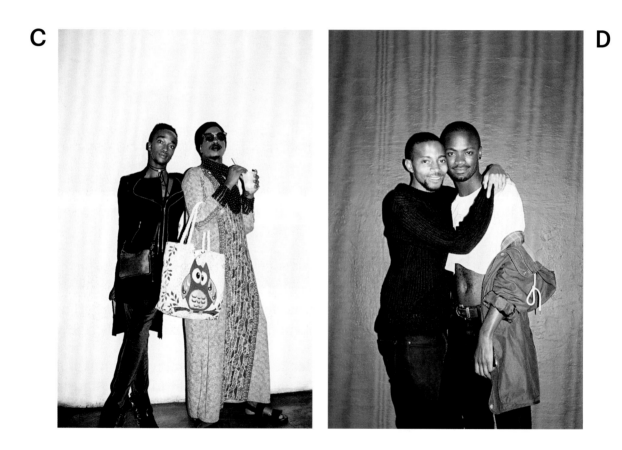

C.
Fela Gucci
Llewellyn and Treyvonne, Johannesburg, South Africa, 2017
Image courtesy of the artist

D.
Fela Gucci
Nkoyisabo and Mpumelelo, Johannesburg, South Africa, 2017
Image courtesy of the artist

E

F

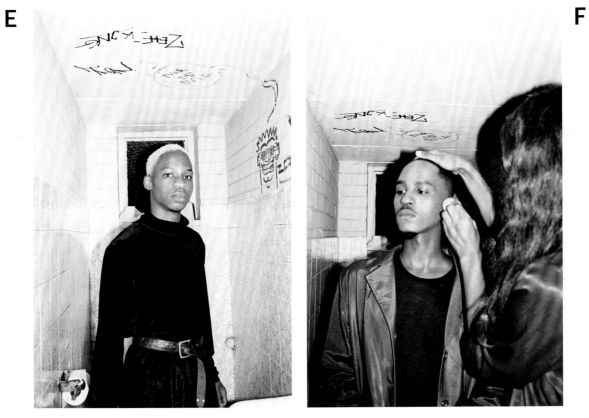

E.
Fela Gucci
Bradley, Johannesburg, South Africa, 2017
Image courtesy of the artist

F.
Fela Gucci
Glomamiii doing Lelo's face, Johannesburg, South Africa, 2017
Image courtesy of the artist

NATIVE TONGUE

OLA OSAZE

As a child, I never questioned the predominance of English in our home. After all, the same values were reflected in every aspect of Nigerian society, including literature, media, and in everyday interactions with strangers on the streets. The language we were taught in school was typically French (or Latin in Father's time), not Edo or Igbo or Hausa or Ibibio or Yoruba or any one of the more than five hundred languages my people speak. Because of this nationwide complicity in the denial and relinquishing of our mother tongues, I can't blame my parents for their choices.

I came to America with my mother in 1991, not too long after yet another military-backed coup rocked Nigeria. The riots and subsequent government-sanctioned reprisals meant more school closures, curfews, harassment, and abuse at the hands of police for indeterminate lengths of time. It also meant more killings. And so in search of a better life we left. I spent a portion of my first year in the United States in a strict Christian high school in High Point, North Carolina. There were White students everywhere. The principal mistook my Nigerian accent for a symptom of deficient

mental capacity and decided to hold me back a year, so I entered school in the tenth grade. On the day we started reading *Hamlet,* I discovered that these White kids did not have a grasp of the English language—the language that I was taught to hold in such high regard. "What does it mean, Ms. Eubanks?" the students cried out, befuddled. With a smirk on my face, I showed them how to master their own language. But inevitably, every day after school I came home to a mom who roared into the phone in Edo or Yoruba, her words colliding one into another at rapid pace and not one of them meaning anything to me.

I can recognize this concerto of hard and soft tones anywhere. I've heard it float above the din of noise on Harlem's 125th Street in the height of summer. I've heard it behind me in the vegetable aisle of the grocery store. The *gb, kp,* and *eh* sounds don't always translate, but they are as familiar to me as breathing.

After twenty-four years in the United States, I realize why English was enforced at home.

I've come to learn about the cultural capital of the language and how essential it is to survival here. It made it easier to hide my undocumented status, especially in the days before 9/11 when there was less scrutiny. My command of English also gave me an advantage, years later, when I successfully filed for asylum. This was my last-ditch effort to gain legal status in the States after many years of being undocumented and a desperate bid to prevent deportation back to Nigeria, where the parliament was hard at work on a "jail the gays" bill. During my asylum interview—the dreaded face-to-face with an asylum officer—I was drilled on the details of my story with the goal of poking holes in it, discrediting me, and disproving my claim. This is the reality for many Black LGBTQIA asylum seekers during the interview and throughout the asylum process. Despite being survivors of violence in homelands where there are actual laws on the books criminalizing us, more often than not, because sentiments like Trump's description of Africa and Haiti (as "shit holes") abound, our experiences are labeled lies and asylum claims denied.

Just like displacement, not knowing my languages is a form of erasure, a symptom and manifestation of White supremacy. It is a continuation of the pillaging the British began in my homeland many years ago, when *they* named it Nigeria and attempted to subjugate the people, eradicate our cultures, and invisiblize our histories. I long for Yoruba and Edo, the familial ways of speaking for which I lack the words.

Today I am an embodiment of myriad tongues. In my everyday life, I speak the English the Brits brought to Nigeria, the English of the African immigrant on U.S. soil that alternates between rolling *R*s and hard *T*s ("water" versus "warra"), the pidgin English that is a marriage between our native tongues, urban slang and a deconstructed English, and the little bit of Yoruba and Edo I'm picking up from websites and apps.

With my Naija friends, with whom I'm usually more at ease, pidgin flows out of me unhindered:

"*How body?*"

"*Body dey inside cloth.*"

"*You dey see am?*"

"*I dey see but I no 'gree. Story don get k-leg, abi?*"

"*I no know wetin do am O. Mumu.*"

[sucks teeth]

Speaking with co-workers—who, given the relatively few African immigrants there are in the U.S. nonprofit world, are usually not African—my language is American English all the way. This never feels completely comfortable. Yet I've had over two decades of practice:

"*Hey there! How's it going?*"

"*I'm doing alright.*"

In my spare time I've been teaching myself my languages gradually. What I do know is how easily the words roll off my tongue, how deeply soothing it is to pronounce them:

Ẹ ku abọ Vbèè óye hé? Ẹ ku aarọ

O ye mi

Kpẹlẹ

Koyo

I say these words to dig deeper into who I am, a child of the red soil of Benin, the gray mountains of Saki, and the oil city of Port Harcourt. These Edo-Yoruba words ground my shaky identification with the country into which I was born yet still barely know. They allow me to picture a different life for myself, one in which we kids were granted access into our parents' polyglot world, and where at night I dream in Edo and during the day— one day—I write in Yoruba.

OSAZE

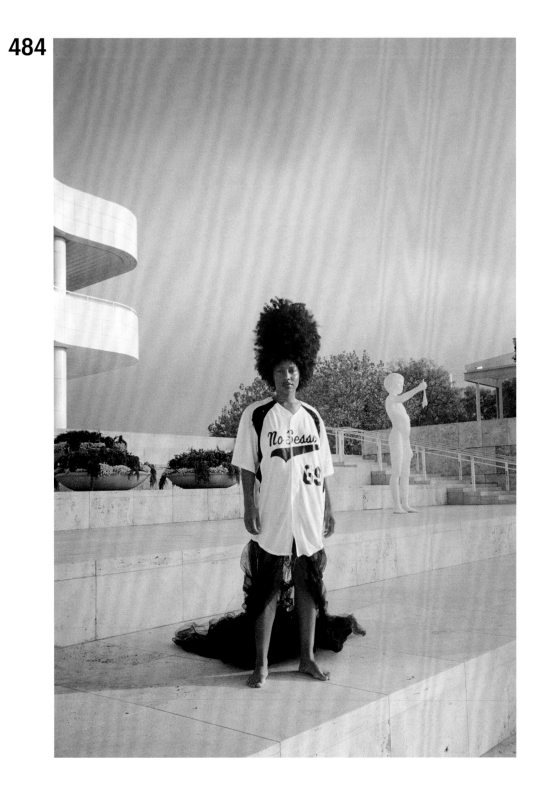

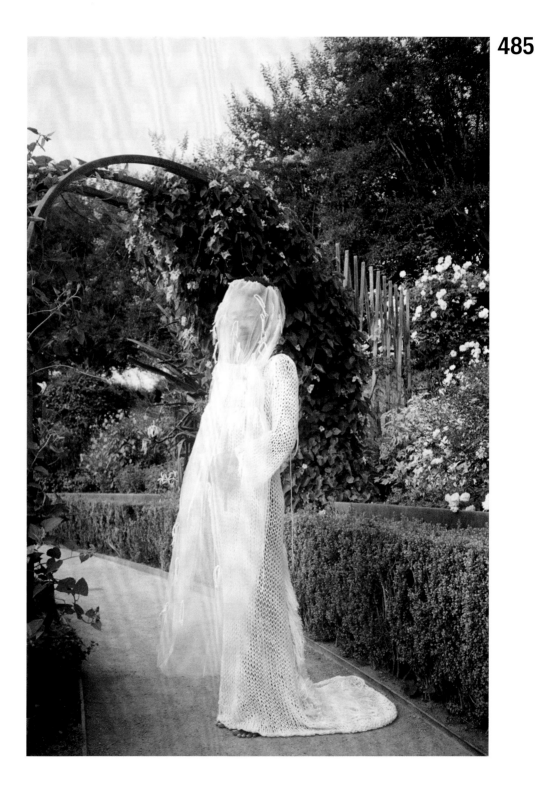

NO SESSO

THE BIRMINGHAM PROJECT

DAWOUD BEY

September 15, 1963. On this day in Birmingham, Alabama, the bombing of the 16th Street Baptist Church killed four young African American girls: Addie Mae Collins, age fourteen; Denise McNair, age eleven; Carole Robertson, age fourteen; and Cynthia Wesley, age fourteen. Several hours later, two young African American boys, Johnny Robinson, age sixteen; and Virgil Ware, age thirteen, were shot and killed in related violent incidents.

ABOVE
Dawoud Bey
Fred Stewart II and Tyler Collins, 2012
2 inkjet prints mounted to dibond,
101.6 x 162.56 cm (40 x 64 in.)
Courtesy of the artist

BELOW
Dawoud Bey
Mary Parker and Caela Cowan, 2012
2 inkjet prints mounted to dibond,
101.6 x 162.56 cm (40 x 64 in.)
Courtesy of the artist

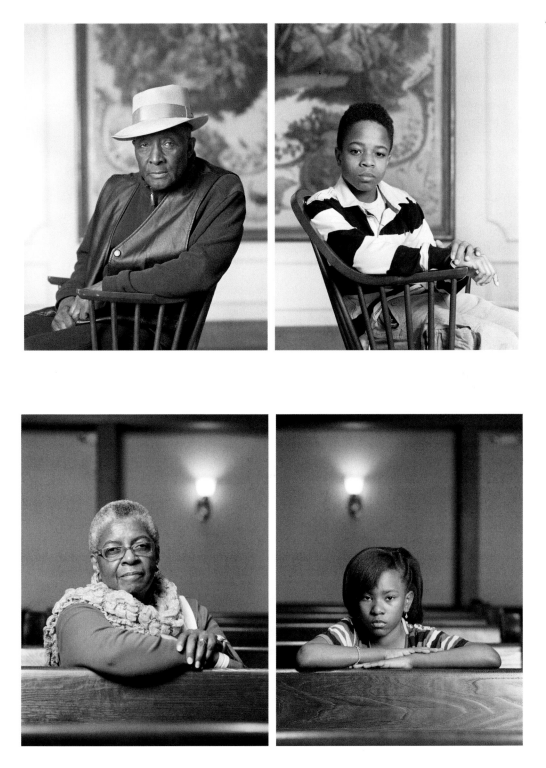

When I was eleven years old, I saw for the first time the published photograph of a wounded Sarah Collins. Sarah was also in the church, but unlike her older sister, Addie Mae, she survived. I trace the beginning of this work to seeing that picture in a 1964 book called *The Movement: Documentary of a Struggle for Equality.* The photograph showed Sarah, a vulnerable Black girl, badly wounded, her eyes covered in heavy bandages, lying in a hospital bed soon after the explosion. Everything changed for me at that moment, and it has taken all of these intervening years to craft a response to the ground-shifting personal drama of seeing that picture. I didn't know it would take fifty years (including seven years of repeated trips to Birmingham) in order to come to terms with what that response might be and how I might give tangible and expressive shape to it, but that is indeed how long the project has been unfolding.

The Birmingham Project considers the past through the present. This is my memorial to those six young lives lost more than fifty years ago, and a tribute to the community of people who were in Birmingham at that traumatic moment and to those born there since that fateful day. Finally, this project bears witness to the resilience of members of Birmingham's current African American community, who are both the subject of and the subjects in these photographs.

The portraits were made in Birmingham over five months in two locations: the original sanctuary of Bethel Baptist Church and the Birmingham Museum of Art. During the civil rights era Bethel Baptist Church was the heart of the Movement. Pastored by the activist minister Reverend Fred Shuttlesworth, Bethel was the site of the formation of the Alabama Christian Freedom Movement for Human Rights, which later became the Southern Christian Leadership Conference, one of the primary organizations of the civil rights movement. My second location, the Birmingham Museum of Art, founded in 1951, was for many years a segregated public institution, allowing Black visitors only one day a week, on Negro Day. I wanted to use both the communal space of the Black church and the public galleries of a formerly segregationist museum as the social and historical context in which to make these photographs.

DEM MAN
CALEB FEMI

them man will say, them man are mandem
and us man are them man

my mandem will say, us man are mandem
and them man are them man

—Kareem Parkins Brown

what could go wrong
if we so happened
to end up under
the same roof, a party,
summer barbecue,
will we all combust?
Are we two separate
groups of Black boys
or is it like they say,
that one set of us is
the real article, the other
a parade of its spare parts?
To be fair, if one day I am
stood in front of a mirror
and my reflection walked
out of his inverted realm
into mine, I guess I too
will protest the singularity
of my personage.
When I am in my room
alone, midnight lights
gone, blackness makes
sense as every thing
looks like me: a fork,
the bed frame, the rug, worn

socks. In blackness the
room looks like a night club.
I look like a night club
everywhere in the city
in every night club
everyone goes there to
look like me—like us
even though after
the staff and the DJ
only a tiny amount of
us are allowed in
who leaked the secret?
whose big mouth
told them blackness
was a sanctuary?
what happened to
the talk of shipwrecks
and worse things
lurking in blackness?
We shouldn't have
played our music so loudly
then they wouldn't have
been lured into our cliffs
we should have learned
from the Sirens
now they crave to be
in the blackness
until the sirens come
and we again
become formless
over the surface
of the deep.

Lynette Yiadom-Boakye
The Myriad Motives of Men, 2014
Oil on canvas, 71 x 51¼ inches; 72⅝ x 53 inches framed
Image courtesy of the artist and Jack Shainman Gallery

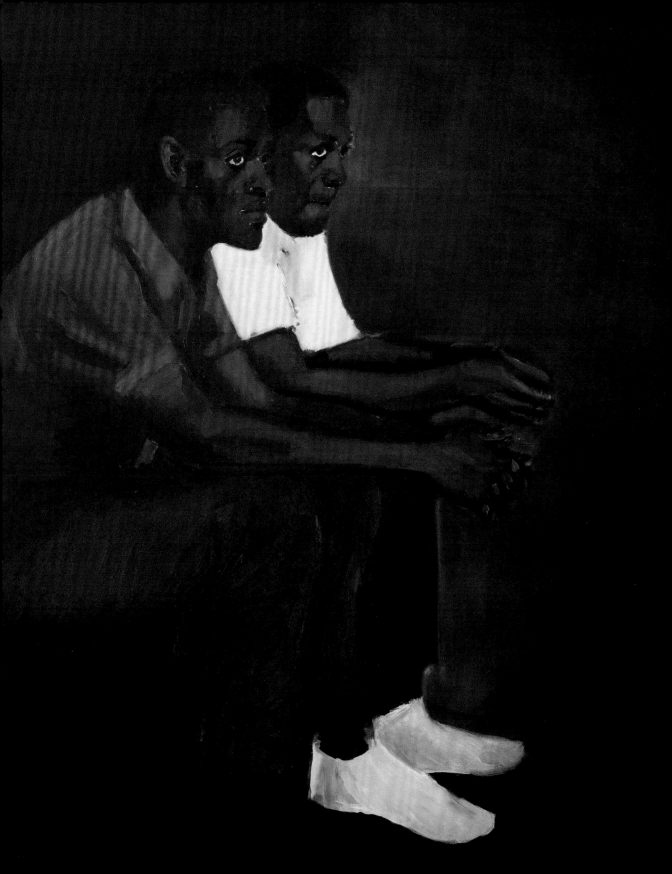

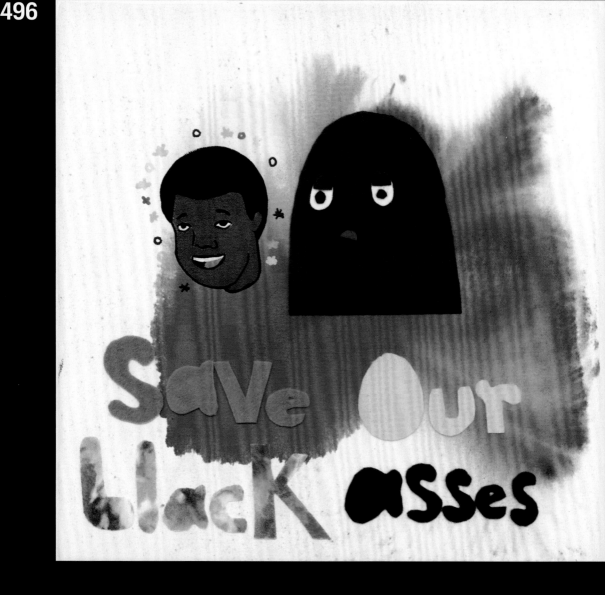

David Leggett
Molly Percocet, 2018
Acrylic, dye, and felt on canvas, 16" x 16"
Image courtesy of the artist and Shane Campbell Gallery, Chicago

ACKNOWLEDGMENTS

498

This book would have been impossible without our friendship, so first and foremost, thank you for the light and deep love that has been sustaining and life-giving throughout this process and beyond.

Thank you to our sweet families, biological and chosen, for having patience with us and loving us unconditionally and giving us safe havens to recover, recuperate, and dance (shoutout to Papi Juice & Gush and bklyn boihood) while we got through some of the thickest parts of this process. Thank you to our agent, Daniel Greenberg, who was one of the earliest people in this journey to believe in this book.

Thank you to Christopher Jackson, Cecil Flores, Nicole Counts, Mika Kasuga, and everyone at One World for your eternal patience, optimism, guidance, and support. Thank you for believing in us and in this. Every writer should be so lucky as to have a team with such an incredible commitment to their wildest dreams.

Thank you to Quinn Hearty for helping us establish a working business agreement to keep our most precious thing, our bond, intact, and for forming our LLC. To Treehouse Taxes for their continued commitment to tax justice and helping us make sense of the least sexy side of writing a book that is also a small business.

Thank you to Morcos Key for designing our book and the visual language to represent our vision.

Thank you to the first quorum of friends who gave us counsel and advice, held our hands, and encouraged us as we set off on this uncertain journey: Thelma Golden, Natasha Logan, Jason Parham, Justin Allen, Bsrat Mzghebe, Dr. Kellie Jones, Jessica Bell Brown, Hassan Rahim, Naomi Shimada, Jessica Lynne, Taylor Aldrige, Naima Green, Lise Ragbir, Taravat Talepasand, Anna Holmes, Wesley Morris, Claire Gutierrez, and Mary HK Choi. We are forever indebted to your early and continued support.

Thank you to our patient and persistent assistants, Kim Small and Sunny Azim, for all of your help with the details, the finest of the fine print, and transcriptions.

In gratitude to the generosity to all the spaces and places that were a refuge while we worked on this project, including Grandchamps, Brown Butter Cafe, Golda, Win Son, Playground Coffee, Saraghina, Mood Ring, Jack Jones Literary Retreat, The Wing, and the MacDowell Colony, where portions of this book were edited and updated.

And finally, last but not least: Thank you to all the writers, artists, and dreamers who gave whole-heartedly and without hesitation, and to every single person who opens this book.

This project is for all of us.

ABOUT THE AUTHORS

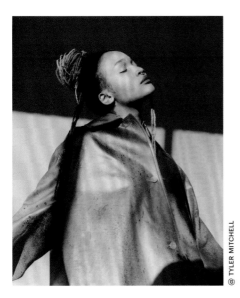

@ TYLER MITCHELL

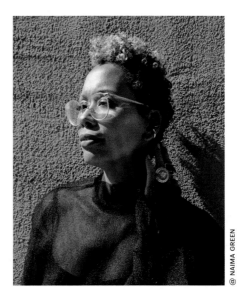

@ NAIMA GREEN

Kimberly Drew is a writer, curator, and activist. Drew received her BA from Smith College in art history and African American studies. During her time at Smith, she launched the Tumblr blog Black Contemporary Art, which has featured artwork by nearly 5,000 Black artists. Drew's writing has appeared in *Vanity Fair, Elle UK*, and *Glamour*. She lives in Brooklyn, New York (just a few blocks away from Jenna Wortham).
Twitter: @museummammy •
Instagram: @museummammy

Jenna Wortham is a staff writer for *The New York Times Magazine*. She is also co-host of the podcast *Still Processing*, an herbalist, sound healer, and reiki practitioner, and currently working on a book about the body and dissociation. She lives in Brooklyn, New York. jennydeluxe.com • Instagram: @jennydeluxe

CONTRIBUTORS

Hanif Abdurraqib is a writer from the east side of Columbus, Ohio.
Abdurraqib.com • Twitter: @nifmuhammad • Instagram: @nifmuhammad

Nina Chanel Abney's large-scale paintings create a collision of sociopolitical commentary and popular culture. The Chicago-born, New York–based artist employs acrylic and spray paint in creating hot-button-themed compositions.
ninachanel.com • Instagram: @NINACHANEL

s.e.a (Suzanne Abramson) is a photographer and artist whose work explores love, joy, intimacy, vulnerability, kink, sex and sexuality, identity, and movement within the confines of our human bodies, specifically queer Black and Brown bodies. She strives to push boundaries that are placed on us, that we place on ourselves and others, while trying to always find and capture moments of beauty. Born and raised on St. Croix, U.S. Virgin Islands, she lives and works in Brooklyn, NY.
Sea-foto.net • Twitter: @seafoto13 • Instagram: @seafoto13

manuel arturo abreu is a poet/artist from the Bronx. They use what is at hand in a process of magical thinking with attention to ritual aspects of aesthetics. They have written two poetry books and one book of critical theory, and they also co-run home school, a free pop-up art school in Portland.
manuelarturoabr.eu • Facebook.com /manuel.arturo.abreu91 • Twitter: @Deezius • Instagram: @mabreu91

Navild Acosta is a multi–award winning and internationally acclaimed multi-medium artist and activist based in Brooklyn, New York. Acosta's embodied experience as a transgender dancer, non-binary queer, Afro-Latinx American citizen surviving poverty has inspired his community-centric work. His work and thought leadership have been featured in many publications, including *Performance Journal, VICE, Brooklyn Magazine, Apogee Journal, BOMB Magazine,* and more.
nivacosta.com • Twitter: @navildacosta • Instagram: @navildacosta

Shadi Al-Atallah is a London based multidisciplinary artist. They create life-sized mixed-media paintings—distorted self-portraits that explore the intersections of mental health, queerness and racial identity. They are mainly inspired by spiritual practices, family history and their childhood in Saudi Arabia. Their latest work uses absurdity and subtle humor to explore "healing" as a concept and examine therelationships between mental health, the body, and spiritual practices.
shadistudio.com • Facebook.com /shadialatallah • Instagram: @ramenate

Courtney Alexander is a multimedia artist, writer, and publisher with a bachelor's degree in studio art from the University of South Florida, currently living and working in Tampa, Florida. Alexander's work began with decontextualizing issues of duality, hypersexuality, and self-awareness through the exploration of fatness, a personal dialogue that serves to facilitate vulnerability and explore the complex nature of her existence. In 2016, Alexander made history as the first Black person to successfully publish and distribute a tarot deck, the widely acclaimed Dust II Onyx, crowdfunding nearly $30,000 via Kickstarter.
dust2onyx.com • Facebook.com /dust2onyxtarot • Instagram: @reallycourtney @dust2onyxtarot

Tyahra Symone Angus is a Boston-based photographer/artist. She has a BA from Smith

College with a concentration in queer Black literature and art, and is in her third semester of the master's program in visual arts at Lesley University focusing on photo-based media, sculpture, and Black vernacular/documentary photography
Afrocenteredmedia.com • Facebook.com /Afrocenteredmedia • Instagram: @Afrocenteredmedia

Appolition gave people an opportunity to help bail someone out of jail with spare change. It was founded in Oakland in 2017 by Kortney Ziegler and Tiffany Mikell, and had a headquarters in Chicago as well. Appolition collected $250,000 in spare change in its first year of operation.
appolition.us • Twitter: @appolition

Jana Augustin uses a mixed technique of analog and digital art to call attention to social injustice, mainly speaking on feminist, antiracist, and queer issues.
Instagram: @janaillustration

Firelei Báez is a Dominican-born, U.S.-based artist who negotiates identity in relationship to nonlinear cultural and regional histories. By rendering spectacular bodies that exist on opposite sides of intersecting boundaries—between human and landscape, for example, or those reinforcing racial and class stratification—Báez carries portraiture into a liminal space, where subjectivity is rooted in cultural and colonial narratives as much as it can likewise become untethered by them.
Instagram: @fireleibaez

Sam Bailey is a writer and filmmaker from Chicago, currently residing in Los Angeles. She attended Columbia College Chicago, where she studied theater. Bailey is the co-creator and director of the Emmy-nominated Web series *Brown Girls,* and the creator (writer/director/producer) of the Gotham-nominated Web series *You're So Talented.* She's previously directed episodes of Freeform's *Grown-ish, Alone Together, Loosely Exactly Nicole,* and *First Wives Club.*
Twitter: @SamQBailey • Instagram: @Samb.chi

De'Ara Balenger has spent the majority of her career in public service, having served in the Obama administration's Department of State and on two presidential campaigns. As co-founder of Maestra, a women's thought leadership collective, she now does work at the intersection of politics, social impact, and culture. Balenger is a fundraiser for progressive candidates of color and board co-chair of the Lower Eastside Girls Club. She lives in Brooklyn, New York, with her partner, Paola Ramos.
Maestra-bklyn.com • Twitter: @dearabalenger • Instagram: @dearabalenger

Sadie Barnette's work relishes the abstraction of city space and the transcendence of the mundane to the imaginative. Born and raised in Oakland, California, she earned her BFA from CalArts and her MFA from the University of California, San Diego. Her work has been exhibited throughout the United States and internationally and is in the permanent collections of museums such as LACMA, the California African American Museum, the Studio Museum in Harlem (where she was also artist-in-residence), the Brooklyn Museum, and the Guggenheim.
sadiebarnette.com • Instagram: @sadiebarnette

BBZ London is an ever-evolving curatorial and creative production collective born, raised, and based in Southeast London with roots in nightlife and clubbing culture, organized by a standout collective of seven queer Black artists and headed by co-founders Tia Simon-Campbell and Naeem Davis. Prioritizing the experiences of queer womxn, trans folk, and non-binary people of color in all aspects of their work, they provide physical and online platforms for this specific community. They work to democratize access to public institutions and challenge institutional behaviors to diversify. They explore experiential practices with interactive installations, sound, poetry, archive, celebratory communion, photography, group shows, film, and more.
bbzblkbk.com • Facebook.com/bbzlondon • Twitter: @bbz_london • Instagram: @bbz.blk.bk

Alexandra Bell is a multidisciplinary artist who investigates the complexities of narrative, information consumption, and perception. Using various media, she deconstructs language and imagery to explore the tension between marginal experiences and dominant histories. Through investigative research, she considers the ways media frameworks construct memory and inform discursive practices around race, politics, and culture. Bell holds a BA in interdisciplinary studies in the humanities from the University of Chicago and an MS in print journalism from Columbia University. She lives and works in Brooklyn, New York.
alexandrabell.com • Instagram: @yesitsalex

Salehe Bembury is a creative by trade, most notably making his mark in the world of footwear design. Since 2009, he has applied his industrial design degree and interdisciplinary skills to a diverse array of footwear brands, starting at Payless Shoe Source. His career then took him to the Nike-owned brand Cole Haan, where he was part of the team that created the LunarGrand, a shoe acclaimed for its effortless combination of style and function. The juxtaposition of craft, technology, and problem-solving made Bembury an even more versatile designer. His budding reputation then led him to Jon Buscemi's company Greats. As the footwear design director, he was the creative force behind Greats' silhouettes, collaborations, and brand positioning. In fall 2015, Kanye West caught wind of Bembury's talents and hired him at Yeezy to handle men's footwear. In 2017, he was hired by Donatella Versace as head designer of sneakers for Versace and Versus Versace.
salehebembury.com • Instagram: @salehebembury

Dawoud Bey, currently based in Chicago, was born in 1953 in Queens, New York. Celebrated for his rich, psychologically compelling portraits, Bey explores in his work a range of formal and material methodologies to create images and projects that reflect the populations and histories of the communities he photographs.

Maty Biayenda was born in Namibia to a French mother and Congolese father in 1998, and raised in the southwest of France (Angoulême). She studied after school from 2009 to 2015 in the life drawing class at École d'Art du GrandAngoulême. Since 2018, she has been studying textile design at ENSAD Paris (École nationale supérieure des Arts Décoratifs de Paris). Based on her experiences growing up in France, Biayenda questions the identity and the existence and interrogates the influences and erasures of Africa in European culture and sociology.

Michael Bilsborough is a visual artist living and working in New York City. An alumnus of Columbia University and the School of Visual Arts, he currently produces abstract drawings and is an adjunct faculty member at the City University of New York.
michaelbilsborough.com

McArthur Binion combines collage, drawing, and painting to create autobiographical abstractions of painted minimalist patterns over an "under-conscious" of personal documents and photographs.

King Britt is an electronic artist and composer whose musical practice is rooted in DJ culture but transcends conventional approaches to production. King has produced, remixed, and collaborated with an extremely eclectic list of artists, including De La Soul, Miles Davis, Solange, Meredith Monk, Alarm Will Sound, and Calvin Harris. He has done scoring work for Michael Mann's *Miami Vice* (film), HBO's *True Blood,* Ava DuVernay's *Queen Sugar,* and CBS's *The Blacklist* as well as multimedia AR projects and consulting for Roland, Ableton, and Moog. Lastly, as a live performer, he has earned hours of practice playing at clubs and festivals across the globe, including Berghain (Berlin), Moogfest (Asheville), Le Guess Who? (Utrecht), and MoMA PS1 (Queens). He currently resides in his hometown of Philadelphia and is a 2007 winner of the Pew Fellowship for the Arts.
KingBritt.com • Twitter: @KingBritt • Instagram: @KingBritt

André Brock is an associate professor in the School of Literature, Media, and Communication at Georgia Tech. His research focuses on race and the digital; topics include videogames, social media, software, digital research methods, and weblogs. His book *Distributed Blackness: African American Cybercultures* will be published in 2020 by New York University Press.
Twitter: @docdre

adrienne maree brown is a facilitator, doula, and writer. Her books include *Emergent Strategy, Pleasure Activism,* and (as co-editor) *Octavia's Brood.*
adriennemareebrown.net • Twitter: @adriennemaree • Instagram: @adriennemareebrown

LaKela Brown was born and raised in Detroit, Michigan, where she attended the College for Creative Studies and earned her BFA in 2005. Brown has attended several residencies, including Ox-Bow School of Art as a fellow in 2005, and again as a professional artist-in-residence. She has exhibited her work widely in group and solo exhibitions. Her untitled solo exhibition with Lars Friedrich Gallery in Berlin, Germany, was featured in *Artforum International* as a critic's pick in 2018. Her solo exhibition Material Relief with Reyes/Finn, also in 2018, was the subject of several publications, including *Hyperallergic.* Brown lives and works in Brooklyn, New York.
lakelabrown.com • Instagram: @lakelabrown

Nakeya Brown was born in Santa Maria, California. A 2017 Snider Prize winner, Brown has generated a vast body of work that uses photography to explore the complexities of race, beauty politics, and gender. She received her BA from Rutgers University and her MFA from The George Washington University. Brown's work has been featured in *New York* magazine, *Dazed & Confused, The Fader, Time,* and *VICE.* Her work has been included in the photography books *Babe* and *Girl on Girl: Art and Photography in the Age of the Female Gaze.*
nakeyabrown.com • Instagram: @nakeya _brown

Rembert Browne is a writer from Atlanta. He lives in Brooklyn.
Twitter: @rembert • Instagram: @rembert

Simone Browne is an associate professor in the department of African and African diaspora studies at the University of Texas at Austin. She teaches and researches on surveillance and the Black diaspora. Browne's first book, *Dark Matters: On the Surveillance of Blackness,* examines surveillance with a focus on transatlantic slavery, biometrics, airports, borders, and creative output.

Destiny Brundidge is an artist and designer living and working in New York City. She integrates many disciplines to explore speculative futures and project her own consciousness onto reality to produce critical investigations. Her interests and foci are wide; she takes advantage of her art and design disciplines to articulate, to understand, and to problem-solve the world around her.
Instagram: @yyesstiny

Brennen Buckner is an Atlanta-bred, Amsterdam-based photographer and visual artist who grew up on the fantastic fantasies of Virginia Hamilton, Ezra Jack Keats, and the like. From flying slaves to Black children playing gleefully in the snow, he found himself entrapped in their illustrations of Black joy. He gravitated toward the arts because of a disconnect between what he was seeing, whom he was meeting, what he was realizing possible. Documenting that story of progress forms the basis of his work.
creatingbrennen.com

Lawrence Burney founded the *True Laurels* blog in 2011 with the mission to provide on-the-ground reporting on the local rap and club music scenes in his hometown of Baltimore and open up a dialogue with the national rap scene. Soon after, he added a physical component to the platform, with a zine that gave artists the chance to tell their own stories with candid diaries. As *True Laurels* has grown, so has Burney, bringing his expertise on Black music in Baltimore and the DMV area to na-

tional media outlets like *Pitchfork, Noisey,* and *The Fader,* where he now works as a senior editor.
Twitter: @truelaurels • Instagram: @truelaurels

Tina Campt is the Owen F. Walker Professor of Humanities and Modern Culture and Media at Brown University and a research associate at the Visual Identities in Art and Design Research Centre (VIAD) at the University of Johannesburg, South Africa. She is the author of three books: *Other Germans: Black Germans and the Politics of Race, Gender and Memory in the Third Reich* (2004), *Image Matters: Archive, Photography and the African Diaspora in Europe* (2012), and *Listening to Images* (2017). Her forthcoming book, *The Black Gaze,* engages the work of Black artists creating embodied practices of "witnessing" that center race and gender in our contemporary moment of visualizing Blackness.

Jordan Casteel has rooted her practice in community engagement, painting from her own photographs of people she encounters. Posing her subjects within their natural environments, her nearly life-size portraits and cropped compositions chronicle personal observations of the human experience. In 2020, Casteel presented her first solo exhibition in New York, at the New Museum. In 2019–20, she presented a commission on New York's High Line and had a solo exhibition at the Iris and B. Gerald Cantor Center for Visual Arts at Stanford University, CA, which traveled from the Denver Art Museum. She is an assistant professor of painting in the department of arts, culture, and media at Rutgers University Newark. She lives and works in New York, New York.
jordancasteel.com • Instagram: @jordanmcasteel

Jonathan Lyndon Chase has lived and worked in Philadelphia his whole life, receiving his MFA from the Pennsylvania Academy of the Fine Arts in 2016. Chase has received numerous awards from PAFA and the University of the Arts in Philadelphia, and was the 2018 artist-in-residence at the Rubell Family Collection Contemporary Arts Foundation in Miami, Florida. He has had publications released for his recent solo exhibitions, *Sheets* (2018) and *Quiet Storm* (2018), and has been reviewed in numerous periodicals, including *The New York Times* and the *Los Angeles Times.*
Instagram: @jonathanlyndonchase

Jace Clayton is an artist and writer based in New York, also known for his work as DJ /rupture. His book *Uproot: Travels in 21st Century Music and Digital Culture* was recently published by Farrar, Straus and Giroux.
jaceclayton.com • Twitter: @djrupture • Instagram: @djrupture

Ta-Nehisi Coates is a distinguished writer in residence at NYU's Arthur L. Carter Journalism Institute. He is the author of the bestselling books *The Beautiful Struggle, We Were Eight Years in Power,* and *Between the World And Me,* which won the National Book Award in 2015. Coates is a recipient of a MacArthur Fellowship. He is also the current author of the Marvel comics *Black Panther* and *Captain America.*
ta-nehisicoates.com • Instagram: @tanehisipcoates

Christian Cody is a twenty-five-year-old fashion photographer from Atlanta, Georgia. He uses his environment and culture combined with fantasy to focus on creating new definitions of beauty in Black identity with the intention of moving the Black narrative forward through various mediums. Since graduating from SCAD in 2016 with a BFA in photography, Cody has worked with entities like Nordstrom, *Billboard,* Nike, and Netflix, and has been featured in *Vogue Homme, I-D* magazine, *Paper, Office,* Vteen, and other publications.
Instagram: @christian__cody

Teju Cole is a novelist, photographer, and essayist. Previously the photography critic of *The New York Times Magazine,* he is currently a professor of the practice of creative writing at Harvard.
tejucole.com

Kia Damon is a nomadic self-taught chef and caterer hailing from Florida. Guided by her

southern upbringing, she challenges what it means to be a chef in modern America. She doesn't shy from questioning the racist and misogynist systems that have kept Black women from the forefront of culinary history. Instagram: @kiacooks

Akinola Davies, Jr., is a multidisciplinary film and video artist. His work is situated between West Africa and the UK, since he identifies as a member of the global diaspora situated within the margins of being part of both worlds. Davies tries to delicately navigate the collision of colonial and imperial tradition and, more important, a return to indigenous narratives. He explores themes of race, identity, gender, and inclusion, telling stories that bridge the gap between traditional and millennial communities. He draws from aspects of collective and individual memory and lived experience. crackstevens.com • Twitter: @crackstevens • Instagram: @crackstevens

Aria Dean is an artist, writer, and curator based in New York and Los Angeles. She currently holds the position of assistant curator of net art and digital culture at Rhizome. Twitter: @lol_prosciutto • Instagram: @lol_prosciutto

Decolonize This Place is an action-oriented movement and decolonial formation in New York City organized around six strands: Indigenous struggle, Black liberation, freedom for Palestine, global wage workers, degentrification, and dismantling patriarchy. decolonizethisplace.org • Twitter: @decolonize_this

Florine Démosthène was born in the United States and raised between Port-au-Prince, Haiti, and New York. Démosthène earned her BFA from Parsons School for Design in New York and her MFA from Hunter College–City University of New York. She has exhibited extensively through group and solo exhibitions in the United States, the Caribbean, the United Kingdom, Europe, and Africa. She has participated in residencies in the United States, the United Kingdom, Slovakia, Ghana, and Tanzania. Her work can be seen at the University of South Africa (UNISA), Lowe Museum of Art, PFF Collection of African American Art, and various private collections worldwide. florinedemosthene.com • Instagram: @florinedemosthene

Documenting the Nameplate is an open-call photography book that celebrates nameplate jewelry culture. This project was founded by Marcel Rosa-Salas and Isabel Flower, and designed by Kyle Richardson.

Jackie Sibblies Drury is the recipient of the Pulitzer Prize for Drama and the Susan Smith Blackburn Prize for *Fairview*. Her other plays include *Marys Seacole; We Are Proud to Present a Presentation about the Herero of Namibia, Formerly Known as Southwest Africa, from the German Sudwestafrika, Between the Years 1884–1915;* and *Really.* Twitter: @jackiesdrury

Mina Elise Echevarria is a fine artist, educator. and Illustrator based in Hartford, Connecticut. minaelise.bigcartel.com • Instagram: @minaelise

Ezra Edelman is an award-winning filmmaker.

Yousra Elbagir is an award-winning journalist working to push counternarratives to the forefront of international media and engage young audiences through innovative storytelling. Her work has been featured on HBO, Channel 4, BBC, CNN, *Financial Times, The Guardian,* and many more. Twitter: @yousraelbagir • Instagram: @yousraelbagir

RJ Eldridge is a writer and multidisciplinary artist who lives in Brooklyn. whoisrjel.com • Instagram: @reginaldsradii

Melissa Bunni Elian is a visual journalist and writer based in Yonkers, New York. Elian was commissioned by Google in 2017 for the Equal Justice Initiative's *Lynching in America* project, a virtual map and report about the estimated 4,000 people exterminated by racial terror in the states. Her independent work focuses on culture and social justice in the African Dias-

pora. Elian is pursuing her master's degree in journalism at Columbia University, where she is completing a project on the manifestation of income inequality and hierarchy in city planning.
hellobunni.com

Yasmin Elnour is a Sudanese visual artist. She works in a combination of mediums, mainly using digital collage to bring her ideas to life. Her intentions are to create a new Sudanese visual language through preserving, educating, and reminding the globalized Sudanese youth of today about their heritage. Her current work explores the Sudanese revolution and the exciting prospect of a brighter future for her country.
Instagram:@kandaka.khronicles.

Odinigwe Benedict Chukwukadibia Enwonwu MBE, better known as **Ben Enwonwu,** was one of the world's most famous painters and sculptors. He was born in Nigeria in 1917 and transitioned out of this life in 1994.

Dr. Eve L. Ewing is a sociologist of education and a writer from Chicago. She is the author of *Ghosts in the Schoolyard: Racism and School Closings on Chicago's South Side*. She is also the author of *Electric Arches*, which received awards from the American Library Association and the Poetry Society of America and was named one of the year's best books by NPR and the *Chicago Tribune*. She is the co-author (with Nate Marshall) of the play *No Blue Memories: The Life of Gwendolyn Brooks*. She also writes the *Ironheart* series for Marvel Comics. Ewing is an assistant professor at the University of Chicago School of Social Service Administration.
eveewing.com • Facebook.com/eveewing • Twitter: @eveewing

FAKA, a cultural movement established by Fela Gucci and Desire Marea, has come to represent more than the "performance art duo" descriptor that has defined the collective since their inception in 2015. The artists explore a combination of mediums including sound, live performance, literature, video, and photography to create an eclectic aesthetic through which they express their ideas about themes central to their experience as Black queer bodies navigating the cis-hetero-patriarchy in postcolonial Africa.
siyakaka.com • Facebook.com/faka0000 • Twitter: @faka_sa • Instagram: @desiremarea @felagucci

Tatyana Fazlalizadeh is an artist and Oklahoma City native who currently lives and works in Brooklyn, New York. She is the creator of Stop Telling Women to Smile, an international street art series that tackles gender-based street harassment. Tatyana's work can be seen on Spike Lee's Netflix series *She's Gotta Have It,* for which she is also the art consultant.
tlynnfaz.com • Facebook.com /tatyanafazlalizadehstudio • Twitter: @fazlalizadeh • Instagram: @tlynnfaz

Caleb Femi is a poet and director featured in the Dazed 100 list of the next generation shaping youth culture. Using film, photography, and music, Femi pushes the boundaries of poetry on the page, in performance, and on digital mediums. Between 2016 and 2018, he was the Young People's Laureate for London, working with young people on a local, national, and global level. His debut poetry collection was released in spring 2020.
calebfemi.com • Twitter: @calebfemi5 • Instagram: @caleb.femi

(F)empower is a collective of queer feminists fighting against global fascism through cultural interventions. (F)empower is made up of artists, activists, organizers, DJs, event producers, gardeners, healers, and witches using their unique powers to usher in a new world.
Instagram: @fempowermia

Brendan Fernandes is an internationally recognized Canadian artist working at the intersection of dance and visual arts, currently based out of Chicago. Fernandes's projects address issues of race, queer culture, migration, protest, and other forms of collective movement. Always looking to create new

spaces and new forms of agency, Fernandes works in hybrid forms: part ballet, part queer dance hall, part political protest, always rooted in collaboration and fostering solidarity. He is a graduate of the Whitney Independent Study Program (2007) and a recipient of a Robert Rauschenberg Fellowship (2014). In 2010, he was shortlisted for the Sobey Art Award, and is the recipient of a 2017 Canada Council New Chapters grant.
brendanfernandes.ca • Twitter: @fernandes79 • Instagram: @brendanfernandes

Rahim Fortune is a multidisciplinary artist and writer from the Chickasaw Nation in Oklahoma. His work centers culture, identity, and self-expression using visual art and storytelling. He currently lives and works in New York City.
RahimFortune.com • Instagram: @RahimFortune

Siedeh Foxie is an intuitive healer and shamanic Reiki master based in Brooklyn. By healing through integrative modalities that utilize conscious touch, sound vibration, plant medicine, and breathwork, she offers spiritual guidance and insights that empower profound change. Her practice is deeply interconnected with the spirit forces of nature and the cosmos, drawing from a blend of the Eastern principles of spirituality and traditions found in the shamanism of the Americas. Foxie believes that everyone has the ability to heal themselves, others, and ultimately the world at large; and that we are all intuitive beings possessing the necessary tools to clear blockage, release trauma, balance energy, and restore harmony to help fulfill our highest soul potential.
stfoxie.com • Instagram: @st.foxie

LaToya Ruby Frazier is a visual artist and photographer. Her first book, *The Notion of Family,* received the International Center for Photography's Infinity Award. She is currently an associate professor of photography at the School of the Art Institute of Chicago.
latoyarubyfrazier.com

Ziwe Fumudoh is a comedy writer and performer, most recently for Showtime's late-night show *Desus and Mero* and Kamala Harris on *Our Cartoon President. The New York Times* describes Fumudoh as a saucy and sarcastic comedian known for her barbed satire of race, politics, and the pitfalls of young adulthood.
ziwefumudoh.com • Twitter: @ziwe • Instagram: @ziwef

Sandra Garcia is a reporter for *The New York Times.* She was born and raised in Harlem by immigrant parents from the Dominican Republic; she learned English in grade school and fell in love with writing. At the *Times* she has written about the Haitian immigration crisis in the Dominican Republic, hoop earrings, the struggles Black women face with the beauty industry, and the emergence of the acceptance of natural hair in the Dominican Republic.
Twitter: @S_Evangelina • Instagram: @S_Evangelina

Alicia Garza founded the Black Futures Lab to make Black communities politically powerful. In 2018, the Black Futures Lab conducted the largest survey of Black communities in more than 150 years. An innovator, strategist, organizer, and cheeseburger enthusiast, she is the co-creator of #BlackLivesMatter and the Black Lives Matter Global Network, an international organizing project to end state violence and oppression against Black people. The Black Lives Matter Global Network now has forty chapters in four countries. Garza serves as the strategy and partnerships director for the National Domestic Workers Alliance, the nation's premier voice for millions of domestic workers in the United States. She is also the co-founder of Supermajority, a new home for women's activism. She shares her thoughts on the women transforming power in *Marie Claire* magazine every month. Her forthcoming book, *The Purpose of Power,* will be published in 2020, and she warns you: Hashtags don't start movements. People do.
Twitter: @aliciagarza

Kerrilyn Gibson is a Brooklyn-based graphic designer, writer, and creative, and one half of

the experiential community On Sunday Co. Born and raised in the Southern United States, Gibson's work and perspective are heavily informed by her relationship with culture, community, race, and religion, themes that recur across her work. Working alongside writer Rhianna Jones, Gibson designed the Afromoji as a representation of the African diaspora at the intersection of tech and visual communication.
Instagram: @kerrilynnoelle

Hannah Giorgis is a staff writer at *The Atlantic*, where she covers culture. Her work has appeared in *The New York Times Magazine, The New Yorker, The Guardian, Bon Appétit, The Fader*, and *Pitchfork*, among others. She is the daughter of Ethiopian immigrants and a child of diaspora.
hannahgiorgis.com • Twitter @ethiopienne • Instagram: @ethiopienne

GirlTrek (T. Morgan Dixon and Vanessa Garrison) is structured to deliver social impact through service and volunteerism. Deeply inspired by the civil rights movement, its operational structure uses three key levers: a highly trained and incredibly talented corps of local volunteers, a distinguished board of directors, and a small and smart central leadership team.
girltrek.org • Twitter: @GirlTrek • Instagram: @GirlTrek

Renee Gladman is a writer and artist preoccupied with crossings, thresholds, and geographies as they play out at the intersections of poetry, prose, drawing, and architecture. She is the author of thirteen published works, including a cycle of novels about the city-state Ravicka and its inhabitants, the Ravickians—*Event Factory* (2010), *The Ravickians* (2011), *Ana Patova Crosses a Bridge* (2013), and *Houses of Ravicka* (2017)—as well as *Calamities,* a collection of linked auto-essays on the intersections of writing, drawing, and community, which won the 2017 CLMP Firecracker Award for Creative Nonfiction, and her first monograph of drawings: *Prose Architectures* (2017). *One Long Black Sentence,* a book of white ink drawings on black paper indexed by Fred Moten, was published in fall 2019. For 2019, she was writer-in-residence at KW Institute for Contemporary Art in Berlin.
Instagram: @prosearchitectures

Naima Green is an artist and educator born in Philadelphia and raised in New York. She lives between Brooklyn, New York, and Mexico City, Mexico. Her work begins from a place of questioning, undertaking both moment-to-moment and long-term archiving and photo-based projects to process ideas around placemaking, notions of home, and intimacy for queer, Black, and POC communities, and herself. She holds an MFA from ICP–Bard, an MA from Teachers College, Columbia University, and a BA from Barnard College. Green's work has been featured in exhibitions at the Smart Museum of Art, MASS MoCA, International Center of Photography, Houston Center for Photography, Bronx Museum, BRIC, ltd los angeles, Gallery 102, Gracie Mansion Conservancy, Shoot the Lobster, the Studio Museum in Harlem, and Arsenal Gallery. Green has been an artist-in-residence at Recess, Mass MoCA, Pocoapoco, Bronx Museum, and Vermont Studio Center, and is a recipient of the Myers Art Prize at Columbia University. Her works are in the collections of MoMA Library, the International Center of Photography Library, Decker Library at MICA, National Gallery of Art, Leslie-Lohman Museum, Teachers College, Columbia University, and the Barnard College Library.
naimagreen.com • Instagram: @naimagreen

Rahawa Haile is an Eritrean American writer from Miami, Florida. Her work has appeared in *The New York Times Magazine, The New Yorker, Outside Magazine, Pitchfork, Rolling Stone, AFAR, Audubon*, and *Pacific Standard. In Open Country,* her memoir about through-hiking the Appalachian Trail, explores what it means to move through America and the world as a Black woman and is forthcoming from Harper.
Twitter @RahawaHaile • Instagram: @RahawaHaile

Errin Haines is editor at large at *The 19th*, a nonprofit newsroom focused on the intersec-

tion of women, politics, and policy. She is an Atlanta native currently based in Philadelphia. Twitter: @emarvelous • Instagram: @emarvelous

Lauren Halsey was born in South Central Los Angeles, where she lives and works. She builds experimental architectures that remix neighborhood poetics and landscapes with living archives, nature, technicolors, afrofuturism, and funk. Halsey has exhibited at MOCA Los Angeles (2018), The Hammer Museum (2018), Community Coalition South L.A. (2017), and the Studio Museum in Harlem (2015), among others. She has completed residencies at Recess (2016), the Studio Museum in Harlem (2015), and Skowhegan (2014). Awards include the Mohn Award (2018), the William H. Johnson Award (2017) and the Rema Hort Mann Foundation Emerging Artist Grant (2015). laurenhalsey.com • Instagram: @summaeverythang

Nikole Hannah-Jones is an award-winning investigative reporter covering segregation and racial injustice for *The New York Times Magazine*. In 2017, she received a MacArthur Foundation Fellowship, known as the Genius Grant, for her work on educational inequality. She has also won a Peabody Award, a Polk Award, a National Magazine Award, and the 2018 John Chancellor Award for Excellence in Journalism from Columbia University. In 2016, Nikole co-founded the Ida B. Wells Society for Investigative Reporting, a training and mentorship organization geared towards increasing the numbers of investigative reporters of color. nikolehannahjones.com • Twitter: @nhannahjones

Jeremy O. Harris is an American actor and playwright, known for his plays *"Daddy"* and *Slave Play*. He was the winner of the 2018 Paula Vogel Playwriting Award, given by the Vineyard Theatre in New York City. jeremyoharris.me • Twitter: @jeremyoharris • Instagram: @jeremyoharris

Jerome Harris is a graphic designer, educator, writer, and curator from New Haven, Connecticut, currently based out of Baltimore,

Maryland. He holds an MFA in graphic design from Yale University and a BA in communications from Temple University. Harris's research into the exclusion of African American graphic designers has manifested as an exhibition that toured the United States throughout 2019. Harris has most recently worked with Chobani, Yale University's Afro-American Cultural Center, the Brooklyn Academy of Music, and fine artist Brendan Fernandes. He also shares his love of music, occasionally spinning as DJ Glen Coco, or choreographing for his dance Instagram page @32counts. jwhgd.com • Instagram: @jwhgd.co @32counts

Cyndia Harvey is an international hairstylist. She is one of the most exciting talents of her generation, renowned for her bold creations and diverse skillset. As both a Dazed 100 member and a *Dazed* magazine contributing beauty editor, she is highly sought after within the industry. Instagram: @CyndiaHarvey

Sean D. Henry-Smith is an artist and writer, primarily working with poetry and photography. They received a BA in studio art from Hamilton College, and have been awarded fellowships and grants from Triple Canopy, Lotos Foundation, and Antenna. Their words and images have appeared in *Apogee Journal, FACT, The Felt, The New York Times,* and elsewhere. *Wild Peach,* Sean's first full length collection of poems and photographs, is forthcoming from Futurepoem. seanhenrysmith.com • Twitter: @surrealsermons • Instagram: @lil_sunchoke

Kevin Hinton loves to create. His work reflects his love for capturing those special magic moments through photography and/or videography. He was born and raised in Washington, DC. In addition to creating stunning photography, Kevin is the creative force behind Kreative71, a digital media production company specializing in photography, videography, graphic design, and music production. He prides himself on providing imagery that inspires others as the world inspires him. kreative71.com • Twitter: @kreativehandsmm • Instagram: @kreative_71

Antonio "Tone" Johnson is an emerging visual artist whose work focuses on concepts of home and healing. Johnson, a self-taught photographer, was raised in West Philadelphia and educated at Morgan State University, a historically Black college in Baltimore. Today, he calls Brooklyn home. His work is undeniably intimate, authentic, and without frills. Johnson's project *You Next* focuses on barbershops as sites for the cultivation of Black male identity and wellness. In exploring barbershops, he's interested in capturing how those spaces and the communities within them are constructed and maintained. Johnson has a steadfast desire to create images of otherwise hidden parts of society. Ultimately, by shining a light on spaces like barbershops, he hopes to create relationships between them and viewers, connections that would not otherwise exist.
Twitter: @antoniomjohnson • Instagram: @antoniomjohnson @theyounextproject

Dr. Ayana Elizabeth Johnson is a marine biologist, policy expert, Brooklyn native, and founder and CEO of Ocean Collectiv, a consulting firm for conservation solutions grounded in social justice.
ayanaelizabeth.com • Twitter: @ayanaeliza • Instagram: @ayanaeliza

Cyrée Jarelle Johnson is a writer and librarian living in New York City. His first book of poetry, *SLINGSHOT,* was published by Nightboat Books in 2019. He is a candidate for an MFA. His work has appeared in *The New York Times, Boston Review,* and *Rewire.News.* He has given speeches and lectures at the White House, the Whitney Museum of American Art, the University of Pennsylvania, the Philadelphia Trans Wellness Conference, Tufts University, and Mother Bethel AME Church, among other venues. Johnson has received fellowships and grants from CultureStrike, the Leeway Foundation, the Astraea Lesbian Foundation for Justic, Rewire.News/Disabled Writers, Columbia University, and the Davis-Putter Scholarship Fund. He is a founding member of the Harriet Tubman Collective and the Deaf Poets Society.
cyreejarellejohnson.com • Twitter: @cyreejarelle

Jasmine Johnson is an assistant professor of Africana studies at the University of Pennsylvania. She writes and teaches about dance, Black feminism, diaspora, and performance. Her work has been supported by the Ford Foundation, the National Endowment for the Humanities, the Schomburg Center for Research in Black Culture, and elsewhere.
jasminejohn.com • Instagram: @jasminejohn

Rhianna Jones is a Brooklyn-based writer, creative, and creator of the Afro Hair Emoji (Afromoji) campaign. Guided by her biracial heritage and aesthetic affinities, Rhianna's work explores fashion, beauty, gender, and cultural narratives. She aspires to inspire through storytelling and self-love, and wants the Afromoji campaign to challenge beauty norms and catalyze larger conversations around cultural representation.
rhiannajones.com • Instagram: @xx_rhiannajones

Jonell Joshua is an illustrator based in Brooklyn, who specializes in editorial illustration and animation. She takes a simplistic analog approach to create her world of visual storytelling with her medium of choice being a mechanical pencil. Her influences stem from her familial roots in Brooklyn, and her teenage years growing up in Savannah, Georgia with her grandparents.
jonelljoshua.com • Instagram: @jonell.joshua

Junglepussy, aka Shayna McHayle, is a first generation Jamaican American artist and actress born and based in Brooklyn, New York.
junglepussy.nyc • Twitter: @JUNGLEPUSSY • Instagram: @junglepussy

Rawiya Kameir is a writer, editor, and producer based in Brooklyn, New York.
rawiyakameir.com • Instagram: @rawiyakameir

Sasha Kelley (Mali Doma) uses photography, place-making, and social practice to examine the topics of Black identity, the creativity of women of color, cooperative communities, and divine archetypes. Kelley's work is cen-

tered in documentation, as well as the intimacy of incubation. Kelley uses her creative practice as a tool to connect the nuance of her personal, social, and political experiences with that of the larger collective.
thehouseofmalico.com/sashakelley • Instagram: @on.mommas

Thebe Kgositsile (Earl Sweatshirt) is a rapper, songwriter, and record producer.
earlsweatshirt.com • Twitter: @earlxsweat • Instagram: @soapmanwun

Setti Kidane is a Black femme photographer from Toronto. Her art focuses on storytelling, vulnerability, intimacy, embodiment, and Blackness. Drawing from her Black femme community, Kidane invites us to view Black women as multidimensional people. Our layers are not ironic or contradictory; rather they speak to the diversity of our community. We can be happy and funny, as well as sad and anxious, and sometimes simultaneously so. Kidane's adoration of Black women inspires her to hold space for them in her artistic work. She wants to see them celebrated and appreciated for all that they do.
settikidane.com • Twitter: @itssetti • Instagram: @itssetti

Solange Knowles is a Grammy Award–winning singer, songwriter, and visual artist. Solange has used her platform to advocate for representation and justice while providing constructive and empowering messages. With the release of her critically acclaimed albums *A Seat at the Table* and *When I Get Home*, Solange has invoked themes of identity, empowerment, grief, and healing that have resonated with millions of voices. She has conducted performance art shows across the globe including at the 58th International Art Exhibition of La Biennale di Venezia (2019); The Getty Museum, Los Angeles (2019); Guggenheim Museum, NYC (2017); the Chinati Foundation in Marfa, Texas (2017); and the Elbphilharmonie Hamburg, Germany (2019). Solange's work in music and the arts has led to her being named Harvard University's Artist of the Year in 2018. She was honored by The New School

as a pioneering figure in fashion and the arts at the 70th Annual Parsons Benefit. She has also been the recipient of Glamour's Woman of the Year Award and Billboard's Impact Award.
solangemusic.com • Twitter: @solangeknowles • Instagram: @saintrecords

Kia LaBeija is a fine artist born and raised in the heart of New York City, Hell's Kitchen. Her current work is composed of cinematic and vibrant autobiographical self-portraits and live performance exploring the catharsis and vast history of voguing. *24,* her critically acclaimed series, is a sociopolitical commentary on the effects of growing up with HIV. She's presented work at the Whitney Museum of American Art, the Brooklyn Museum, the Studio Museum in Harlem, the Museum of the City of New York, the Bronx Museum of the Arts, and The International Center for Photography. LaBeija is a world-renowned voguer, dancer, performance artist, and mother of the iconic House of LaBeija. She played the title role of Dove in Band Pillar Point's viral music video, and appeared as a principal dancer in Ryan Murphy's Golden-Globe-nominated ballroom drama POSE. She is a 2019 Creative Capital Awardee alongside her partner, Taina Larot, for their upcoming project *Wom(y)n With a Y.* LaBeija is a graduate of the New School University, where she holds a degree in the arts.
Instagram: @goodnight_Kia

Deana Lawson is a photo-based artist born in Rochester, New York, whose work examines the body's ability to channel personal and social histories, addressing themes of familial legacy, community, romance, and religious spiritual aesthetics. Lawson is the recipient of a Guggenheim Fellowship, an Art Matters Grant, a John Gutmann Photography Fellowship, a Rema Hort Mann Foundation Grant, an Aaron Siskind Fellowship Grant, and a NYFA Grant in 2006. Lawson currently teaches photography at Princeton University.

Thomas J. Lax is a writer, interlocutor, and curator. He recently co-organized the exhibition *Judson Dance Theater: The Work is Never*

Done (with Ana Janevski and Martha Joseph) and is preparing an exhibition on Just Above Midtown, also known as JAM—an art gallery and a self-described "laboratory" for artists of color established by Linda Goode-Bryant in 1974. Previously, he worked at the Studio Museum in Harlem for seven years. Lax is on the board of Danspace Project and is on the advisory committees of Contemporary And, Participant Inc., and Recess Assembly. A native New Yorker, Lax holds degrees in Africana studies and art history from Brown University and Columbia University. In 2015, he was awarded the Walter Hopps Award for Curatorial Achievement and he was a 2017 Center for Curatorial Leadership Fellow.
Instagram: @thomaslax

Kiese Laymon is a writer and professor from Jackson, Mississippi.
Twitter: @KieseLaymon

Carolyn Lazard is a Philadelphia-based artist working across video, sound, sculpture, and performance. Lazard has screened and exhibited work at the Walker Art Center, the New Museum, the Whitney Museum of American Art, Camden Art Centre, Kunsthal Aarhus, and the Stedelijk Museum. They have published writing in *The Brooklyn Rail, Mousse Magazine,* and *Triple Canopy.*
carolynlazard.com

David Leggett is a visual artist who lives and works in Los Angeles, California. He received his BFA from Savannah College of Art and Design (2003), and a MFA from the School of the Art Institute of Chicago (2007). He also attended Skowhegan School of Painting and Sculpture (2010). His work tackles many themes head on: Hip-hop, art history, popular culture, sexuality, the racial divide, and the self are all reoccurring subjects. He takes many of his cues from standup comedians, which he listens to in his studio. He ran a daily drawing blog, Coco River Fudge Street, from 2010 to 2016. He has shown his work throughout the United States and internationally, including a recent two-person show at Various Small Fires Gallery in Los Angeles (2018). He

received the visual artist award from 3Arts in 2009.
davidleggettart.com

Sarah E. Lewis is an associate professor of history of art and architecture and African and African American studies at Harvard University. She served as guest editor of the "Vision & Justice" issue of *Aperture,* which received the 2017 Infinity Award for Critical Writing and Research from the International Center of Photography. Her book *A Caucasian War,* on race, whiteness, and photography, is forthcoming from Harvard University Press. Her articles on race, contemporary art, and culture have been published in many academic journals as well as *The New Yorker, The New York Times,* and for the Smithsonian and the Museum of Modern Art. She is also the author of the bestseller *The Rise: Creativity, the Gift of Failure, and the Search for Mastery,* translated into seven languages and selected as the reading requirement for all incoming freshman at many universities. She has lectured at many universities and conferences including talks for South by Southwest, TED mainstage, and the Aspen Ideas Festival. She has been profiled in *The New York Times, The Wall Street Journal*, and other publications. She lives in Cambridge, Massachusetts, and New York.
sarahelizabethlewis.com • Facebook .com/SarahElizabethLewis1 • Twitter: @sarahelizalewis • Instagram: SarahElizabethLewis1

Chokwe Antar Lumumba is the mayor of Jackson, Mississippi.
Facebook.com/MayorChokweALumumba • Twitter: @chokwealumumba

Emilio Madrid is a photographer specializing in editorial portraiture and high-end event coverage. He is currently the staff photographer for Broadway.com and works predominantly in the theatre industry.
emiliomadrid.com • Facebook.com/emiliomk • Instagram: @emiliomk

Kerry James Marshall was born in Alabama in 1955 and grew up in Watts, Los Angeles. He

is a 1978 graduate of the Otis College of Art and Design and currently lives and works in Chicago. Marshall uses painting, sculptural installations, collage, video, and photography to comment on the history of Black identity both in the United States and in Western art. He is well known for paintings that focus on Black subjects historically excluded from the artistic canon, and has explored issues of race and history through imagery ranging from abstraction to comics.

Rene Matić is a visual artist currently studying and working in London. Her work predominantly explores the intersections of her own experience as a queer womxn of color, aiming to expose, combat, and question power relations and structures within the art world and society more widely.
renematich.com • Instagram: @bad.gal.rene

Tiona Nekkia McClodden lives and works in North Philadelphia, Pennsylvania. She is a visual artist, filmmaker, and curator whose work explores and critiques issues at the intersections of race, gender, sexuality, and social commentary. Her interdisciplinary approach traverses documentary film, experimental video, sculpture, and sound installations. Themes explored in McClodden's films and works have been re-memory and more recently narrative biomythography. McClodden's work explores shared ideas, values, and beliefs within the African Diaspora, or what she calls "Black mentifact." McClodden has exhibited and screened work at the Institute of Contemporary Art—Philadelphia, Museum of Modern Art, Whitney Museum, MOCA LA, Art Toronto's VERGE Video program, MCA Chicago, MoMA PS1, New York, Museum of Contemporary Art, Cleveland; Kansai Queer Film Festival in Osaka and Kyoto, Japan; and the London Lesbian and Gay Film Festival, among a range of international film festivals and film programs. Her work was featured in the 2019 Whitney Biennial, curated by Jane Panetta and Rujeko Hockley. McClodden has been awarded the 2018–19 Keith Haring Fellowship in Art and Activism at Bard College, the 2017 Louis Comfort Tiffany Foundation Award, and

the 2016 Pew Fellowship in the Arts in Philadelphia, PA. She attended the 2016 Sommerakademie Zentrum Paul Klee as a nominated fellow, and attended the 2015 Flaherty Film Seminar as a Philadelphia Fellow.
tionam.com • Instagram: @tionam

Muna Mire is a writer and producer based in New York City.
Twitter: @Muna_Mire

Azikiwe Mohammed's artwork has been shown in galleries both nationally and internationally. A 2005 graduate of Bard College, where he studied photography and fine arts, Mohammed received the Art Matters Grant in 2015 and the Rema Hort Mann Foundation's Emerging Artist Grant in 2016. He is an alumnus of Pioneer Works in Brooklyn, New York, and Mana Contemporary in Jersey City, New Jersey. His work has been featured extensively in magazines, including *VICE, I-D, Artforum, Forbes, BOMB*, and *Hyperallergic*. Mohammed has presented solo exhibitions in venues including the Knockdown Center, Maspeth, New York; SCAD Museum of Art, Savannah, Georgia; Ace Hotel Chicago, Illinois; IDIO Gallery, Brooklyn, New York; Mindy Solomon Gallery, Miami, Florida; and Anna Zorina Gallery, New York; as well as multiple solo offerings at Spring Break Art Show, New York. He has participated in group exhibitions at MoMA PS1, Queens, New York; Antenna Gallery, New Orleans, Louisiana; Charlie James Gallery, Los Angeles, California; and the Studio Museum in Harlem, New York, among others. He lives and works in New York.
azikiwephoto.com • Instagram: @misterace12

Jameel Mohammed began a career in design at age sixteen, interning for Nicole Miller and Narciso Rodriguez while still in high school at Phillips Exeter Academy. In 2013 he enrolled at the University of Pennsylvania to begin a bachelor's degree in political science. When a necklace he designed caught the eye of the COO and fashion director of Barneys New York in 2014, he decided to focus on jewelry design, and accepted an internship at the company, where he learned the ins and outs of

merchandising and retail buying. He founded KHIRY in 2015 after being pointedly told by the CEO of a global luxury goods conglomerate that the only true luxury brands were of European origin.
Instagram: @khiryofficial @jameelkhiry

Indya Moore is an actor, model, social activist, writer, and director. Born and raised in the Bronx, Moore has appeared in such publications as *Vogue, Teen Vogue, Elle, GQ,* and *L'Officiel,* as well as collaborations with such designers as Louis Vuitton and Calvin Klein. Moore currently stars in the groundbreaking Golden Globe and Emmy–nominated FX series *Pose* and was included in *Time* magazine's 100 Most Influential People list in 2019. Their first feature film, *Queen and Slim*, came out in November 2019. Moore finished shooting *A Babysitter's Guide to Monster Hunting* for Netflix and is shooting *Escape Room 2,* their first studio film.
Twitter: @IndyaMoore

Devin N. Morris collapses personal experience, memory, and space to delicately envision new realms. The artist considers his upbringing in Baltimore and navigating the world as a Black queer man in his depictions of real and imagined characters engaged in acts of kindness and care. His explorations of the domestic space, including collage and immersive environments, place the viewer inside abstracted rooms that subvert traditional values and social boundaries. Morris's photographs extend his practice of collage into physical assemblage. Through this work and his annual publication *3 Dot Zine,* Morris reimagines the physical and social boundaries of marginalized communities, radically reimagining queer existence. Morris was born in Baltimore, Maryland, and is now based in Brooklyn, New York.
devinnmorris.com • Facebook.com/DNMor • Facebook.com/3DOTZINE • Instagram: @devinnmorris @3dotzine

Wesley Morris is a critic at large at *The New York Times* and a staff writer at *The New York Times Magazine,* where he writes about popular culture and hosts the podcast *Still Processing* with Jenna Wortham. For three years, he was a staff writer at Grantland, where he wrote about movies, television, and the role of style in professional sports, and co-hosted the podcast *Do You Like Prince Movies* with Alex Pappademas. Before that, he spent eleven years as a film critic at *The Boston Globe,* where he won the 2012 Pulitzer Prize for criticism.
Twitter: @wesley_morris

Pyer Moss was founded in 2013 by Kerby Jean-Raymond. Jean-Raymond describes Pyer Moss as an "art project" or "a timely social experiment." The brand uses its platform in the fashion industry to challenge social narratives and evoke dialogue. Pyer Moss continues to redefine itself every season with collections and runways that combine storytelling, activism, debate, and social commentary. The collections are produced in New York City, Italy, and Portugal. Pyer Moss is sold on no particular schedule at exclusive high-end boutiques worldwide. In 2018, Pyer Moss launched its highly anticipated collection with Reebok named Reebok by Pyer Moss as part of their newly announced partnership with the footwear giant. In 2018, Pyer Moss won the CFDA Vogue Fashion Fund Prize. In 2019, Jean-Raymond became the artistic director of Reebok Studies, a new division he created at Reebok.
pyermoss.com • Twitter: @pyermoss • Instagram: @pyermoss

Zanele Muholi is a visual activist and photographer born in Umlazi, Durban, and living in Johannesburg. Muholi's self-proclaimed mission is "to rewrite a Black queer and trans visual history of South Africa for the world to know of our resistance and existence at the height of hate crimes in SA and beyond." Muholi co-founded the Forum for Empowerment of Women (FEW) in 2002, and in 2009 founded Inkanyiso, a forum for queer and visual (activist) media. They continue to train and co-facilitate photography workshops for young women in the townships. Solo exhibitions of Muholi's work have taken place at

institutions including the Stedelijk Museum, Amsterdam; Autograph ABP, London: the Mead Art Museum, Amherst; Gallatin Galleries, New York; Open Eye Gallery, Liverpool; Brooklyn Museum, New York; Kulturhistorek Museum, Oslo; Einsteinhaus, Ulm; Schwules Museum, Berlin; and Casa Africa, Las Palmas. Muholi was shortlisted for the 2015 Deutsche Börse Photography Prize for her publication *Faces and Phases 2006–14* (Steidl/The Walther Collection). Muholi is an honorary professor at the University of the Arts/Hochschule für Künste Bremen.
Instagram: @muholizanele

Zora J. Murff is a visiting assistant professor of photography at the University of Arkansas. Murff received his MFA in studio art from the University of Nebraska–Lincoln and holds a BS in psychology from Iowa State University. His work has been exhibited nationally and internationally, and featured online and in publications including *Aperture Magazine, The New Yorker, VICE, The British Journal of Photography,* and *The New York Times.* Zora was named an honoree for PDN's 30: New & Emerging Photographers to Watch, selected for the 2019 Light Work Artist-in-Residence Program, named the Daylight Photo Award Winner, and also selected as a LensCulture Top 50 Emerging Talent with his collaborative partner Rana Young. Zora's first monograph, *Corrections,* was published by Aint-Bad Editions in 2015 and his second monograph, *LOST, Omaha,* was published by Kris Graves Projects in 2018.
zora-murff.com • Instagram: @zorajmurff

Renée Mussai is a curator-scholar of photography and visual culture. An advocate for curatorial activism, she has organized numerous exhibitions globally, notably Black Chronicles II–IV (2014–18), Zanele Muholi: Somnyama Ngonyama (2017), and Lina Iris Viktor: Some Are Born To Endless Night—Dark Matter (2019). She is senior curator at Autograph, London, an arts charity that works internationally in photography and film, cultural identity, race, representation, and human rights. Mussai lectures and publishes internationally on photography, cultural politics, and curatorial practice, and is a regular guest curator and former non-resident fellow at Harvard University's Hutchins Center, a research associate in visual identities in art and design (VIAD) at the University of Johannesburg, and associate lecturer at the University of the Arts London.
autograph.org.uk • stevenson.info/artist /zanele-muholi • Instagram: @mussairenee

Angel Nafis is the author of *BlackGirl Mansion* (Red Beard Press, 2012). Her work has appeared in *The BreakBeat Poets Anthology, BuzzFeed Reader, The Rumpus, Poetry Magazine* and more. She represented New York City at the National Poetry Slam and the Women of the World Poetry Slam. She is the founder, curator, and host of the Greenlight Poetry Salon. She is a Cave Canem graduate fellow and the recipient of the 2016 Ruth Lilly and Dorothy Sargent Rosenberg Fellowship and a 2017 NEA Creative Writing Fellowship. Nafis earned her BA in English and creative writing from Hunter College and her MFA in poetry from Warren Wilson College. With poet Morgan Parker, she is The Other Black Girl Collective.
angelnafis.com • Twitter: @AngelNafis • Instagram: @anaffy

National Memorial for Peace and Justice: The Equal Justice Initiative is a private nonprofit organization that provides legal representation to indigent defendants and prisoners who have been denied fair and just treatment in the legal system and examines the history of racial injustice in America.
eji.org • Facebook.com/equaljusticeinitiative • Twitter: @eji_org • Instagram: @eji_org

Clementia "Ment" Nelson is an African American artist, born and raised in the rural Lowcountry of South Carolina. He is a namesake of the late South Carolina senator and pastor of Mother Emanuel AME Church, Clementa Pinckney.
mentnelson.com • Instagram: @mentnelson

Flo Ngala is a photographer from Harlem, New York, whose images range from big acts in music to small moments in everyday life. With a passion for image making, she cites photo-

journalism and portraiture as her focus. Ngala currently resides in New York City.
flongala.com • Instagram: @flongala

Italian for "no sex/no gender," **No Sesso** is the Los Angeles fashion house founded by Pierre Davis in 2015. She helms the brand with Arin Hayes and together they've created a line that challenges the conventions of fashion, art, culture, and design. A community-powered brand that focuses on empowering people of all colors, shapes, and identities, No Sesso has stolen the spotlight with collections that feature a wide range of prints, fabrics, reconstructed materials, and most notably, their signature hand embroidery. Making nonconformity as beautiful and inclusive as it can possibly be, No Sesso celebrates the community it serves with their collections, fashion presentations, parties, educational activities, and more."

Kene Nwatu is a Nigerian visual and musical artist, creating work exploring individual identity and interactions through nomadic expeditions and youth subculture within communities concerning music, vices, and fashion. Nwatu has participated in two solo and five group exhibitions in Lagos, Paris, Bamako, Bozeman, and many more cities since 2013. Nwatu has worked as a photo and video journalist for media outlets such as BBC, *Vogue, T: The New York Times Style Magazine, Jeune Afrique,* and *Guardian Life,* and has worked commercially with brands such as Nike, Vlisco, and Arise Fashion Week. Kene Nwatu has taught photography workshops with the African Artists' Foundation in Lagos, Nigeria, and KUTA Art Foundation in Abeokuta, Ogun, Nigeria. Nwatu has participated in two trans-African road trips with The Invisible Borders Trans-African Photograpers Organization.
Instagram: @kenenwatu

Toyin Ojih Odutola was born in 1985 in Ile-Ife, Nigeria, and lives and works in New York. She is best known for her multimedia drawings and works on paper, which explore the malleability of identity and the possibilities in visual storytelling. Interested in the topography of skin, Ojih Odutola has a distinctive style of mark-making using only basic drawing materials, such as ballpoint pens, pencils, pastels, and charcoal. This signature technique involves building up layers on the page, through blending and shading with the highest level of detail, creating compositions that reinvent and reinterpret the traditions of portraiture. Ojih Odutola credits the development of her style from using pen, which holds a special significance through its function as a writing tool, as her work is also akin to fiction. She often spends months crafting narratives that unfold through series of artworks like the chapters of a book.
toyinojihodutola.com • Facebook.com /ToyinOjihOdutola • Instagram: @toyinojihodutola

Alexis Okeowo is the author of *A Moonless, Starless Sky: Ordinary Women and Men Fighting Extremism in Africa,* which received the 2018 PEN Open Book Award. Her work has been anthologized in *The Best American Sports Writing 2017* and *The Best American Travel Writing 2017,* and she has received fellowships from the MacDowell Colony, the Russell Sage Foundation, New America, and the Alicia Patterson Foundation. She is the 2019 PEN/Civitella Ranieri Foundation Writing Fellow.
alexisokeowo.com • Twitter: @alexis_ok • Instagram: @aokeowo

Yetunde Olagbaju is a multidisciplinary artist and curator, currently residing in Oakland, California. Through their work, they utilize performance and emotional excavation as a through-line for inquiries regarding trauma, collective memories, legacy, and healing. By creating work that exists within and expands upon nonlinear time, they seek to create meaningful exchanges of narrative and explore methods of emotion-based storytelling and archiving.
yetundeolagbaju.com • Instagram: @ye.tunde

Mimi Onuoha is a Nigerian American, Brooklyn-based interdisciplinary artist and researcher whose work addresses cultural contradictions within technology. She has spoken and exhibited nationally and internationally in venues like Mao Jihong Arts Founda-

tion (Chengdu) in collaboration with Le Centre Pompidou (Paris), FIBER Festival (Amsterdam), the Scottsdale Museum of Contemporary Art (Scottsdale), La Gaitê Lyrique (Paris), nGbk (Berlin), and B4BEL4B Gallery (San Francisco). In 2014 she was selected for the inaugural class of Fulbright-National Geographic Digital Storytelling Fellows, and in 2017 she was nominated as a Technical.ly Brooklyn Artist of the Year. Onuoha is currently the 2018–19 creative-in-reference at Olin College of Engineering. Her artist book (collaboration with Mother Cyborg) *The People's Guide to AI* was released in spring 2020.
mimionuoha.com • Twitter: @thistimeitsmimi • Instagram: @onuohamimi

Ola Osaze is a trans masculine queer of Edo and Yoruba descent, who was born in Nigeria and now resides just outside of Houston, Texas. Osaze is the project director for the Black LGBTQ+ Migrant Project, a national movement-building initiative centering trans and queer Black migrants. Osaze has been a community organizer for many years, working to build the power and leadership of LGBTQ+ people of color, Black, and migrant communities with Transgender Law Center, the Audre Lorde Project, Uhuru Wazobia (one of the first LGBT+ groups for African immigrants in the United States), Queers for Economic Justice, and Sylvia Rivera Law Project. As a writer, Osaze is a 2015 Voices of Our Nation Arts workshop (VONA) fellow, and has had writings published in *Apogee, Qzine, Saraba Magazine, Black Looks,* and the anthology *Queer Africa II.*
Twitter: @olaosaze

Jason Parham is a writer and editor from Los Angeles. His essays and criticism have appeared in *Wired, The Fader, The New York Times Book Review, The Atlantic,* and on Gawker. He is the founder of *Spook,* a literary journal by and for creatives of color.
spook-mag.com

Morgan Parker is the author of the poetry collections *Magical Negro, There Are More Beautiful Things Than Beyoncé,* and *Other People's Comfort Keeps Me Up at Night.* Her debut YA novel, *Who Put This Song On?,* was published in September 2019 by Delacorte Press, and her debut book of nonfiction is forthcoming from One World/Random House. Parker is the recipient of a 2017 National Endowment for the Arts Literature Fellowship, winner of a Pushcart Prize, and a Cave Canem graduate fellow. She is the creator and host of *Reparations, Live!* at the Ace Hotel. With Tommy Pico, she co-curates the Poets with Attitude (PWA) reading series, and with Angel Nafis, she is The Other Black Girl Collective. She lives in Los Angeles.
morgan-parker.com • Twitter: @morganapple • Instagram: @morganapple0

Leah Penniman is a Black Kreyol educator, farmer/peyizan, author, and food justice activist from Soul Fire Farm in Grafton, New York, which she co-founded in 2011 with the mission to end racism in the food system and reclaim our ancestral connection to land. She holds an MA in science education and a BA in environmental science and international development from Clark University, and is a manye (queen mother) in Vodun. Penniman has been farming since 1996 and teaching since 2002. The work of Penniman and Soul Fire Farm has been recognized by the Soros Racial Justice Fellowship, the Fulbright program, Grist 50, and the James Beard Award, among others. Her book *Farming While Black: Soul Fire Farm's Practical Guide to Liberation on the Land* is a love song for the land and her people.
soulfirefarm.org • Twitter: @soulfirefarm • Instagram: @soulfirefarm

Rasheedah Phillips is a public interest attorney, a mother, an artist, a writer, the creator of The AfroFuturist Affair, the co-creator of Black Quantum Futurism multimedia arts collective, and a founding member of Metropolarity Queer SciFi collective. Phillips is the recipient of the National Housing Law Project 2017 Housing Justice Award, 2017 City & State Pennsylvania 40 under 40 Rising Star award, 2018 Temple University Black Law Student Association Alumni Award, 2017 Pew Fellowship, 2018 Atlantic Fellow for Racial Equity, and 2019 Barristers Association of Philadelphia Outstanding Young Attorney Award. She is the co-creator of the award-winning Community Futures Lab project, a socially engaged art

and research project that explores communal temporalities, futurism, and the preservation of memory and history in a Black community undergoing redevelopment, gentrification, and mass displacement. She currently serves on the board of the Leeway Foundation and the zoning board of the Brewerytown-Sharswood Community Civic Association. blackquantumfuturism.com • Twitter: @afrofuturaffair • Instagram: @blackquantumfuturism

Pontsho Pilane is a South African writer and award-winning journalist who focuses on health, gender, and how they intersect. She was one of the leading journalists covering the 2015 #FeesMustFall protests in South Africa. pontshopilane.co.za • Twitter: @pontsho _pilane • Instagram: @pontsho_pilane

Momo Pixel is a game designer, art director, and musician. Starting her career in 2015, Pixel worked as a copywriter, writing commercials for Nintendo. In 2016, she created Momoland an annual interactive pixel-art experience. And in 2017, with the help of Wieden+Kennedy, she released *Hair Nah*, a video game to keep people from touching Black women's hair. *Hair Nah* became a global sensation, featured on CNN and in *Rolling Stone, Essence, Teen Vogue, VICE UK,* and many more. With a bright aesthetic and a niche for honesty, Momo Pixel's work aims to address the social issues of culture and create a new space for Black creatives. Momopixel.com • Twitter: @Momouhoh • Instagram: @Momopixels

Donovan X. Ramsey is a journalist committed to examining patterns of power in America and amplifying the stories of everyday Black Americans. He is the commentary editor at the Marshall Project and author of *When Crack Was King,* a people's history of the crack cocaine epidemic. donovanxramsey.com • Twitter: @donovanxramsey • Instagram: @donovanxramsey

Kameelah Janan Rasheed is a learner and an interdisciplinary artist who seeks to make her research visible through an ecosystem of iterative, provisional projects as well as through experiments. These projects and experiments include sprawling, Xerox-based "architecturally-scaled collages" (*frieze* magazine, winter 2018); publications; large-scale text banner installations; digital archives; lecture-performances; library interventions; poems/poetic gestures; and other forms yet to be determined. Instagram: @kameelahr

Tabita Rezaire is infinity incarnated into an agent of healing, who uses art as a means to unfold the soul. Through screen interfaces and collective offerings, her digital healing and energy streams remind us to see, feel, think, intuit, download, know, and trust beyond Western authority and toward the soul. Rezaire is based in Cayenne, French Guyana. She has a bachelor's degree in economics (France) and a master's of research in art: moving image from Central Saint Martins (UK). She is a founding member of the artist group NTU, half of the duo Malaxa, and the mother of the energy house SENEB. She has shown her work internationally at MoMA (New York), New Museum (New York), Gropius Bau (Berlin), MMOMA (Moscow), Museum of Contemporary Art (Chicago), HeK (Basel), ICA (London), V&A (London), National Gallery (Denmark), The Broad (Los Angeles), MoCADA (New York), Tate Modern (London), and Museum of Modern Art (Paris), and contributed to several biennales such as the Ghangzhou Triennial, Athens Biennale, Kochi Biennale in 2018, Performa and Karachi Biennale in 2017, and Berlin Biennale in 2016. tabitarezaire.com

Aaron Ricketts is a photographer, creative director, and founder of The Ricketts Company. Twitter: @aaronricketts_ • Instagram: @aaronricketts_

Deborah Roberts is a mixed-media artist whose work challenges the notion of ideal beauty. Her work has been exhibited internationally across the USA and Europe. Roberts's work is in the collections of the Whitney Museum of American Art, New York; Brooklyn

Museum, New York; The Studio Museum in Harlem, New York; LACMA, Los Angeles. Roberts is the recipient of the Anonymous Was a Woman grant (2018), the Pollock-Krasner Foundation Grant (2016), and the Ginsburg-Klaus Award Fellowship (2014). She received her MFA from Syracuse University. She lives and works in Austin, Texas.
deborahrobertsart.com • Instagram: @rdeborah191

Guarionex Rodriguez, Jr., was born and raised outside of Boston, in Lynn, Massachusetts. Growing up, he spent summers in Santo Domingo, Dominican Republic. He graduated from MassArt in 2011 and is currently based out of Brooklyn, creating work about scenes and community.
guarionexjr.com • Instagram: @guarionex_jr

Martine Rose draws its inspiration from the experiential tension between individualism and belonging, exploring the potential of clothing to serve as cultural signifiers. By exploring both personal and imagined histories, Martine Rose takes icons or motifs from the past and reimagines their use in the present—contexts are subverted, references collide, and the result makes each collection feel "offbeat," and yet "in tune." Volume, proportion, and fabrication are used in an equally dynamic way to blur the lines between the familiar and unconventional, questioning the former functionality or past popularity of certain aesthetics through their reappropriation today.

Sheena Rose is a contemporary Caribbean artist who lives and works in Barbados. Rose is a Fulbright Scholar and holds a BFA honors degree from Barbados Community College, as well as an MFA from the University of North Carolina at Greensboro. She has a multi-disciplinary practice. Rose has been a participant in the Havana Biennial, Venice Biennial, Gwangju Biennial, and Jamaica Biennial, and has exhibited in such art institutions as MoCADA, Queens Museum, Turner Contemporary Gallery, and the Royal Academy of Arts. She has been the recipient of a number of international artist residencies and her work has

been included in a number of art fairs, festivals, and auctions such as Prizm Art Fair, Third Horizon Film Festival, and Rush Philanthropic Arts Foundation Auction.
sheenaroseart.com • Instagram @sheenaroseinc

Cameron Rowland lives and works in New York. Rowland received a BA from Wesleyan University in 2011. Rowland's work has been exhibited in solo exhibitions at the Institute of Contemporary Arts, London; Museum of Contemporary Art, Los Angeles; Galerie Buchholz, Cologne, Germany; Établissement d'en face, Brussels; Kunsthalle Freiburg, Switzerland; Artists Space, New York and Essex Street / Maxwell Graham, New York. They have participated in group exhibitions at the Museum fur Moderne Kunst, Frankfurt, Germany; 33rd Bienal de São Paulo, Brazil; Secession, Vienna; Whitney Biennial, Whitney Museum of American Art; Punta della Dogana, Venice; the Museum of Modern Art, New York, New York and elsewhere.

Mambo Elizabeth Ruth (Soleil Levè Bon Mambo) is a Haitian Vodou mambo sou pwen, witch, rootworker, and diviner who, in 2015, relocated to central Ohio after spending her adult life as a resident of Chicago. Ruth is the owner of Big Liz Conjure and Erzulie's Conjure Garden. Her magical practice is hoodoo (traditional African American folk magic). She also studies traditional witchcraft, and combines both in her magical workings as appropriate.
biglizconjure.com • Facebook.com /biglizconjurecorner • Twitter: @BigLizConjure • Instagram: @biglizconjure

Zoé Samudzi is a writer, sociologist, and photographer examining visuality and productions of Blackness.
Twitter: @ztsamudzi • Instagram: @Babywasu

RaFia Santana is a Brooklyn-born multidisciplinary artist using animated graphics, self-portraiture, music production, and performance to self-soothe, bend perception, and make jokes. Santana has exhibited their

work at the Schomburg Center for Research in Black Culture, MoCADA, Tate Britain, the Museum of the Moving Image, and Times Square. They have been featured in *Vogue, Teen Vogue, Paper* magazine, *Cultured Magazine, VICE,* and other leading publications.
rafiasworld.com • Instagram: @rafiasworld

Tschabalala Self is a Harlem-born painter. She received her BA from Bard College in 2012 and her MFA from the Yale School of Art in 2015.
tschabalalaself.com

serpentwithfeet is a vocalist and performance artist whose growing body of work is rooted in gospel and Black mysticism—key components of his artistic journey from a childhood stint as a choirboy in Baltimore through his time at the University of the Arts in Philadelphia, where he studied vocal performance and theatre before relocating to Los Angeles. His last album, *soil*, is a return to the sensibilities and wide-eyed curiosity of his musical youth. The release of *soil* saw him rediscover and ultimately return to the unhinged version of himself he was sure he had outgrown. In April 2020, serpent released a three-song EP titled *Apparition*. He is currently at work on the follow-up to *soil*.
Twitter: @serpentwithfeet • Instagram: @serpentwithfeet

Pierre Serrao is working at the intersection of food, art, and culture. As one of the culinary masterminds behind Ghetto Gastro, Serrao crafts multi-sensory experiences influenced by his travels around the globe and the energy of the Bronx, with a little extra flavor on top coming from his Bajan roots.
ghettogastro.com • Twitter: @ghettogastro • Instagram: @chefp @ghettogastro

Alice Sheppard trained with Kitty Lunn and made her debut with Infinity Dance Theater. After an apprenticeship with AXIS Dance Company, Sheppard became a core company member and toured nationally and taught in the company's education and outreach programs. Since becoming an independent

dance artist, she has danced in projects with Ballet Cymru/GDance and Marc Brew Company in the United Kingdom. In the United States, she has worked with Marjani Forté, MBDance, Infinity Dance Theater, and Steve Paxton. Alice Sheppard is the founder and artistic lead for Kinetic Light, a project-based ensemble working at the intersections of disability, dance, design, identity, and technology to create transformative art and advance the intersectional disability arts movement. A USA Artist, Creative Capital grantee, and Bessie Award winner, Sheppard creates movement that engages intersectional disability arts, culture, and history to challenge conventional understandings of disabled and dancing bodies.
alicesheppard.com • Facebook.com/KineticLight • Twitter: @wheelchairdancr • Instagram: @wheelchairdancr

Amy Sherald is an American painter based in Baltimore, Maryland, best known for her portraits. Her choices of subjects look to enlarge the genre of American art-historical realism by telling African American stories within their own tradition.
amysherald.com

Cauleen Smith is an interdisciplinary artist whose work reflects upon the everyday possibilities of the imagination. Operating in multiple materials and arenas, Smith roots her work firmly within the discourse of mid-twentieth-century experimental film. Drawing from structuralism, third world cinema, and science fiction, she makes things that deploy the tactics of activism in service of ecstatic social space and contemplation. She lives in Los Angeles and is on the art program faculty at California Institute of the Arts. She has a BA in creative arts from San Francisco State University and an MFA from the University of California, Los Angeles School of Theater Film and Television. Smith is the recipient of the following awards: Rockefeller Media Arts Award, Creative Capital Film /Video, Chicago 3Arts Grant, The Foundation for Contemporary Arts, Chicago Expo Artadia Award, Rauschenberg Residency, Herb Alpert Awards in the Arts in

Film and Video 2016, and United States Artists Award 2017. She was the 2016 inaugural recipient of the Ellsworth Kelly Award.
cauleensmith.com

Danez Smith is the author of *Homie* (Graywolf Press, 2020) and *Don't Call Us Dead* (Graywolf Press, 2017), winner of the Forward Prize for Best Collection and a finalist for the National Book Award. They are the co-host, with Franny Choi, of VS, a podcast sponsored by the Poetry Foundation and Postloudness.
danezsmithpoet.com • Twitter: @danez_smif • Instagram: @danez_smif

Sable Elyse Smith is an interdisciplinary artist, writer, and educator based in New York and Richmond, Virginia. Using video, sculpture, photography, and text, she points to the carceral, the personal, the political, and the quotidian to speak about a violence that is largely unseen, and potentially imperceptible. Her work has been featured at MoMA PS1, the New Museum, the Studio Museum in Harlem, JTT, Rachel Uffner Gallery, and Recess Assembly, New York; Yerba Buena Center for the Arts and Artist Television Access, San Francisco; Birkbeck Cinema in collaboration with the Serpentine Galleries, London. Smith has received awards from Creative Capital, Fine Arts Work Center, the Queens Museum, Skowhegan School of Painting and Sculpture, the Rema Hort Mann Foundation, the Franklin Furnace Fund, and Art Matters. She is currently an assistant professor of sculpture & extended media at the University of Richmond. She is working on her first book.
Instagram: @sable_elyse

Zadie Smith is an English novelist and essayist, who is currently a tenured professor in the creative writing department at New York University.
zadiesmith.com

Fannie Sosa is an award-winning Afro-Sudaka mover and shaker, artist, and activist. Currently finishing their PhD, titled "Pleasure Against the Machine: Pleasurable Strate-gies for Anti-Colonial Survival during the Capitalocene," they have been creating and sharing pleasurable anticolonial strategies and mixed-media knowledge packages for ten years. Sosa wrote "A White Institutions Guide for Welcoming Artists of Color and their Audiences" (WIGWACATA) in 2016. The guide has been utilized by more than 200 cultural institutions around the world to better their equity practices. They live and work between Europe and South America.
fanniesosa.com • Facebook.com /fanniesosabaila • Twitter: @fanniesosalove • Instagram: @fanniesosalove

Doreen St. Félix is a critic and essayist. Her work has appeared in *The New York Times, The New Yorker, Vogue,* and others. In 2019, she was the recipient of a National Magazine Award.
Twitter: @dstfelix

Mecca Jamilah Sullivan, PhD, is the author of the short story collection *Blue Talk and Love* and winner of the 2018 Judith Markowitz Award for Fiction. Her work has earned the James Baldwin Memorial Playwriting Award, the Charles Johnson Fiction Award, the Glenna Luschei Fiction Award, and honors from the National Endowment for the Arts, the Bread Loaf Writers Conference, Yaddo, Hedgebrook, Lambda Literary, the Publishing Triangle, the Mellon Foundation, the Social Sciences Research Council, the American Association of University Women, Duke University, the Center for Fiction, and others. Her scholarly monograph *The Poetics of Difference: Queer Feminist Forms in the African Diaspora* is forthcoming. She is an assistant professor of English at Bryn Mawr College, and is completing a novel.
meccajamilahsullivan.com • Facebook.com /meccajamilah • Twitter: @mecca_jamilah

Megan Tatem created the "recipe" symbol that appears throughout this book. She is a New York based designer, and works at *The New York Times.*
Twitter: @tatemegan • Instagram: @tatemegan

LVaughn "Vino" Taylor is a photographer and videographer in Chicago. His specialties include music videos and portrait, event, and concert photography.
Instagram: @lvaughn_taylor

Rodan Tekle is a digital artist and designer living and working in NYC. In her ongoing research, she is interested in exploring the cinematic and documentary possibilities associated with the daily encountered, lived within a screen environment.
rodantekle.com • Instagram: @rodanada

Hank Willis Thomas is a conceptual artist working primarily with themes related to perspective, identity, commodity, media, and popular culture. His work is included in numerous public collections, including the Museum of Modern Art in New York, the Solomon R. Guggenheim Museum, and the Whitney Museum of American Art, among others. Thomas is a recipient of the Gordon Parks Foundation Fellowship (2019), Guggenheim Foundation Fellowship (2018), Art for Justice Grant (2018), AIMIA | AGO Photography Prize (2017), and Soros Equality Fellowship (2017), and is a member of the New York City Public Design Commission.
hankwillisthomas.com • Facebook.com/hankwillisthomas • Twitter: @hankwthomas • Instagram: @hankwillisthomas

Tourmaline is an award-winning artist and filmmaker. Her work includes *Salacia, Atlantic is a Sea of Bones, The Personal Things, Lost in the Music,* and *Happy Birthday Marsha!* She is an editor of *Trap Door,* an anthology on trans cultural production (New Museum & MIT Press).
tourmalineproductions.com • Twitter: @tourmaliiine • Instagram:@tourmaliiine

Gioncarlo Valentine is an American documentary and portraiture photographer and writer. Valentine hails from Baltimore and attended Towson University in Maryland. His work focuses on issues faced by marginalized populations, most often focusing his lens on the experience of Black/LGBT communities. Through his images, Valentine seeks to reckon with his traumas, dissecting complicated ideas of home, community and longing. He is interested in showing the everyday experiences of Black and Brown people, irrespective of an outside gaze, from a place of love and authenticity. Ultimately, his goal is to aid in the deconstruction of antiquated internalized notions around race and gender while building an archive of Black histories.
gioncarlovalentine.com • Instagram: @gioncarlovalentine/

Linda Villarosa runs the journalism program at the City College of New York in Harlem and is a contributing writer at *The New York Times Magazine.* She is working on a book about race, health, and inequality.
lindavillarosa.com

Amira Virgil is a streamer and content creator living in New York. She creates content with a focus on individuality and diversity.
xmiramira.com • Twittter: @Xmiramira

Kara Walker is best known for her candid investigation of race, gender, sexuality, and violence through silhouetted figures that have appeared in numerous exhibitions worldwide.
karawalkerstudio.com

Carrie Mae Weems is widely renowned as one of the most influential contemporary American artists living today. Over the course of nearly four decades, Weems has developed a complex body of work employing text, fabric, audio, digital images, installation, and video, but she is most celebrated as a photographer. Activism is central to Weems's practice, which investigates race, family relationships, cultural identity, sexism, class, political systems, and the consequences of power. Over the last thirty years of her prolific career, Weems has been consistently ahead of her time and an ongoing presence in contemporary culture. Her work is organized into cohesive bodies that function like chapters in a perpetually unfolding narrative, demonstrating her gift as a storyteller. *The Kitchen Table Series* (1990), for instance, is one of Weems's most seminal works, and considered one of the most important bodies of

contemporary photography. Through her work, Weems tackles a number of complex contemporary issues, demanding reconsideration of predominant narratives throughout our history.
carriemaeweems.net

Leilah Weinraub is an American film director and conceptual artist. best known for *Shakedown* and *Hood by Air*.
leilahweinraub.com

Kehinde Wiley is an American painter from Los Angeles, known for his larger-than-life portraits that interrupt tropes of portrait painting, often blurring the boundaries between traditional and contemporary modes of representation and the critical portrayal of Black and Brown people.
kehindewiley.com • Twitter: @kehindewileyart • Instagram: @kehindewiley

Amanda Williams is a visual artist who trained as an architect. Her creative practice navigates the space between art and architecture, through works that employ color as a way to highlight the political complexities of race, place, and value in cities. Williams has received critical acclaim, including being named a USA Ford Fellow and a Joan Mitchell Foundation grantee. Her works have been exhibited widely and are included in the permanent collections of the Art Institute of Chicago and the Museum of Modern Art in New York. She lives and works on the South Side of Chicago.
awstudioart.com • Instagram: @awstudioart

Raquel Willis is a Black queer transgender activist, writer, and speaker dedicated to inspiring and elevating marginalized individuals, particularly transgender women of color. She is currently the executive editor of *Out* magazine and the founder of Black Trans Circles through Transgender Law Center (TLC).
raquelwillis.com • Twitter: @RaquelWillis_ • Instagram: @raquel_willis

Loveis Wise, who created the contributor portraits for the conversations throughout this book, is an illustrator and designer based in Philadelphia, from Washington, DC. She has worked with clients such as *The New York Times, The New Yorker,* Cartoon Network, and Google.
loveiswise.com • Instagram: @loveiswiseillu

Alisha Wormsley is an interdisciplinary artist and cultural producer. Her work is about collective memory and the synchronicity of time, specifically through the stories of women of color. Wormsley's work has been honored and supported with a number of awards and grants to support programs: The People Are the Light (part of the Hillman Photography Initiative), afronaut(a) film and performance series, Homewood Artist Residency (recently received the mayor's public art award), the Children of NAN film series and archive, There Are Black People in the Future body of work. Wormsley is currently working on a public park design around community and sustainable water, a temporary installation in Pittsburgh's Market Square, and creating a public program to put her text "There Are Black People in the Future" in residence to open up discourse around displacement and gentrification. Wormsley has an MFA in film and video from Bard College. In 2019 she was awarded the Presidential Postdoctoral Research Fellowship at Carnegie Mellon University.
Alishabwormsley.com • Instagram: @alishabwormsley

Lynette Yiadom-Boakye was born in 1977 in London, where she is currently based. Her paintings are rooted in traditional formal considerations such as line, color, and scale, and can be self-reflexive about the medium itself, but the subjects and the way in which the paint is handled are decidedly contemporary. Her predominantly Black cast of characters often attracts attention.

PERMISSIONS AND CREDITS

Shadi Al-Atallah, *I used to feel (before Lamictal)*. Mixed media on unstretched canvas, 145 x 180 cm.

Pages 166–71: Sable Elyse Smith; Images: Copyright s.e.a.; Christian Cody; Reginald Eldridge, Jr.; Kevin Hinton/Kreative71; Copyright 2018 Jazzmyn Hollis; Copyright 2016, The House of Malico/Sasha Kelley; Setti Kidane; Kene Nwatu, 2017; Copyright 2019 Guarionex Rodriguez Jr.

Page 181: @goodpals/@homieswithhanford

Pages 182–84: Originally published in *Harvard Divinity Bulletin*. Images: The Artist and Kohn Gallery, Los Angeles

Page 188: © Kerry James Marshall. Courtesy of the artist and Jack Shainman Gallery, New York

Page 189: © Toyin Ojih Odutola. Courtesy of the artist and Jack Shainman Gallery, New York

Pages 192–95: Kia Damon

Pages 196–99: Hanif Abdurraqib. Images courtesy of the artist and Monique Meloche Gallery, Chicago

Pages 200–1: Image courtesy of the artist and JTT, New York

Pages 202–11: All images taken by Devin N. Morris for 3 Dot Zine

Pages 212–215: Documenting the Nameplate

Pages 216–17: Angel Nafis (previously published in *Prelude* magazine). Image: Nakeya Brown

Page 220–21: Art by Cyrée Jarelle Johnson, Vilissa K. Thompson, and Micah Bazant; Jonathan Ernsey/Reuters Thompson

Page 222: Aaron Ricketts, the Ricketts Company

Page 224–27: Courtesy Yasmin Elnour (Kandaka Chronicles); AFP via Getty Images

Page 243: Image courtesy Jana Augustin

Pages 244–45: Courtesy of the artist

Pages 246–49: Photographs by Nadia Huggins

Pages 254–57: © Kara Walker

Pages 258–63: Morgan Dixon and Vanessa Garrison, "The Trauma of Systematic Racism Is Killing Black Women. A First step Toward Change . . . ," TED2017

Pages 266–67: Meron Menghistab; Anya Savnoe; April Thomas

Page 269: Courtesy of the Ben Enwonwu Foundation

Page 272–3: Jameel Mohammed

Pages 278–81: © 2019 Jerome Harris. Essay and illustration by Jerome Harris

Pages 290–93: BBZ London 2019; © Michael Bilsborough

Pages 304–11: Images © Zanele Muholi. Courtesy of the artist, Yancey Richardson Gallery, New York, and Stevenson Cape Town/Johannesburg

Pages 312–13: Courtesy of the artist Deborah Roberts

Page 317: Image: Maty Biayenda

Pages 318–21: © 2015–2019 manuel arturo abreu; Image: © 2016, RaFia Santana

Page 322: Flo Ngala

Page 326: Angela Weiss/AFP

Page 329: E. Jane, *Sandra Bland is Not Alive and Someone Is Responsible*. 2016. Instagram post.

Page 333: Image: Courtesy the artist and Lehmann Maupin, New York, Hong Kong, and Seoul

Pages 336–39: Copyright Kia LaBeija—All Rights Reserved.

Pages 340–43: Eve L. Ewing, 2017. Image: Zora J. Murff

Pages 344–45: Equal Justice Initiative/Human Pictures

Page 346: Adam Anderson/Reuters; Matthew Stockman/Getty Images

Pages 348–49: Kameelah Janan Rasheed

Pages 351–52: Courtesy the artist and Casey Kaplan, New York; M. Florine Démosthène

Pages 358–61: By Sarah Lewis © 2019; images courtesy of the artist and Jack Shainman Gallery.

Pages 362–65: BCP Literary, Inc.

Pages 366–67: Write/Speak/Code + DAG Images.

Page 376: Angela Weiss/AFP; Caster Semenya by Dana Scruggs for *Out* magazine; Paras Griffin/Getty Images; courtesy and copyright of Awol Erizku

Pages 386–93: Antonio M. Johnson

Pages 400–01: "Pop for You" © 2015, Courtesy of Junglepussy™

Pages 402–06: © Teju Cole

Pages 408–09: Kerrilyn Gibson 2019

Pages 414–15: Images courtesy of the artist

Pages 416–21: Pyer Moss Apparel, LLC

Page 423: Nontsikelelo Mutiti

Page 426: Marcio Jose Sanchez/Associated Press; Michael Reaves/Getty Images

Page 438–39: Tourmaline

Pages 440–45: *Shinnecock Nation* by Rahim Fortune (2018); *Drums Along the Hudson* by Rahim Fortune (2018)

Pages 446–49: POSE © 2018 Twentieth Century Fox Television. All rights reserved; *Shakedown at The Study*, 2008 by Leilah Weinraub

Pages 456–61: Images: Gioncarlo Valentine

Page 463: Image courtesy of the artist and Charlie James Gallery

Page 471: Shani Jamila

Pages 480–81: Ola Osaze

Pages 490–93: © Dawoud Bey, courtesy of the artist and Sean Kelly Gallery

Pages 494–95: Caleb Femi; image: © Lynette Yiadom-Boakye. Courtesy of the artist, Jack Shainman Gallery, New York and Corvi-Mora, London

Page 496: David Leggett, courtesy of the artist and Shane Campbell Gallery, Chicago

Hanif Abdurraqib

Nina Chanel Abney

Suzanne Abramson (s.e.a)

manuel arturo abreu

Navild Acosta

Shadi Al-Atallah

Courtney Alexander

Tyahra Simone Angus

Appolition

Jana Augustin

Firelei Báez

Sam Bailey

De'Ara Balenger

Sadie Barnette

BBZ London

Alexandra Bell

Salehe Bembury

Dawoud Bey

Maty Biayenda

Michael Bilsborough

McArthur Binion

King Britt

André Brock

adrienne maree brown

LaKela Brown

Nakeya Brown

Rembert Browne

Simone Browne

Destiny Brundidge

Brennen Buckner

Lawrence Burney

Tina Campt

Jordan Casteel

Jonathan Lyndon Chase

Jace Clayton

Ta-Nehisi Coates

Christian Cody

Teju Cole

Kia Damon

Akinola Davies, Jr.

Aria Dean

Decolonize This Place

Florine Démosthène

T. Morgan Dixon

Documenting the Nameplate

Kimberly Drew

Jackie Sibblies Drury

Mina Elise Echevarria

Ezra Edelman

Yousra Elbagir

RJ Eldridge

Melissa Bunni Elian

Yasmin Elnour

Ben Enwonwu

Eve L. Ewing

FAKA

Tatyana Fazlalizadeh

Caleb Femi

(F)empower

Brendan Fernandes

Rahim Fortune

Siedeh Foxie

LaToya Ruby Frazier

Ziwe Fumudoh

Sandra Garcia

Vanessa Garrison

Alicia Garza

Kerrilyn Gibson

Hannah Giorgis

Renee Gladman

Naima Green

Rahawa Haile

Errin Haines

Lauren Halsey

Nikole Hannah-Jones

Jeremy O. Harris

Jerome Harris

Cyndia Harvey

Sean D. Henry-S

Kevin Hinton

Jazzmyn Hollis

Shawné Michae

Sasha Huber

Nadia Huggins

Frankie DeCaiz

Juliana Huxtabl

Samantha Irby

Texas Isaiah

Arthur Jafa

Ayana Jamieso

Shani Jamila

E. Jane

Antonio "Tone"

Ayana Elizabetl

Cyrée Jarelle Jc

Jasmine Johnso

Rhianna Jones

Jonell Joshua

Junglepussy

Rawiya Kameir

Sasha Kelley

Thebe Kgositsil

Setti Kidane

Solange Knowle

Kia LaBeija

Deana Lawson

Thomas J. Lax

Kiese Laymon

Carolyn Lazard

David Leggett

Sarah E. Lewis

Chokwe Antar L

Emilio Madrid